2

DATE DUE

BLACK ARTISTS
OF THE NEW GENERATION

Black Artists of the New Generation

ELTON C. FAX

Foreword by ROMARE BEARDEN

Illustrated with photographs

DODD, MEAD & COMPANY
NEW YORK

To the memory of my mother

Library of Congress Cataloging in Publication Data

Fax, Elton C
 Black artists of the new generation.

 1. Afro-American artists—Biography. 2. Afro-
American art. 3. Art, Modern—20th century—United
States. I. Title.
N6538.N5F29 709'.2'2 [B] 77–7053
ISBN 0–396–07434–0

Acknowledgments

Because I could never have written this book without the aid of others it is fitting here that I make special mention of those individuals and sources who helped me get it together.

To each of the twenty artists who took the time and trouble to furnish me with photographs and to talk so frankly about their lives and work I am profoundly grateful. Without them this book could not be. In this connection I am also indebted to friends who brought to my attention those artists of their particular regions of whom I had previously known little or nothing. Edith Adams of Santa Fe, New Mexico; John Biggers of Houston, Texas; Alonzo Davis of Los Angeles, California; Tom Feelings of New York City; Reginald Gammon of Kalamazoo, Michigan; Thomas Johnson of Columbia, South Carolina; Joan Maynard of Brooklyn, New York; E. J. Montgomery of San Francisco, California; and John Wilson of Boston, Massachusetts, have been particularly helpful in that respect. Nor can I forget the aid offered by Agnes Conway of Brooklyn, New York, and Noel Hinton of Ann Arbor, Michigan, who filled in the gaps as I interviewed Onnie Millar and Al Hinton.

There was that critical period when I desperately needed the tranquil environment in which to set down on

paper the material I had gathered and carefully organized. I was led to that environment through George and June Branche who, along with Fritz and Emily Kunreuther, recommended me to The Rockefeller Foundation. The latter then extended me an invitation to work for one month in an atmosphere of peaceful luxury at its Bellagio Research and Study Center in northern Italy. There at the Villa Serbelloni I was able to get the writing well started under the caring eyes of Villa hosts, Bill and Betsy Olson and their staff of local assistants. And I worked there in complete confidence that back home my loving and trusted partner, Betty, was taking excellent charge of a demanding situation.

It is also to Betty that I owe special thanks for the reading and typing of the manuscript. And to my friend and colleague, Romare Bearden, I am particularly indebted for the reading of the manuscript and his subsequent writing of the foreword to it.

Finally I want to thank my publisher and especially my editor, Allen Klots, for doing what they always do with such efficiency and understanding.

Preface

In the opening sentence of my preface to *Seventeen Black Artists* I issued this warning: "If you are looking for a story loaded with fashionable cocktail party clichés about art and the people who produce it this will not be to your liking."

Black Artists of the New Generation is an extension of *Seventeen Black Artists*. As its title suggests, it deals mainly but not exclusively with the younger postdepression artists; for it is they whose lives and works were so directly touched, and often seared, by the fiery turbulence of the nineteen fifties and sixties. One must realize, however, that as we use the term "young" we consider that full creative maturity does not normally occur before the artist reaches his forties and fifties. Six of these twenty artists are past forty-five. The remaining fourteen are younger and the average collective age is thirty-eight.

Like my other book this does not pretend to present "the elite" group of black artists. This, too, is a symbolic group. Though all have demonstrated their professionalism, any acclaim and public success they have received are not my sole reasons for selecting them. The media they work in are as varied as their styles, and they live and work in all the major geographic areas of this country. Along with most other American artists they find the going rough if they try

to support themselves and their families solely by art. So most of them teach in order to survive. Even so, they are subjected, as artists, to one form or another of brazen exploitation and shameless official neglect.

These twenty artists, representing a nonwhite minority, are too often expected to fit into a special niche. It is a niche not necessarily comparable to the full range of their skills. That fact in itself is mirrored to some degree in what they feel, think, and produce. And what they produce sometimes zeros directly in on such inequities as they are forced to face. Where they deliberately choose not to comment upon that aspect of their experience one knows that such side-stepping is itself often a form of protest against unfair pressures induced by racism. It is precisely because such pressures exist that a book like this is not only possible but necessary.

I must make it clear also that I have not chosen to write about these particular artists on the basis of cronyism. Indeed more than half of them are people I had never seen before they granted me interviews. The others, with the exception of Onnie Millar of Brooklyn, New York, are people I had barely met, though their works were known to me. Nine of the twenty here are women.

Like their predecessors all of these artists, possessing varying strengths and weaknesses, struggle valiantly against odds. Indeed they work as much because of opposition as in spite of it. Their lives, like those of all humans, include encounters with joy and grief, frustration and fulfillment. Like their predecessors a few of them chose to meet those encounters with a defiance of conventional custom. At their best, however, all of them are true delineators of our national character and reliable chroniclers of our times.

And here again, as I did in *Seventeen Black Artists*, I issue a warning. To those readers seeking mere fashionable chit-chat about twenty American artists who are black, do not proceed beyond this page. You won't find it here either.

Foreword

One evening in Paris shortly after World War II a fellow artist asked me to go with him the following morning on a round of art galleries. He was anxious to find a gallery in which he could have a show. Not only did he want moral support, but since his French was limited, despite his having been in France for several years, he wanted me to translate for him.

Often one has a premonition of quagmires ahead, so I quickly told him that my French was almost as bad as his. He was persuasive, however, and I sensed a note of desperation in his voice. Reluctantly I consented to go along with him.

This artist's father was a wealthy industrialist in the midwestern United States. The problem though, at least for the son, was that the father wanted his son to give up the idea of an art career, return to the States, and go into the business. In fact, he refused to send this young artist money or otherwise assist in his career. At the time my friend asked my help he was living on his G.I. Bill which I knew was about to expire. I therefore understood his desperation in trying to make some connection in the Paris art establishment.

The next morning I met him rather early. He had loaded his paintings onto a pushcart and we started out to-

ward the rue de Seine where there are a number of galleries. All day long we went from gallery to gallery, encountering the same despairing raising of the arms. We left each gallery with the feeling we were the bearers of plague, not art. Finally, near closing time for the galleries, we came to one on the Right Bank. When the owner saw us he walked to the rear of the gallery. With his arms folded behind his back he continued to stare out of the rear window. After a while I cleared my throat to draw his attention. Without turning around he said, "I know what you are here for. Please tell your friend, even if he is Rembrandt, to leave. Kindly leave. What I need now is *customers*, not any more artists."

When we were outside my friend asked me what the gallery owner had said. I told him that the owner, even without looking at his work, was certain that he was a good painter, but that the gallery was solidly booked up for the next two years—so solidly he couldn't possibly squeeze Rembrandt into his schedule. From his expression I could tell that, after a long day of disappointments, my friend knew that I was only trying to lessen the sting of rejection.

On our way across the Pont Neuf to our briar patch on the Left Bank my friend suddenly dumped all his paintings into the Seine. I thought he must have lost his mind, so I grabbed him lest he, himself, might follow his works.

"Don't worry," he said. "I'm just making certain I have some kind of exhibit before I leave."

The paintings floating on the swift current of the river did cause a commotion. My friend said more people were seeing his paintings from the bridges than if he had achieved a gallery exhibition.

"I'm going home," he told me as the paintings disappeared. "This art world is too tough for me."

I mention this incident as an indication that the attempt to find a fairly secure place in the art world is extremely difficult for anyone, no matter how richly endowed the artist

is with talent or with worldly possession and influence. This does not by any means imply that selling one's art or being represented by a gallery is to have reached the bowers of bliss. It's the ability to give each day the best justice one can give on canvas, or stone, or whatever the medium, to those things of the visible world as well as to the concepts of the unseen world of emotion and imagination. This is arduous. I understand that Churchill and Eisenhower derived a great deal of relaxation from their painting. Not so for the true artist, because the canvas, the stone, are constantly saying "No" to him. I think it was Melville who said to a young writer that he'd rather feel his spine than read his work. Courage and perseverance are basic requisites.

In view of all this, it has been enlightening for me to have read the illuminating interviews with twenty young black artists skillfully conducted by Elton Fax. The artists interviewed come from nearly every section of the country. To support their art they have had, and some of them continue, a wide divergence of employment. One woman sculptor was an employee of the U. S. Internal Revenue Service; one man was a professional football player; another artist was the son of a cowboy; another a computer analyst; and, for one final example, one young woman was trained as a bacteriologist. One thing they all share in common, however, is the travail they had in acquiring the rudiments of an art education and in continuing to function as artists. In no case was there a wealthy father to whom they could return (if the vibrations in art became discordant) and become the firm's Vice President.

In reading these interviews a pertinent fact comes to mind that is indicative of how the opportunities to obtain an art education for minorities has improved. During the 1920s and 1930s when black students sought an art education there were only a few art schools to which they could find admission. The Art Students League and the National Acad-

emy in New York City; The Chicago Institute; The Philadelphia Academy; and the John Herron Art Institute in Indianapolis come most readily to mind. During those years, the colleges for the most part had not inaugurated the large art departments of the present. Among the black institutions, Howard, Fisk, and the Atlanta University complex were practically the only ones offering competent art instruction. But this has changed. It is encouraging to learn that students enroll at Texas Southern for the advantage of studying with John Biggers. From personal observation I find that Fisk has good opportunities for the art student, and in addition has a working agreement with Vanderbilt University whereby students in either institution can take courses on both campuses. And I found the art course at Hampton Institute with its personal attention to the students most admirable. I'm sure this is true of other black colleges as well.

Despite the obvious advantages presently available, I do sense a feeling of isolation, perhaps loneliness, which comes through the statements of some artists interviewed. This aspect is not advantageous for the young artist. It is the camaraderie and the opportunity for the exchange of ideas that is so important to an artist's development. One cogent reason that so many painters and sculptors went to Paris was that they learned as much about their craft at discussions around café tables as they did at the art academies. During my years as a young artist in the Harlem of the 1930s nearly all the artists knew each other and were frequently together. But maybe loneliness and isolation are part of the malaise of this era.

On the other hand, the energy and desire shared by all these artists is unmistakable and this is very encouraging. After all, art must go where energy is.

ROMARE BEARDEN

Contents

Maurice Burns

HE is a brainy and a gifted man. Eccentrically attired, tall and handsome, he doesn't begin to look his forty years. Ten years ago it seemed to his wife and their associates that Maurice had everything going for him. In the words of one of Bessie Smith's old blues tunes, Maurice Burns had "the world in a jug and the stopper right in his hand."

I was living on the twenty-eighth floor of a Chicago luxury high-rise, wearing Brooks Brothers suits and driving an expensive sporty Porsche. I even had attaché cases to match each outfit I wore—the whole works. We ate and drank in all the expensive restaurants and bars—on a liberal expense account. My wife was elated over our success.

He pauses, smiles, and lifts his long legs to the couch of his adequate, but far from luxurious studio in Santa Fe, New Mexico.

. . . But, man, I just couldn't see devoting the remainder of my life to that and to the pursuit of its shaky values. There I was thirty-one and already trapped in that life. I simply couldn't stand the feeling!

Just what did happen to change Maurice Burns's view of the world, and especially his view of his relationship to

it? The answers lie deep in the events ranging from a childhood in an Alabama town to his success as a computer expert for the Chicago Telephone Company.

He was the third child, the only boy, born to Maurice and Ruby (Goins) Burns, both natives of Alabama.

> I was born in Talladega, the county's seat. It's a small Alabama town complete with Ku Klux Klan and all. We lived in a small area where we used outdoor toilets, wells, and all the other blights of the underdeveloped community. We lived in McCansville, an area where the paved highway ended—where the street light and all other electrical and other modern improvements ended. That was McCansville—the section that started where everything else ended!

He laughs with that robust irony black people in America have learned to use as a safety valve. Laughter at such things comes easily to this light brown, bearded man whose grandfather, Andrew J. Burns, resembled a typical white-haired redneck. The old man's second wife, Lillie Turner, was pure Chocktaw. Their son, Maurice, the artist's father, was of Indian-African-Scots mixture. Of his grandfather's first marriage Maurice, the artist, knows little. That side of the family, considering itself white, has kept aloof from the other side. Maurice remembers how as a child he would ask the kinds of questions children ask about such things and how mysteriously and unfailingly his questions went unanswered.

> But my ninety-four-year-old maternal grandmother still lives in Alabama. She, too, is of mixed blood. So I'm going down there and really look into the files. There's a lot of information I must have, for one of the main things I've had to face for myself was not ever to deny who I am.

Black children of McCansville, when they attended elementary school at all, went to the grade school on the campus of black Talladega College. That is where Maurice went until a school for black youngsters was built.

It was on the other side of town, and that meant we had to walk four miles through the white area every day. Yes, we had to pass their huge high school and stadium and we had better go in a group, too. Even so we were compelled to engage in rock fights with the white kids. And those fights usually ended with the cops coming in to chase us off.

A knowing look, a pause, and then—

We came to regard that as one of the hazards of going to school—a thing we accepted as one accepts a hard rain.

Once settled in the school Maurice recalls that the class sessions were little more than slightly advanced baby-sitting ventures. The overcrowding made it impossible for the teacher to give needed individual attention to anyone, and kids with bright active minds fell into mischief. Maurice was very bright. At home he took clocks and electric irons apart and reassembled them. And in school he was writing in longhand while his classmates struggled with crudely printed letters. Moreover he drew constantly and was always in some mischief.

Recreation was limited in Talledega, and like most youngsters Maurice liked movies. In order to see them black folk never entered by way of the lobby. They bought their tickets, then went around the corner and up the fire escape stairway to that section reserved for them. One day Maurice decided to buy some popcorn before climbing the fire escape, so he went to the lobby where it was sold. "WHO LET THAT NIGGER IN HERE?" the startled clerk bellowed. When

Maurice told his parents about that they decided then and there to leave Alabama.

The senior Burns was a bricklayer and a good one. It was a trade he'd learned from his father. He worked fast and clean and it didn't take long for him to become a crew foreman. So when he resolved to move his family north to Gary, Indiana, he felt confident of finding work there upon their arrival in 1949.

Gary, Indiana's reputation in 1949 was nothing to be envied. Political corruption attracting organized crime and vice had earned it the nickname, "Sin City of the Midwest." The United States Steel Corporation and the Democratic political machine were the town's chief employers. The former had attracted immigrants from middle Europe and black migrants from the South to labor in its vast mills. Rivalry for jobs induced and kept the fires of bitter feeling smouldering between the two groups. Bricklayer Burns, in seeking a better way of life from that in Alabama, had unwittingly brought his family into a new area of racist hostility.

As a black man who was an expert at his trade he could get all the work he could do in the South, even though he couldn't buy popcorn in the lobby of a movie house. The old South was oddly inconsistent in such matters. In Gary he could enter the lobby of a theater but was barred from earning a livelihood. The trade unions who handled the big contracts didn't want to admit black artisans. But the Senior Burns managed to get into the union anyhow. Still his problem wasn't solved. His son describes it this way.

My father often had the experience of being sent from the Union hall to the work location, working for two hours, given his check, and let go while others continued working. They had to pay him for at least four hours.

Thoroughly familiar with his father's bricklaying skill, Maurice, himself a promising apprentice, was not surprised that a small local contractor offered steady work. When the firm made the elder Burns foreman he sent to Alabama for some buddies to join his crew in Gary where they did a number of larger jobs requiring several months. As it became too cold to work outside they had ample indoor work to keep them busy. The Burns crew was gaining respect in Gary.

Young Maurice, meanwhile, was enrolled in the seventh grade of the Gary Roosevelt High School, whose staff and students were all black. There he remained until he finished high school.

I was a gangling skinny kid then. Why when I was sixteen I was six feet tall and weighed a whopping 135 pounds! Coming up as I had from the South the teachers and pupils alike assumed I just had to be a slow, dumb, country nigger. So they put me in a slow class. Now even though I got started two weeks late, in another two weeks I was ahead of the class. So they put me in the advanced group with the gifted students and there I stayed until graduation.

Though Maurice was constantly drawing while at Gary Roosevelt High little attention was paid to his skill, largely because he was regarded as "a smart troublemaker." But he was also good in math and the school's counsellors advised him to look toward a career in engineering. "Now that's a coming thing for our young men," they'd tell him. Or they would advise the old standbys—medicine, law, or teaching—to which blacks with intelligence traditionally aspired.

The summer following graduation from high school Maurice worked with his father's bricklaying crew. He then entered Purdue University in the autumn of 1956. There were about fifty black students among the 12,000 at Purdue

and most of them were on the football and basketball teams. Maurice Burns played basketball and ran cross-country. But with little desire to be an engineer he dropped out after three years to travel through the South with his father's all-black crew. That trip gave him a thorough understanding of why his father had left their native Dixie.

> As we drove through hostile white towns—and this was as recent as 1959—we saw the occasional warning sign—"NIGGER, WHEN THE SUN GOES DOWN BE GONE!" To steady our nerves we'd stop by the moonshiner's and get a bottle. We'd pass it around once and that was it! At first I couldn't abide the stuff, but before long, man, I'm telling you I became a "white lightning" connoisseur! Man, I could smell it, shake it, or just look at it and tell you if it was any good!

Because of his age when he left school, Maurice was drafted into the armed services and was sent to Fort Leonard Wood for basic training. There he was tested for special training. He passed with such high grades that the authorities told him, "You qualify for any kind of school you want us to send you to." Maurice chose a school of electronics in New Jersey for one year's study. His first fifteen months in the army combined basic military training and special schooling. But in 1960 Maurice struck a snag that prevented him from obtaining official clearance.

He had started running around with a "soul brother" from Albuquerque, New Mexico, named Esau Bradley. Maurice describes Bradley as "a character with a mouth full of gold teeth who wore red suede shoes he'd had custom made in Mexico." Worse still from the army's viewpoint, Bradley was an outspoken "militant" who eagerly devoured every sermon Malcolm X ever preached. Maurice grins as he recalls their erratic meanderings together.

> Every weekend when we were on leave I was up in New York with Bradley. We were there when Fidel

Castro and his entourage moved from a midtown hotel to the Theresa Hotel in Harlem where Nikita Khrushchev paid him that highly publicized visit.

With that kind of gadding about New York it is not difficult to understand the disapproval of the conservative army organization of such maverick conduct. Bright Maurice Burns, fully aware of what he was doing, was not surprised by the army's retaliatory action.

The military actually didn't want any of "us" in this top-secret crypto clearance which is the highest clearance given. So they used every excuse to keep me out. My flitting about with Bradley provided the perfect excuse. So they took my crypto clearance. I couldn't work in a Military Occupational Specialty (M.O.S.) after I was fully trained!

That denial of clearance, designed to teach Burns a lesson, neither shocked nor crushed him. "It only increased my militancy," he laughs. Meanwhile, because of his background in math, Maurice had qualified above white soldiers for entrance into meteorology school, which he attended. When he finished, the authorities had him teach the whites over whom he had qualified and after Maurice taught them, they got the promotions. He remained Private First Class for three years!

It was then that I reached the turning point. I had a scheme for everything they came up with, all within my legal rights, and they couldn't pin a court martial on me. But I never got rank even though I was teaching classes and named *Soldier of the Month*.

Even so he managed, in comparison with many blacks, "to use the army as a country club." Whenever he spoke he did it quietly and sharply, never missing the chance to let them know he considered racist whites to be his real enemy.

For that he was constantly shifted about. From New Jersey he was sent to Oklahoma and from there to Okinawa by way of Hawaii and Japan. He later went to Korea. All told Maurice saw three years of service in the Far East, sixteen months of it in Okinawa. Again he exhibited a talent for being "troublesome" during training sessions in Okinawa.

I'd get up in class and raise a question that was bound to embarrass the American position with regard to nonwhites.

And to clinch his unpopular position with the authorities, Maurice Burns became friendly with the Okinawans, visiting their pubs, bars, and homes, and finding general acceptance among them. Such deportment was officially frowned upon by whites even as they had no qualms about patronizing Okinawa's brothels.

It was Maurice's understanding of the character and scope of white America's racism that prompted his friendship with Okinawans. He knew that to racist whites, Orientals and blacks were subhuman.

I got out just before the big buildup in Vietnam. At that time they were using Special Forces as advisors and they were using regular army guys in Ordinance and Quartermaster and Signal Corps services.

March of 1963 was when Maurice Burns arrived in California. A great deal in which he held a personal stake was about to take place in the United States. He hung around Los Angeles for a short time dabbling in art but not taking it seriously. From Los Angeles he went to Chicago and thence to Marion, Indiana, where one of his sisters lived. There he went to the local RCA factory where TV tubes were made and sought work, being careful as he applied to list his math qualifications and overseas army service. He got a job—flattening empty boxes!

In the year marking the centennial of the Emancipation Proclamation the only job a black veteran of his skills could get was a menial one. Maurice Burns readily recalled the warnings of Malcolm X that black men in America could expect no justice from white men. Meanwhile, highlighting the fact of American racism was the now historic March On Washington from which Martin Luther King's, "I Have A Dream" address emerged as one of the world's great speeches. Maurice Burns had been back home from Asia barely five months. Three months later President John F. Kennedy was murdered in Texas.

Thoroughly disgusted with events Maurice returned to Gary to lay bricks with his father, before taking a turn at selling clothes. Just a few weeks following the advent of 1964 came another shocker. Malcolm X was shot dead on a Sunday afternoon in New York City's Audubon Ballroom.

During that year Maurice returned to school. He took night courses in advanced math at the Illinois School of Technology, before getting a job as an installer with the telephone company in Gary. Still his leaning in art took him to various exhibitions in and about Chicago. In the interim the telephone company was about to install its new electronic "touch dialing" system. Maurice speaks of that period.

We were tested for various jobs in the new system and since I came out quite well on the tests they sent me to computer school in Chicago. When I finished with that they put me in charge of a computer center on Chicago's West Side. That was the summer Martin Luther King, Jr. was in Chicago, and all that trouble and rioting had broken out there.

The "trouble" in Chicago was but one more of many violent episodes occurring in the nation's northern black communities during 1964 and 1965. New York, Jersey City,

Philadelphia, and Dixmoor, Illinois, were the settings for others.

True, Martin Luther King, Jr. did receive the Nobel Peace Prize in 1964, Sidney Poitier was the first black film actor to win an Oscar, and Carl Rowan was appointed director of the United States Information Agency. But such achievements were all but submerged under the news and dramatic pictures of rioting and looting by angry and frustrated blacks. Nor did the equally shocking news pictures of unprovoked state police violence against peaceful black marchers in Selma, Alabama, soften white attitudes toward blacks. None understood that better than Alabama-born Maurice Burns. And here he reveals the depth of his mistrust and his anger.

> Man, now that I finally had a job equal to my skills I was very careful not to mess up. That's all the racists would need. Oh, I showed my rebellion a bit here and there and once in a while someone would pull me aside and coaxingly urge me to "tone it down just a little." But because I was the best programmer they had and since I worked on the most advanced system, they had no choice but to tolerate my small idiosyncrasies.

As has already been stated, Maurice and his newly acquired wife began to live well in the sense that they enjoyed a number of physical comforts. Still the job and what he particularly regarded as its superficial and meaningless nontechnical requirements irked him. And he was ever aware of the racism festering beneath the elegant manners and polite talk. Again, the anger.

> They tried all sorts of little subversive tricks to make me look bad, but I always managed to keep a step or two ahead of them. Then, too, my marriage was growing shaky. (We'd married late in 1965.) After seeing

two white workers, who knew less than I, promoted ahead of me I finally left the company.

Maurice Burns wasn't out of work long. Garland Frazier, a black man in charge of the computer section at Chicago City College, asked Maurice to join him there. He did. Things went well for it was a civil service job and in his own words, "I did a good job where others before me had faltered." Soon he was in for a big raise and lots of responsibility. At the same time his marriage of four years began to founder. Things grew desperately acute and he had taken all he could handle emotionally.

Recalling that tests he took prior to leaving the army indicated as strong a leaning toward art as toward technology, Maurice sought and got G.I. Bill support. It had been suggested to him that he try the department of design at Illinois Tech, and since he did not have a degree, he was urged to get that also.

But I defied all practical convention and decided to study drawing and painting. My wife and I were splitting and I'd had it! Everyone told me what a mistake I was making. But that had been a constant pattern every time I had left a job—from bricklaying, to the phone company, to computers. This time I decided I'd do what I wanted most to do! I let my wife have all the furniture and stuff and I sold my Porsche and took off —FREE AT LAST—for the Rhode Island School of Design.

The change had not come quite as suddenly, however, as might appear. Maurice had, in the interim, been sketching at night at the New Chicago School of Art, where the students were mainly black fashion illustrators and commercial artists. He had also met a lot of white artists and photographers in Chicago. One of the latter was Kurt Cole Burkhart from the well-to-do Indiana town of Rochester. At

one point Burkhart wanted Maurice to be his representative but as Burns puts it, "I was really getting into drawing." Whereas he had heretofore sought a profession from which he could earn good money, attending school with commercial artists and photographers was refreshingly stimulating and challenging. And while Maurice thought many of them were good at what they did, their work lacked the individuality and feeling he felt all art should have.

You could put a two-hundred-pound model before them and their drawings would still come out twelve heads tall and commercially slick. I wanted to get some character into whatever I was doing.

So it was as much the decision to do serious study as the desire to leave the immediate area that brought on the move to New England. Rhode Island was chosen in an odd way. Maurice had been scanning a copy of *National Geographic* magazine featuring the State of Rhode Island. The early American architecture appealed to him and his attention fastened upon a picture of a little house directly behind the oldest Baptist church in the United States. His eyes brighten as he exclaims, "Would you believe I wound up living in that very house?"

It was 1969 when Maurice Burns, ready to pursue the serious study of painting, arrived in Providence. John Torres was one of the first persons he met there. Torres, a vigorous young black sculptor from Jamaica, New York, had much to do with getting gifted black students enrolled at the Rhode Island School of Design. Indeed his interests extended well beyond the needs of artists who were black. It was he who during the 1960s had sought and found money at the Ford Foundation to establish a summer workshop in Saxons River, Vermont, for promising high school art students.

The selectees came from all over the United States. They represented moneyless, gifted young people, male and

female, from the nation's Indian, Chicano, Puerto Rican,
Oriental, white, and black communities. Torres believes im-
plicitly in the distribution of needed assistance among all
qualfied citizens. For his pains he was, on one hand, way-
laid and severely beaten by a gang of blacks who opposed
his plan to involve nonblacks in the program. The beating
resulted in the loss of an eye. On the other hand he was be-
loved by those he helped, many of whom went on to pur-
sue studies in professional schools such as that at Rhode Is-
land. Before John Torres joined the staff very few blacks
were enrolled in that school. Once there he saw to it that
those in whose behalf he had been working got the chance
to share the school's resources.

Using the extraordinary skills that had characterized
his working career, Burns could have finished in two years.
Since he wasn't there to earn a degree, and since he wanted
to paint, he switched from design and stayed for three years
on the G.I. Bill. With palms extended he emphasizes his re-
lationship there with the minority students.

Because I was the most experienced of the group
there was a lot of pressure on me to become an in-
volved activist. But they didn't know I'd been involved
in *Operation Breadbasket* in Chicago and had paid a
few dues in the army. So at that period in Rhode Is-
land I decided to put all my energies into the thing
I came there to do—PAINTING! And while I shied away
from meetings, the kids were welcome at my place to
talk and to see my work. In that sense I did set an ex-
ample for them.

At the end of his second year at the Rhode Island
School of Design Maurice received a scholarship to the
Skowhegan School of Painting and Sculpture in Maine. Two
black artists from Fisk University, David Driskell and Earl
Hooks, were there during the same summer. But the person

whose influence Burns felt most strongly was the eminent black painter, Jacob Lawrence, who was teaching at Skowhegan. Until he talked with Lawrence, Burns had believed that the work of a black artist had to be in the nature of protest to qualify as "black." Lawrence assured him that his first obligation was to be true to his vision and to produce the best art he possibly could. "You are born black," he told me, "and whatever you do when you let your emotions go —whatever comes out will be a reflection of your black experience."

At the end of the summer Maurice won the Skowhegan award given to "The Most Improved Painter." And when he returned to Providence he was, on the strength of his ability and seriousness, automatically passed for the remainder of that year. On his own to paint as he pleased he did just that while attending those academic courses that excited him. He smiles, rubs a hand over his bearded chin and the words come deliberately.

> Throughout my three years there in Rhode Island I concentrated intensely on painting. And since I never bothered to go home for Christmas I was able to give full time to my studies. Then for a brief time I contemplated graduate school and had acceptances from Yale, the University of Massachusetts, and the Maryland Institute. Because of its name Yale appealed to me and I might have gone there but for one thing. I had a loft studio in Providence and I was much more free there than I could have been at Yale. Besides I knew that the degree itself would not improve my painting.

He stayed in Providence, put six paintings and some graphics in a show there, and on the following day went to New York for a visit. The trip was far shorter than he intended it to be. Word came to him that a fire had gotten to his studio and he rushed back to Providence. Everything

he had done except what was in the show was a mass of
smouldering gray ash. The year was 1972.

Maurice Burns is, fortunately, the kind of man who
meets and likes people who, in turn, like him. Some of the
contacts he makes are with knowledgeable and well-placed
persons. Shortly after his studio loss a letter arrived from
London. Would he be interested in attending that city's
Royal College of Art? He certainly would and before he had
time to mourn the destruction of his work he was off to
England. Through the aid of a scholarship, remaining funds
from his G.I. Bill, and a spirit of adventure, he was making
a fresh start.

Following his pattern of being cultivated by the influ-
ential, Maurice was the London house guest of a renowned
man, who like himself had received an award from the
Skowhegan School. The host was Sir Kenneth Clark. Hav-
ing learned that Maurice also knew Skowhegan, the emi-
nent British historian was anxious to talk with him about
the progress of the school. Maurice understandably trea-
sures the autographed copy of one of Sir Kenneth's volumes
on art. He is equally appreciative however (and he is quick
to tell you so) of what he learned of the British approach
to teaching art.

> I found them more interested there in quality and
> execution than in ideas. They want to see you *do* it, not
> hear you *talk* about it. For me their approach was more
> comprehensive and deliberate, and it made me slow
> down and take careful thought about what I am and
> what I want to do.

With arms folded and head reflectively tilted upward
Maurice recalls that period of study as a highly important
one for him. Moreover, he liked the British for their ca-
pacity to accept him simply for what he was. "Many, if not
all of the defenses I had didn't apply there," he quietly as-

serts. Most of all, he was glad to be away from America since he had not been happy about the election of Richard M. Nixon to the presidency. And the British sojourn was so productive that he completed a three-year course in two. In September of 1974 he returned home with a Master's degree from London's Royal College of Art.

Prior to his trip to England and while studying in Rhode Island, Maurice had been introduced by John Torres to Conrad Spohnholz, the director of the Edward Mac-Dowell Colony in Peterboro, New Hampshire. Torres had wanted the young artists he had recruited to get firsthand knowledge of the colony and its function straight from its director. As a result of that meeting Maurice Burns was invited to work at the Colony. And since Colony Fellows are allowed several residencies at MacDowell, Maurice applied again and was welcomed immediately upon his return from England. Following that second residency at MacDowell, Maurice had a call to come teach in Santa Fe, New Mexico. It was John Torres who issued the call in 1975.

John knew of my experience and how I had related to people back there in Providence. He knew also of my interest in Third World people and he believed I could do the required job. John had been out there for two years and he knew the climate well.

The "climate" Maurice speaks of has nothing to do with weather but with politics. The job Torres had in mind for him was at the Indian school and he took it, holding it for just one term. Maurice loved the contact with the Indian students, but the "climate" created mainly by staff was not at all to his liking. True, there had been a bit of icy student and teacher opposition in the beginning until they found out Burns was sincere. Most of them thawed and settled down to work. Their Indian teachers, however, remained obdurate. Maurice sees the latter as filling a niche

identical to that of old guard black southern educators fear-
ful of offending the big white bosses and losing their jobs
along with that smidgen of pseudo-power they are per-
mitted to hold.

The students are waking up, but the old guard sup-
presses them. The former want the school as a façade
but they are fearful of individuality. "Be good students.
Attend your classes every day and be careful not to be
too militant." That's the attitude of most of the older
staff. But the youngsters are beginning to question the
wisdom of such a tack.

He pauses and laughs softly at what both he and his
interviewer know and understand so dreadfully well. You
ask him where those Indian students now stand in relation
to their black counterparts and where he himself now
stands.

The young Indians are just about where black kids
were in the early 1960s. They're getting back to their
braids—their old culture, their old identity. The atti-
tudes of that school do not fit their needs. I couldn't go
back there and be a part of that. So I decided that I
needed my own studio and that I'd devote all my time
to painting!

Maurice Burns has his own studio in Santa Fe, New
Mexico, and there he paints. He paints Indians, Afro-Amer-
icans, and those whites who do not share equally in the
feasting on the rich national pie. He laughs in contempla-
tion of how his paintings of young blacks with Afro hair
styles actually intimidate some white viewers. "They often
mistake my *Gospel Singers* for Black Panthers and my *Por-
trait of Brenda Branch* for Angela Davis." The same view-
ers will stop before Burns's incisive and subtle painting of
a brooding white girl. "Now that I like!" one will exclaim.

The girl who modeled for that painting was strung out on dope.

I'm familiar with the whole range of art—abstract, conceptual, whatever. And I've weeded out to find out where I fit. I was into figure work before it became the thing, and with it I feel I'm on solid ground.

He goes through his stacks and rolls of rather large canvases—all paintings of people—brown, black, white—all in their respective environments. As he shows them he makes this final comment.

At one time my preference was for black models because I personally could identify with that subject. But after talking with Jacob Lawrence a broader view of the artist's subject matter came into my consciousness—I feel more at peace with what you see me doing here.

What Maurice Burns is doing here is a far cry from the frantic pursuit of material gain he left behind in Chicago a decade ago. He moves, talks, and works serenely, and he gives no indication of wanting to reverse his direction.

Shirley Stark

THOUGH they come from different sections of the country Maurice Burns and Shirley Stark hold several things in common. She too has lived and worked in New Mexico. Like him she is intelligent, tall, spare, and good looking, and they both like to work on a large scale. There the resemblances temporarily vanish for while he paints, she carves heavy and massive stone. Moreover Burns, who began to draw seriously as a teenager, paints representationally. Stark, a relative latecomer to her art, carves and welds in the abstract. But now their paths converge again, in that each is an artist and each is black.

Shirley Stark articulates with crisp clear diction as she talks of her childhood.

Yes, I'm a native New Yorker, but I was taken to Baltimore at an early age because my mother wanted me to pass my formative years in an atmosphere more restrictive than New York's. You see, my grandparents had come from Anne Arundel County in Maryland so there were lots of my kinfolk in that area. Irene and Arthur Stark were my parents. She was from Pennsylvania and he from Kentucky, but they were divorced early and I don't know him. So I spent the first seven years of my school life in Baltimore.

The light filtering across her medium brown hands and face reveals a bone structure that is both finely carved and strong. She smiles slightly and you realize that this woman reminds you of a taller version of actress Ruby Dee. Because of that resemblance and association you are momentarily surprised by her next revelation.

As a child I yearned to be a nun because of my closeness to this order of black nuns—The Oblate Sisters of Providence, very strict and very elegant in some ways. But by the time I made my first communion I understood that the community was going to be a little close for me so I got out of the notion.

But Shirley Stark clearly and fondly remembers Baltimore's white marble steps ("I used to scrub them clean") and Druid Hill Park and the central branch of the Enoch Pratt Free Library. She thinks of the city as having been very pretty during the middle 1930s. There, before World War II, she, not yet eight years old, pasted the N.R.A. (National Recovery Act) blue eagle insignia in the family's window. And though she heard that times were hard she was young enough to believe her folks were wealthy because "We did eat every day." Still she remembers that her mother and her aunt wore their winter coats too long, for in the spring they simply removed the fur collars from them. But that was really not bad, as Shirley saw it then and sees it now.

So she went to her Aunt Rose and her Uncle Joe's home, and from there to a flat on McCulloh Street, and later to Myrtle Avenue—all before returning to New York City. She recalls it all with approving understanding as she talks easily in her spacious and orderly Brooklyn studio loft.

You see, I was there in Baltimore because my folks were particular about where and with whom their kids lived, even when times were tough for them!

Shirley was brought back to Harlem to attend school within three blocks of where she was born. It was the infamous P.S. 136, and it was there that, as she puts it, "I got my education." She speaks of the school in a way that Ruby Dee, another alumnus, speaks of it. Both experienced the feeling of being in the school without being a full participant in all that went on there. It brought to Shirley the full meaning of "standing outside looking in" even though she was in the middle of it all. For her it was seeing in school what goes on out in the street.

Shirley was unhappy at P.S. 136. To begin with, the girls (it was an all-girls' school) had to go in shifts because of overcrowding. Her session ran from 12:30 p.m. until 4:00 p.m., "three-and-one-half hours of pure hell." She remembers that there was little point in carrying one's complaints to teachers for many of them were, in her view, much like the students—hard and insensitive. Besides, they all wore middy blouses with ties of different colors for each grade. Everybody hated them.

I had a fight there one day—with a pin. It was my first fight. Indeed I didn't know about fighting before that, but that's when I learned. It took place in the stall in the rest room where this girl, obviously a lesbian, cornered me. I had only a small straight pin to defend myself with but it sufficed. She never bothered me again.

The perceptive observer is not deceived by the slender body and the delicate bone structure. It is the tough sinew and strong bone of a woman fully capable of cutting hard stone and it is the frame of a woman who passed her first difficult school test in the toilet of one of Harlem's most notorious schools. Still she is balanced enough to acknowledge that there was another aspect of life at P.S. 136. The school did bring fine entertainment in for the girls

and those who were receptive could get from it another type of education. Shirley Stark, though not then overly fond of school, was a bright girl who did love learning. She simply felt there was a lot of stuff going on in school that wasn't at all necessary to her well-being. As to the books assigned for reading she'd already read them at home, though she admits she didn't understand them. But that, too, was all right for she was certain she'd get around to understanding them later on.

With the Japanese bombing of Pearl Harbor in 1941 and America's entry into war, Irene Stark took her daughter to Youngstown, Ohio, where Irene went to work in a defense plant. There were relatives there with whom Shirley stayed as she continued school, first at Rayden High School, then at South High School. In the interim she briefly attended Pittsburgh, Pennsylvania's Fifth Avenue High School. Irene Stark moved about wherever honest work was to be found. And she always managed to land with Shirley in a place where family members could assist by providing a safe home for her daughter. However it was in Youngstown, Ohio, that Shirley's life style suddenly changed.

> I quit high school in Youngstown. I'd had enough of all those schools and he was a sailor in the war, and he was gorgeous, and we got married because that's the way it was done then. "Good" girls got married. It didn't last. We were kids and it was costly in many ways.

Through it all Shirley kept in close contact with Irene, whose maternal strength she needed and respected. It was therefore natural that the daughter would return to New York where, at twenty-one, she married again. Shirley is matter-of-fact and nonself-pitying as she talks of both marriages. The first, she insists, "was nothing to talk about because he was in the navy and I didn't get to know him." But the second, she admits, was "a battle." Because she was ac-

customed to roaming around on her own, Shirley felt that
once she had left her place of employment and had gone to
listen to Charley Parker blow his horn, her mate should
have, in her view, "been happy knowing where I was." Such
a thing as being home and having his dinner prepared was
not important to her, anymore than her getting home to
share a meal he might have cooked. Shirley expelled a
stream of blue cigarette smoke as she elaborated upon her
carefree youth.

Yet, strangely enough, nothing evil ever befell me in
my wanderings down on 52nd Street and all about this
city. I guess I was just plain dumb and lucky! Besides
if I wanted, in the middle of the night, to get up and
try to draw something until I got sleepy again I thought
that was okay too. I'd always done it when I was single.
And I'd always drawn. I just assumed everybody could
draw! So just as my mother used to get up and play the
piano I did my thing, too!

It wasn't long before Shirley could see their marriage
teetering dangerously. But she's old-fashioned enough not
to want to "go from man to man" so she arranged to send
her husband on ahead to Detroit with the understanding
that she would follow. Shirley had come to the conclusion
that New York City was far too impersonal for their marriage
and that perhaps they could make it work in the Detroit
setting. True to her word she joined her husband there.

Working out their marriage from her viewpoint meant
going to work and going back to school. She hadn't earned
a high school diploma but that didn't matter at the moment
because she had not applied for government work requiring
one. But she did get its equivalency and by the time she was
steadily employed she was enrolled at the University of De-
troit. In her late twenties then, Shirley was a psychology
major with a full-time job and a husband. Endowed with

abundant energy she also managed to sell real estate and take extension courses in real estate at the University of Michigan at Ann Arbor. The assessment she gives of their marriage at that point is grossly understated: "The marriage wasn't exactly working out." She describes herself at the time as "a good dancer and housekeeper but a bad bridge player." In many ways she was "correct" and in many ways "incorrect." Like most of us she tried to be as correct as possible in every way. And though she managed to get through each day she was unhappy and unfulfilled.

Luckily, Shirley had a neighbor, Cledie Taylor, who was also a friend. Cledie lived just down the street and what excited Shirley about her friend was that she was a sculptor, a fine metalsmith, and an art teacher. Sensing Shirley's need to do something creative in art, Cledie one day gave her a handful of plasticine. "Here, see what you can do with that." The moment Shirley felt the material she knew she had found what she needed. Her eyes glow with excitement as she recalls her reaction. "THAT WAS IT!" Then with a wry smile and in a calm and lower register:

> Well, it caused a little friction in my household. So after a twelve-year marriage I packed up my three sculpture tools on Saturday, said "Goodbye, Sweetie," and filed for divorce on Monday. On Tuesday I entered the art department at Wayne State University.

The year was 1961. It was a year in which in nearby Chicago, Elijah Muhammed, leader of the Nation of Islam, showed signs of failing health. Rumor within the group had it that Malcolm X was trying to take over the Nation, a rumor Malcolm denied to his death. It was also a year in which the Board of Directors of The National Urban League named Whitney M. Young, Jr. its new National Director. In the spring of that same year the Congress on Racial Equality (CORE) had its most harrowing experience in Anniston,

Alabama. With assurances that the U.S. Supreme Court had ruled all discrimination against bus passengers using bus terminal restaurants illegal, thirteen "Freedom Riders" decided to test the law. Seven were black. When they arrived at Anniston a howling mob met them, setting the bus afire. Luckily all the riders escaped with their lives.

That same year a social scientist, Kenneth Bancroft Clark, was given the NAACP's annual Spingarn Medal for rendering what the association deemed the greatest service in advancing race relations. And it was also in 1961 that black G.I. Maurice Burns, whose story preceded this, was having his troubles (albeit holding his own) as a member of the U.S. armed forces in Okinawa.

In attending art classes at Wayne State University Shirley Stark was not seeking a degree but rather some knowledge of the sculptor's craft. Working along with her there were Cledie, Diane Young, James Smith, Shirley Woodson, and James Jennings. Each was supportive of the other and Shirley remembers with profound gratitude that no one told her she was "too old" or that she had no "talent." Her reminiscences on that beginning prompt this observation.

> Nothing happens unless it is time for it to happen. There was turmoil for every one of us and there was a lot of pain for me in what I call "those nondescript years." And I'm not saying that mine was greater than anyone else's. In fact, I'm glad I had it, for without it I could not be an artist. You see, it's what the artist does with his anguish that counts—his making of order out of it that makes for his statement and his reason for being.

Shirley Stark's reference to her "nondescript years" is a reference to the struggle to work full time and pay for the courses she was taking at night. Her daytime job was with the Internal Revenue Service where she had risen from a

lowly keypunch operator to a supervisory post. In one sense she missed the comfort of the lower-echelon job, for there she could sit at the keypunch machine and think about her sculpture at the same time. If she made a mistake a light would flash as a warning to her.

Still, being a few notches higher wasn't bad and she did enjoy some mobility in her position. To offset total frustration she helped the workers form a union which heretofore had never existed on that job. Although knowing nothing about unions she got herself elected union secretary, from which position she hoped to learn. "All of this activity," she says, "was for my existence. Sculpture and its study enabled me to live!"

During the period of Shirley's "existence" on the job the union's president was fired for some offense the Internal Revenue Service would not countenance. That firing hit Shirley with a stinging wallop. Along with the restrictions and the routine, and the fear, it all amounted to more than she cared to bear. Suddenly the security provided by the job wasn't important anymore. She had to have a little fresh air —a little breathing space. So she took a leave of absence in 1967 and went off to Italy!

It wasn't as spontaneous a move as it seemed. She'd been talking with her friend and fellow artist, Shirley Woodson Reid, with whom she'd been studying at Wayne State University.

> Shirley urged me to go to Europe, and to tell the truth I didn't need much urging. I wanted to see MICHELANGELO's work and—yes—

At this juncture the slender woman's gesture indicates there is something else about her decision she must not fail to say.

> Now this, by the way, is the first time the question of race ever came up in relation to my work. People on my job, for instance, wanted to know why I wasn't

following the trend and going to Africa. I told them exactly why. "BECAUSE MICHELANGELO'S WORK IS IN FLORENCE, AND THAT'S WHERE I'M GOING!"

She laughs merrily and sips her sherry before growing somber again.

It was my first time overseas and I was full of joy except for two occasions. I was in Perugia when Martin Luther King, Jr. was killed and I attended his memorial service in Paris. . . . But I was happy when I came home for I knew I wasn't kidding myself. I was going to be a sculptor—and I am!

Making the rapid transition from soft plasticine to stone was not a real problem for Shirley Stark. Perhaps it was because she is a natural carver—that is, a very direct person to whom the directness of carving has a natural appeal. Or it may be attributable to something she repeats from time to time.

I'm a latecomer to art, and I'm glad I came late because there can't be much nonsense with me now. I have neither the time nor the inclination for it.

Upon her return from Europe Shirley had another long talk with Shirley Woodson Reid. The latter had been to the MacDowell Colony in New Hampshire and the former was quite impressed with the growth she saw in her friend's painting. Perhaps a period there would do something similar for her work. And though she, Shirley Stark, had not participated in shows—had no impressive paper records of her work—had cared only about working—she decided, with Shirley Reid's urging, to apply for a grant of stay at the MacDowell Colony. She got it. Loading her little Volkswagen "bug" with stone, tools, and a few personal belongings, Shirley took off from Detroit in a blizzard! Destination: Peterboro, New Hampshire. She had succeeded in wringing

another leave of absence from the Internal Revenue Service.

At the MacDowell Colony she came to a full accounting of what Shirley Stark was about. And it was there that she realized she could handle only one full-time job at a time. With nothing but her material and her will to work with it, Shirley accomplished more in two months than she ever dreamed was possible. And she explored. Recalling how, after quitting high school at fifteen, she had gone into a war plant and welded tank treads, Shirley had acquired a welding outfit. Paying a little on it each week she had it with her, paid for in full, when she arrived in New Hampshire. But she knew nothing about using acetylene and oxygen. Then, at Mac Dowell, she met sculptor John Torres.

John is known to everyone in Peterboro. In a short time he, his brother-in-law, and a local welder at the garage had shown Shirley what to do with acetylene and oxygen.

At MacDowell I welded, I carved African rosewood —a rich and very beautiful wood—and I carved stone. I like it all. But I especially like to carve. Carving is taking away the nonessential. I like making the simple statement, both in my work and in my verbal communiqués. I'm sure my social graces have declined because, poetically, I just don't favor using sixty words when six will do.

Shirley Stark's social graces were put to the test upon returning to her desk at Internal Revenue Service in Detroit. She had applied for another work-study grant—this time to the Wurlitzer Foundation in New Mexico—and she had been accepted. What she did not know was that I.R.S. had decided to grant her no more leaves of absence. What I.R.S. did not know was that Shirley Stark wasn't planning to ask for any more. So when she mentioned her good fortune in seeking the Wurlitzer grant she was abruptly informed by her supervisor that she couldn't have leave to take it. That was all Ms. Stark needed.

I'm not asking any of you for a leave. I'm telling you
I am leaving this job in two weeks—PERMANENTLY!

She laughs as she mimics the mincing steps she took
back to her desk. Then—

There I primly perched myself and as I patted my
polished hair I thought. . . . OH MY GOD! WHAT HAVE I
DONE? But I packed my little Volkswagen and I drove
to the Southwest, a region I had never before seen.
You know, as provincial as New Yorkers think others
are, we are just as much so. We think the world begins
and ends here and of course it doesn't.

As soon as Shirley saw the mountains she felt completely
relaxed and at home. She was particularly cognizant of the
"rhythm of the land" and the presence of the Indians made
her conscious of ritual. And she found that each Wurlitzer
grantee had his own place—a small kitchen, bath, and a
room to work and sleep in. Those were designed for paint-
ers, not sculptors. There was, however, a house with a ga-
rage, and she worked in the garage. For a moment her voice
becomes almost trancelike.

I'd never before seen basalt—that volcanic stone the
pre-Columbians and ancient Egyptians carved in. And
I kept looking at it out in the Rio Grande and wonder-
ing if I could carve it. It has a dark and brooding and
metallic look from the magnesium iron ore in it and
from what the elements have done to it over the cen-
turies. But I wasn't ready to tackle it at that time.

Shirley was ready, however, to cross the Rio Grande
into which she had looked so longingly. There in old Mexico
she found many kinds of basalt, some soft, others heavy and
dense. She went to the city of Oaxaca, arriving before the
town was later taken over by "hippies" from north of the
border. There she stayed in a modest little hotel whose
owners let her use the roof for carving. For awhile she

carved cantera, a stone native to Mexico. Then she began to sketch. Shirley sketched in the streets and in that area so popular with artists the world over—the public marketplace. She saw its movement, its pathos, indeed its very ethos. And she saw the faithful poor worshiping in their filthy rags before the altars around which the ornate gold and silver rose majestically—and menacingly. She watched them walking on their knees from the back of the cathedral to the altar —they who were made to feel so guilty, so unworthy; and her initial reaction was anger. But that surge of emotion subsided as she realized that the ornate church was all they felt they had. It would have been the same to be angry at an impoverished family on welfare that has a color TV. "Why not? They have nothing else, so they ought to have it if they want."

The sight of young thinly clad mothers in Mexico City suckling infants at midnight in doorways where they huddled against the chill night wind; and the glib assurances of the sotted, overfed expatriate Norte Americanos that the people whose suffering she felt "aren't really that poor"; that and the fact that she, Shirley Stark, who spoke no Spanish, was seeing and feeling this without having someone with her who could share it—all that became a part of the misery of the trip. She began to feel ill.

She had been in Mexico the better part of the summer and was on her way to Yucatan when her resistance gave out. It started with chills, fever, diarrhea, and¨vomiting called "Montezuma's Revenge," and it developed into a nasty cold. Fearing that Yucatan's tropical climate would not be good at that time she followed her instinct to turn back and head for Taos. It's a good thing she did. Doctors in Taos began treating her for pleurisy and pneumonia. And after only a week in the hospital she drove from Taos to Detroit. Though hardly ready for such a trip she managed to make it and there she stayed put for the next few months.

Pleasant as it was in Detroit with her "art family," those who had encouraged her from the very start, Shirley yearned to return to New Mexico. But how to get there?

I simply sent out prayers on the hot line and got another grant from Wurlitzer for six months and that, too, was extended for three additional months.

This time Shirley rented an old adobe house in which no one had lived for four years. It had electric wiring but no plumbing, and it had become home to an assortment of spiders and bugs. Shirley still laughs as she talks about the old house.

I'm certain the folks in town began taking bets on how long I'd last in it. But I got some paint and putty and mixed a little mud and I made it very livable. I'd watch the sun rising and at seven A.M. I was in my studio working. It was in that studio that I decided to carve basalt, and I discovered I'd have to have pneumatic equipment for that. So I borrowed money to get the equipment. Then I got a grant from the Draco Foundation in California and with that money I paid for the equipment.

I lived in that old adobe house for three years and the only reason why I left it was because I had an opportunity to work on a large scale.

As Shirley Stark had said earlier, nothing happens until it is time for it to happen. For a sculptor to work large it is necessary to be either commissioned or wealthy. There is no other way the average artist can afford the needed equipment and assistance required of large work without lots of advance cash. Such a commission came to Greek sculptor, Dimitri Haazi, at the International Sculpture Symposium in Eugene, Oregon, and Shirley Stark along with others were to be his formal assistants. Dimitri, whose sculpture may be

seen at New York's Lincoln Center, usually is associated with bronze. This time, since the work was to be done in Oregon, he chose to work in basalt because it is native to Oregon. Shirley, who had been carving the stone all along, was a natural choice as an assistant. It was a project that occupied her attention during 1972 and 1973. A few of her comments on that experience are most revealing.

That was a hard symposium because chauvinism is by no means limited. The young men in the Northwest seem to believe they're doing the Northwest Passage. And since I was the only woman, and obviously black, they gave me a hard time. But I got what I went for.

I would not have known, for instance, about footings used in the foundation structure of monumental sculpture. And Haazi began with 150 tons of basalt! !

In addition to that his assistants were appointed as lecturers on Fine Arts at the University of Oregon. And there was a chance to work with John Chamberlain, Bruce Beasley, and Roger Bollamy. LaVerne Kraus was a professor of printing and she was especially kind to me, for when it got a little hot and heavy for me at the sculpture site I would go off and do my etchings. They certainly had their notions of what women should or should not be doing. The women doctoral candidates were doing their dissertations on *Community Reaction to Sculpture.* HUMPH!

At one juncture there Shirley was interviewed by the news media. She is certain that the woman interviewer edited the tape for, as she put it, "This woman was trying to tell me there was no racial problem in Eugene." Shirley had to remind the interviewer that she had stayed in the town of Medford and that the man whose name the town bears had been a top dog in the Ku Klux Klan. Moreover, she recalled seeing no blacks employed in any of the stores or

businesses she entered. And the Mormon influence, she dis-
covered, is strong in Eugene, Oregon. Mormons traditionally
have never championed the cause of equal rights for black
Americans. It was Shirley Stark's impression that "We were
quite invisible there."

Yet, during her stay of eight weeks of "dues paying" in
Eugene she encountered splendid people too. Among them
she considers Hope Pressman, organizer of the symposium,
Bob Harris, Dean of the School of Allied Arts and Architec-
ture, and Rosaria Hogethen, the first woman professor of
Architecture at Oregon University, top-notch in every way.
They, along with LaVerne Kraus, did much to neutralize the
unpleasantness of which she could not help but be fully
aware.

There seemed so much to see—to learn—and this gifted
woman who started later than many was determined to ab-
sorb as much as possible. From Oregon she went on to Brit-
ish Columbia to have a look at the totems carved by the
Haida Indians. That trip to the Northwest led her to Cali-
fornia, which she had not seen before.

> I slept overnight in the Grand Canyon, saw the sun-
> set and sunrise, and came on back to New Mexico and
> another Wurlitzer grant.

An invitation to come to Pittsburgh, Pennsylvania, in-
duced Shirley to split her Wurlitzer grant. She had been ap-
pointed to hold the Mellon Chair in Sculpture for a semester
in 1975 at Carnegie-Mellon University—the first woman ever
to do so. It seemed that she was destined to cut new pas-
sageways and that inevitably involved a degree of bumping
and jostling. Shirley is not in the least reluctant to speak her
mind about it.

> I had to face the fact that everyone at Carnegie-Mel-
> lon was not ready for a black woman sculptor to hold

that chair and here again it was like going to war all the time. It wasn't the students but the faculty. They'd tell me that Richard Hunt had been there and it seemed to me that the inference was that he was worthy and I was not.

Shirley's touchiness on such matters did not, however, prevent her from having a good relationship with another prominent black woman sculptor, Selma Burke. Dr. Burke, one of the modern pioneers in the profession, is the founder of the Selma Burke Art Center in Pittsburgh. Moreover it was she who had the first one-woman show at Pittsburgh's Sarah Schaiffe Gallery. A warm, friendly, amply proportioned woman, Selma Burke's experiences reach into the "Harlem Cultural Renaissance" of the 1920s when America's black poets, Countee Cullen, Claude McKay, James Weldon Johnson, and Langston Hughes, raised their literary voices in protest against America's white racism. Indeed Selma Burke and Claude McKay were married for a time. Dr. Burke's career as a sculptor did not burgeon, however, until a decade later when the excellence of her work began to attract both national and international attention during the rough years of the great Depression. Since then she has steadily practiced her craft with rewarding results. She has also made a significant contribution in the area of involving the Pittsburgh community in art activities through the center which bears her name.

Selma Burke's presence at Carnegie Institute during Shirley's stay at Carnegie-Mellon University was most opportune for both of them. Selma's influence is amply expressed in this remark by Shirley.

It was good to have the chance to talk with this woman of whom I had lectured so often. In many ways my contact with her has been for me a real education. Her graciousness and her grand manner mingle so well with a profound kind of humility.

Some of the more traditional staff members must have found Shirley Stark's teaching methods unique, to say the least. They were indeed different from those usually employed by the average art instructor in that they were the direct translations of her own creative beliefs into positive action. The mere teaching techniques did not go far enough into imaginative study to suit her.

Anyone can teach techniques. But one needs to be opened up and made aware. I'd hold classes in Homewood Cemetery because Brancusi's *Bird In Flight* is there. Moreover, my students had to work with a composer because I object to the division of the arts. So it took half the semester to show them that the composer was not an outsider.

I even involved the physics department (and upset them a bit, too!) by insisting they let our students see demonstrations. I fought to have my best students have computer time, for in sculpture there's a lot of figuring that can be done by computer drawing. THAT'S WHAT TECHNOLOGY IS FOR—TO HELP YOU DO YOUR WORK!

Shirley even had students of sculpture aware of the pool, since water is one of the elements with which man is in constant touch. One student who wanted to work in video was assigned by her to put a project of other students which was derived from the pool in video. In short, she was able to relate the specific sculpture interests of her class to other areas of human and natural activities. With her daring approach it seemed only natural that Shirley would not stand in awe of anyone no matter what his or her position. The dean, for instance, was difficult to contact until she one day told his secretary in polite but firm language that she was growing weary of waiting and that "it is time Mr. _____ sees me." She got her appointment.

Before Shirley left Carnegie-Mellon University the authorities invited the eminent black painter, Romare Bearden,

to receive an honorary doctorate. This was an event in which Shirley Stark was called upon to perform a silent, but rather delicate and important part. She had met artist Bearden once in Detroit and was struck by his resemblance to characters found in Peter Breugel's paintings. Moreover, she asserts, she liked his work. It is enlightening to listen to her version of what transpired behind the scenes.

This event proved a bit upsetting to the head of the department. As the one whose duty it was to write the speech introducing Mr. Bearden, he was upset because Mr. Bearden is black and he didn't know exactly what to say. . . . So he asked me to read what he'd written. Since I too was black he wanted my blessing. At the very worst he wanted me to tell him what, if anything, was wrong with it.

I thought the speech was rather terrible. As luck would have it I'd been invited to New York to give a talk at Lehman College, so I told him I'd be happy to go see Mr. Bearden and perhaps Mr. Bearden could give him some information that would make his introductory speech more meaningful. He accepted the offer and Bearden did go over the speech.

Things went smoothly at the graduation ceremonies, and Bearden's acceptance speech was regarded by those who heard it as "magnificent." *The New York Times* for June 21, 1975 excerpted a portion of that speech on its Op-Ed page directly under a four-column reproduction of a splendid Bearden collage. Shirley finds Romare's collages "rhythmic and the music" she sees in them is, for her at least, reflective of that period when he did not paint but went into song-writing instead.

One asks Shirley Stark what she thinks of being labeled a "black artist" and one catches the faintest hint of a sigh before she replies.

One of the reasons why I left Detroit was because of the "static" I was getting on whether my work was "white" or "black." For some it wasn't "black enough." Hopefully, the first thing should be that I'm making art. And in order to make art (if it is that) I believe it must transcend race. It must not limit itself. It must be universal.

She is more detailed and, one suspects, at ease as she discusses the various media and techniques she likes to use. And she loves the excitement and the challenge of experimentation. Shirley picks up a piece of heavy off-white printing paper. At first glance it looks completely blank. You look again and it isn't blank at all.

Here is one of my dimensional prints—one of my intaglio embossments. Now, I certainly get a little static on these because they have nothing to do with black or white! It's white on white and it is sculpture in that it is raised forms. And it has to do with my liking for paper.

Shirley's race against time ("I'm a latecomer to art") is an ever present fact of her life.

I often tear the paper in relation to the shapes. And I don't make the "plates" from metal but from masonite. It's a cheaper material and you throw them out when you're through. Besides, with a jigsaw I can cut them into any shape I choose. It's quick and it's my most immediate form of sculpture.

As to her work in bigger, heavier media she makes necessary adjustments without sacrificing her principles. Stone poses problems of weight—problems she was not equipped to solve. Certain heavy pieces of basalt, which she would have preferred to carve vertically, were so heavy she feared

that hoisting them with block and tackle from the roof would literally bring down the house. So she uses flat thinner slabs and carves horizontally. Moreover, the subject of solar energy and "sculpture for solar architecture" occupies much of this artist's current thinking. She is convinced that modern man has grossly violated the land and that he is "turning back"—that indeed he "must go back." Her tone is quiet and resolute.

Some of my black colleagues contend that this is "not relevant" and I don't quarrel with them. They do their thing their way and I do mine my way. So I'm not about black or white or male or female. I am about humanity. You have to do what you have to do—and what I have to do is sculpture for solar architecture. I don't know how I'm going to do it but I shall do it.

Shirley Stark makes one believe that whenever this indeed will be done, she will be among the doers.

Alfred Hinton

Sʜɪʀʟᴇʏ sᴛᴀʀᴋ had just settled into high school in Youngstown, Ohio, when mill worker Ed Hinton decided he was through with his native Georgia. He had boarded a bus one day on his way home from the mill and, since all of the seats in the "colored section" were filled, had sat his weary body in a vacant seat in the "white section." A quick exchange of hot words between him and the white bus driver, and within seconds Ed Hinton was looking into the muzzle of the driver's gun. Hinton, a mild-mannered black man, quietly left the bus. What no one else knew was that, mild as he appeared, Ed Hinton had his own gun in his pocket and who knows what would have occurred had he gotten to it first.

Ed's father had died shortly after Ed was born, and with a sickly stepfather the boy learned early to work at odd jobs to help support the family. He left school after the ninth grade when there was no tuition money for further schooling. Black youngsters of his day in Georgia had no free high schools. But Ed Hinton always valued education and he wanted it for his own four sons. Alfred, the youngest of them, was delivered by a midwife in the house Ed Hinton had built.

My parents [says Alfred] came from small farming communities near Columbus, and I was born in Colum-

bus in 1940. One of my three brothers died shortly after birth and one of my remaining brothers, Ralph, draws and paints as a hobby. He works as a meat processor. I think we must have inherited our talent from my grandmother who is a maker of fine quilts, and also from my mother, Johnnie Mae.

Al Hinton recalls drawing and painting from the age of three. He and Ralph used to engage in drawing contests, with their parents acting as judges. And because Alfred was the younger his parents boosted his little ego by always awarding him first place. In that way Al was encouraged to the point where he was never hesitant to show others what he could do. Meanwhile, after the bus incident, Ed Hinton headed north in search of work which, because of America's entry into World War II, was plentiful. He quickly found employment with General Motors in Saginaw, Michigan, and sent for Johnnie Mae. The boys remained in Georgia with their grandmother until their parents established a new home for them. That did not take long.

Enrolled in school in the newly adopted city, young Al Hinton continued to exhibit better than average ability in drawing, an ability that did not escape the sharp eyes of his white teachers. They readily assigned him to do most of the seasonal drawings that traditionally adorn the blackboards of public schools everywhere. Al Hinton rapidly became one of his grade school's celebrities. Something bothered him, however, and he nestles his massive body comfortably on a sofa as he explains it in a resonant baritone.

I began to notice in this school, which was predominantly white, that whenever white kids drew black people they came up with the black faces—minstrel lips and rolling eyes. I noticed this as early as the third grade. And do you want to know something? By the time I reached the fifth grade I resolved to draw no

more white people. Instead, I began to concentrate on drawing black people—and drawing them as honestly as I could.

If Al's white teachers were in any way moved or affected by what he did they never showed it. He suspects that since he was the best artist in his class the teachers preferred to let him do things his own way. Humoring the boy would certainly enable them to do their job more smoothly. Moreover a little indulging on their part would in no way alter the situation in which they held firm and practically undisputed control.

Saginaw had two high schools when Al Hinton was a youngster there. One was Arthur Hill High School where the children of upper-class families went, and the other was Saginaw High where lower-middle-class whites, poor whites, blacks, and Mexicans went. Al, a six-footer, was thirteen when he entered Saginaw High School. The following year he was two inches taller and weighed 230 pounds. The football coaches grew ecstatic. Al laughs as he recalls their ill-concealed eagerness to get to him.

Man, they could scarcely wait for me! My brothers, all smaller than I, had played football as backs. So the coaches' prospects of making a lineman of me were as high as a Georgia pine. And they were amusing, too, because I had never played football. All they knew was that I was big and black. And they assumed I'd be ONE HELLUVA FOOTBALL LINEMAN!

Al conceded that at the time he didn't really mind all that collective salivating on the part of the coaches. After all he was a kid and the attention fed his hungry ego. Then, too, his older but smaller brothers, all good athletes, had earlier accused him of eating up all the food without first bringing athletic glory to the table to justify such feasting. Now Al could square things up a bit, though he knew that

his older brothers, deep down inside, along with their parents loved him and always gave him their fullest support.

Though he did play football in high school and did fulfill the coaches' dreams Al never let the game prevent him from producing his art. And, as the best artist in his class, he along with brother Ralph (a senior) were called upon regularly to produce special art work for the school's bulletin board. In addition to drawing and painting Al began to carve, using wood as a medium. One especially memorable piece of his work in wood, *Mother And Child*, was shown not only in Saginaw, but in an exhibit that traveled overseas. Shortly thereafter Al had his first experience with the kind of exploitation of the young so commonly practiced by adults who would not tolerate having the same thing done to them.

> When my art teacher saw my *Mother And Child* carving she was so pleased with it she asked me to do one for her, which I did. But now here's what got to me. I had neglected my other art assignments to get this done for her, yet she lowered my grade because I'd fallen behind. That was a real blow to me. But I had my first lesson in how people ruthlessly exploit the artist.

To intensify his hurt, Al developed Myasthenia Gravis, a muscle weakness causing vision fatigue. Discovered during his junior year in high school, the disease was incorrectly diagnosed, and he had unnecessary eye surgery, which of course did not correct the condition. So with time lost at that, plus his regular school assignments, plus art, plus football, young Al Hinton's senior year was full of woes. The biggest woe of all was lurking in the wings just offstage.

As was customary each year, designated participants in Michigan's statewide Hi-Y program assembled at Lansing, the state capital, to take over the government for a weekend. Alfred Hinton had been selected to represent his district

which included not only Saginaw but Manistree and the Upper Peninsula as well. That was Michigan's largest district and the youth selected to represent it had always been automatically nominated to become governor for three days. Young Hinton was the first black to be so honored by his peers of the district. The year was 1957, the same year President Eisenhower had to order federal troops into Little Rock, Arkansas, to facilitate the legal desegregation of that city's schools. Al clearly remembers every detail of his own experience.

I went down to Lansing all prepared to be "governor" for three days. My coach, James Bromley, was a very influential white citizen who had recognized my abilities in art and athletics as well as my outgoing personality. So he took me around and coached me well, for it was a foregone conclusion that with the state's biggest district behind me I was to be "it." When we got to Lansing, however, we discovered that the authorities had changed the rules upon learning that for the first time a black schoolboy would be named "Governor" in 1957.

To anyone familiar with Michigan's capital city such is no surprise. It was in Lansing only a generation earlier that a black man, Earl Little, his pistol blazing, drove off a gang of whites who had set fire to his home. Luckily he managed to get his family out before the house collapsed into a fiery heap. Earl Little's five-year-old son, Malcolm, never forgot that terrible night. Later on as Malcolm X, he exposed and condemned Lansing's racism in his celebrated autobiography. Lansing's attitude toward blacks had not changed when high school senior, Al Hinton, arrived there to find a new set of ground rules concocted just for him.

The rule had been that the candidate had to read from a prepared speech following which ballots were passed and the formality of electing the Governor was

consummated. In my case, however, I was given a subject I'd not been previously briefed upon and I was told to extemporize on that subject for five minutes. This demoralized me. And though I bravely tried, my speech flopped and the white kids naturally voted in someone else. Bromley was furious!

Bad as that was, it wasn't quite all. Those normally sent by their districts as young Hinton was, and who lost the vote, automatically became State Senators. Al was denied that, too, and sent instead to the State House of Representatives where he could not even be a member of the elected governor's cabinet. Angry as his advisor, James Bromley, was, there was nothing he could do, especially since no public outcry against the injustice was made.

A young instructor just out of the army, Bromley had wanted to be a lawyer before taking the job at Saginaw High School. But two years later as he carried a second black candidate to Lansing, Bromley was ready. He had thoroughly coached the boy in extemporaneous speaking and debating. And when the authorities tried the same trick the young man rose to the challenge and won in a sweep.

Hinton was graduated from Saginaw High in 1958 with the offer of a football scholarship to the University of Iowa. In high school he had played the middle guard defense and rival coaches called him "the dirtiest player ever to come out of his school." In response to the charge Al readily acknowledges that he was indeed rough, not well trained, and that "I did have a lot of anger and hostility I let loose on the field. I liked to hit people and make them bloody and confuse them into making blunders."

Just before entering college Al came close to being killed. It happened in the hamlet of Mio, a place in northern Michigan near Grayling, with a population of 600. He was working as a summer camp counsellor when, with a

group of other counsellors, they sneaked into a drive-in movie without paying. They were caught, told they'd be reported to camp authorities, and ordered to leave which they promptly did. One of the fellows, however—the one who drove the truck—suggested they ought to go back, apologize, and hope that perhaps the owner of the drive-in would relent and not report the incident. He was fearful of losing his job. The others agreed and they returned and waited in the truck until their companion talked with someone inside. The idea seemed to be a good one for the driver of the truck returned to the others with assurances that everything was forgiven. A small shudder passes through Hinton's big frame even now as he recalls what followed.

At camp the next morning one of the local handymen rushed excitedly to us asking what on earth we'd done in the drive-in. It seems that even though all of us let the driver do the talking while we waited in the back of the pick-up truck—and even though the man with whom he talked assured him that everything was okay —the word was out that we'd tried to rob and beat up the drive-in owner and that I—THE BIG BLACK ONE—was the instigator. The word also was that all during that quiet encounter—such as it really was—the owner had drawn a bead on me and that I could have been killed without ever knowing why. That was the climate in northern Michigan in nineteen fifty-eight.

Al went to Iowa University to study art without realizing that it offered one of the best art programs in the entire area. He had been preceded there by another black art student, Harold Bradley, who later went to Rome and got into motion pictures. Hinton hadn't been there long before the art department began to pressure him to give up football. He had to explain that he was able to go there primarily because of athletic ability that provided a scholarship. On

the opposite side the athletic department had little under-
standing of his wanting to be a painter. So a kind of tug-of-
war ensued and lasted during his entire time at the Univer-
sity of Iowa. The experiences Al had as both art student and
athlete at the university reveal attitudes that one finds com-
monplace in American life outside the college campus. He
speaks first of attitudes as he found them in the art depart-
ment.

> Many of the faculty at Iowa couldn't relate at all to
> my work. I was doing paintings and prints depicting
> life in the black community. At one point I wanted to
> do a poolroom scene and this upset my instructor who
> found it difficult to accept my drawing style. There was
> one exception among my white teachers there, a painter
> named Bob Knipschild, of whom I'll have more to say
> later.
> What I found especially difficult was to take the
> "black feeling" and put it into a white context. It just
> doesn't come out the same way. So the result was that
> they felt my work was too "ethnic"—that my shapes
> and forms were too crude and awkward. So some of
> my closest friends were people not in the art depart-
> ment, but writers who were more receptive to the kinds
> of things I tried to do in the writer's workshop. I also
> attended there.

Al studied art, physical education, and sociology at the
university. During his senior year Oliver Jackson, a black
painter, worked in Iowa's art department as an assistant in-
structor while working on his M.F.A. degree. In him Hinton
found a kindred spirit. He was Al's first black teacher. So
with Jackson, Bob Knipschild, and Michael Harper, a black
poet, Al was able to survive all the frustration he was ex-
periencing during his junior and senior years in the art de-
partment.

With Jackson my work opened up. The man *talked* to me and I could relate to him. Here was a black artist with whom I had actual contact. Jacob Lawrence and Romare Bearden, whose names I knew and whose works I'd seen, were in New York and therefore remote to me. As to many of our pioneer black artists I'd never even heard of them.

As a man who had wanted to draw and paint long before he'd put on shoulder pads and an athletic "cup," Al Hinton's most scorching remarks center about his experiences in football, both college and professional. White racism, he insists, pervades sports continually, the presence and public acclaim of a few leading black athletes notwithstanding. He began as early as high school to learn the truth of that. It haunted him as it haunts others right through college and into the professional game. Here is a sampling of what he observed between 1958 and 1962 at Ames, Iowa. There are moments in this brief monologue when his normally pleasant voice takes on a menacing iciness.

Let me tell you something. One of the reasons Iowa lost the momentum it had in the 1960s was because of its racist attitudes. They were all shook up about interracial dating—I mean the fact of white girls going out with black boys. At the same time they'd recruited these black athletes to a school and a community without black women who could be their social companions. So in 1962 a rumor went around that black athletes would no longer be recruited—that the emphasis would have to be on getting natives of Iowa to come to the school. I observed when I returned to the campus after nineteen sixty-two a lot of beautiful black women students there.

At this juncture Al's wife, Noel, nods in support of the truth of her husband's words. Al continues.

I was voted All-American in my senior year. And I discovered that publicity helps in this and that All-American candidates are "pushed" from their sophomore and junior years in college. My publicity didn't come until my senior year because three others had been pushed ahead of me. One of them, a black player, was injured and that threw him out of it. The other two, both white, simply didn't perform up to their publicity.

While I appreciated the honor, it had a hollow ring because I hadn't been pushed for it right along. It was as if they had to get an All-American on the team that year. However, it did get me into pro football—that plus the fact that I was voted the "Most Valuable Player" and I captained Iowa's team.

Al Hinton was not graduated in 1962 after four years at Iowa. But he did enter pro football that year. And he has a few strong things to say about how colleges and universities treat the very black they so avidly recruit and exploit.

You can count on your fingers the number of black athletes who are graduated from colleges. They'd never be heard from unless they got into pro football. But you can't see that while you're being exploited. In college white athletes are given money. Very few black players get the same treatment. I recall going in and asking for some of the things white guys get—a car, money, a sponsor. Well, they always wound up reminding me how lucky I was just to be in school! And though they continually reminded me and other black players that we should be happy with what we had, we were never happy!

Al was quickly drafted into pro ball by the Dallas Texans who later became the Kansas City Chiefs. At the same time the Dallas Cowboys wanted him but, like all

other draftees, he had nothing to say about where he was going. "You went where you were drafted—PERIOD!" By this time, however, Hinton began to make a few decisions of his own. Recalling his father's experience in Georgia, not to mention his own close brush with a possibly violent end even in northern Michigan, he wanted no part of the South. And whatever it might have been to anyone else as far as he knew, Texas was way down south. And Texas was definitely not for Al Hinton.

For the moment at least Al had put aside his art for reasons purely mercenary. To a young person with a modicum of financial security or backing such a decision might seem foolish. It could be quite alien also to a more mature person with a sense of strict dedication to art. But to an angry and frustrated young man who has all his life existed on the edge of deprivation, the lure of money he can earn playing a game—even a dangerous game—is hard to resist. For Al Hinton there was yet another reason—a reason induced by the feeling of having been grossly cheated in college. Occasional pocket change grudgingly doled out with the advice that he was damned lucky to get that and a "free" education, too, could never hope to match the sports car, snazzy wardrobe, and the sheepskin!

So Al Hinton, flat broke and proud, reflected upon all of that—and remembered. He remembered the humiliating fiasco at Lansing, the bungled eye surgery, the additional wood carving that cost him a lower grade, yes, and those art teachers at Iowa who challenged his ability to do it in their traditional manner. To make matters even worse he hadn't, at the end of four years, earned sufficient credits to be graduated. Worse still, his football scholarship had expired and he couldn't stay without that or money. Al made his decision. "TO HELL WITH ALL OF YOU with your sanctimonious talk and evil doings! Yes, I'll take your pro-ball money. YOU'RE DAMNED RIGHT I'LL TAKE IT! But I won't go

South to get it!" Al Hinton headed due north to join the Winnipeg Blue Bombers as a defensive lineman. Bud Grant was their coach.

Hinton was in Canada, off and on, between 1962 and 1968. He loved the Canadian people. They gave him the feeling that he could go as far as his abilities would take him. And while he was fully conscious there of discriminatory practices against the Indian, he never felt that Canadians directed such toward him. But if he had any preconceived notion that the football situation there would differ from that in the United States he was in for a few surprises. He tells what he found.

Canadian football is American controlled and American coaches and general managers take their attitudes with them to Canada. Of course, when I tell some people about the presence of racism in my life—in the life of our entire country—they say, "THIS MAN IS PARANOID —HE'S CRAZY!—Why, nobody thinks and acts the way he says they do. Those things simply couldn't happen in America or Canada!"

Well, the truth is that they do act that way. I sustained a severe toe injury and instead of getting the same kind of rest accorded the white players, the coach declared, "I'm gonna give Hinton every opportunity to make this team!" So I played with my injury and that affected not only my playing but my attitude toward the coach. You see, the Canadian doctors had recommended two weeks' rest for me, but to no avail. So I was put on waivers and I went down to Toronto to play.

On the pleasant side of it Al's earnings at age twenty-two amounted to $20,000 for five months' work. He estimated that length of time to be accurate since he played for three months, took one month to get in shape, and another month to recover.

I figured, then, that I could have all that money and paint too. It was a grand delusion, and I didn't know how to handle it.

In 1963 Hinton decided to go back to Iowa to get his degree. Two years previously he had met and liked fellow-student, Anne "Noel" Pearlman. Noel, an intelligent and attractive young woman, had encouraged him to return to school. Her interest, along with the physical and emotional bumps he was taking, helped him see the good sense of it. In the interim he had been temporarily cut from pro football. Al's reception at Iowa wasn't exactly a gala homecoming either. The Iowa coaches were cruelly frank. "Hinton, we don't want you back here. We don't think you can graduate."

At first Al thought the coaches might have regarded him as an embarrassment since he'd been cut from the pro team. But he later found that their main fear was that he might get to their younger black players who had neither his insights nor his experience, and tell them what life was all about. So to get him out of the way they suggested he "go down to Parsons College where you can buy your degree." Hinton stood pat. He wouldn't budge except to return temporarily to Canada to make some money and also to make the All-Pro team. Then when he went back to Iowa to resume work on his undergraduate degree he was given the red carpet. "HI, AL! HOW'VE YOU BEEN? WE HEAR YOU'RE DOIN' GREAT. HOW GOOD IT IS OF YOU TO COME BACK!"

By then Al was sick of them. He didn't want to have any dealings with them, and it was all he could do to be civil while working for his degree. It was 1965 when Al Hinton completed his undergraduate work at the University of Iowa and that same year when he and Noel Pearlman married. He promised her first, however, that he'd give up football since she regarded it as "a little boys' game" rather

than fit employment for a mature intelligent man. Noel's influence was strong but so was the lure of the game.

Noel, meanwhile, was attending graduate school at Western Reserve University in Cleveland, Ohio. It was 1966 when Al found a job in a settlement house, The League Park Center, in that city's section called Hough. Located on Cleveland's east side, Hough, a blighted black area, is to Cleveland what Watts is to Los Angeles and Harlem is to New York City. During the 1960s Cleveland had become a racially polarized city. Its labor force had been swelled by white blue-collar "ethnics" with roots in Eastern Europe and by black migrant workers from the South. Both groups desperately competed for jobs with the blacks coming out on the short end.

To make matters worse, black residents were enraged in 1964 when the Rev. Bruce Klunder, a white clergyman favoring blacks' civil rights, was deliberately crushed to death under a bulldozer. They were infuriated anew by Cleveland's police chief, Richard Wagner. Fearful of *The Revolutionary Action Movement*, a local black organization, Wagner demanded retention and strong use of Ohio's death penalty in the effort to destroy the group. Finally, when Cleveland's Mayor Locker refused even to see a group of conservative black leaders who opposed Wagner's recommendation, Hough's youthful black residents openly threatened to "turn Cleveland upside down and blow Whitey's mind."

Hough's median family income had shrunk from $4,732 to $3,966 between 1960 and 1965, and fatherless families swelled from 23 to 32 percent. Its residents occupied rotting homes while their children played in unspeakable filth. Carl Stokes, who later became Cleveland's first black mayor, had been barely edged out by Locker in a bitter 1965 race. He was to try again—and make it. But Hough was tired of waiting. During the humid summer of 1966 it exploded

into a fiery and bloody riot lasting four days and nights. Al
and Noel had come to Hough earlier that year before the
riot. Of the effectiveness of his work there Al Hinton is by
no means confident.

> Settlement house work in Cleveland depressed me.
> I was working with welfare clients—many of them
> blind and disabled—taking them to activities and the
> like. . . . And though the people of Hough liked me I
> always felt they sensed my having been tainted by the
> brief brush I'd had with "the good life." My experi-
> ence in Canada—unpleasant as it might have been—
> had shielded me from the realities I was constantly
> touching in Hough.

Most frustrating of all was Al's feeling of almost total
impotency in the job. The authorities had put him there to
teach art and he could see that art was not the communi-
ty's immediate need. He saw instead their need to know
how to tell time, how to tie their shoes, and how to do sim-
ple arithmetic. Indeed he actually began to feel he "was be-
ing used to delude and decoy them away from those things
they needed for sheer survival." So he began, through the
use of art, to teach them creative arithmetic, and he used
art to teach them how to better serve their immediate physi-
cal needs. Still it was a depressing and discouraging ex-
perience.

> The trips I made to the Department of Welfare to
> get those things I recommended as their real needs
> were useless. And later when the riot came I could
> easily identify with the angry youth. What had been
> previously happening when the city had angry people
> to deal with was that the city threw basketballs out to
> them or gave them art programs. In that way their
> anger became drained and diluted so that it could not

be most effectively directed where it should have been directed.

Finally in frustration and anger the Hintons, "fed up with this country," left Cleveland. On the recommendation of friends who were artists they took such little money as they had and went to San Miguel de Allende in Mexico. Any expectation of finding in Mexico a complete absence of human misery might possibly be realized by looking only at the luxurious haciendas one finds along Paseo de la Reforma, as one moves in the direction of Toluca. Once past those, however, the hovels of the wretchedly poor as well as their numerous inhabitants are plain for all to see. Al Hinton saw. And he remembers clearly and, to his credit, honestly.

> There with our little car we were considered rich. I associated as best I could (with a limited command of Spanish) with Indians, the despised group in Mexico. Still I was regarded as a "Gringo" and an ugly American. That really depressed me.
>
> Yes, I did love the art of Mexico for it is the art of the people. But my state of depression kept building and my anger was building again and since football provided a living as well as a tension release I went back to Canada.

The Hintons arrived in Canada as the Hough riot was breaking in Cleveland. Al felt like a deserter. And that feeling was with him the night the incident occurred that separated him permanently from pro football.

It so happened that a large percentage of ball players in camp were southern whites, many of them with racist attitudes. To accommodate them a quota existed on black players and it was arranged that there would be an even number of them so that no black player would be without a black roommate. Usually there were rarely more than four

black players—sometimes only two. So out of a total of
eighty or so recruits only fourteen would make it and re-
main. And of those fourteen the blacks were still a minority.

In that same year of 1965 the Lions International of
Canada had invited the then Governor of Alabama, George
Wallace, to speak to its group. Although the invitation drew
protests (and picket lines) of various liberal Canadian
groups, the invitation stood and Mr. Wallace came. At about
the same time the pro footballers were ready to reenact an
annual ritual. Rookie players are required to perform for the
vets upon a special occasion and a rookie who refuses or
declines to perform endangers his chances of making the
team. Al Hinton relates what took place at this particular
ritual ceremony.

> One of the vets, a white Alabamian, rose and extolled
> the virtues of Governor Wallace. He then designated
> one of the black rookies to rise and sing *Dixie*. Well,
> the boy wanted to make the team and he went through
> a bit of suffering to get through a chorus of the familiar
> song.
> Then I rose and countered by having a white rookie
> stand up and sing "We Shall Overcome." The coaches of
> course were shaken up and they quickly branded me a
> troublemaker. You see, in football everyone thinks and
> acts "team effort." But the artist is an individual. And
> unless you're a superstar there is no room for the in-
> dividual in the game of football.

That was the beginning of the end of Al Hinton in pro-
fessional football. He was soon released and blackballed by
all the other teams. And Noel, his wife, sighed with happy
relief. The Hintons decided that life in Canada would be
preferable to that in the United States and Al began to get
back to his art which had been neglected while he was so
deeply involved in football. As he looked about for some-

thing he could do for a living, Noel worked in the Toronto school system as a social worker. Al did land a job as art director for a small theater group and through that contact met the fabric designer, Khadejah, who had immigrated from New York. Khadejah, a black woman, had tried unsuccessfully to set up her own company in New York and was giving Canada a try since she felt her color would not be the hindrance there that it had in New York.

Al's drawing skill was what Khadejah needed in order to project her ideas, and for a while they worked together harmoniously. Al found the contact with her good for him and looked toward being a partner when she established her firm. But at the end of a year of working with Khadejah he discovered that he lacked two things. The first was a set of credentials that would have automatically offered the second, which was professional recognition as artist-designer. As it was, he was playing second fiddle and getting no recognition, a situation he never suffered even during the most trying years of his athletic career. He had no sooner left Khadejah when an old friendship he'd formed at Iowa resurfaced to aid him.

Bob Knipschild had been one of the few white teachers of art at Iowa who hadn't found Al's drawing and painting style "crude" and "offensive." After a stay at Iowa he went on to become Chairman of the Graduate Program at the University of Cincinnati. When an application came across his desk from Al Hinton seeking a scholarship to study painting and filmmaking, Knipschild remembered and extended a helping hand to his former pupil. The warmth and feeling with which Al speaks of this man and his influence on him is unforgettable.

Bob Knipschild helped steer me toward a kind of professionalism I needed. Working with him revealed two important things to me. Number one: as soon as I got rid of football good things began to happen to me.

Number two: I found that I needed this country for here is where my energy is. This is where the challenge is—the challenge that generates creative energy. I found that you don't have to survive in Canada. All you have to do is be there. But here I have to survive, and to survive I have to be creative.

It was 1970 when Al Hinton received the offer of a job as art instructor at Western Michigan University in Kalamazoo; and he recalls being assured by the administration that he would be treated just as any other faculty member. He found that to be generally true. He also found painter Reginald Gammon, another black artist, on the staff. Gammon, a native of Philadelphia, had preceded Hinton at Western Michigan by only four months. Indeed it was Gammon's understanding when he went there as a visiting scholar that his stay would not extend beyond four months. Obviously Gammon was so effective in what he was doing that the university decided not only to keep him if he'd stay but to add still another black member to its art staff.

Both men liked and complemented each other from the day Gammon called to welcome Hinton to the department. The older of the two, Gammon admired the sensitive talent of the giant painter who had been such an awesome defensive player in a game as "macho" as American football. Hinton, knowing that his colleague had lived in New York, admired the man who knew and was known to Hale Woodruff, Jacob Lawrence, Romare Bearden, Benny Andrews, Inge Hardison, Norman Lewis, and other established black artists. And as they, in the course of their work, began to travel about together the respect of each man for the other increased. Their travels took them, among other places, behind the walls of Michigan's Jackson prison. The year was 1972.

Reggie and I became involved in this work among prisoners after Benny Andrews had been invited out to

Western Michigan. Benny talked of his prison art program in New York, and his talking plus the prodding of the university brought us around to believing we might be able to do something constructive out here at Jackson.

The prisoners did their drawings and paintings entirely on their own and once each month Reggie Gammon and Al Hinton went in to give critiques and encouragement. Both men were profoundly moved by what they saw and felt. Indeed their reactions closely resemble those of Alfred Smith whose work in the Norfolk Prison of Massachusetts will be mentioned in a later chapter. Says Al Hinton:

> I was shocked at the number of black men in prison in ratio to our numbers outside. The authorities wanted Reggie and me there because the white instructors found it difficult to deal with the black prisoners and the stuff they were doing. Besides, the prisoners were doing "very black" work and wanted a black feedback on what they were doing.
>
> I found real people in prison. One of those in our program was accused of murdering my family doctor in Saginaw. He introduced himself and as we talked I discovered how desperately prisoners want to talk with people other than guards and each other.

Working with Reggie Gammon in the prison program has had its influence on Hinton's own painting—especially those carefully drawn and painted canvases he calls "my imprisoned landscapes." And although Gammon still works at Western Michigan University and Hinton has moved on to the University of Michigan at Ann Arbor, they still maintain a close relationship as teachers and professional painters. They have shown their works jointly and separately at Western Michigan University, and they both are affiliated

with Gallery Seven founded in Detroit by artist Charles Mc-
Gee.

Hinton serves on the Michigan Council for the Arts.
The Council pushes for minority participation on their
panels and in their projects involving grants to deserving
individuals. Al has moved from panel member to coordi-
nator for the western part of the state and his position pays
him only in the satisfaction he derives from seeing that
minority artists are encouraged and aided. Programs of
longer range, combining his interests with Gammon's, in-
clude forming closer ties with black artists elsewhere in the
nation. And when Al speaks of his own painting his state-
ment is simple and clear.

> My art is heading toward expressing social ironies.
> But they are more subtle now than my earlier figura-
> tive things. And because I don't always employ black
> symbols many of our people think I'm not black
> enough.

Here he laughs and enfolds his two children in massive
arms as he completes the thought.

> On the other hand, many white people are quite up-
> set by it. They think of it as an assault upon them per-
> sonally. In reality I'm painting from my own experi-
> ences—all of the things I've related in this interview.
> Often my expressions in art are as subtle as the racism
> that generates them, and that is where I think my work
> will continue to move.

Michael Brooks, one of Al's students, speaks up at this
point.

> The beautiful thing about being one of Al's students
> is that he has never turned his feelings of antipathy for
> what was done to him by white teachers upon those of
> us who are his white students.

Hinton's response that black people have developed the kind of humanism that enables them to survive both the hatred of whites and "our own counter-hatred" is doubtless true. In Al's particular case it may also be that he is no longer the brutish defensive lineman purging himself of self-doubts and aggressions. He is Alfred Hinton, painter, teacher, humanist. And he is a happier and more fulfilled man.

Carole Byard

THIS gifted artist draws with the combination of strength and beauty that every art student learns to respect and love. And as Carole Byard unfolds the narrative of her life you began to apprehend the sources of both her strength and her beauty.

Our house was always full of relatives—cousins, aunts, uncles—and lots of love. My brother and I grew up very close, possibly because our mother had died when I was two—a very heavy thing in our childhood. All the kids, or most of them in our school, had mothers —more mothers than fathers. Mothers' Day and Christmas were emotional times for us, and we were emotional kids who expressed our feelings openly.

Carole's father, William, and his father were natives of New Jersey, as were Carole and her brother, Michael, who were born in Atlantic City. Carole, one year younger than Michael, was born in 1941. Their mother's people had come from the West Indies—Barbados and Grenada. Carole's mother, Viola Eugenia Longdon, was born in Panama, while her parents were en route to the United States.

Following her mother's early death, Carole recalls fantasizing that Viola wasn't really dead—that it was a mistake and that if she were "good" her mother would return.

Meanwhile the children were raised by their father and their grandmother, Leta Byard. Carole, who from the beginning was nicknamed "Sugar," speaks of her father.

> I remember that shortly after mother died my father went away into military service. I recall the little plastic recordings of his messages to us—sent from Japan. And the experience of his coming home frightened me for I hadn't seen him in so long. I was about four years old. William Byard, my father, was the type of person everyone loved. My mother and he were quite devoted to each other. He never married again.

The picture Carole has of her father is that of a handsome giant of a man who did manual labor and who often worked two jobs, sweeping and cleaning to provide for his family. Of herself she recalls that as a child she was not talkative but especially interested in reading and spelling. It was her brother who constantly drew and she, fascinated, would urge him on. "Michael, draw the man for me." It seemed to her that no one ever drew more effectively.

Carole was about nine and in the fourth grade when she herself did a drawing that made her feel there was something quite wonderful about being able to make one's own drawings. What she had drawn was a copy of Myron's famous *Discobolus* or *Discus Thrower* she had made from a reproduction in an encyclopedia. She had enlarged it and drawn it on a piece of green construction paper.

> Though I was pleased with the result, I kept the drawing as a very personal secret. And I used every chance I could get to do something more in art than what was assigned in school. This, too, became a private and secret kind of mystery for me.

One reason, perhaps, for the privacy of Carole's efforts was that her elementary school had no regular art program

and that the only art teacher she saw was the one who came
once in a while during the school year. It was only after she
entered junior high school that she actually had an art class
and that, for her, became "a place to linger at the end of
every period."

Carole was eleven or twelve when, for the second time,
she was confronted by a family tragedy. The grandmother
who raised her and her brother had a stroke that crippled
her right side. Shortly thereafter she developed cataracts
and subsequent blindness, with the result that she was de-
pendent upon others for help. So the "love" of which Carole
speaks as part of her upbringing—a part of the family life—
was cheerfully shared with the ailing grandmother.

> We took care of her—my father, my brother, and I.
> For three years I looked after her—she and I sharing
> the same room. We had a hospital bed and a wheel-
> chair for her, and my aunts helped look after her, too.
> She was a courageous woman.

It was while in junior high school that Carole became
confused as to her abilities and the direction she would fol-
low later. In elementary school her grades had been high.
There she and all the other children with whom she studied
were black. And as is so often true with black children at-
tending de facto segregated schools, they had heard the
warnings that in the mixed school setting they might suffer
by comparison with white children whose preparation had
been more complete. Sure enough Carole's grades did drop
in the mixed junior high school. Still she clung to the no-
tion of becoming a doctor, a general classroom teacher, or
even an art teacher.

Atlantic City High School became a real training
ground for Carole Byard. To begin with, the war with Hit-
ler's Germany and the Japanese was over and the nation be-
gan to settle once again into the familiar routines that were

most familiar and acceptable to its white majority. Carole
speaks of it calmly and without hesitancy or bitterness.

My father had been laid off when his job, under gov-
ernment control, was transferred back to civilian hands.
He'd been driving heavy equipment in the construction
industry and was replaced by a white union worker.
And it was upon entering Atlantic City High School
that I noticed that blacks and whites lived separately
in the town, with the blacks on the North Side, though
a few whites still chose to live with blacks.

Now we didn't live in the kind of slum we know in
New York. We occupied two-family houses and we
knew everyone in the neighborhood for we lived in one
place for several years. It was a real community.

Still working secretly at it, Carole enjoyed drawing
and painting. She had seen and was impressed by reproduc-
tions of Van Gogh's paintings and through the pages of a
paperback art book she came to know Siqueiros's famous
Echo of a Scream. That particular work made her realize
that "one could really touch people with painting."

Secrecy might have permanently obscured Carole's abil-
ities were it not for a remarkable teacher whom she remem-
bers simply as "Mrs. Gerard," who taught art at Atlantic
City High School. Before meeting Mrs. Gerard it never oc-
curred to Carole that she could make a career of art, though
she admired others whom she thought could. Mrs. Gerard
was perceptive, honest, and helpful. And because she was
firm in her insistence upon having assignments done, she
was able to pick out those she considered serious students.
Carole was one of them.

Through my guidance counsellor, Mrs. Gerard was
able to direct me to an art scholarship to the Columbus
College of Art in Columbus, Ohio. I didn't even have
the bus fare to Columbus. As badly as I wanted to be

a painter I had to be realistic. My father had been laid off his job. So I wrote the school in Columbus asking if they would hold the scholarship for me until I could get enough money to get there and use it. They agreed and I got a job and began putting some money away.

The year was 1959, two years after the opening in New York City of the offices of the American Society of African Culture. Membership in the society of predominantly black artists and scholars included Duke Ellington, Langston Hughes, Jacob Lawrence, Mercer Cook, and Horace Mann Bond, to name but a handful. Carole Byard had never heard of the group, so culturally desolate was Atlantic City, with no museum, no theater, and only a small library. It did have seaside resort hotels, restaurants, bars, and of course its famous "Steel Pier" from which popular dance music was broadcast by radio across the country. Atlantic City's black population for the most part provided services to vacationers.

Carole had found work first as a resort hotel chambermaid and later as a factory hand. While trying to accumulate enough money to take her scholarship offer in Ohio, life was made brighter with the gift of a painter's easel from her brother. Besides, she was keeping steady company with Michael's best friend and though the immediate present left much to be wished for, the future loomed promisingly bright. Then a third tragedy intruded itself into her life. Her boyfriend, who had journeyed south to visit his family, was accidently drowned there. Carole's memory of it is still vividly sad.

I'd come in from work as a chambermaid—a job I had just quit on my birthday, and the family was so strangely glum. Finally my father told me what had happened. And though I'd faced death of loved ones this had come so unexpectedly. . . . The whole year had

been riddled with tragedies for me. I went south and stayed two months with his family in Louisiana and upon returning I had no money left for school. My father, out of work, had cancer. So I just postponed school.

Carole was not long out of work. She found a civil service job at a nearby airbase where the pay was much better than she had been getting, and at nineteen she was helping to support the family. And though she bought pretty clothes and a car, for such things seemed important to her then, she never abandoned the thought of returning to school. The fact of having converted her room at home into a studio bore testimony to a continuing love affair with art.

By this time Carole had enrolled in an adult education course in neighboring Northfield, New Jersey. In the beginning she was conspicious because she was the lone black student. As she began exhibiting in shows in the Northfield–Cape May–Atlantic City area, the mere curiosity of whites gave way to respect. Carole Byard started winning awards. Word got to her through her job of the Fleischer Memorial Art School in Philadelphia which she could attend free of cost and to which free limousine transportation would be provided by the government. Carole leaped at the offer. Remembering her reaction to that chance to study art, she smiles.

> When I heard about those free classes I got me a seat in that chauffeur-driven car and went on to the Fleischer Memorial. Again, I was the only black commuter.

It was 1963, a year memorable for acts of violence here in America, particularly those affecting the lives of thousands of this nation's black citizens. The most shocking occurrence was the assassination of President John F. Kennedy on November 22nd in Dallas, Texas. Black voters had

supported Kennedy. His death had been preceded by the assassination of NAACP Field Secretary, Medgar Evers, just as he was entering his Jackson, Mississippi, home on June 12th. A month and five days previously, Public Safety Commissioner Eugene "Bull" Connor in Birmingham, Alabama, loosed fire hoses and police dogs on peaceful civil rights demonstrators led by Martin Luther King, Jr. And on Sunday, Sept. 12th, four black girls attending their Sunday School class in the very same city were murdered in the sudden fire and debris of a bomb explosion. It was also a year in which black journalist Carl T. Rowan became the United States Ambassador to Norway, and the famous "March on Washington for Freedom and Jobs" was joined by over 200,000 black and white Americans of all creeds and faiths.

Her consciousness of these and other events increased Carole Byard's eagerness to take the fullest advantage of any opportunity to improve and advance herself.

I used to get to Fleischer Memorial before the school opened, as much as one-and-a-half hours early. And I'd stand outside and wait. As it began to grow cold, a black woman, who was the housekeeper, let me sit inside completely alone in that grottolike interior until the basement where I took my sculpture class was opened.

The sculpture instructor, Mr. Ranzetti, a regular daytime teacher at the Philadelphia Museum School, bore a reputation for being most demanding. He required that at the end of each session every student break up what he or she had done and start afresh at the beginning of the next class. And though he did feel that Carole was making progress he was restrained and conservative in handing out praise. Still Carole persisted. When she found that she could also take a class in painting on a different evening she caught

the limousine to Philadelphia two nights each week. A short time later, deciding against continuing with the painting class, she took sculpture for two nights each week.

One evening as she was walking through the basement studios she saw a tiny black woman working on a piece of sculpture in one of the side rooms. The woman was a good sculptor and her presence both thrilled and awed Carole, who was too shy at that stage to speak to a stranger so far advanced in art even if she were black. Her reminiscence on that encounter reveals a sensitivity typical of Carole Byard.

> I was spellbound and fascinated and I never dared say anything to her, though I shall never forget her presence there—working in terra cotta. She was a sculptor, all right. Today's young people would not be as demure as I was, of course; but she was so respected, whoever she was, that although I was bursting to know her I couldn't bring myself to intrude—even if she was just a tiny person.

Perhaps it was a combination of the double session in sculpture along with the inspiration the young black woman silently absorbed from the older one that spurred Carole Byard to devote two full uninterrupted years at her studies. But it paid off. In both sculpture and painting her technique improved as her concepts developed. She painted in bright, often flat colors and her work, though representational or figurative, was stylized.

> Painting was something I had to study. In drawing I always felt more comfortable, so I did a lot of it.

When Carole was ready to show what she had done she won two first prizes.

One of the first persons she sought out to share the joy of her success was her former teacher, Mrs. Gerard. That was heartwarming and welcome news to the high school

teacher who was always happy to pass such information on to her current classes. But Mrs. Gerard, ever pushing for more from her students, questioned Carole.

But why haven't you gone on to professional school, Carole?

It's been lack of money, for one thing, Mrs. Gerard. Besides, I'm twenty-three now. In four years I'll be twenty-seven.

That's quite true, Carole. And you'll be twenty-seven in four years no matter what you may or may not do. So you may just as well be twenty-seven with that training as without it.

Mrs. Gerard's advice made sense and Carole Byard knew it did. Moreover, the job she worked on each day no longer interested her. As she says, "I had gotten over the thrill of working with air traffic control and of having had a few flights." But what really alarmed her was that five years had slipped by since she was offered that scholarship to the Columbus College of Art. There was but one thing she could do now that would bring her any sense of fulfillment and she did it. In the manner of Shirley Stark, who would be leaving Detroit four years later, and of Maurice Burns, who would abandon Chicago a year after that, Carole Byard sold her car and gave up her government job with its enticements of sick leave and sundry benefits.

My friends thought I was CRAZY! But my father was elated. And even though he had leukemia of the lymph glands and the doctors had given him but six months to live, he kept on working for ten years more. Meanwhile I packed and took off for New York City in nineteen sixty-four.

Making the sudden move from Atlantic City to New York was not, in Carole's case, a total severance of roots

from their source of nourishment. One recalls that she had grown up in a close-knit, loving family environment where from infancy she had been called "Sugar" and where she remained "Sugar" into her adult life. So when word went out that she was quitting her job to go to art school in New York it made no difference to her family that outsiders thought she was "crazy." The family, led by her ailing father, was completely behind her. "Sugar's goin' to New York and Sugar's gonna MAKE IT! YOU HEAR ME?"

It was good to hear it, and it was far more than sweet talk. Carole's Aunt Millicent lived in New York City and Millicent was Sugar's mother's youngest sister. Just three years older than Carole, she was delighted at the news and immediately arranged for her niece to come and share her apartment on Harlem's West 139th Street. Millicent recalled how proud the family had been when Sugar was graduated from high school. For several months thereafter they proudly called her "High School Graduate," and now that she was making even further efforts at learning their pride in her grew more intense. Carole has never forgotten Millicent's support, as this simple statement of hers attests. "Millicent fed and housed me." She then speaks of her entry in school.

I went to the New York Phoenix School of Design at Thirtieth and Lexington and I was twenty-three years old. Phoenix was strict and heavy on academics. You learned basic drawing and you practiced no tricks—no beards, dungarees, or long hair at that time.

I was quite disappointed when I started back to school for I had thought I'd find all kinds of people—people of all ages interested in every facet of the arts. But they were actually like children. It was as if I had gone back to high school. All of them (with the exception of a handful of "us") were white and frivolous. You see, having such close contact with Grandmother

Leta Byard did much to mature me . . . to make me
know that there are many things one does out of love
and out of a sense of commitment.

Carole had enough money to cover the first six weeks
of her schooling and she did not miss a single day or a
single class. In fact she put in overtime on work at school
when classes were over, in full consciousness of the fact that
her funds had run out and she wanted to get as much as
possible before having to either make another payment or
quit. And though she suspected they wanted to say some-
thing to her about more money she had sized up the situa-
tion there rather well.

I just couldn't believe they'd ask a serious student
like me to pay up or leave in view of the dearth of
serious students.

Carole believed that her presence had helped set a tone
for others less committed than she. It was a tone, she felt,
that was quite in harmony with the policies of the school.
Obviously Director Kerwin Adams felt likewise. Sensing the
young black woman's financial situation he offered Carole a
job as class monitor—posing the model and keeping tabs on
attendance and time and such routine matters as would free
the instructor to give full assistance to the students. Mr.
Adams also, for purely economic and practical reasons, sug-
gested to Carole that she consider the course in illustration
rather than confine her studies strictly to painting. Carole
combined the two.

From that first two weeks at Phoenix Carole Byard had
established herself as the type of student who exemplifies
the school's purposes, and Phoenix extended itself to help
her. Counting on her fingers she enumerates the opportuni-
ties offered her by the school.

I got other jobs in the school—in the office—the library
—everything to make it possible for me to pay for my

education. I even had a job pasting cloth swatches in sample books—a job that provided my carfare. And I went the whole four years on scholarships.

At the end of each year Carole won at least one award of some sort at Phoenix. She recalls the year when "they called my name four times in connection with as many special mentions." Back home in Atlantic City Carole's family was elated as time for her graduation approached. They had good reason to be. Less than a month before the end of the term the school's director had approached Carole with an offer. Would she be interested in teaching at Phoenix? Carole laughs as she tells how her family had seriously considered hiring a bus so that "everybody could get to Sugar's graduation."

She accepted the offer of a job at her alma mater, starting as an assistant instructor in basic drawing and moving on to a full instructorship teaching life drawing, pen and ink, and painting. It was even proposed that she think a bit ahead toward participation in an international exchange program which Phoenix and other schools conducted with Brussels, Belgium. Carole Byard's immediate future looked very bright indeed in 1968.

That was a year of mixed gains and losses for Afro-Americans at large. The angry rhetoric of Stokely Carmichael and H. Rap Brown exhorting blacks to separate themselves from white America had been consistently refuted by Martin Luther King, Jr. Echoing the King doctrine, Roy Wilkins of the NAACP had declared in December of 1968 that "Separation is not the way of the future." The "moderation" of King and Wilkins was answered by King's murder in Memphis, Tennessee. Infuriated black youths rioted in protest in 126 American cities.

While the number of black athletes in hockey and horseracing in 1968 was fewer than five, Arthur Ashe, Jr. won the

men's singles title in the first U.S. Open Tennis Champion-
ship. And during the same year the percentages of black
athletes in pro football, major league baseball, and pro
basketball rose 26, 30, and 44 percent respectively. In en-
tertainment the splendid screen play *Uptight,* with an all-
black cast, certainly no "Uncle Tom–Aunt Jemima" farce,
marked a new breakthrough for black dramatic performers.
On the other hand, the Afro-American community was pro-
foundly shocked and saddened by the murder of Senator
Robert F. Kennedy. Carole Byard, sensitive and alert to all
those events, was steadily building a frame of reference
from which she would later make her statements in art.

Having previously hired a teacher of Chinese origin, the
Phoenix School was quite ready to hire Carole, and she ex-
perienced no special problem there as a teacher simply be-
cause she was the first black to be so employed. Still she
entertained a few private feelings about her situation.

> There weren't a dozen blacks enrolled at the school.
> And I liked teaching there except that I was also so in-
> volved in creating and I hadn't really set my course as
> most of the older teachers had. They even asked me to
> serve as the student advisor, which I did, though I
> must say I missed having so little or no contact with
> black artists and students.

Carole taught there for three years. She never did, how-
ever, make that proposed exchange trip to Brussels. Her fa-
ther had succumbed to cancer in the interim and she had
moved from Millicent's to her own place on 142nd Street.
Like so many New York apartments it was small, but she
was able to do certain drawings and canvases there while
casting about for larger space and more contacts. She found
the latter first.

The Black Artists Guild was comprised of Afro-Ameri-
can artists working in various disciplines—art, dance, and

theater. Carole became one of its founding members in 1971. Each of the artists was a respected member of his or her particular profession, and in the early days of the Guild's existence Carole designed several record album covers for Stanley Carroll and Strata East. She explains that even now, with the group no longer intact as it was during 1971 and 1972, she still retains contact with the musicians, dancers, and actors who upon occasion ask her to design posters for them.

The period of the 1960s and early 1970s encouraged many black intellectuals and artists to visit the continent of Africa. Many such visits were stimulated by news stories and pictures proclaiming the end of official European colonial rule in Africa, especially West Africa. That area is believed to be the section from which the antecedents of most Afro-Americans were transported as slaves to the Americas. The aforementioned American Society of African Culture, founded in 1957, was yet another influence in that direction. Presided over by such black scholar-educators as Horace Mann Bond, John A. Davis, Mercer Cook, and James Ivy, the Society aroused intense interest in Africa among black American artists and scholars. Knowing, and especially seeing, the motherland became an important thing to do.

Yet publicly acclaimed black artists and scholars were not the only Afro-Americans interested in knowing more about current Africa and the African heritage. In the tradition of the late scholar-author Joel A. Rogers, a few went to Africa on their own resources. Still others sought and found the means to travel there through foundation grants. It was through the latter source that Carole Byard made her visit to Africa in 1972 and it was an experience she still enjoys talking about.

I applied for a Ford Foundation grant of $3,600 and was amazed to get it. The grant was set up to cover black artists and five of us were chosen. Charles Russell,

Quincy Troupe, Jackie Early, and Terry Morgan were the four others. Our grants were for travel anywhere in the world and I chose Africa. I traveled alone. And I went to Senegal, Ghana, Ethiopia, and Egypt—carrying with me my travel easel and paints. That trip to Africa was the most moving event in my life.

Her first long journey anywhere except for the sad trip she had made to Louisiana when her boyfriend drowned, this was Carole's first sojourn in a foreign land. Experienced travelers generally work out some form of travel itinerary in planning long trips, but Carole's lack of experience led her to start without forming even the most casual plans.

Nobody knew specifically where I was going—when I'd be arriving—and there was no one to meet me at any place along the way. I was just overwhelmed at being able to do this by myself. . . . And everyone was most friendly toward me. I met and stayed with a a Nigerian family in a village near Ibadan, and I found it hard to leave them on account of the communication we established with each other. They were my "family" as long as I was with them.

Perhaps the most dramatic of Carole's encounters in all the countries she visited occurred at Shango's Tomb in Nigeria.

Upon my arrival at Shango's Tomb I went quietly inside and there I saw an old woman seated on the ground. She was a very beautiful old woman who, I was told, was all of two hundred years old. I looked especially at her eyes—eyes that had a bluish tint. And when she finally rose she was so tall. Children were there in the cave with her and whenever anyone entered to ask anything of Shango his reply would come through the old woman.

In the Yoruba culture of Nigeria, Shango was the mythical king of the city of old Oyo. He was believed to have been a powerful warrior at once strong, generous, and (when the occasion demanded) tyrannical. It is said that he could make thunder, and that once in so doing he inadvertently destroyed his palace and his wives and children. In his great despair and remorse Shango committed suicide. Believers in Shango are certain he is not dead and they subsequently love and fear him. The old woman Carole saw in the cave obviously is one of the believers whose loyalty to the mythical king remains unshaken.

Over on the eastern side of the continent Carole was "thrilled" with Egypt—its art, its weather, its desert, and its great Pyramids of Giza. Ethiopia, however, depressed her severely. And though its land and people are beautiful, the obvious want and hunger of the many as opposed to the affluence and the splendor enjoyed by the few prompts her to remark, "I'd go back to see it, but I'd never long for it."

That trip to Africa changed Carole Byard's life in that it slowed her down a bit to the place where she takes longer and more careful looks at things—particularly what she terms "natural things." And upon returning to New York City she took time to look around her immediate surroundings there in Harlem. One of the places she focused upon was the Studio Museum in Harlem. Located on upper Fifth Avenue between 125th and 126th Streets, the Studio Museum has, since its opening in 1968, been a mecca for black artists. In addition to its being a showplace for their work the Studio Museum also provides studio space for artists-in-residence, as well as for those students who come to draw and paint on a day-to-day basis.

Carole Byard became one of the Museum's studio artists in 1972. Moreover, she taught life drawing there in its Education Department, working with students from Harlem whose ages ranged from sixteen to twenty-five. Of that class

she recalls, "It went very well in spite of a few advance apprehensions about drawing from the nude figure." Along with her students Carole came into close contact also with many black artists who visited and worked at the Studio Museum. One such contact was the sculptor Valerie Maynard, whose narrative also appears in this volume. Carole comments upon their association.

> We had an immediate rapport. Our friendship has been a very wholesome and beautiful thing. . . . And that's been a vital part of my growth.

After much diligent searching about the city of New York Carole finally found a more adequate studio apartment in the lower West Side development for artists called "Westbeth." Surrounded there by her paintings, prints, and illustrations she finds, as do most artists, that she can use even more space. Still Westbeth is better suited to her needs than the cramped quarters she lived and worked in during her residency uptown in Harlem.

Not long after moving in she got her first children's book to illustrate.

> Ron Hobbs, a black agent, got it for me and before I could even get it started another book assignment came to me.

As fine an artist as she is, Carole admits she hardly knew how to begin to illustrate a book. She was especially puzzled as to how one properly prepares a "dummy." That along with the rest of the book illustrator's craft and jargon was wholly alien to her experiences as a painter and a sculptor. Finally a friend told illustrator–painter–author Tom Feelings about Carole and her problem. Carole speaks with great feeling of this splendid and generous black fellow artist who rushed to her aid.

Tom came over here to me, brought his own sketches, and showed me how to proceed from the initial thumbnail sketches to the final drawings. He's a beautiful guy!

Conversations between artists invariably conclude with some mention of work or plans for the immediate and even the reasonably distant future. Carole Byard has a few of her own.

I'd like for my work to grow so that many people could gain something from it. I would like to just continue painting. And I'd like to confront those things that I would have looked at earlier as obstacles and see them as learning posts or stop posts from which I can keep on going.

To emphasize her interest in making her work available to larger numbers of people, Carole entertains a seemingly workable plan.

I am starting a company now for I am interested in making art available to more people . . . like publishing some of my lithographs and telling other artists how to raise money through exploiting their own works. And as I become involved with illustrating books I realize that art has a lot of power.

Her thoughts for the future include the making of educational films utilizing art and designed specifically for the use of children. And judging from Carole Byard's achievements to date, it is likely indeed that she will realize some of those aims.

Bertrand Phillips

AFTER the shooting and cursing and screaming and slashing had subsided and while the mounds of gray ash were still smouldering, they counted thirty-eight dead and 537 wounded in the Chicago riot of 1919. Fear and hate had given that city and the nation itself one of the worst racial clashes on record.

The climate for it had been created by the fear of white blue-collar workers that their jobs and their neighborhoods were about to be taken over by blacks newly arrived from the South. That fear coupled with the anger of both groups provided the highly inflammable ingredients. The spark that set it off was the stoning and subsequent drowning of a black youth by whites at a section of a lakefront beach which the latter had claimed exclusively for themselves. But the riot solved no problems at all. Black migrants kept coming to Chicago, and among them was quiet, dignified Alfred Phillips.

A native of Pike Road, Alabama, Phillips had worked as a nonunion coal miner in Birmingham, and had served in the Quartermaster Corps of the U.S. Army during World War I. Then, along with thousands of other blacks, he left the South in search of work in Chicago. He quickly found a job as a waiter before entering the Pullman service. He had

become a "railroad man" and he remained one for forty years.

Alfred Phillips met and married Doesrous Thurman, a native of Lexington, Mississippi, and a graduate of Livingstone College in Salisbury, North Carolina. Although she had qualified to teach in Chicago's public schools in the early 1930s she was denied the right. So she settled down to rear four children, of whom Bertrand is the third. It is moving and heartwarming to hear Bert Phillips speak so respectfully of his parents—especially his father.

> In spite of the menial and demeaning work he did, my father was a man of tremendous dignity, honor, and integrity. In my thirty-seven years I haven't seen many with the attributes of my father. I could put full trust in him—never deceiving—and always projecting an image I wanted to emulate.

One gets the impression from the achievements to date of their four offspring that both parents and their teachings are highly regarded by their children. Winifred, the oldest, is an occupational therapist. Alfred is a physicist, Bertrand an artist and university teacher, and Reginald a teacher in Chicago. Bert reaffirms that impression with these words.

> We were trained and inspired by mature parents whose principles enabled their children to aspire to certain meaningful objectives in life. Not only did we receive home training and the normal schooling but such extras as art and music lessons to the extent that our parents could afford.

Bert makes it clear also that his mother never worked outside the home. She preferred to remain there with her family, as her husband's work kept him away from home so much. That was agreed upon early between husband and wife and there was no deviating on either side from the

agreement. Bert summarizes the arrangement and its success in one of his typically uncluttered observations.

> Their understanding and appreciation of one another were profound even though my mother's orthodox religious leanings were stronger than his.

Religion was indeed brought into the lives of the Phillips children—often to Bert's dismay and discomfort. His mother, a strict and faithful member of the A.M.E. Zion Church, insisted upon regular attendance to regular services, Sunday School, and any extra rituals she felt would be good for the soul. Bert resented it, and even today resents the thought of it. He is resistant to the sense of guilt he was made to feel as a child going to church.

> I didn't believe I deserved to have such feelings. Why, it terrified me to believe I was such a sinner in need of repentance.

His resentment of the intensity of his religious discipline was motivated by the fact that similar rigid guidelines had been set for conduct in school. When the family moved to another South Side address the elementary school Bert attended, though almost totally black, was staffed primarily by white teachers. That held true during the first eight years of Bert's schooling, a fact he laments because he found the staff generally insensitive to black children and their needs. He recalls that they were white Anglo-Saxon Protestants for the most part. What he also recalls with anguish was that in her rigidly religious manner his mother held to the principle that persons in authority were automatically right. In fairness to her, however, Bert adds that his mother was "more progressive in other things."

Still the maternal rigidity brought hardship upon Bert who, as a child, was hyperactive at home and in school, but especially in school. And things reached the point where the

teachers were sending his mother daily behavior cards which she was required to read and sign. He speaks of his hyper-activity.

> I never grew tired. Indeed I didn't begin to feel fatigue until I was twenty-two. So with all that energy and no way to expend it all (my mother never favored sports, though I did) I was forced into a mode of life I hated as a child. Study and reading were not my favorite activities.

> So I didn't do well in the three R's—even with my mother sitting over me with a ruler. And even though I know my mother had a love and concern for me and meant well even as she popped me with that ruler, the effects are still with me.

As a man, Bert Phillips is intense, intelligent, and articulate. He is not given to making statements before taking ample time to think of what he is saying. So one listens and one knows that what this man says has been first well filtered through a bright and perceptive mind. As he speaks, for instance, of having revisited the school he once attended, one feels that the impressions he transmits are no less lacking in thought because they are charged with a controlled fury.

> I recall going back to my school to take some photographs of paintings by William Edouard Scott—paintings given to the school by the graduating class. Scott had lived in the community and I recall seeing him when I was a kid. The man who was my eighth grade teacher, and who was then and still is the assistant principal, is no more sensitive now than he was then to the needs of black children. The contempt with which he was speaking to the kids indicated that he was completely alien to them and their parents. And I now know that he and others like him never had the interests of the people at heart.

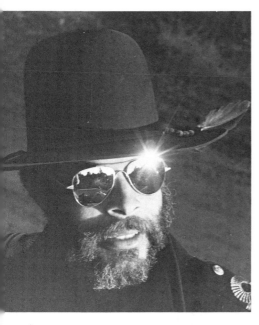

Maurice Burns

Painting by Maurice Burns

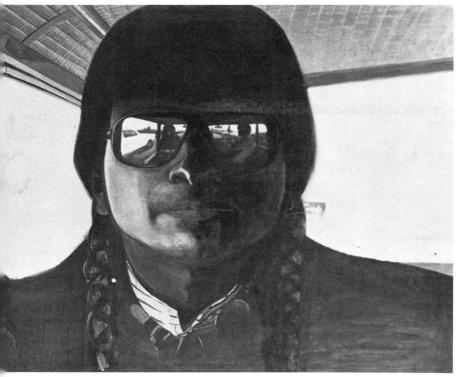

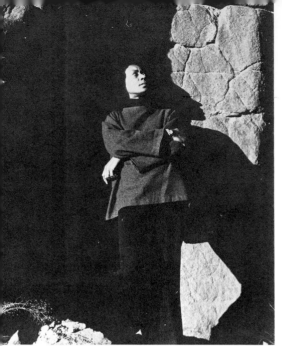

Shirley Stark, Rio Grande Gorge, 1975

Below: "Arcana." Sculpture in Oregon Basalt by Shirley Stark. Collection: Midland Federal Savings, Denver, Colorado

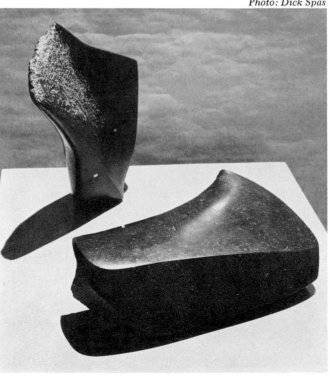

Alfred Hinton

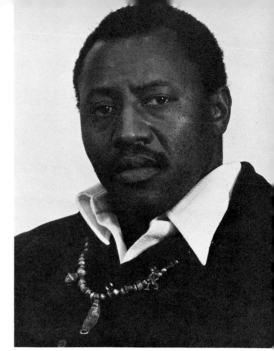

Below: An "Imprisoned Land-
scape" by Alfred Hinton

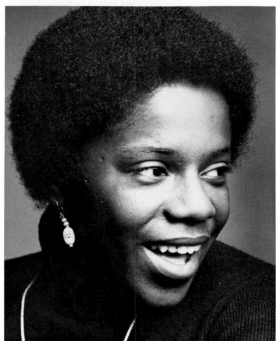

Carole Byard

Below: "Slave Ship." Oil and charcoal by Carole Byard

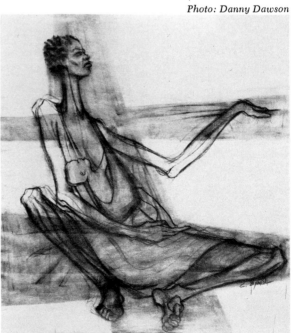

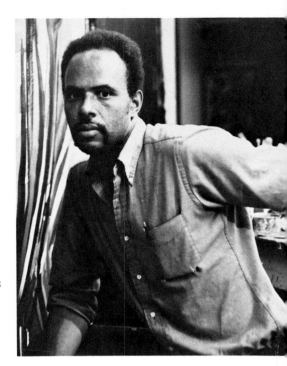

Bertrand Phillips

"Body and Soul." Painting by Bertrand Phillips

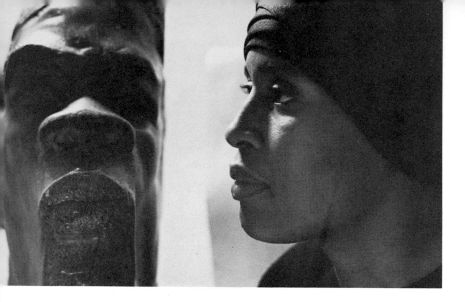

Valerie Maynard with sculpture

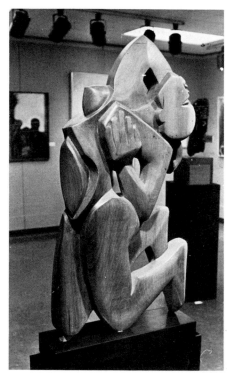

"Ascension." Sculpture by
Valerie Maynard

Kermit Oliver, left, and painting by Kermit Oliver

Trudel Obey, left, and painting by Trudel Obey

 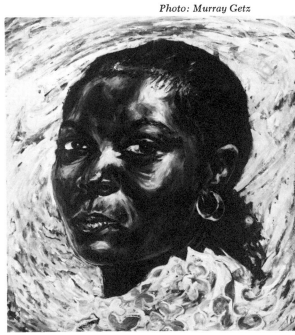

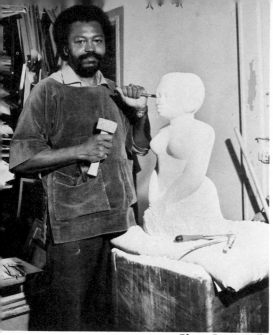

Otto Neals

Photo: Leroy Ruffin

Below: "Black Madonna." Marble sculpture by Otto Neals

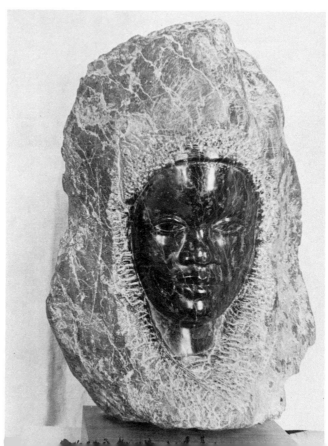

Kay Brown

Drawing by Kay Brown

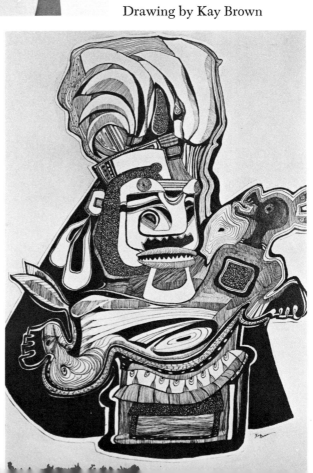

Alfred J. Smith, Jr.

Painting by
Alfred J. Smith, Jr.

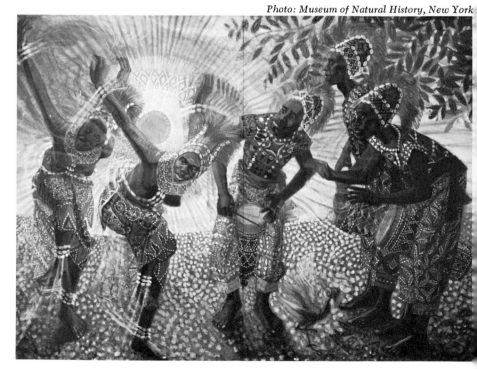

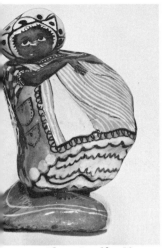

"Stone Figure—Child," left, by Onnie Millar, right

"Target Child." Sculpture by Manuel Gomez

Manuel Gomez

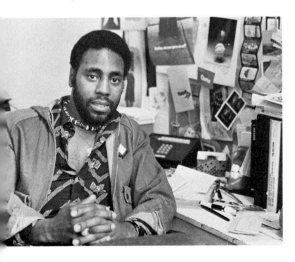

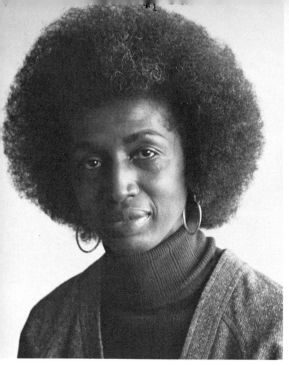

Miriam B. Francis and copper repoussée, right, by Miriam B. Francis

Emory Douglas

Drawing by Emory Douglas

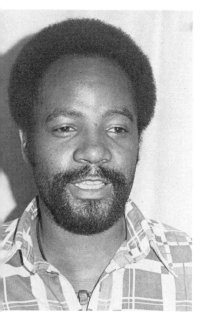

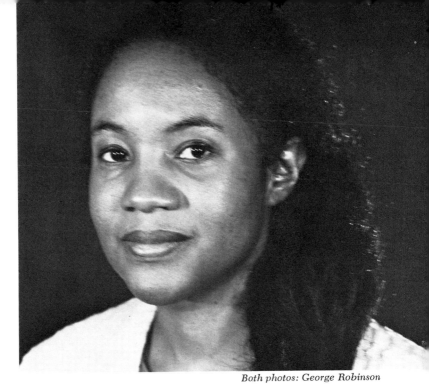

Both photos: George Robinson

Rosalind Jeffries

"Rebirth." Oil on canvas and collage by Rosalind Jeffries

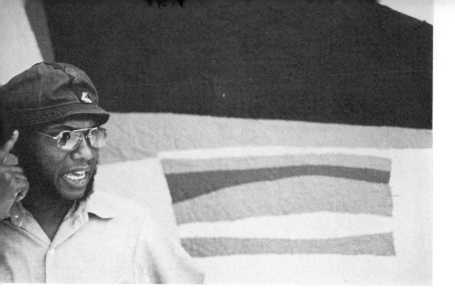

John W. Outterbridge

"Shopping Bag Society." Painting designed for the floor, Rag Man Series, by John W. Outterbridge

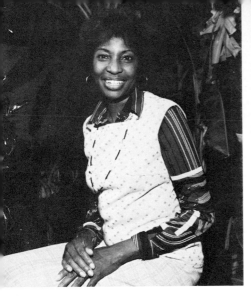

Horathel Hall

Bird Face Mask by Horathel Hall

Leo F. Twiggs and, right, "Sentinel." 1969. Batik on hardboard. On loan. Collection of the City of Atlanta, Georgia

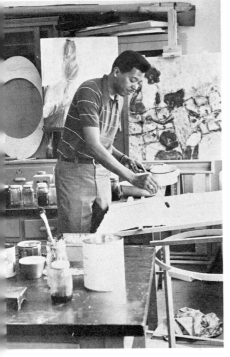

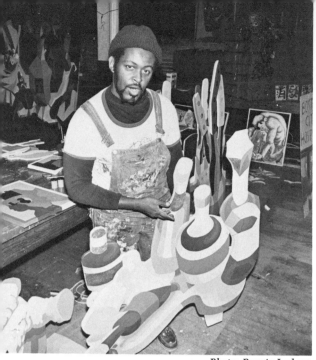

Dana Chandler

Photo: Reggie Jackson

Dana Chandler's studio, late Spring 1976

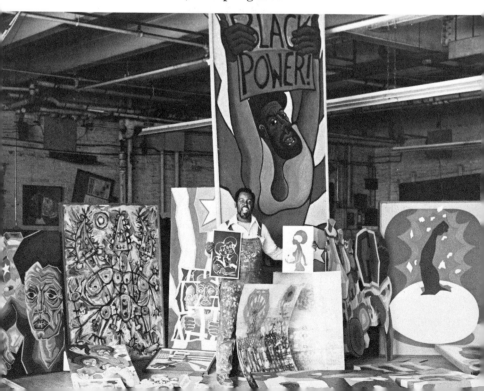

Bert Phillips's interest in art began to take root during childhood. Following church services on Sundays his mother took her children to the Chicago Art Institute, the Field Museum, and the Chicago Historical Society. And during the mid-1940s she enrolled the three oldest children in classes at the South Side Community Art Center. When that center closed she took them to the Junior School of the Chicago Art Institute. It was there while learning the rudiments of drawing and painting that Bert Phillips met Richard Hunt, now an internationally recognized black sculptor.

Bert was eleven or twelve and Hunt a couple of years or so older when, together, they studied in Nellie Bar's sculpture class. Her husband, Paul Wieghardt, a painter and a pupil of the Bauhaus, taught at the Institute. The couple had come to the United States during World War II, and Bert's contact with each became a significant part of his later development, though it was somewhat stormy with Paul. His contact with Nellie Bar was invariably pleasant.

Nellie Bar took special interest in Richard Hunt and me. And there were but a handful of us black kids there whose parents made the sacrifice to make the classes available to their children.

In the Phillips's home no sacrifice seemed too great if it meant exposing the four children to things that would enhance their physical and mental health and growth. Health and learning were high-priority items in their lives. Sports and expensive toys and clothes were low on the list of essentials. So it was quite consistent with such a parental outlook that the special training in art given to Bert in grammar school would continue through his high school years.

The ethnic composition of Chicago's Hyde Park High School was 70 percent white and 30 percent black when Bert Phillips entered in 1953 and when he left four years later. In spite of his special exposure to art Bert went to that

high school totally unprepared to function in a normal way. He took his art assignments seriously and he wanted to learn and to perform creditably in his other subjects but he simply couldn't. By his own admission he was still a hyperactive behavioral problem—even to his art teacher, Miss Isaacs, who "recognized my talent even as she deplored my conduct."

Bert might not have been self-conscious of his shortcomings if he had gone instead to Englewood High School, which actually was the school for the district in which he lived. But he hadn't wanted to go there even though his sister had. So his father arranged with a friend who lived in Hyde Park to have Bert registered as a member of the friend's household. In that way he would have the advantage of attending a school with a high academic standard. But for Bert the way at Hyde Park High School was hard, and he found the frequent confrontations with his parents even harder.

I graduated somehow or other in the usual four years —mainly by going to summer school. But my grades were so low . . . I'm the third kid—my sister's through school and my older brother's going to the University of Illinois. And my parents, like so many black parents, would have been elated had I aspired to enter the study of law or medicine. But my grades wouldn't permit that.

Bert sought to assure his parents that he wasn't opposed to young men who wanted to be lawyers and doctors. It was simply that he wasn't interested in that kind of study. "Well, you're going to get interested," they retorted. For a while a tug-of-war ensued, with the strong-willed son holding his ground while gaining a bit of theirs. Finally both parents consented to his enrollment as a full-time student at the Chicago Art Institute. Once there Bert Phillips underwent a complete change.

At age eighteen he began to think seriously of his life—
of what he'd have to be doing for himself in the next four
years. Not once did he or any of the other youngsters or
his mother have to get out and help earn a living. Their fa-
ther did that for them. Many of his peers, however, had to
pitch in and aid their working parents. That the Phillips's
kids didn't, meant that their parents sacrificed many things
to keep such a burden off the children so that the latter
could be what each is today. Bert knew that. It was his clear
assessment of the advantages he had that helped tone him
down.

> My hyperactivity began to subside and for the first
> time in my life I began to get down to the serious busi-
> ness of study.

The early years at the Institute's Junior Classes had
given Bert a head start on students who hadn't attended
them. In those days his concentration had focused on sculp-
ture. And since building three-dimensional forms had been,
as he says, "intuitive" he now began to seek new challenges.
He found them in drawing and painting. Indeed the creat-
ing of the illusion of a third dimension on a two-dimensional
surface through the use of color became his biggest challenge
as a regular four-year student. Bert was conscious of yet an-
other challenge that, while not then immediate, would have
shortly to be faced. He speaks of that.

> Because I'd been warned by my parents that I'd have
> to be (one) "better than the whites," and (two) "pre-
> pared to earn a living"—I "chickened out" on the course
> in painting and majored instead in Advertising and De-
> sign. Still I took as many extra courses in painting as
> the painting majors took, for that was my first love in
> art.

Bert's half-hearted courtship with advertising and de-
sign was not destined to last. He was quick to note that the

advertising media were not making use in 1959 and 1960 of black models. All the exercises assigned in the classes used white symbols with which he did not feel he wanted to work. Therefore, without hesitation he withdrew from that area of art to concentrate wholly upon painting. He then began to study with Paul Wieghardt, whose wife, Nellie Bar, had been his sculpture teacher several years earlier.

It was traditional at the Institute that at the end of each year students would compete for the foreign travel fellowships. Bert recalls that those fellowships were more prestigious than the B.F.A. degree and that Paul Wieghardt's students dominated them. It appeared that he was at least traveling in the right company if he hoped to win such a distinctive award. So to make certain that he would be considered a serious contender he began to devote much time to the study of color.

On one particular day the model was posed against a purple cloth drapery. Feeling that the purple was not in harmony with the colors he was using for the figure, Bert decided to make the drapery in his painting orange. He was working confidently at his canvas as the teacher, Paul Wieghardt, made the customary rounds of the class, stopping before each easel to offer his critique. When he arrived before Bert's canvas he grew irritated and his German accent seemed especially heavy.

Vas iss dis, Phillips? De drapery iss purple und you haf painted it orange!

Before Bert could reply Wieghardt spoke again.

Ven I return I vant it *purple!*

Bert continued with his painting and when Mr. Wieghardt returned a crimson glow crept to the teacher's hairline as he saw that the drapery was still orange. This time his anger was unmasked.

VAS ISS DIS I ESK YOU, PHILLIPS? DOT ISS DE TROUBLE
WITH YOU. DOT ISS VY YOU PEOPLE HAF NO LEADERS! I
KNEW HORACE PIPPEN—A GOOT PAINTER, BUT AN ALCO-
HOLIC. ARE YOU NOT HARDHEADED? YOU GET OUT OF MY
CLESS!

In his anger Wieghardt rose to his tiptoes to shout at
the pupil towering over him. Bert did not budge nor did he
offer any reply whatever other than a quiet "I don't want to
paint like you, Mister Wieghardt." That ended the incident.
Phillips did not leave the room and he knew that since he
had created no disturbances Wieghardt couldn't force him
out.

I thought about the wonderful relationship both
Richard Hunt and I had enjoyed with Wieghardt's wife,
Nellie Bar—how she had made everything good possi-
ble for us both. Hunt had won a fellowship and had
in fact begun to get recognition while still a student—
getting big commissions even while in the army. So I
would not, in view of all that, be verbally abusive to
Wieghardt. Still I had no intention of being intimidated
by him.

Bert passed Mr. Wieghardt's course with a high grade.
But he didn't get the fellowship he had hoped for nor did
he and Paul Wieghardt ever form a really close relation-
ship, though the rapport Bert and Nellie Bar had enjoyed
never changed. Changes did occur elsewhere, however.
With the coming of a new dean at the Institute, Mr. Wieg-
hardt's prestige waned with the result that students study-
ing painting with other teachers began to win the coveted
foreign travel fellowships. It was 1960, and Bert was enter-
ing his senior year at the Institute. Two additional interests
arrested his attention. The first was photography.

I had become interested in photography after see-
ing the work of black photographer, Roy DeCarava, in

his book, *The Sweet Flypaper of Life,* as well as in a couple of Harry Belafonte's TV specials using Roy's exquisite work. So I studied the fundamentals at the Institute with Harold Allen who as a teacher required that his students approach the medium with the same professionalism he himself used.

For me the photograph is as visually rewarding as the etching. I'd sometimes walk from the Art Institute to the South Side, making a photographic record of what I saw in the black community. The photograph began to develop a high priority for me and I wanted to pursue it seriously once the course was over.

That high-priority interest in photography encompassed social and political forces in the lives of black Americans as Bert Phillips began some specific readings and observations. He read James Weldon Johnson, Langston Hughes, and especially Richard Wright. Moreover he read all of the black newspapers including *Muhammed Speaks.* It was through the reading of that paper that Bert made his first visit to Muslim Temple Number Two in Chicago. Controlled excitement grips him as he recalls the blustery winter night he first saw and heard Malcolm X.

Malcolm X came in with his galoshes on. Nobody could do that except Malcolm, for the Mosque, a sacred place, was immaculate. All of the Ministers from all over the country had assembled there. As soon as the speaker recognized Malcolm he relinquished the floor and Malcolm spoke.

I was sitting up front with all the non-converts, and though I adored Malcolm I could not rise to face the East and raise my palm and bow with any conviction. Oh, I went through the motions all right because we were hemmed in by the formidable Fruit of Islam guards, and I didn't want the brothers to "waste" me

for blasphemy. But I was really not convert material. Malcolm and I did talk after the service and he assured me that I'd be welcome and needed at the forthcoming rally. And I'd have gladly gone. Because of my mother's fears for me, however, I never got there.

What happened was that Malcolm had called Bert at home and in Bert's absence had left information on the precise time and place with his mother. Doesrous Phillips, shaken by Malcolm's phone call, never told her son about it until months later. She regarded Malcolm as extremely dangerous—a defier of established authority who must be studiously avoided. So, true to her conviction that authority was always right, she wanted her son to have no part of him.

Her motherly protectiveness did not, however, quench the fires of disenchantment and discontent in Bert. As he proceeded with his work in painting and photography he simultaneously followed the movements of both Malcolm and Martin Luther King, Jr. His study and analysis of both men revealed a sharp understanding of what they were about.

Malcolm and Martin were paving the way—almost single-handedly. And they were linked—though their techniques differed. At first I did not understand King. I thought that he was too accommodating. But now that I know more about both men I realize how similar they were.

It might be added parenthetically that, dissimilar as many felt the two men to be, the fact is that both were hounded and killed. Moreover, in spite of the "official" and "conclusive" probings and findings to date in both murders, many still feel that the same sinister forces were involved in each assassination and that the full truth has yet to be revealed.

In his senior year at the Institute Bert Phillips entered the competition for a traveling fellowship. The competing assignment was to depict the legend of Icarus. Bert's painting took one of the smaller awards, a prize of $1250, and with that he and two fellow prize winners went to Mexico. There Bert stayed for three months during which he studied at the San Carlos Academy, where he found his Mexican-American friend, Carlos Amando, with whom he had studied in Chicago. Amando was likewise doing advanced work at San Carlos.

The year was 1961, a year in which Robert C. Weaver was appointed Administrator of the Housing and Home Finance Agency in Washington. Another black, Clifton P. Wharton, was named U.S. Ambassador to Norway, and James B. Parsons became U.S. District Judge in Chicago, the first black named to a Federal District Court in the continental United States. Such pluses helped balance the many minuses of which Afro-Americans were so keenly conscious.

In Mexico Bert learned that the communist painter, David Siquieros, was in prison during 1961 and that his wife was arranging a massive public meeting protesting that imprisonment and demanding her husband's release. Bert Phillips met Señora Siquieros and attended the gathering. He was thrilled to be in such close contact with a man and an art movement he had heard and read so much about when he was attending classes in the Junior School of the Art Institute of Chicago. In those days, as young Bert pored through the volumes of illustrated art texts in search of any artists whose works might have special meaning to him, he found three. They were Mexico's "Big Three," Diego Rivera, José Clemente Orozco, and David Siquieros.

Later, as an undergraduate student at the Institute, he took careful note that original works by Diego and Siquieros were not included in the Institute's collection. Bert's comment on those omissions is unequivocal.

That, I feel, is no accident but an attempt to deny
their validity because of the content of their work. I
found that Rufino Tamayo, on the other hand, was
quite popular there.

Bert Phillips resolved to make up in full for all that had
been denied him in the way of contact with the art of Mex-
ico's "Big Three" as he and his buddies scoured Mexico
City and environs looking at everything they could find by
the trio of masters.

Viewing the famous Rivera fresco, *Man at the Cross-
roads*, in which Lenin joins the hands of black and
white workers, gave me a feeling of the surging power
and strength of the form. And what I felt said simply
—"THIS IS FOR YOU!"
These murals gave me a foundation unlike anything
else—a view of the possibilities that existed in art and
how I, an Afro-American, could use this to depict social
things in my own world that relate to something big-
ger than the forms I was accustomed to seeing in the
gallery of the Art Institute of Chicago.

Bert's recognition of the power of art to move people
is strongly similar to Carole Byard's reaction when, as a
mere schoolgirl, she saw a reproduction of Siquieros's *Echo
of a Scream*. That reproduction of a single work convinced
her that she had to be a painter. Significantly both young
black artists were motivated by the same source to use their
skills in commenting upon the unjust and intolerable social
conditions both knew so intimately. Still another dividend
accrued to Bert as a result of his visit to Mexico, and the
usual slow pace of his speech quickens as he recalls it.

Going to Mexico marked the first time in my life
when I felt like a human being. I could go anyplace, do
anything—go to the front without being intimidated or
harassed. There I just let my burden down at the bor-

der. And I went into Mexico as a FULL MAN! And I must admit that I wasn't prepared for that since I felt that American racism had taken hold there. Of course I was mistaken.

The Army reached out in 1962 and caught Bert up in the draft which sent him to Louisville, Kentucky, for basic training and thence to Fort Gordon, Georgia. An IBM machine in the Pentagon then tapped him for service with the Military Police. And though his tall, lithe, muscular frame suggests certain physical attributes for such an assignment, Bert was not pleased. He speaks briefly about it and then only with obvious discomfort.

I didn't want to go to M.P. school. In fact, I hated it. It was totally divorced from my art, my nature, and my black experience! Still I knew how to function without making waves even though I went through a lot of inner turmoil. For the two years I served I managed to survive the overt racism I saw and felt and heard.

The one positive aspect of his military experience was being able to see much of the art housed in Italy, France, Denmark, Greece, England, Austria, and Germany. He returned to the United States in 1964, a year in which both pluses and minuses for black Americans were conspicuous. Of the former, the Civil Rights Act established two bodies —the Community Relations Department and an Equal Opportunity Employment Commission. Its most immediate effect was to begin the termination of race discrimination in hotels, restaurants, and theaters in the larger cities of the South. Then, in the presidential election, the black vote in Arkansas, Florida, Tennessee, and Virginia enabled Lyndon Baines Johnson to carry those states. Indeed 95 percent of the nation's black vote went to Johnson.

The negatives of 1964 were particularly disturbing to

America's black communities. Three Civil Rights workers—James Chaney, Andrew Goodman, and Michael Schwerner —were stealthily and brutally murdered in Mississippi. Goodman and Schwerner were white. And Malcolm X announced his split with the Nation of Islam founded by Elijah Muhammed and the founding of a movement of his own. Personally distressing to Bert Phillips and his family was the death in Chicago of seventy-one-year-old Alfred Phillips. Having been discharged from military service, Bert found a job in the rolling and shearing mill of the United States Steel Corporation. It was an interlude he vividly remembers.

> The working conditions there were appalling. Indeed the air was so foul that I quit smoking. There was no flushing toilet in the mill I worked in and we used to eat our lunch on the cold steel. Most of the workers were Mexican and blacks, while the inspectors' jobs went to young white kids. Yet the men who were so terribly exploited never rebelled. To my questions about their apathy they'd merely say, "Well, Slim, after you've been around long enough you'll find out." I finally left.

During this period Bert's paintings treated the theme of oppression, and he found that where earlier he had groped about for direction he now had it—thanks to his sojourn in Mexico. As he puts it, "I was now able to zero in on what was disturbing me." Meanwhile he continued to work at manual labor, finding another job at the American Can Company. There, although working facilities in general were better than at U.S. Steel, the noise was "awful" and chances for advancement were practically nil. Laborers, he found, unless skillfully organized, commanded little or no respect from those who hired them. So after one month at U.S. Steel and a brief stint at the American Can Company

Bert made up his mind to visit three places. They were New Orleans at Mardi Gras time; Selma, Alabama; and his mother's sisters' home in Mississippi.

Malcolm X was killed the day before Bert left Chicago for New Orleans via Greyhound bus, and the memory of that trip still hurts.

There in New Orleans I took a cab driven by a black cabbie and I asked him what the reaction of folks there was to the assassination. The cabbie obviously didn't know who Malcolm was. Nor did many others with whom I spoke seem to know or care. That hurt more than Malcolm's killing.

From there I went to Selma, Alabama, and I was in Selma that Sunday of the initial *March to Montgomery*. This was the day the police, their marshalls, and the posse gassed those marchers . . . when they waded in and beat heads. I was trying to do a little photography and to document as much as possible but the gas was just overwhelming! It was so strong that gas in the clothing kept the eyes watering after the marchers assembled in the church to regroup their forces. I kept from getting badly hurt by just running like hell!

During the late 1960s Bert Phillips returned to school, taking night courses at the University of Chicago. He also took a one-year course in electronics, finishing as an electronics technician. His reason for turning in that direction is easy enough to understand. "You see, my B.F.A. wasn't very useful to me." But he was a bit hasty in coming to that conclusion, for it was impossible for him to stay away long from the work he knew and loved most.

I entered graduate school at Northwestern University in nineteen seventy and had been there about a year when Elmhurst College, in the small community

of Elmhurst just west of Chicago, asked me to join their staff as a full-time teacher of art.

The contact had been formed through exhibitions of Bert's paintings that had been seen in the area. At the same time black students all over the nation including the Chicago region had been demanding Black Studies programs and black faculty members. Bert went to work at Elmhurst College and, following two years there, was offered a contract by Northwestern University to work as a part-time staff member. Northwestern had come to know him through his work both in its own graduate school and at Elmhurst. At the latter school he had also taught Afro-American Art History and he had established an etching studio. Things began to work well and when he received his M.F.A. degree, Northwestern asked him to become a full-time staff member. That is where he presently teaches.

Bert Phillips lives in a house owned by his mother. It is a quiet, sturdy, well-kept house on Chicago's South Side and Bert is its caretaker. He rents a part of it to carefully chosen tenants while his mother occupies another house which she owns. The property, Bert explains, was acquired by his father through frugal, judicious, and, most of all, honest dealing.

My father was a man who believed in dealing fairly with everyone. Such little property as he acquired was not gotten over the backs and at the expense of those less fortunate than he.

It was obviously such an attitude toward life and people that so endeared Alfred Phillips to his son. And Bert exhibits the respect he maintains for his parents' joint labors in the manner of his careful handling of what they acquired. It wasn't long ago that the house Bert occupies with his quiet senior citizen tenants was occupied by some far

less desirable people. "Police were in and out of here all the time and the place was a shambles," he recalls. That, however, has been changed with Bert serving as resident caretaker. And since he prefers to paint fairly large canvases, his basement studio is ideal. As he shows one canvas after another he talks casually of his work at Northwestern University, to which he daily commutes by car.

Teaching has enabled me to become a more proficient painter and while I am wholly committed to my work there, I haven't fraternized to any great extent with the academic community there.

An observation from his interviewer that one can easily discern in his work a high regard for the great Mexican modernists evokes this spirited response.

Of the three great Mexican painters I feel that Siquieros, as the complete artist, is perhaps the greatest and most advanced since Michelangelo. His understanding of integrating painting with architecture is truly profound . . . and he has fought to turn art away from the church and the cultural establishments—curators and art historians.

In fact, the example Siquieros has set in using industrial equipment in both easel and mural painting and getting beyond the traditional modes is remarkable in its advancement. His advancement (almost singlehandedly) in the use of acrylics has been a great inspiration to me in my use of the same medium. Siquieros is the reviver in content and form of a great tradition set during the High Renaissance.

Such is Bert Phillips's conviction. His work, while distinctly his own, especially in the use of color, clearly mirrors that belief.

Valerie Maynard

Vₐₗₑᵣᵢₑ MAYNARD is a good-looking woman with the resonant voice of a singer and an open personality. She doesn't conceal a sense of humor and there is a bit of mischief in her as she begins to talk of certain things such as her family, whom she obviously adores.

My mother's name is Willie—Willie Fred but they'd call her Willie P., and my father's name is William. They met in Florida when she was twelve and he fourteen. My mother had been brought up to New York from Florida by my grandmother to go to school. At the end of the school year they'd go back to Florida for the summer.

Now my mother's family wasn't too happy about my father's declaration that he was "coming to New York to marry Willie P." They were sort of bourgeois and had certain ideas of whom their girls should marry. They had land and they'd brought their daughters up to be "finished ladies." So when both father and mother were eighteen and sixteen respectively they were, at his insistence, married in New York. Their wedding picture was like a Tom Thumb affair!

Valerie's laughter fills her spacious New York City studio. Her mother, she says, was a "thin, shy, compassionate"

soul who was loved by everyone who knew her. Her sickly youth had conditioned her to empathize with the woes and problems of others. William Maynard was her complete antithesis. Valerie says of him that "he was a Gemini with a temper, who, if things weren't just so would set about making them just so." There were three children, one boy and two girls, of whom Valerie is the second child.

> My brother, William, was born first. I came along two years later in nineteen thirty-eight and my sister, Barbara, eleven months after me.

The children were born in New York City.

In the early part of their marriage the young Maynard couple shared the house with William's mother, who was elated to have them with her. Having had six sons and no daughters the senior Mrs. Maynard was pleased to welcome "Willie P." as the daughter she'd always wanted. That "Willie P." was a gentle and lovable young woman made her mother-in-law happy. But steel fiber was woven deep beneath the velvety surface of Willie P. Maynard. Like every other woman she wanted to be mistress of her own home.

It wasn't long before Willie P. took her three children to Florida with the warning to husband William that they'd be back only when he'd established a home of their own. William got the message and he soon had his family back in New York on Harlem's West 142nd Street where they stayed for the next eighteen years.

William Maynard was a robust and energetic man. An athlete who had boxed for a time, he had worked during the years of the Depression on the government-initiated W.P.A. road building project. Never did he neglect his wife and children. His own people had come to New York from Bermuda and the Caribbean, and had brought with them that driving ambition to "make good" so characteristic of immigrants. Following the tradition, William Maynard was de-

termined that his family would have a few advantages he missed. As Valerie puts it, "God knows he did everything that you could think of to get money for us."

From the very outset Valerie Maynard knew her life would not be humdrum. She puts it this way.

> My first thought that I can remember was—"Where is this place? Where am I?" The next thing I can remember is feeling like something extraordinary is going to happen in my lifetime—many things, in fact. I was really clear about that!

Valerie was not mistaken. Extraordinary things have happened and are still happening in her adult life though her early years were no more eventful than those of most children. She attended P.S. 5 on 141st Street between Eighth and St. Nicholas Avenues, and she recalls that she was always doing art of one sort or another. At one time it might be a house interior or exterior constructed from a shoebox or at another time something else made of cloth or paper. Still, although she drew and painted and played with modeling clay, she remembers few of the things she did with those media. For her and her brother and sister life was full of many excitements.

> My mother insisted that the three of us get out and see things. And though we didn't have money she'd get those dimes together so we could ride the Fifth Avenue Bus. It was fantastic! Then she'd take us to Rockefeller Center to ice skate, leave us for two or three hours, and come back for us. . . . And during the mid-nineteen forties, say nineteen forty-five, when I was in elementary school I'd go to see my grandparents in Florida every summer. Very early in life I was traveling on the planes by myself and being met by aunts and other relatives.

At home in New York, however, great caution was taken to protect the Maynard children from harm. And even though Valerie recalls the Harlem of her childhood as a warm and friendly place where, as in a small town, you knew everybody on your block, their parents were still cautious.

My father insisted that the three of us travel together. . . . "I don't want to see one of you without the other two." . . . And though William, my brother, was the eldest I was the one who had the responsibility for us.

That sense of responsibility to others is something Valerie took seriously. While she was a quiet child who didn't begin to talk much until adulthood, she was alert to injustices done to others. A beating administered to someone became a beating administered to her, and she often found herself in "a defending position" regarding the preservation or restoration of others' rights. Little did Valerie Maynard then realize how involved she was later to become in defending others.

School and community activities kept the growing girl, Valerie, fully and, for the most part, happily busy. One of her unhappy experiences was having to leave P.S. 5 to enter Junior High School 136. To so many Harlem girls, including Shirley Stark who had preceded her there by a full decade, P.S. 136 symbolized one of the last places to which any girl wanted to be condemned. Says Valerie,

I was petrified—SCARED TO DEATH—of going to P.S. One Thirty-Six! I cried and carried on—told my mother I didn't want to go there. It was really a horrific place! But I had to go anyway. . . . In my first few days there somebody took something of mine—a hat, I believe— and I lived on a block with some pretty rough girls

who told me if I didn't get my hat back they were go-
ing to beat me. And I understood completely.

Valerie didn't take long to find the girl who had her
hat, and she didn't ask any questions at all— "I just started
beating on her." She retrieved her hat and from that day on
had no more trouble. Her sister, Barbara, with a more ag-
gressive personality, was known to be a brawler and rather
enjoyed the frequent fights she had at P.S. 136. Both girls,
however, were active in the Minisink Community Center
in Harlem where most of their energies were channeled into
activities more productive than fighting.

Minisink had a summer camp site outside New York
City, one of several such places available to Harlem young-
sters, who were thrilled to get away from the city's swel-
tering streets. And though Barbara Maynard was a bit
younger than Valerie she went to Camp Minisink first. Val-
erie remembers her sister's reaction.

> Barbara came home raving about camp. And though
> at first I was reluctant to go I was okay by the time I
> got off the bus. You see, until I went to Minisink the
> Maynard's were my world and that, to me, was THE
> world. After Minisink I began to realize that my fam-
> ily was far larger indeed than the folks I lived with.

The teachers at P.S. 136 were mostly white when Val-
erie attended school there and they were not, as Valerie
recalls them, noticeably hostile to her. Indeed they were
especially attentive because she was quiet and polite and
quite the opposite of Barbara, whose short-fused temper
kept her constantly fighting. It never ceased to amaze those
white teachers that two black sisters could have such dif-
ferent personalities. Somehow they managed to believe that
all members of black families had to be either angels or
imps—that there could be no mixtures. Valerie, a bright

youngster, noticed how baffled and how curious her teachers became about the Maynards.

> They tried to find out what our family was like, but I kept that private and separate from school. This puzzled the teachers who couldn't understand the difference between Barbara's aggressive personality and mine. I never liked that, especially since they called on me to calm Barbara down before sending for our parents who were always at the school on account of Barbara's fighting.

Of her own encounters with her teachers Valerie remembers that though she was in a special art class in the lower grades she still kept her art as private and personal as possible. One teacher, however, a Miss Fagin, urged her to plan to study fashion design while another suggested she prepare to teach art. But at rough P.S. 136 she received the usual advice to "be a clerk," or something they believed black girls could "reasonably and safely" aspire to becoming. In short, theirs was the typical white American view of non-whites they happened to be in a position to teach and advise.

As a counter-measure Valerie's mother would take her children to Greenwich Village to look at the outdoor art exhibits for which the area is so well known. It was inspiring to see the works and to see some of the artists there at work on the sidewalks. Still Valerie was a bit disappointed that at that time she saw no black people in the drawings and paintings and certainly she saw no black artists there with their works. In the museums and in the art books she saw as a child the only black image she recalls is that of the woman attendant in Manet's painting of the harlot, *Olympia*. She didn't know then that Jacob Lawrence, Romare Bearden, Stella Wright, Selma Burke, Norman Lewis, and Charles Alston, to mention but a few, were working within

easy reach of her. Still she kept looking for such symbols in art with which she could personally identify.

Whatever Valerie found wanting in that area of her life was more than made up for through the inspirational contacts she had with two Harlem churches. One was the Abbyssinian Baptist Church pastored by the Reverend Adam Clayton Powell, Jr. The other was the Mother A.M.E. Zion Church pastored by the Reverend Benjamin C. Robeson. During Valerie's elementary and junior high school years the Reverend Powell was serving in the House of Representatives as the Congressman from Harlem—a post to which he was elected by his constituency in 1945 and held for more than twenty years. "Adam" as he was called in Harlem was a flamboyant and handsome maverick whose appeal was magnetic to everyone—especially to the women and the youth of his district. He was also a very able politician who when not basking in the spotlight was responsible for sound legislation.

The Reverend Robeson, an older and less spectacular man, was no less effective or respected in his own right. The older brother of actor-singer Paul Robeson, "Reverend Ben" rose as a pillar of strength during the days when his illustrious brother was hounded and persecuted by officialdom in his own land for the then unpopular social and political views he outspokenly held. When Paul was denied the right to travel abroad and perform and when the stages of America were closed to him, his brother Ben opened the church so that those who wished could hear the great voice sing the songs of faith and freedom. Youth especially responded to both black clergymen and teenager Valerie Maynard spent many hours in both churches.

Valerie, meanwhile, continued to increase and improve her art efforts, and when it was time to enter senior high school she could have easily taken the test for the High School of Music and Art. That was one of the specialized

schools established in New York City for its gifted youth, and admission was through competitive examination. No doubt Valerie, with her good academic record plus her art ability, would have been accepted. But she didn't want to go there, preferring instead Seward Park High, another good but nonspecialized school. Why Seward Park? Because for a time Seward Park High School had not accepted girls from the notorious P.S. 136 because of some havoc previously wrought by a group from the Harlem junior high school. So Valerie was one of the girls of her class who wanted to test the validity of Seward Park's ban on girls from their school. They were admitted.

No one thoroughly acquainted with Harlem would attribute all the city's vices or virtues to Harlem alone. Like any other section of a great center such as New York, Harlem was a mixture of good and bad, and none knows this better than Valerie Maynard as she speaks of the place of her birth.

> I was a pretty street-wise kid since there were "wars" between the gangs of various blocks—ours versus 143rd Street and so on—and we saw it all! My father, meanwhile, had been a cop, but only for a short time since my mother constantly feared for his safety. He then became a bartender and as such he would walk me around the neighborhood so that I could see for myself that the lives of the kids of the hustlers and drunkards were never as stable as he wanted ours to be. My father is still quite a guy and he can tell you some fantastic tales about New York.

Having spoken candidly of her acquaintance with the rough side of Harlem, Valerie recalls yet another side equally true but far less publicized.

> I was an avid reader—had always been. And the Schomburg Collection was for years my little haven. It

was my "peaceful little acre" and that's where you'd often find me. It was there I began to learn that things as had been commonly believed about us just ain't necessarily so.

Valerie was referring to the special collection of books, manuscripts, prints, photographs, newspapers, magazines, and art accumulated by the late Arthur Schomburg. A Puerto Rican scholar of African descent, Mr. Schomburg spent the greater part of his adult life amassing any material he could locate that related to the achievements of people of African origin, no matter where they lived in the world. Schomburg was able to sell his collection to the New York Public Library which installed it in Harlem, put Mr. Schomburg in charge of it, and named it for him. The Schomburg Collection continues to grow after more than two-score years and is used today by scholars of all races from every part of the world. Its special appeal to black youth, however, is rooted in the manner of its very inception.

When Arthur Schomburg was a schoolboy in his native Puerto Rico he once asked a teacher why the books they used carried no pictures of black people and no information of their achievements. The teacher's reply was brief and stinging. "Arturo, your people have never achieved anything worthy of putting in books." Young Schomburg did not believe that was true and resolved from that day to prove the teacher wrong. His collection's precious volumes and artifacts are an indication of a black boy's belief in the worth of his people.

Valerie Maynard's haunting of the shelves of the Schomburg Collection was her reaffirmation of her worth. So also was her insistence that she be admitted to classes at Seward Park High School. Valerie hadn't been at Seward

Park long before she met a fellow and they married. As she puts it,

> I stayed married for two minutes and went to Florida for about eight months. Then my mother fell ill and I came back to New York.

Actually she was married longer than two minutes, and she did finish Seward Park High School. Graduated with her was a Chinese fellow and together they were named "Class Artists." In the interim, however, she had her first active professional exposure to art.

> I saw an ad in the New Rochelle paper for an apprentice for an art studio, and I answered by mail. "After reading your letter I read no more," the lady told me when I got the job. She was a portraitist and she had a school where I posed and taught kids—rich white kids. I had my own studio and I was just elated. . . . I'd work there for days, sometimes never going home. I was married at that time, though when I got to work in my studio it never occurred to me that I should stop and go home and cook. I'd just go into a trance and he understood that pretty well. But then I realized I had an awful lot to do and see. So I began to get out of the situation and today we're fantastic friends. He, his mother, and his sisters—they still come to all my shows.

During her final year in high school she returned to a place her mother had often taken her previously. This time, she returned to the Greenwich Village section of New York as one of the outdoor exhibiting artists rather than a spectator.

> People passing by looked at me and imagined that I was minding the work for somebody, for I now realize

I looked to be twelve rather than seventeen. Nobody would believe that I had done the work myself.

That showing and the subsequent art which Valerie produced during the next couple of years launched her into the sea of New York City's artists. And in 1959, as she was turning twenty-one, Valerie moved to East 7th Street where she lived and worked among artists of the "East Village." With resourcefulness she was able to earn enough to maintain herself and to develop her drawing and painting. In a short time she had arranged with the management of the building she lived in to get her own apartment rent-free in exchange for taking care of the building. She then obtained a part-time job with the Parks Department—a job in which she used her creativity by working with people wanting to learn basic manual skills.

I had learned to build furniture. . . . And I learned how things were made by taking them apart, studying their construction, and putting them back together. . . . I learned how to make shoes and at one point I even worked with preschoolers in the Park Department program.

Working with people was not difficult for Valerie, who had been trained earlier to do so by her mother as well as by the Minisink Community program. In a short time she had formed friendships with people of the theater. They in turn admired her abilities as a designer of costumes, posters, and stage sets. Working with the theater and its related arts became a vital part of Valerie Maynard's experience during her early twenties. She looks back with special pride to that period between late 1963 and 1964 when she painted, among other things, a backdrop for a musical chorus performed by people from the neighborhood streets. Simultaneously she flung herself into an orgy of drawing, turning

out as many as fifty sketches a day. She was far too busy ever to imagine there would soon be a challenge awaiting her nearly four hundred miles away.

It was in New York City during 1965 that Valerie was offered work at the Job Corps Training Center for Young Women in Poland Springs, Maine. The women came from all areas of the country and since they were unemployed and the Center was designed to train them for employment, the selection of instructors was a vital matter.

As the person in charge of training in arts and crafts, Valerie Maynard was a "natural." She had already developed an imaginative resourcefulness in her work with the Park Department on the East Side. Besides, as a Harlemite familiar with many of life's realities, she could relate to the girls, most of whom were from America's black urban communities. Two thousand of them were in Valerie's program and she taught them how to make handbags, shoes, and such items as they could use. She called that area of her program "Arts for Survival." For those desiring drawing and painting she taught that also. Things went well for a while. Valerie sips her tea slowly before elaborating.

In the beginning the program was composed of girls whose personalities were essentially normal. However, as the need for job training grew more desperate many girls with severe emotional disturbances came to the Center. They began to assault and "shake down" the less aggressive ones until one black girl from Tennessee came tearfully to me and reported that she'd been threatened and confronted by a band of toughs. I immediately called a group of them together.

Valerie talked to the girls. She spoke of the need among them to refrain from victimizing one another. She exhorted them to concentrate their energies upon learning to do for themselves those things which would make it unnecessary for them to perpetrate shakedowns on anyone, and most par-

ticularly upon each other. And she spoke to them of the
Harlem she knew so well—not the make-believe Harlem of
romantic and melodramatic fiction—but the real place of
mingled hope and heartache, dismal failure and brilliant
achievement. As she talked more and more girls came to sit
in and listen. Soon she had a large crowd, and their added
numbers stimulated Valerie to continue talking. They, re-
garding Valerie as one of their peers, responded by giving
rapt attention.

> I talked for three or four hours. . . . And I became
> aware shortly of apprehension among the authorities.
> They weren't accustomed to seeing these girls so rapt,
> and of course, they weren't accustomed to having ar-
> ticulate black women or men around who could hold an
> audience for so long.

Valerie could see, almost smell the fear as it settled
upon those in command, and she told the girls as she talked
that their meeting might be running into trouble. She cau-
tioned, "Whatever happens, don't let them remove me bodily
from your presence."

Somehow, some instinct had warned her that once out
of sight of the girls she might be tranquilized and who-
knows-what-else? A small knot of supervisory personnel be-
gan to move in toward Valerie and the girls immediately
formed a protective phalanx. From her position on the stair-
way Valerie could see a contingent of State Police outside.
Their presence and the air of general tension brought an
end to the meeting and after a brief time, with no further
effort on anyone's part to create a disturbance, the police
left. Valerie then proceeded unchallenged from the building
to her living quarters.

Upon attempting to return to her duties the next day
she was not permitted entrance and on the following Mon-
day was called into a meeting. Valerie relates what tran-
spired.

I listened to the most incredible distortions of what I had said to the girls, including an alleged prediction that "the world was coming to a destructive end." And I was told that I could not return for two weeks—and then only after I had seen a psychiatrist.

At first I balked at the idea but after being assured by someone there I trusted, I agreed. But I selected the psychiatrist from the telephone directory. It happened that I picked the state's number-one psychiatrist. And by a stroke of luck I was able to make an appointment with him through his wife.

At the office of the psychiatrist Valerie had related just about half of what had transpired when the doctor chuckled.

Your story reminds me of my own experience when I was fighting General Electric some years ago right here—a young outsider like yourself. They did exactly the same thing to me!

The Center eventually asked Valerie to return to work but she declined, convinced "that they would have to destroy me in order to control the girls." It was 1967 and she returned instead to New York City.

Back home Valerie once again was able to give full time to her art, and for several months her work progressed with little more than the normal interruptions. Then once again came the unexpected—this time in a letter from Germany. It was from her brother, William, and it read in part: "I'm in Germany and I've been arrested for murder."

Murder? MURDER?? No, it couldn't be! Yet there it was in William's own handwriting.

The nightmare had started during the previous year. Marine Sergeant Michael Kroll, a native New Yorker and a decorated veteran just returned from Vietnam, was driving his car in Greenwich Village shortly after four A.M. on April

3, 1967. He saw two men, one black, the other white, scuffling with Apprentice Seaman Robert E. Crist, who was also white.

Kroll stopped his car and broke up the fight as Crist explained that he had been solicited by the pair for a homosexual act. Crist and the unidentified men went off in different directions as Kroll returned to his car. A few moments later as Kroll drove along Fourth Street he was seen by the assailants who allegedly shouted insults and obscenities at him. Kroll again stopped and got out of his car, at which time the black man allegedly pulled a shotgun from under his jacket and shot Kroll in the face, killing him instantly.

An emotion-charged search for the killer ensued and ended six months later with the arrest of thirty-two-year-old William Maynard in Hamburg, Germany. New York City police, aided by Interpol, the international police agency, asserted that Maynard had jumped bail and fled the country to evade charges involving the theft of a car. Maynard, an articulate young man, countered that he was in Germany on legitimate business. He was nonetheless held by Hamburg police and extradited to New York in spite of efforts by author James Baldwin, who had once employed him, to prevent extradition.

Back in New York, Maynard was charged with murder, though direct evidence against him was practically nonexistent. He went through three trials covering a period of six years. In the interim the charge was reduced to manslaughter. Numerous appeals, legal motions, and court appearances culminated in dismissal of the case on August twenty-third, 1974. The key reason for that action was the disclosure that Michael Febles, the prosecution's chief witness in all three trials, had a psychiatric history and was a convicted "peeping Tom." Moreover, the District Attorney's office had declared that Maynard would be eligible for parole in a few months even if convicted in a fourth trial.

Whatever the circumstances might have been, it was Valerie's view right from the outset that her brother was innocent until proven guilty. So from the time of William's arrest in 1968 until his final release in 1974 she worked for his vindication and freedom.

We tried to fight extradition. Even Jimmy Baldwin who was in England at the time went to Germany and wrote something about it in the German papers. Anyway they brought him back here, claiming he was trying to run away. We got a couple of lawyers and were ripped off by them, and my brother was locked up in the Tombs for three years.

Within that time Valerie had consulted every lawyer she could get to, including Louis Nizer. Her incarcerated brother had written letters to everyone of influence including the President of the United States. Among the first letters he wrote was one to editor James Wechsler of the *New York Post*. And as Valerie formulated her plans for seeing and talking with interested people, Mr. Wechsler was high on her list. Her visit to his office coming after William's letter moved Wechsler to investigate and then write several times about the case in his regular *Post* column.

Those Wechsler stories did much to bring to public light the plight of William Maynard and others like him held for so long in prison without due process of trial. Valerie found ample evidence of their effectiveness as she spoke of her brother's case on radio, television, and in the churches. Wives, mothers, and sisters of men similarly jailed in the Tombs and elsewhere responded with empathy and support, and though William Maynard was being constantly shifted from jail to jail his loyal sister always knew where he was.

At one point, when pushed by the court to stand trial, Maynard attempted to represent himself—a risky move that

ended in a mistrial. Then, through Robert Bloom, who was defending "The Harlem Six," William found attorney Louis Steele. Aided by the support generated through the media, Steele finally brought the case to a conclusion and William Maynard was a free man. Through it all—the entire six years of it—Valerie Maynard never ceased her work as an artist. She affectionately rubs the ears and muzzle of her pet chow and recalls that trying interlude.

During all of this the one thing I insisted upon was carrying on my art production. I was at the Studio Museum in Harlem at the time which was a blessing, for whenever I couldn't get there because of having to be in court or at Attica or Elmira I'd call Carole Byard or someone else and ask if they'd take the printmaking class I was teaching. They'd always help me.

Valerie had begun working on her first show for the Studio Museum in Harlem before she went to work there in 1968. Prior to that she had worked out of her own studios, one in Harlem, the other in Brooklyn, where she made and sold pocketbooks and shoes in order to pay her rent. Then she had gone to Vermont during the summer of 1968 where she began a new facet of her art career—a facet she finds at once painful and thrilling to recall.

At Vermont I started talking to Phillip Smith, the Haitian artist. The next thing I know I'm out there carving. One piece I called *Justice Blinded* and it was based on my brother's situation. . . . I knew then I was a sculptor, but I didn't want to take on the responsibility of what you see in this room.

She indicates with the sweep of an arm the spacious Westbeth studio full of carvings in stone and in wood—some complete, others still in preparation. Large drawings—strong, beautiful figure drawings—line the walls. They are, without question, the drawings of a sculptor.

One turns to sculpture because one tries to draw around paper—to see people as sculptures. . . . Artists are constantly trying to make the message clearer and I'd work until I couldn't say anything more in a given medium. Now I'm with form and I hope it'll always be that way. Yet, I'm still afraid of carving . . . every piece I'm 'fraid to death to start!

Oddly enough the lawyers working on William Maynard's case never knew the extent of Valerie's work in art during the course of their association, even though she had a show at their offices.

But after the whole thing was over I invited them to come over to my loft on 126th Street where I moved from when I came here to Westbeth. They couldn't believe I was doing all that work plus my court appearances, speaking dates, and all. . . . But I knew that no matter what happens you still have to be what you are.

Being what she is induced Jeff Donaldson, who headed the Art Department at Howard University, to ask Valerie if she'd come down there to teach. Donaldson had presented a show of her work at the university's gallery. Valerie hesitated before going down to Washington to talk details, but once there she consented—on the condition that she spend no more than three days a week at the school. Sculptor Ed Lowe was on sabbatical and Valerie went in to teach all sculpture classes. That was three years ago. Valerie loves to teach.

For me teaching is like sharing because you're always getting as much back.

Valerie Maynard is a strict disciplinarian in the studio, always insisting that students give the very best they can give. She clearly recognizes the relativity of the term "best" and she grades students accordingly.

I failed half my class both terms and I'm about to do it again.

What she demands very simply are an honest concept and an honest effort to interpret that concept. And she will tolerate no copying of her own work by her students.

Don't do as you see me doing, for you haven't been there and you don't know the nuances that make up my experience. I will absolutely give you a zero if you try to copy me in the slightest way.

Her students have to model in both relief and round and they have to cast both forms so that the castings look "gallery ready." The piece in the round has to be a self-portrait, half of it with the skin on it, the other half in geometric planes. It is no "snap" assignment and many students wail and gnash their teeth at the outset but they soon settle down to the seriousness of the work.

As strenuously as she teaches Valerie never neglects to produce as an artist. A visitor from Sweden saw her work in 1974 and became excited enough about it to put on four traveling shows and to invite Valerie to Stockholm and eight other Swedish cities. Moreover she did a film in October 1975 for Swedish television. The Nafasi (NAFASI) Film Production Company, a young black group, also did a fifteen-minute film that has been shown at various cinemas. And, of course, she continues to participate in group shows all over the country.

Carole Byard is a close and trusted friend with whom Valerie hopes to do many things. They are especially excited about the possibility of combining Carole's painting and Valerie's sculpture on some large-scale works for installation in the park at Harlem's Dewey Square. But the shaky financial situation of New York City, which was to sponsor the project, has forced postponement of that plan. Still there are things they can jointly do.

Carole and I would like to start a company putting out prints by artists, as well as videotapes of an educational nature. It's important to me to be close to our root system, though I will go wherever I am needed and sent. Still when I go to these colleges and I see a fantastic black mind stewing alone in some obscure place I want to help. You see—I know what it is to be out there!

Yes, Valerie Maynard does know what it is like "out there."

Kermit Oliver

No two artists could have more contrasting backgrounds than Valerie Maynard and Kermit Oliver. She was born and reared in one of the world's largest and most publicized black communities in America's most populous city. His early life was spent in a southeast Texas ranch town of fewer than 5000. Valerie's father worked at a variety of urban jobs while Kermit's father worked at the only job there was to do—cattle ranching. Both Valerie Maynard and Kermit Oliver are firmly committed artists and each gives full and honest expression to those things each knows. In his placid manner Kermit talks of his family and early environment.

The rural town of my birth is called Refugio and that means "city of refuge," and since it is ranch land rather than farmland those who wanted agricultural work had to leave Refugio to get it. My father is a cowboy, as was his father, who was drowned by a horse, when my father, the eldest of seven children, was only fourteen. So my father, who went to work to help rear his younger brothers and sisters, became a cowboy at an early age.

America had been at war with Japan less than two years when Kermit, the third of four sons, was born in 1943 to Carl and Catherine Oliver. Carl, because of his early experi-

ence as a ranch hand, tended cattle for a wealthy owner, and because of his skill served as foreman among other cowhands. Though he never carried the title of "foreman" over white workers, he supervised them nonetheless. Carl Oliver's life and work were in marked contrast to those lesser-skilled blacks in South Texas cotton country, who, as sharecroppers, lived as best they could on the white owner's land. The Olivers lived on their own plot of land and Carl was a good provider.

Carl's family had come to Texas from Jamestown, Virginia. Of Indian, African, and Irish descent, they had, as slaves, adopted the surname of Kindling. Because they had lived near the James River all of the boys were given the middle name "James." When the slaveowner moved from Jamestown he sold the darker of his children in Louisiana. Carl was one of them and he adopted the name "Oliver" from a gambler he knew there. Meanwhile, slaveowner Kindling took the lighter children to Victoria, Texas. It wasn't long, however, before their darker brothers and sisters located them and settled in nearby Indianola and finally in Victoria.

Carl Oliver's adoption of a gambler's name by no means indicated his admiration for gamblers and their lifestyle.

My father was a Deacon in the church, and while he was not fanatically religious, he and my mother brought us up in the Baptist faith, participating in some form of religious activity four days each week. You see, we four Oliver kids were for a while the only youngsters in our church. So the Sunday School and the B.Y.P.U. [Baptist Young Peoples' Union] existed just for us. Our preacher, Reverend McBeth, a seminary graduate, could lecture and also give forth with a real hellfire and brimstone sermon when he felt he should. He was not a commonplace person during the mid and late 1940s in that rural area.

Kermit regards his childhood as "cloistered" mainly because "we had no 'kid group' around us." The boys therefore stuck close together at home, at school, and in church. In all three settings they were obliged to maintain a high standard of deportment and at all times protect the family's good name. Since there was no frantic scramble to exist from day to day, no demands of a material nature were ever put upon the boys. Each, however, was encouraged to be his own person—to learn to think and act for himself. One's early upbringing often governs the course of one's adult life, a truth Kermit eagerly embraces.

Because the emphasis was upon individual self-awareness it is quite difficult for me to become involved in social activism. Both the influence of home and church bore heavily upon me as a kid and I still am guided by that experience.

School was never trying or difficult for Kermit because he knew and accepted the teacher's role of proxy parent, and the same rules that applied at home applied at school. Life at school, especially in the elementary grades, held no unexpected obligations, and by the same token, no unexpected traumas. Even the fact of growing up black (their church and elementary school were all black) in a small predominantly white Texas ranch town did little to rupture the easygoing pastoral life. That is something Kermit Oliver makes no attempt to slough off as he talks honestly about it.

In the community itself one knew that in the rural southern area a "gentleman's agreement" existed between black and white. But because we were so much a numerical minority, lines were not as harshly drawn as in communities where blacks were more numerous. We engaged in sports with whites with nothing more serious resulting than would have been true had we all

been black or white. So the things I paint reflect fond memories of a placid life I knew as a growing boy.

I recall the quiet dignity of the black people I knew as a child and I appreciate the quality of that quiet dignity. I was delivered at birth by a black midwife—a woman blind in one eye—and I find little or no lamentation in that fact. Indeed that is what gives meaning to the work I do.

Art done in the tradition of the average school curriculum can be phenomenally dull and Kermit found that his earliest school art "was always done in conjunction with other classroom projects." Two boys, however, were singled out as having a bit more creativity than the others. They were Lonnie Elliot, the preacher's son, and Kermit Oliver. Kermit credits Lonnie's mother, Susie B. Elliot, for readily recognizing his talent and his above average intelligence. As his second grade teacher she spared no pains to encourage him and today he recalls Mrs. Elliot as "a great influence in my educational life." That Kermit Oliver was bright is seen in the fact that he was but twelve years old upon entering the ninth grade at Refugio High School. It was his first time in a nonsegregated setting, and his sharp mind was quick to discern any change in what for him had been the norm.

Here I found a change in cultural attitudes. In my all-black religious and junior high school environments my talent was held to be a "natural" thing—a thing with which I had been "blessed by God Almighty." In the white environment it was something upon which one places a premium—a price.

So at Refugio High School, doubtless because of the emphasis white teachers placed upon cultivating a talent for whatever it may prove to be worth, Kermit became notice-

ably conscious of doing things in art that "would please someone other than myself." At the same time he found that he was engaged in a moral conflict of sorts. Should he go along with his early teaching and humbly accept his talent as a "gift of God" and let it go at that or should he begin to cultivate and nurture it—then "soar with it as high as I can fly in my associations with my fellow man"? He wondered, too, if he should keep his work quite private, expecting no reward for it. Should he do that or should he move out ahead in the open with it because it was the only thing he did better than anything else?

Kermit was aware that while his academic work was strictly a school matter to be handled in school, his art work extended beyond those confines. Academic work was often verbal and he was not nearly as verbal in high school as he is today. But he communicated easily through cartoons and illustrations for the various high school publications. Particularly memorable to him are the portraits and illustrations of literary figures and events his teacher of literature assigned him to do. He was certain then that he would pursue the study of literature and history beyond high school. But an art student helped him change his mind. Kermit laughs softly in recollection of that turnabout.

My older brother, Carl, had gone to Texas Southern University to study drafting and he became friendly with Cecil Taylor, a senior student in the art department. That's how I was introduced to that department at T.S.U. Then when I saw Dr. Biggers's murals and drawings I knew in which direction I wanted to go.

Two of the Oliver brothers were already at Texas Southern when Kermit arrived and each was pursuing his own course of study. Running true to their early training at home they were seeking to increase both knowledge and skills in an individual way. The day Kermit entered the art depart-

ment and met dynamic John Biggers, he felt he had made the right decision for himself. When he heard Biggers deliver a lecture in that evangelical manner of his, Kermit was momentarily transported back to the church in Refugio with the scholarly Reverend McBeth "turning on the gospel heat." As Biggers finished his "sermon" and said to his freshmen students, "Okay, let's get to work" that was the "Amen" Kermit was waiting for. He was in the right place, and the year was 1960.

What Kermit Oliver found at Texas Southern was a vital, rapidly growing department barely eleven years old. It had been established by John Biggers of North Carolina who had brought two gifted and well trained artists with him, fellow North Carolinian Joseph Mack and Carroll Simms of Arkansas. They had hoped, since Houston is only minutes' flying time to Mexico, to find the influence of Diego, Orozco, and Siquieros well entrenched in that city's art community. Says Dr. Biggers,

> Instead we found a wasteland. The majority group culture was limited and there was no culture as far as visual arts and blacks were concerned.

Still, in what appeared at first to be a culturally barren desert, the three hopeful young men found gems. The first of those gems were black and they were women who taught art in Houston's segregated black schools. Among them were Willie Lee Thomas, Laura Sands, and Fannie Holman, who had been trained in such places as the Art Institute of Chicago and similar professional schools in the state of California. These women knew what art was all about. But under the restraining limitations of the public school system there was only so much they could do with what they had.

When Biggers, Mack, and Simms set up their department, these women, eager to reestablish their association with art and to lend support to the trio of young black pio-

neer artists-teachers at T.S.U., attended the latter's classes. Says Biggers,

> They did this to help us build our art department for they wanted art to grow in this community.

More than that these women, as teachers and matriarchs of art in Houston, touched and were felt by talented individuals in Houston's black community. A few of them will be mentioned in the following chapter.

Among the white gems Biggers and his two associate teachers found when they went to Houston were the generous and dedicated patrons of art—without whom artists cannot hope to exist for very long. They include Susan B. McAshan and Mrs. Kenneth Dale Owens, each of whom has supported not only Houston's museums but also the black art movement at Texas Southern University from its very inception in 1949.

Kermit Oliver, coming north to Houston from Refugio, had no way of knowing the events and the people who had made what he saw so attractive. What he did know was that he felt a spirit at T.S.U. to which he could personally identify. And he liked John Biggers's approach, which focused upon an appreciation of the black American's southern roots, his traditions, and his contributions to America's development from slavery to the 1960s. Kermit, though not familiar with the specific rural themes of the South that "Doc" Biggers talked, drew, and painted about, did know the cowboy's Texas. That was something he could expound upon and he set his sights in that direction.

> Doc was very sensitive to my needs in those days, especially my needs in the area of technique. He didn't tell me what to draw and paint but he showed me how I could most effectively use the media to express my own ideas. And I had many ideas—ideas I intended to

put forth on paper and canvas as soon as I felt technically ready to give them the fullest possible expression. Doc's help in that direction was what I most needed and appreciated in my earlier period with him at T.S.U.

As he began to feel the sureness that grows with increasing control of the tools of one's craft, Kermit started the initial essays into the pastorial themes with which he was later to become firmly identified. Meanwhile, however, he found himself caught in the flak of pictorial crossfire created by social and political events and the reaction to those events by most of his own peers at T.S.U. He puts it succinctly.

In this respect I recall that most of the artists at T.S.U. were doing work that borrowed from the news media during the riotous and rebellious nineteen sixties. They were taking the photographic scenes of violence, mostly of police instigation, and re-creating them in paintings and graphics.

That, to say the very least, was not Kermit Oliver's approach to his art, and as he reflectively sips tea in his home in Houston he unhesitatingly tells why.

I was at odds with much that many of the others were doing there with the subject matter they chose to depict. Few of them were technically able to draw and paint the violence—material that I felt best lent itself to the photographer's art form.

One had to be neutral—he had to bring no bias to the subject—if he hoped to do it well. My fellow students, on the other hand placed a premium, it seemed, on emotionalism, since they were urban kids brought up in this. Mine, on the other hand, was an environment of humility, self-sacrifice, and sustaining one's self. So I

was accused of standing aloof when, in their view, I should have been more the activist. But in truth I never indulged in the shouting of slogans proclaiming our beauty because I never once assumed that we weren't beautiful.

Kermit's mildly stated acknowledgment of being unpopular with his more emotionally charged and less technically prepared peers is typical of his style. The cool meditative approach to the cascade of brutal events taking place was hardly balm to the scorching feelings of his fellow students. And one can also be sympathetic under the circumstances with the hot impatience of those less disciplined. What, in their limited study or in their feelings of outrage, did they know or care about the profundity of the Gandhian philosophy practiced and preached by Martin Luther King, Jr.?

Who, in their eyes, but a bunch of young fools would "sit-in" peacefully at lunch counters waiting for service that never came as hostile whites crowded about, cursing and pouring catsup and mustard over their heads and clothing? And who but a crowd of older idiots would board a "freedom bus" bound for hostile Southern cities and towns knowing that they would be intercepted by goons bent upon mayhem and even murder? And what special kind of stupidity did it require to dress in one's best and venture into Lester Maddox's Atlanta, Georgia, restaurant to be on the receiving end of Maddox's "Axe-Handle Specials"? It took, thought Kermit's critical peers, a rare talent indeed to speak eloquently of a dream of love, equality, and brotherhood, while not yet fully dried and healed from the hosings and the beatings administered by the adversary.

Those were the sentiments of the young urban and rural blacks of the South who had never known the serenity and relative security of the black rancher's family, who, though

not affluent, were not obliged to grub daily for the meanest crumbs. How could those angry students be expected to feel kindly toward the good-looking, dreamy young man who might easily be mistaken for Egyptian, Malaysian, Mexican, Indian, or anything other than the Afro-American he knows himself precisely to be? And yet those who opposed his manner, his rig, his style, had to admire his talent, and, in a sense, his quiet confidence too. Most of all they had to respect his consistency and the sincerity with which he calmly went about his particular business.

What they felt about Kermit Oliver was akin to what they felt about Martin Luther King, who had to be martyred before they could acknowledge the respect they secretly held for him. So Kermit Oliver's position posed a dilemma—not for him but for his opposing fellow students. He knew where he stood and where he intended to go. And of his own position he says this:

> I consider myself a peaceful revolutionary for I place all these happenings in the larger context of man's inhumanity to man—PERIOD! The characters—the principals—were black and white but to me that was incidental. This was man against man—an age-old conflict.
>
> So besides doubting my ability to put into my paintings the impact and intensity carried in the news photographs I was guided by my reading of philosophy and of the Bible. Those sources told me that this was but a cycle . . . a repetition of man's behavior and misbehavior throughout his history. I also began to question the limitations of the Baptist theology I grew up in.

That questioning began to take serious root in 1965 and extended into the next two years.

Meanwhile Kermit continued in the earliest part of the 1960s to work according to the dictates of his conscience. He found as he moved along that what he was producing was, in actuality, reflective of what John Biggers meant as he

lectured his classes on *Black Dignity* and *Taking Pride in the Black Experience*. Biggers's striking effectiveness lay in the fact that he painted and drew exactly as he talked, and Kermit respected that. So as he himself moved along he found that the "Black Experience" became one of survival through adaptability and knowing how to accept the partnership of decent whites with whom he could jointly work.

His marriage in 1962 to fellow art student Katie Washington obviously began to do much to strengthen further already rooted beliefs. Katie, the attractive mother of their daughter and son, and a capable artist herself, breaks the silence.

I'm a Texas girl from Waco but I was graduated from high school in Seattle, Washington, where my mother and father lived. I spent my school months with them and came back to spend the summer months in Texas with my grandparents. After finishing high school I went back to Waco where, through a summer school workshop, I came to hear about T.S.U. That was in nineteen sixty-one. That fall I was accepted as a student at T.S.U. and there Kermit and I met. The following year we were married.

When the 1965 school year began John Biggers was not at his post at Texas Southern University. Through a program of exchange he went to the University of Wisconsin at Madison and his place was taken by Wisconsin's Larry Judkins. The Biggers family and the Judkins family even exchanged residences for that year. Kermit Oliver, ever receptive to new points of view, listened intently to the young white artist-professor from the celebrated midwestern university.

I owe much to Mr. Judkins because he helped show me how to forcefully present the ideas that were flowing so prolifically from me. So here again I met with someone who was important—as Doc had earlier been—in aiding my technical growth.

Having expanded his reading along with his work at the easel, Kermit discovered Charles Bouleau's *The Painter's Secret Geometry,* a study of the compositional techniques of the world's great painters. That book helped considerably in sharpening Kermit's understanding of the two-dimensional character of painting as well as the meaning of the space within the picture area. Larry Judkins, quick to spot unusual ability, succeeded during his year at T.S.U. in having three of his students included in a show at Houston's Courtney Gallery. They were Henry Wilson and Katie and Kermit Oliver. That seemingly routine event marked, for Kermit at least, the planting of a potent seed in fertile soil.

Still, one had to earn a livelihood and with a wife and daughter Kermit Oliver's sense of responsibility steered him into teaching. There in the city of Houston he encountered agonizing problems.

I tried it for awhile but I didn't like it. There were the discipline problems with kids who were thrust into art because they couldn't make good anywhere else.

But the aspect of teaching he found most difficult to cope with was that of petty internal politics.

If you are truly dedicated to helping kids and work hard at it, there are always those not so motivated who will feel threatened by your industry. I was teaching seventh- and eighth-grade kids Art History as it was taught at T.S.U. and my kids were passing the course— a course many college students were flunking. But the authority over me was dissatisfied. "Just keep 'em busy with something they can show and possibly sell," he told me. "Their minds aren't ready for what you are doing." I now know that the supervisor was TERRIFIED. I, on the other hand, was HORRIFIED! As a black man he should have known better!

Rather than trying to make a go of it and possibly taking his resentment out on the kids and his own family, Kermit quit. He chose instead to take a chance on freelancing and possible starvation. At least he'd be doing both with dignity and clarity of conscience. His friend and former teacher, John Biggers, gave him a sendoff by making a contact at the University of Texas Press, who contracted Kermit to illustrate two books. Then, in 1970, the Courtney Gallery that had previously shown him in a group exhibition gave Kermit his first one-man show. That, coming in the wake of a disgraceful show of police force at T.S.U. caught many Houstonians by surprise. Those who were certain that the first black artist's one-man show in a white gallery would be a scathing polemic in oils were completely unprepared for the profoundly conceived and beautifully executed symbolism they saw. They were indeed quite overwhelmed by the young black painter who had fortified his painter's technique with a study of literature, philosophy, and world mythology. It happened again the following year.

I had my second one-man show at the Debose Gallery here in downtown Houston. I've been there ever since. But only during the past two years have I begun to sell with even moderate financial success and consistency. They, the Debose Gallery, are my present agents.

Kermit Oliver is not bound to the gallery by a written contract, nor is he required by the gallery to produce a given number of canvases each year. He works methodically and slowly and paints what he pleases. That what he likes to do is saleable is all to the good. And though he wants to be fairly paid for his work he doesn't want it priced beyond the reach of those who wish to own it.

My expectations are minimal and when my work ceases to sell I know I'll hear it from the gallery. Be-

sides, I do not paint merely to support myself. Painting and drawing are natural functions for me. If there were no gallery in my life I would still paint and draw. It's something I must do.

Kermit is a fine woodcraftsman, as samples of inlay furniture he has made for his home reveal. Indeed he finds woodcraft closely akin to painting—in much the same manner as did the celebrated Iowa painter, Grant Wood. Certainly he carries not the slightest hint of a man fearful of his ability to earn a livelihood. Kermit smiles as he contemplates that bugaboo of all freelance artists—the lean periods of no sales.

I still make picture frames, you know, and if I had to sustain myself by that I could do it.

One believes firmly that he could. Yet one also believes that it is highly unlikely that Kermit Oliver will ever have to put aside his painting for framemaking unless he chooses.

Trudel Obey

My mother comes from Normangee, Texas, a town of less than one thousand people, located just west of Huntsville. Her maiden name was Randall—Alvessie Randall. My father, John Henry Mimms, lived close by Normangee in a place so small it doesn't even have a name. In fact, there was only one family there when he was growing up and that was his family.

Trudel Mimms Obey laughs a little nervously as she checks your reaction. She wants to make sure of you—of what you are, of where you stand. So she gives it to you straight and clean, no embellishment, no cover-up. Then she pauses. She's come on pretty strong and she wants to know if you are interested in a strong story or if all you want is pablum. In one swift moment she has her answer and she settles down to a serious session. It is obvious that, beneath her slow southern speech and hospitable manner, this young woman thinks quickly and doesn't like to waste her time.

She is a stunning woman of medium height and build, and as the younger of her two daughters cuddles close to her she strokes the child gently and reassuringly. Then, suddenly conscious of her visitor again, she speaks.

I'm the youngest of five—two boys and three girls. My mother had a time trying to get me to leave her to

enter the first grade in school. I guess I was afraid because I was the baby of the family. . . . And to tell the
truth, I think my mother spoiled all of us in her own
way. This one here is very much like I was.

It had not been easy for black folks in rural Texas to
buy land even if they had the money. But Trudel's fair-
skinned grandfather, mistaken for white, did purchase land
which he passed on to his son John Henry Mimms. He also
owned and operated a garage which he likewise passed on
to Trudel's father. The result was that throughout her childhood Trudel Mimms never saw her parents going outside
the home to work for anyone, since they always maintained
a business of their own. And even when an improperly
jacked-up car fell on her father and crippled him for life, he
came back after months in the hospital and resumed work
in his own garage.

With his strong wife, Alvessie, and two growing sons
to help him after school hours there was no stopping John
Henry Mimms. Admiring friends and neighbors affectionately nicknamed him and praised his courage. "Man, I'm
telling you nuthin' can keep ole 'HOP' Mimms down for
long!"

As a schoolchild Houston-born Trudel was shy and
withdrawn.

I went to the Eighth Avenue Elementary School out
in the all-black Heights area—and though it was not as
bad as the notorious Third Ward, the teachers were
tough. And I'm sure it was my fear of them that gave
me a mental block because I always wanted to make
my comments in drawing while in school. I found that
I could articulate verbally at home but not in school.

Trudel's silence in the classroom enabled her to hear
whatever went on about her. She listened and she watched
everything and everyone and she notes that her younger

child, Tamu, is much as she was. Her mother talks to you
and Tamu says nothing. But Trudel assures you that a little
later on Tamu will be discussing with her dolls everything
she recalls of the evening.

Trudel speaks again of her teachers, all of whom were
black, and to whom she felt little or no closeness. As a
teacher she understands that her own classroom problems
of discipline are created in large measure by overcrowding
both at home and in school. And as she talks of her youth
one recalls her fellow Texan of the same age, Kermit Oliver,
who never as a child experienced urban congestion in hous-
ing or schooling. One then understands how possible it is
for two black children growing up in the same southern
state at the same time to develop entirely different tempera-
ments and outlooks. And one also understands why the art
of Kermit Oliver and Trudel Mimms Obey is so vastly dif-
ferent.

I always drew when I was a child in school. And I
suppose that's why I missed out so much on my other
studies. Well, the teachers found out that I could draw
and they kept me busy doing that. I kinda' regret some
of that now because as I look back I see how much I
did miss. Even as far as high school I remember that
my biology teacher kept me so busy drawing I really
learned little or nothing about the subject other than
what came to me by way of the drawing.

So Trudel in Texas along with Al Hinton in Michigan
learned early how adults exploit the talents of children to
their own advantage and to the decided disadvantage of the
exploited child! However, it was on her own and in her
spare time that she drew the things that really moved and
inspired her—scenes of the pastoral life she could enjoy dur-
ing the summer months away from Houston. Then she and
her sister were sent to visit cousins who lived on a farm.

I loved it there—the smell of the earth, the clover, and the red dirt that looked and smelled o-o-o-o-h so good . . . good enough to eat!

But September came and they were back in steamy, sweltering Houston and back into school where she could be certain of real fun only when engaging in competitive sports, which she loved.

Junior high school was for Trudel a bad experience—with a teacher who made free use of ridicule in the classroom.

Some kids need that kind of approach but for me it was more destructive than anything else. But I shouldn't really blame her for she had a rough time at that period just trying to be a teacher. As a teacher I now understand her position.

Trudel takes the same understanding view of her parents, who did not have her educational advantages and who therefore established with their children a less intimate relationship than she has with hers. The Obey children, Kimkena and Tamu, are growing up with books given to them by their mother to read. Trudel makes a special effort in that direction for she notes that among the kids she teaches those who go in heavily for athletics and sometimes drawing do so because they aren't led by their parents into reading. That lack, she finds, makes for division among pupils. Those who read have answers. Those who don't or can't read have to find other ways of expressing themselves. How dreadfully well Trudel, who as a child played rough sports and drew pictures, knows that!

There was yet another hurdle—a very personal one—she had to get over while growing up and it is painful to hear her describe it.

What really got to me as a kid was the way so many of our folks made a great "to-do" about color. If you

were yellow you were mellow—if you were black you stayed back. That existed all through school. I can't think of a single teacher in the public schools I attended who didn't favor the light-skinned kids with "good" hair.

Trudel is referring to the attitude of self-deprecation among many blacks prior to their acceptance during the 1960s of blackness as a thing of beauty. For many years, and certainly during Trudel's childhood, hair straighteners and skin bleaches found an eager and often frantic market among Afro-Americans seeking to "improve" their looks.

Why, the same attitude existed in my own family where I happened to be the darkest child, and where I really felt the color prejudice of my father's mother. She ALWAYS called me "Black Gal," while calling my sisters and cousins by their given names.

When I'd be playing out in front of the house with my friends she'd call me. "GIT ON IN HEAH, BLACK GAL, AN' GIT THIS WORK DONE!" So I'd be called in to sweep and mop while my sisters sat around eating and having a good time. It got to the place where my playmates, if they saw her coming, would warn me so I could get out of the way and avoid being embarrassed. I especially remember the Christmas when she gave my sisters nice underwear and gave me a powder bowl! Indeed, I've not gotten over that to this day.

Compensations often exist, however, in even the most trying circumstances, and a very strong one existed for Trudel. She discovered it in her maternal great-grandmother, Martha Randall, who was called "Ma" by everyone who knew her. Though "Ma" Randall had been a slave she was certainly nobody's "Aunt Jemima." Indeed Trudel says of her that "Ma was one of the greatest influences in my life." As was true of Carole Byard's grandmother, "Ma" was blind

and she depended upon Trudel to lead her about and help in those things she found impossible to do for herself. Still it was the young girl who sought and gathered courage and strength from the physically handicapped old woman.

Trudel remembers, for instance, asking her mother why she and other black children were not permitted to go and have fun in a local park nearby. Her mother, avoiding the child's questioning eyes, and seeking to shield the tender feelings from the truths of white racist laws and practices, would reply, "That's in the hands of the Good Lawd, chile. You'll get there when he's ready for you to get there."

Not so with Ma Randall. She would tell it like it really was—beginning with her own slave-girl experiences and running it on down to the present, making certain that Trudel missed little of the true nature of black-white relations. And even as she invoked the name of God, the old woman never gave quarter in her opposition to oppression.

Lawd, forgive me, but I'm gonna die hatin' white folks!

Ma's simple, elemental approach to right and wrong appealed to Trudel, who, in the honest manner of children, was not given to equivocation.

Ma told me the truth about things and I loved her for it. . . . It wasn't that I didn't love my mother who was trying to keep the ugly side of life from me. I knew she meant well. . . . It was that I wanted most to hear the truth and that's what Ma was giving me. And her influence worked such changes in me that both my mother and father couldn't come to terms with what was happening within me. . . . They'd often say "That is one strange chile! She ain't actin' the way we raised her to act."

I looked after Ma until she died. I was about sixteen,

and we didn't know her age, though my mother was certain she was over a hundred. But even now I look at my paintings and they tell me about Ma. I see her in them and sometimes I tremble with excitement!

Ma Randall's indomitable spirit helped sustain Trudel during those difficult days through junior and senior high school. Between the seventh and ninth grades she studied the violin, and even though her parents sacrificed a good deal to pay for the lessons Trudel got them just the same. She made progress with the instrument until she entered Yates High School. There, once again, she came face-to-face with in-group discrimination.

The locale of Yates High School differed from that of both her elementary and junior high schools in that it was in a middle-class rather than a lower-class black area of Houston. Many parents of Yates students were teachers, lawyers, doctors, and the like, and though her parents were not "professionals," Trudel was there because it was the only black high school offering instruction in violin. Her progress had been rapid enough to justify her continuing with a view to becoming a music major later on. But that was not to be and Trudel's eyes mirror chagrin as she relates what happened.

It was really something there. If they didn't know you or your folks at Yates you simply weren't there at all as far as they were concerned. One teacher there stopped my whole career in music. Because my parents lived across town—didn't hob-nob with his crowd —and since he'd never heard of them, he refused to recognize my ability with the violin.

Now, in junior high school I played advanced violin. That's as high as one could go there. When I got to Yates this music teacher put me on third violin—the worst position because you don't get a chance to play

much. He just plain blocked me out! So I took up the clarinet and he did the same thing again. I dropped the whole business until I could find someone who would honestly recognize my abilities.

As if the setback in music at Yates were not enough, Trudel, when seeking entrance to the art classes, was advised by the school's counsellor that art was "a waste of time." She did finally get to take it during the last half of her senior year. By that time, however, she was in a quandary. Should she seek higher education in music or art? That she should seek higher education was not in question for she could see all around her what was happening to those without sufficient learning. It was then that her parents came to her aid with a suggestion.

Though their resources were limited they could give Trudel a start. And since she'd been so shabbily treated by the black snobs in Houston who themselves were limited, it wouldn't hurt a bit more to seek knowledge in a predominantly white setting. There, too, she would doubtless find snobbery, but the snobs wouldn't be as limited in techniques or in outlook.

It was autumn of 1961 following graduation from Yates High School when Trudel Mimms, with the blessing of her parents, set out for the Chouinard Art Institute in Los Angeles, California. And in Trudel's words, "It was a *trip*, too!"

At Chouinard, the first school she had ever attended with whites, she felt none of the same traumas that had hounded her throughout her school career in Houston. There was none of that dreaded light versus dark—good hair versus bad—nonsense to contend with. Nor did it matter to her teachers and fellow students who her parents were or what they did for a living. Indeed this typical white American attitude that all nonwhites are pretty much the same had a few advantages for Trudel. But she was still not free

of pressures and anxieties of yet another sort, as she readily admits.

> One thing is that I was withdrawn and that was because I was the "only one" in the class. I felt that all eyes were upon me at every moment; and since I had for my entire life been made to feel that I didn't measure up I felt that I just had to be the best in the class. Pressure seemed to ooze from everywhere, and even at that distance I could still hear my paternal grandmother calling me "Black Gal."

In addition there were two other black students at the school and none ever got to know the others during Trudel's stay there. Those were the days just prior to the period when black students in white school settings deliberately banded together. Before that, however, self-consciousness and the fear of segregating themselves after seeking escape from segregation forced Trudel and the two other black students at Chouinard into the unnatural posture of studiously avoiding one another.

In spite of inner fears and confusion Trudel was strongly encouraged by her teacher of painting, whom she recognizes today as a sympathetic and a perceptive friend.

> He could see the fear in me—that it came through in my reluctance to use color. "USE MORE COLOR!" he'd say. And he could also see the power in my painting—a thing I could not see then at all.

Trudel bridled and balked under his insistent goading and nagging, but he kept at it. Muttering curses, she began to use more color. The teacher brought a paint rag full of various wipings from the palette and told her to paint it as an exercise in the bolder and freer use of color. That and her anger loosened Trudel up. She let the color fly with rewarding results.

I know now that the anger I felt while under that teacher's guidance was due to Ma's influence that made me see only my teacher's whiteness as he nagged and urged me on. Now I realize that the man was actually helping me out of my shell. I owe a lot to him.

She still has and cherishes the study she made of the colorful paint rag which she calls "*Chouinard.*" And though Trudel remained at the California school but one year she returned to Texas knowing how important that year had been to her development in directions other than the technique of drawing and painting. She puts it this way.

That experience in integration made me realize that one of the values of it for us is that it helps us discover ourselves. *They* are technical. *We* are creative. . . . They could talk with greater fluency about art and artists but very few of them could get there and create as effectively as they could talk. I left there after one year only because I knew my mother could not afford to send me there longer and I felt she had sacrificed enough.

The art department at Texas Southern University was twelve years old in 1962 when Trudel Mimms arrived home from California. She decided to sit in on one of John Biggers's lectures and she happened to catch him delivering his lecture on *John Henry, the Steel Driving Man.* That sold her. It so happened that her beloved "Ma" had died just before Trudel left high school. The void left by her passing ached to be filled by someone who understood the two aspects of truth—the beauteous and the nonbeauteous—as profoundly as "Ma" had. Hearing John Biggers gave Trudel Mimms the strange sensation that here, reincarnated and ready to continue serving her thirst for more truth, was Ma. As in the case of all Biggers's students, Trudel still refers to him affectionately as "Doc."

I could feel that Doc really believed in what he was saying, and that feeling echoed memories of "Ma," since both of them were dealing with a truth I hadn't been hearing often from those around me. Of course I realize that my parents and many others could also see the same truths. But in their circumstances they just could not face them!

That, for Trudel, was the difference. For her the willingness to face up to reality was the quality that set leaders like Martin Luther King, Jr. and Malcolm X and their followers apart from the herd—that firmed up their resolve "to face the heretofore unfaceable truths." So adopting that resolve for herself as well, Trudel settled down in 1962 to continue her study of art at Texas Southern University. But the road ahead was not as smooth as it appeared to be. Additional maturing experiences yet awaited her.

Things moved along well for Trudel during the first months at T.S.U. for she was progressing in her studies in the art department. Then she met Melvin Obey and when they married in 1967 Trudel had abandoned her formal studies in art and taken a job at the Texas Instrument Company, an electronics firm in Houston. There she learned to wire recorders and circuit boards. That was not all Trudel Obey learned during her five years at that firm.

I learned a lot about how society really functions. It had not previously been my experience to know anything about labor-management relations but I learned much and I learned it quickly at that firm. Things that I saw going on there just enraged me so I began to open my mouth about them—not just once or twice—but often—too often. So I finally had to quit.

Obviously both partners in their marriage venture were being simultaneously initiated into the rudiments of how to

survive on a job, for Melvin was eased out of the post office
for what Trudel describes as "speaking out against his super-
visor." So there they were, both out of work in 1967. Luckily
their first child was two years away. Still tough times for
them loomed ominously ahead, for it would not be easy for
either one to find work in Houston. The very climate of the
city in 1967 subjected black workers to a scrutiny resembling
that enveloping the entire nation during the McCarthy
purges of the early 1950s.

"Militant" blacks—and that meant any blacks who
spoke out against any established custom no matter how un-
just—walked a shaky highwire in Houston during 1967. That
was because of civil rights demonstrations leading to a police
action which put the city in an uncomfortably defensive
position before the eyes of the nation.

Extensive news coverage familiarized most Americans
with details of the 1970 massacre of students by the Na-
tional Guardsmen at Kent State University in Ohio. Few
recall, however, that the police invasion of the campus of
Texas Southern University three years earlier resulted in
death and the destruction of property that necessitated a
thorough Senate investigation. Here, briefly, is what took
place.

On May 16th and 17th, 1967, a racial disturbance in-
volving Houston city police and students occurred on the
campus at Texas Southern University. One policeman was
killed and one student critically injured. Several students
and policemen were injured and extensive damage was
wrought upon occupied residence halls as military-type as-
saults were made upon the students inside.

Underlying it all were a series of violations of the rights
of Houston's black citizens, who retaliated with picketing
demonstrations in which they were joined by Texas South-
ern University students. One protest was against the placing
of a city garbage dump near a black residential area. An-

other was against the attacks upon black school children by
white school children.

Though the picketing action was vocal it did not as-
sume a violent character until the police moved in with dogs
to make arrests. Neither men no beasts were gentle or per-
suasive. And the placing of black areas under police "pro-
tection" meant simply that the police had become an unwel-
come occupying force. That is the role they were filling on
the afternoon of May 16th on and around the campus of
Texas Southern University.

By nightfall the cordon of police made it impossible for
anyone lacking special permission to enter or leave the cam-
pus. That night between ten and eleven o'clock gunshots
were heard on campus and it was thought that an exchange
of fire was taking place between students and police. It
was then reported that students seized two tar barrels being
used for construction and set them afire. At that point the
police began to move in, military fashion, on Lanier Hall,
simultaneously firing at and into the dormitory building.

Some 1500 rounds of ammunition were emptied into
the dormitory by a contingent of about 500 officers. Students
inside saved themselves by lying flat in hallways and cover-
ing themselves with mattresses. Others took refuge in the
basement. Police officers armed with rifles and clubs flooded
the building's interior with light and entered with dogs.
Half-naked students were cursed, kicked, and beaten with
rifle butts and clubs and bitten by the dogs as they were
rounded up for arrest. Even the dormitory's matron, Mrs.
Mattie Harbert, though not arrested, was roughed up by the
officers. But the worst came a few hours later, when it be-
came official that Probationary Patrolman Louis Kuba had
been mortally wounded by a single gunshot.

Between four and seven A.M. on May 17th the police
returned with wrecking hooks and axes with which they sys-
tematically bashed in ceilings and doors, while strewing

clothing and other personal effects of students over the place. They smashed radios and TV sets, all in the "search for concealed firearms" which they did not find. Damage to Lanier Hall and to personal property was estimated at $30,-000. As to the patrolman's death, it had to be theorized that the officer was struck in the forehead by a ricocheting police bullet, since the fragments taken from his body could not be linked to any weapon supposedly fired by a student.

Two well-known Texas dailies, *The San Antonio News* for May 19, 1967 and *The Houston Chronicle* for May 18, 1967, commented upon the conduct of the police. Never noted for sympathies for radical groups or causes, the former blasted the police in its news story under the headline —HOUSTON POLICE COVER THE DEPARTMENT WITH SHAME. The latter quoted liberally from critics of police conduct.

With the local news media's extensive coverage of the T.S.U. affair plus the reporting of twenty cases of arson occurring in white-operated black shopping areas within one month, it is easy to imagine the impact upon white Houstonians with little or no knowledge of root causes. From their viewpoint "the niggers were out of hand and had to be put back in their place." One way was to beat up a few, throw them in jail, and destroy their personal belongings. Another was to fire them from jobs—especially if they had too much to say about the way they were being exploited. Bertrand Phillips, working out in Chicago for U.S. Steel and the American Can Company, didn't like being exploited there and he quit. As Trudel recalls, she and Melvin were not so fortunate.

> The period between nineteen sixty-seven and nineteen teen sixty-nine was really tough for us, especially since our first kid came in nineteen sixty-nine. But my mother and father helped us as we struggled until my husband found steady work. There were times, though, when I

was ready to say "forget it," but I now know how lucky I was to have my mother behind me. She actually helped us hold our marriage together until the stormy period passed.

Though Trudel had not been in attendance at T.S.U. since 1962 she had never really cut her ties to the art department, which she visited intermittently. Her conversations there with "Doc" helped her bear, with some degree of hope, the difficulties she was having. Finally she returned in 1971, a trifle battle-worn, but a more mature woman than the fiery girl who had left nine years earlier.

> For the first time I really started learning. That's why today I am convinced it is not too good for kids to get out of high school, go four years to college, then start right in teaching others! Usually, they're not as mature as the responsibility they carry requires that they be. I know that when I went back to T.S.U. after several years I listened to what was being said and I enjoyed the privilege of being there to hear it.

Along with Biggers, Trudel found Carroll Simms another strong influence in her life. Simms, who started the department with Biggers, is described by Trudel as "one of the most earthy and natural men I've ever known." From Simms she learned that intelligence had as much to do with being natural as it does with so-called "hard thinking." Working with him reminded her of the enjoyable times she had as a child visiting relatives on the farm, and her sculpture is strongly derivative of his teaching. Certainly she was inspired also by the presence in the art department of Miss Fannie Holman, mentioned previously as one of the pioneers in promoting art among blacks in Houston. Now retired from the public school system, Miss Holman teaches weaving at T.S.U. She is described by Doc Biggers as "the true elder in the department to whom the kids easily relate."

Athene Watson is another veteran artist-craftsman, whose guidance inspires the young.

Trudel's return to T.S.U. also coincided with the addition to the staff of three splendid young artists, Harvey Johnson, Harry Vital, and designer Leon Renfro. Through previous training and experience each of them blended well with the spirit guiding T.S.U.'s art program. It followed that they too would be inspirational to Trudel. She was graduated in 1975.

> I left school and began to teach. Again, I see Doc in my teaching. And I am certain that all I have experienced has prepared me as much for the art of teaching as for the art of painting and sculpting.
>
> I'm in Miller Junior High School in a ghetto area, and I have the seventh grade. They're going through adolescence and they're something to handle. Discipline becomes a problem. But there's a lot of energy in their art, and I encourage them to work out of their own experience. And when I hang their work up and just sit alone sometimes and look at it I—well, some of it is simply beautiful.

The public schools of our nation whose art programs are run by artist-teachers like Trudel are fortunate indeed. Too many schools, however, are run by men and women who are totally insensitive to the real meaning of children's art and how it should be produced. Rarely can young people create art truly reflective of themselves in a military atmosphere, and it should be expected that once they leave a rigidly controlled classroom and enter the art room they will throw off the hobbles. Trudel encourages them to do just that. Little attention indeed does she pay to the laughter and unpredictable movements of youngsters as they go about their work in her classroom. But she is concerned about their feeling free to be honest and truthful in what-

ever they may produce. Nor does she care what their parents do for a living or what the skin color or hair texture of the child may be. She laughs as she speaks.

I see every problem I ever had in each of those kids. And I recognize that, like the very rich, the very poor are free to do as they feel without ever losing out.

Paying the dues she has paid enables this woman to properly read the score. That is what makes her effective as both a teacher and a practicing artist. She steps lightly around the room arranging canvases and drawings for the visitor to see, pausing before a portrait study.

This painting, for instance, is of the son of one of my girl friends. Ha! It's a shame! She asked me to paint him and when I finished I didn't want to give it up. You see I got something in it I don't think she'd see and appreciate anyway.

A wicked laugh escapes from her.

Her sights were set on a photographic image—nothing more.

Now the deadly serious tone.

And I'd be cheating myself to do that sort of thing. I don't believe in playing with truth and that is what I got in that painting.

She stops beside two charcoal drawings.

This drawing, *The Rite of Spring*, was inspired by Stravinsky's music and by my love of violin. This one, I call it *The Family*, is also charcoal.

The last one she shows is an oil, an immediately recognizable likeness.

And here's one I've started of Muhammed Ali, o-o-o-o-o-o-o-o!

The wicked laugh again, only softer this time, and with eyes half closed. And then, her concluding comment.

My aim in painting is to pass on to others the kind of strength and faith in truth that's been passed on to me by people like Ma, Doc, and Simms.

Otto Neals

You could see them during the 1930s in any northern industrial city, alighting from the buses and the trains. Their clothes were shabby and worn, and such luggage as they carried was of the cheapest material—mostly cardboard. So the traveling bags and paper boxes of these southern migrants had to be reinforced with ropes to prevent their meager contents from spilling out at an embarrassing moment. These black travelers, poor as they were, still had their personal pride. They would be no laughing stock for anybody, especially for white folks, if they could help it.

Trudging into the waiting rooms they sometimes had difficulty locating loved ones amid the throngs, but as they found each other in loving embrace waves of contentment swept them together in spirit as well.

These black migrants had come north more in hope than in despair, for the financial crash of 1929 and the ensuing Depression of the 1930s had hit the mainly agricultural South an especially cruel blow. In 1930 only 9½ percent of American farms had electricity. Three years later eggs were selling for eight cents a dozen, wheat for twenty-five cents a bushel. Southern-grown cotton glutted the market, and black sharecroppers who grew and harvested it for white landlords still used mule-drawn plows and still picked cotton by hand. They and their poor white counterparts

were the poorest of the poor. But the blacks had yet another thing against them. They were the victims of lynching as well as other forms of discriminatory terror. Coming north would, at the very least, deliver them from the latter scourge. So they came.

Della Neals was one of them, and she was a woman of strong will and character. She had left her husband, Gus, and their three children, Mary Lee, Otto, and Leroy, in Lakeside, South Carolina, while she set out to find work in New York City. Although Gus had been a good worker when he could get work to do, Della knew that the chances of a black male finding work were far less than hers. She could always find some form of domestic work to do—a fact well known to countless black women who, though often trained for better occupations, were forced during the Depression to slave in the homes of white women.

Within months after Della Neals started working in New York she sent for her husband and three children and they established their first home in Brooklyn. Otto was four years old.

> When I was four or five I recall that a cousin who helped raise me—he was eight years older than I and had come to New York shortly after we had—used to draw. And as I watched him I was fascinated and I was motivated to imitate the older boy.

Otto Neals is a quiet man. Of average height and build, he attracts no particular attention when seen among a group of people. He is slow to speak unless spoken to and will gladly offer you an opinion—if you ask him for it. This seeming shyness, however, is never edged by any noticeable sense of uncertainty in the man himself. He is quite content to keep his own counsel. And though he is largely self-taught in the arts of drawing, painting, and sculpture, he neither parades nor seeks to hide the fact as he moves

among those whose formal training is often extensive. Among those of his peers who know him best Otto Neals enjoys a healthy measure of professional and personal respect. He speaks slowly and softly of his childhood.

Our family had moved into Brooklyn, where I've lived all my life—first in Prince Street in the Boro Hall section where we stayed for a short time with a relative. Then we moved to Flatbush and Myrtle Avenues, and from there to Brownsville. I attended Brooklyn's public schools and reflect now that the educational system was far different from what it is now.

During my earliest years in school I was always among the top ten of my class which was, as was the neighborhood itself, ninety to ninety-five percent Jewish. This was in grade school. When my family moved to Bedford-Stuyvesant my school there was ninety to ninety-five percent black, and the work I was given to do there was work I had previously done in the predominantly Jewish class. So at about the fifth or sixth grade I found myself settling down to the level of the teaching. I became another one of the mob for there was nothing to strive for in those schools. My teachers all along the way were white.

Such art as Otto produced during his early years was done mostly at home on his own time and under his own guidance. Except for a few blackboard decorations done at the request of teachers at Halloween, Thanksgiving, Christmas, and Easter, his art production in the schoolroom was practically nil. But he felt the urge, nonetheless, and even tried developing a few ideas of his own, using the format of the comic strip as a guide. It would be a matter of five years or so before "comic" books would become popular not only among the nation's children but also among many nonliterary adults.

When it came time to enter high school Otto faced what had become and what still is a problem for nonwhite minority students in New York City's de facto segregated schools. Because of the poor level of teaching and the correspondingly poor level of learning it is assumed by school authorities that all such children will automatically be happiest and most productive in the trade high schools.

Few, if any, grammar school personnel bother to do any serious looking into individual cases and records to see if exceptions exist. And the parents of the children are too often either ignored or led to believe by school authorities that the only place in high school for their children is in the vocational atmosphere. That is what happened to Otto Neals, his excellent early elementary school record and his obvious art ability notwithstanding.

> I was sent to the Brooklyn High School for Special Trades, and that was my own third choice! The High School of Music and Art and Haaren High School were my first and second choices. I didn't know then that one had to take a competitive test to get into Music and Art and the teachers in junior high school never told me. . . . The high school I got into was a very poor school, taking in mostly a hoodlum and gangster type of boy. Many of them became high school drop-outs. Even though I survived its so-called "art course," I think I'd have done far more in a better school.

Otto says this with a quiet finality packed with controlled rage, for he knows he was cheated and he still resents it. His resentment is heightened by the knowledge that the "art" to which he was exposed was but a poor course in sign painting. Ironically, however, what Otto does for his day-to-day existence finds its roots in the courses he was given at that school. Moreover, his alma mater bears not only a new name (The George Westinghouse Technical

and Vocational High School) but presently enjoys a far higher rating than it had when he was a student there.

Even as Otto Neals squirmed for four years under the limited course of study, he was obliged to recognize that some positive events were taking place elsewhere. One such involved the rapidly accelerated development of areas of the world that had for generations been unknown and misunderstood by most Americans. Little did Otto then dream that he and his children would visit one or more of those areas.

One of the salutary effects of World War II for America was that it shook this nation from its cocoon of isolationist thinking. We learned then that if men could fly great distances nonstop in a short time to drop destruction on their neighbors, they could use the same transportation for more constructive purposes. If we Americans wished only to destroy we could do it. We certainly had the means. But to what avail? Besides, our atomic advantage was only temporary and our thinkers knew it. So we wisely joined in an effort to establish a world body dedicated to the establishment of worldwide peaceful cooperation. In 1945 the United Nations organization was founded in San Francisco, California.

Black Americans met there with that body, among them Walter White, W. E. B. DuBois, and Mary McLeod Bethune. They represented the National Association for the Advancement of Colored People. But the most prominent black American participant at San Francisco was the State Department's acting chief of its Division of Dependent Territories. He was Ralph Johnson Bunche. That initial gathering of the world's statesmen and scholars took place at the same time Otto Neals was entering high school in Brooklyn, New York.

Black American readers, especially those who read the black press, kept in step with the U.N. and they were fa-

vorably disposed to its aims. Indeed they became ardent supporters of *The Universal Declaration of Human Rights,* which declared in the opening line of its first article, "All human beings are born free and equal in dignity and rights." The enthusiasm of black organizations for this doctrine had surfaced many years previously in the writings of DuBois, Garvey, and other black scholars. And only a year before the U.N.'s founding twenty-five black American organizations met in New York. There they called for the removal of colonialist exploitation from Africa, the West Indies, India, and other territories, and its replacement by political and economic democracy. Their support for African, Asian, and Caribbean freedom is still strong among black Americans. And Otto Neals's life and work were to be profoundly touched by it.

It was nineteen forty-nine when I finished high school, and went to work in a couple of factories. One was an ironing board factory where I nearly lost a finger when the stamping machine "skipped" and caught my hand. Luckily I still have it. It was interesting enough work as that type of thing goes, but I stayed only a year before going on to another assembly-line job doing spot welding for metal kitchen cabinets. But the Korean War cut in on the supply of metal, and the promotion I was slated to get never came through.

Meanwhile, I'd taken and passed the exam for the Post Office and went in as a clerk. I was just about twenty-one, living at home and helping support the family. A year later, January nineteen fifty-two to be exact, I was drafted into the Korean War.

Basic indoctrination took place in Oklahoma where Otto encountered for the first time the more overt instances of American racism. There he encountered the refusal of local restaurants to serve blacks and other nonwhites—a

regional custom of that time; and though Otto didn't like it, he disliked cold weather just as much and did not look forward to going to Korea. He did get an unexpected break, however. His order to go to Korea was rescinded and he was sent instead to Fort Bragg, North Carolina, where he endured more racism. Again it was jim crow on public carriers and in one case where a restaurant refused service the fellows tried to take it apart and landed in jail for the effort. Says Otto of his short hitch in the army—

> Looking back at it, though I hated being humiliated in my own country, I'm even more glad they didn't send me off to Korea to kill and brutalize other people of color who were only trying to shake off the yoke of oppression.
>
> I did manage to make the rank of Operations Sergeant. But I am also reminded of the time I, then a corporal, was acting as a platoon sergeant. They had given me a platoon to train—a mixed platoon—and I completed the training of my men in marching, the handling of weapons, and so forth. Well, there came the day my trainees were to show their stuff before the "Brass," and do you know what? We were as sharp as could be—had taken ribbons for our drilling skills and everything. When the real day came THEY HANDED MY JOB OVER TO A CRACKER WHO DRILLED MY MEN AND TOOK ALL MY BOWS. I DIDN'T EVEN GET IN THE PICTURES THAT WERE TAKEN OF THOSE FORMALITIES!

Following his army days Otto returned to the postal service where he continued as a clerk for the next nine years. For six or seven of those years he tried without success to get into the art department of the Brooklyn central office. He finally made it, beginning at the very bottom, and went up to the very top. But Otto chose to hold top spot for only one year before relinquishing it to the man just behind him.

I prefer this to working as a clerk. There isn't the pressure and I can do many of my own sketches for my creative works while I am on the job.

The department he works in does posters and printed materials, all related to postal matters, for public relations. Most of what he does, however, is lettering which he learned, not in high school, but shortly thereafter when he worked part time for a professional sign painter. Much of what Otto Neals does on his job is printed by the silk-screen method. So while the post office glorifies the position by conferring the title "Illustrator" upon Otto, he knows that basically he is doing a letterer's job for Uncle Sam. That's all right with him. He reserves his sensitive draftsmanship for his own work in graphics, painting, and sculpture.

Otto continued living at home until the mid-1950s, when he married Vera Anita.

My wife's relatives are from Guyana. She is a proud, strong-willed woman who was raised by her great-grandmother in Guyana and Barbados following the death of her parents while she was an infant. She came to the United States when she was about seventeen or eighteen.

Otto's marriage was his first direct link to those black peoples outside the United States whose destinies are so closely tied to the principles set forth in 1945 by the United Nations organization. Those were the trying days of his adolescence when, as a student in a vocational high school, his future looked so bleak. Now with the encouragement of Vera Anita and their children Otto was ready to forge more links to that chain. As a start he and Vera named their son Hassan and their daughter Nadia Rekeya.

At this point Otto was no longer working at his art in a purely private manner. He had joined a group of Harlem-

based artists who called themselves the Twentieth-Century Creators. Numbering about twenty or thirty, they found a place where they could meet, work at their art, and occasionally hold informal showings of their work. But as is so often true, individual tastes and differences of personalities created a split and the dominant faction formed an independent group.

The name, *Weusi*, that they took is Swahili for "blackness." Five members of the Weusi founded the *Nyubba Ya Sanna* (The House of Art), currently located on 132nd Street in Harlem. The basic aim of the group is to produce art that is reflective of both the African heritage which has for too long been obscured here, and the special experience of the black artist in America. In conjunction with that latter aim Otto cites yet another of his own activities.

I must say that the outdoor Fulton Art Fair in Bedford-Stuyvesant played a significant role in my life during the late 1950s and the 1960s. You see, Tom Feelings, who was always active in the fair along with Jake Lawrence and Ernie Crichlow, had also attended the Brooklyn High School for Special Trades. And though I was a year or so ahead of him some of our classes were combined. Then, too, I came to meet Leo and Delores Carty along with Joan Bacchus and Charlotte Amévor at the fair, and my association with them stimulated me to move ahead steadily with my work.

Along with the increased joy that came with increased artistic production, sorrow also came to Otto. During the middle 1960s, the years of harsh struggle in both the South and the North caught up with Otto's parents. His mother, who had come to New York to pave the way for the family thirty years earlier, went first. Sixteen months later she was followed by her husband, who had lain ill for two years after suffering a stroke.

Now with her children approaching their ninth and tenth birthdays, Vera Anita wanted to visit her family homesite in South America. It had been nearly fifteen years since she had left home and she wanted her husband and children to see the land in which she had grown up and the people who had raised her. Otto's enthusiasm matched that of his wife. As he expresses it,

I wanted to visit a land whose people were black and whose functioning was in black hands.

They made their first trip as a family in 1969—a trip that Otto still speaks of as though it happened only a few weeks past.

I was highly impressed by the warmth of the Guyanese people—a characteristic of which everyone speaks. Because of my wife's background there, we were not confined to the tourist attractions of Georgetown but went instead to live in Victoria Village eighteen miles east of the capital city.

He describes the Georgetown area as a section below sea level protected by modern concrete dikes and quite in contrast to rural Victoria Village, where homes are set high on stilts to prevent their being flooded during the heavy rains. Guyana is a tropical, hot, and humid country whose coolest area lies in the northeast. Its vegetation, liberally endowed with medicinal herbs, is a fact of which Otto soon became dramatically aware.

Shortly after we arrived my daughter, Nadia, fell quite ill, running a fever of one hundred and two degrees. As she lay moaning in pain, my wife's aunt rushed to the yard, gathered a small bush and from it made a poultice and a tea which she gave to Nadia as a pack and a beverage. In less than an hour the child was running around as though nothing had ever happened to

her. We, who scoff at such remedies, forget that the drugs purchased at the pharmacy come primarily from herbs, plants, and roots. And it is sad to note that Guyana is losing its old people who have knowledge of natural medicines—knowledge that is not being written down.

Otto Neals's two visits to Guyana (he made a second in 1970 to attend a Pan-African conference) coincided with one of the country's happier periods of recent date. The Guyana of, say, a decade or so earlier would have been far less pleasant and inspiring. Neals speaks of dividends he derived from his Guyana visits.

My own work has been helped and it has advanced because of those two trips to Guyana. You see, I'd always been interested in the forming of a link uniting the peoples of African descent elsewhere to those of us here. We are really one people. So I made sketches in Guyana and I took photographs from which I developed more drawings and paintings. You see in my work the closeness of family groups and the respect for the elderly that I found there.

Upon his return to New York Otto Neals expanded his art to include sculpture. To work as effectively in that medium as he wished he needed studio space away from home. The samplings of the handsome hard woods of Guyana he had brought back with him begged to be carved, especially the Green Heart and the Purple Heart woods that are his favorites. So in casting about for working space he found it in Brooklyn, close to an artist he had met at the first Fulton Art Fair staged in the late 1950s.

Vivian Schuyler Key is a painter and sculptor whose serious studies and accomplishments began during the period of the Harlem Cultural Renaissance of the 1920s. Along

with others of that period—Nancy Prophet, Augusta Savage, Richmond Barthé, Hale Woodruff, Palmer Hayden, Aaron Douglas, and Edwin A. Harleston—Mrs. Key showed her paintings in the exhibits presented by the Harmon Foundation during the late 1920s. A strikingly handsome and sturdy lady, she stopped painting to rear a family. Now she is back at work as both sculptor and painter. The three heads she is currently modeling of Malcolm X, Langston Hughes, and Lorraine Hansberry are works she hopes will be eventually made permanent through casting in bronze. For both Mrs. Key and Otto Neals the two-and-one-half years they have spent working together have been mutually beneficial. Otto is more productive because he has ample working space. Vivian draws inspiration from the vigorous talent of the younger artist.

It was 1974 when the urge to see yet another black country moved Otto Neals to travel again.

I chose West Africa because I wanted to see the place from which my forebears had come. So last year I made the trip to Ghana and Togo. Ghana came first. Even more than that, I greatly admired Kwame Nkrumah since it was he who called for unity among all of Africa's peoples. And I feel that if they could come together, I, too, could be free.

Otto walks over to an arresting head of Ghana's first black president—a head that he carved from a piece of pine. He then designates an etching of Nkrumah on his wall, talking quietly as he does.

One of my pieces was selected, by the way, for hanging in the Ghana National Museum. It's that etching you see there. I feel good about that since it shows how profoundly they now respect his memory and because they have placed a work in their museum done by an Afro-American.

Recalling the tide of emotional anger that had induced them to depose their former leader, Neals says that Ghanians with whom he talked openly expressed shame over the harsh and hasty treatment of their deceased leader. A measure of the depth of their remorse is seen in the renaming of many places for Nkrumah. Those are the places from which his name had been withdrawn by those in Ghana who had been persuaded to overthrow him.

One of the reasons Otto was able to develop so close a relationship with Ghanians is because of a friendship he had previously formed in New York with an artist who comes from Ghana. He is Nii Ahene Mettle-Nundo, a member of the Ga tribe, whose family lives in the small coastal town of Labadi near Accra. Natives of Labadi had a reputation among the British for fierceness in battle and for a recalcitrant nature that does not yield easily to domination. Nii Ahene, a fellow member of the Weusi group in Harlem, made easy contact for Otto possible when his friend went to Ghana.

I stayed there in Labadi with friends of Nii Ahene—living right in the village compound. Then I went up-country to Kumasi, the rain forest area of Ghana. I can't explain why, but Kumasi was a mysterious place, and I felt the strangeness of it, though it wasn't an uncomfortable strangeness. Everyone else who's been there tells me they've experienced the same thing.

He also found that the hospitality extended him in Guyana was multiplied in Ghana, as the following incident shows.

I was in a village called Tepa, thirty-nine miles from Kumasi, where I saw these stacks of cocoa-pods watched over by an old woman. I asked the fellow I was with to ask her if I could have one. He spoke to her in Twi,

telling her who I was and what I wanted. The old woman welcomed me and expressed her joy at meeting an Afro-American brother. She then explained that the pods were not hers but sent a boy off to get me one that belonged to her. And she urged me to return the next day. I did, and she had a sackful waiting for me. That was the spirit of the people. They were not grasping and though they loaded me with presents they would accept no presents from me in return.

Otto points to the wall at a watercolor of a heavyish, strong-looking woman serenely seated outside her home. It was a study he'd made of Nii Ahene's grandmother, his hostess in Labadi. Though Otto describes her as "well along in years" she is a hardy woman, fully capable of performing strenuous chores. As he speaks of other works in the studio, carvings, drawings, and paintings, one senses his preference for sculpture and printmaking.

I love to work in wood and stone. You can touch and feel such materials as you work them. Take these Guyanese woods for example. They are quite dense indeed and you can see that as I worked with them I was thinking of traditional African carving—though there's much of me in them too.

Of his prints he acknowledges a great debt to Robert Blackburn, a black artist of New York who is one of the nation's finest printers of lithographs and etchings. Blackburn's downtown print workshop is well known among artists all over the country. Of Blackburn Otto declares that "Bob exerts a great influence upon me as well as upon many other of the younger brothers and sisters."

When Otto is asked for his views on abstract and representational approaches the answer is swift.

It all depends upon the statement one wants to make. I don't think I could have made the same statement here, say, in this composition I call *African Background,* by using a representational style.

He speaks quickly of other works in the room.

I did these pastels in Guyana, building them slowly and fixing them as I went along.

The pastels he speaks of glow as if illuminated by an inner light. They are remarkably fresh and brilliant although it is extremely difficult to fix pastels without dulling their lustre.

In sculpture I begin carving into the stone or wood with manual tools—though if I had power tools I'd do the rough blocking out with them and then use the hand tools for finer work.

The subject shifts to galleries.

I've given no serious thought to being associated with any big commercial gallery. With the Harlem gallery I spoke of earlier I can reach the people of the community and those are the ones who are important to our group. That is one of the reasons for founding it. So I'm satisfied with that. If it should happen that I'd have an involvement with a downtown gallery that satisfies me—well—okay. But I'm not pushing for that.

He thrusts his hands deep in his pockets and laughs slightly as if recalling an incident he is not sure he wants to mention. We prod—but ever so lightly—and he laughs again.

You know, I've never had a grant or a fellowship. Once someone sent a man to Harlem—he was white— to see us. He said he represented a group quite willing to spend money of which he said there was plenty. But

something he said indicated that we'd have to change our direction—away from our political and social militancy. One of the guys grabbed him and put him out in the street. . . . We had just started out as a group, and that expressed our feelings then. . . . And it's our feeling now.

The finality of the statement is unmistakable. Otto Neals is quite an artist—and quite a man.

Kay Brown

OTTO NEALS and Kay Brown are contemporaries who hold much in common even though one came from a small Southern town while the other is a native of New York City's Harlem. Although as youngsters in New York they never knew each other, their lives as adult artists are closely interwoven.

I am from a family of middle-class West Indians and I am a sort of rebel in that I didn't necessarily adhere to the kind of values that were theirs.

That is what you like about Kay Brown. She lays it right out on the line without leading you through a maze of defensive cover-ups. You look at her and you are a bit surprised that she is a small and unspectacular looking woman, for you had heard so much about her from students and fellow artists. And all that you've heard has seduced you into expecting to see an imposing exterior. Then, realizing that you should know better, you listen as she talks about herself.

My parents were Jane and Gotlieb Bell, and I had an uncle who was a physician and that posed a bit of a problem for me growing up since my playmates stood in awe of his position.

She smiles in contemplation of the many changes in the thinking of people coming from the Caribbean during her

youth and those coming today. The stiff, rigid, puritanical mores of that area were certainly not out of harmony with similar views held by many born right here in the United States. It was (and is) from such rigid adult pretensions that bright youngsters everywhere rebel in one way or another. Kay Brown was a bright and honest child.

The sharp clear diction and the native New Yorker's way of sounding the "t's" gives full credence to Kay's adoption of things and ideas more American than Caribbean. She does admit, however, to being a little different from her peers in that when they were off "partying" she'd prefer to sit in the park reading a book. Her interest in learning was just as strongly embracing as was the protection and love of a brother and many aunts and uncles, who were always close by. Yet as the only girl she began, as she grew older, to realize "how unprepared I was for life's realities . . . its deceits and ugliness which I was to discover as a teenager."

Elementary school in Harlem was, for Kay, a joyous experience. Public School 113 was new and modern then and it was there that she discovered her artistic abilities. It was there also that those abilities were respected and encouraged by her teachers.

> My teachers were encouraging because I presented my geography lessons in an artistic way. In the sixth grade my teacher decided to do a mural on the Underground Railroad of the slave period—a mural for the school's auditorium. I was one of those chosen and I was so happy to be one of the artists on that project. Our school was predominantly black and our teachers predominantly white. And even though I consider myself a "cultural nationalist" whose aim in life is to help my own people advance through the work I do, I am still grateful to some of my white teachers—especially in college—who helped me in my development.

Kay Brown is cognizant of the turmoil in New York City's schools today—the strong anti-teachers' union sentiment among many blacks and Puerto Ricans who are convinced that the teachers in general are as much organized against them as they are against poor classroom working conditions. As a teacher, she doubts that there exists the same level of staff interest and student participation as existed in the black neighborhood school of her childhood.

Kay's leaving elementary school for junior high school was not the most joyous transition for her parents, who wanted her to go to a "better" school. Since Kay had maintained a place in the top-most level of her sixth grade class, the family was fearful of her tumbling from that position should she attend a junior high school of less than the highest standards. Junior High School 81 was, in their judgment, such a school. Still, they had little or no choice in the matter.

As for Kay, herself, although she did find the kids at P.S. 81 far tougher than those of which her parents approved, she believes to this day that she learned much from her association with them. They were surely less insulated than she and being with them each day "helped me enlarge my view of life around me." Her father especially was most unhappy. He had dreamed of such careers as law and medicine for his two children and was disappointed when, later, his son chose a career in photography.

"My father was not able to free himself from the idea of 'class' that one finds among many West Indians," says Kay rather sadly. She brightens, however, as she recalls that she was again placed in the top section of her class at P.S. 81, and that her brother Hugh, a prominent commercial photographer today, pioneered along with Gordon Parks and Roy DeCarava in cracking racial discrimination in the industry.

Customarily all pupils living in Kay's junior high school district attended Harlem's Wadleigh High School. Again her

parents objected and this time they won. Kay went instead to Washington Irving High School, whose population was predominantly middle-class white. There she was not urged to become a clerk or to prepare in any way to join the horde of undistinguished eight-hour workers that white teachers so often felt black boys and girls should aspire to be. Her teachers and advisors urged her instead to prepare for college.

Still, Kay longed to extend her study of art—a course that the academic program at Washington Irving did not offer as a major to its academic students. The authorities did, however, permit her to return after graduation to take a postgraduate course with students in the art program. It was, as Kay recalls, a bit unusual for them to bend the rules and she is grateful for that chance to get a bit of art technique at that school level. She was graduated in 1950.

That was at once an eventful and a challenging year. Doubtless the three most significant events of a positive nature, as far as black America was concerned in 1950, were one court ruling and two prize awards. In the case of *Sweatt* vs. *Painter,* the United States Supreme Court ruled that in education "separate by definition must be unequal." And the Nobel Peace Prize went for the first time to a black American, Ralph J. Bunche, while the Pulitzer Prize for poetry went to Gwendolyn Brooks. Encouraging as such signs of progress were, they were offset by a serious problem affecting the daily lives of thousands of black Americans—the problem of discrimination in employment.

Following World War II, which had necessitated the drawing of black labor of all categories into industries handling government contracts, the postwar cutbacks were felt most drastically by blacks. The old policy of "last hired and first fired," so well known to blacks, was operating again with customary efficiency. As protests mounted labor unions and employers were reminded over and over with proclama-

tions and orders that it was illegal to withhold jobs from qualified workers on the basis of race.

A special committee was formed by the nation's president, and that committee conducted a community relations program designed to "influence" the states and cities to do the right thing by nonwhites seeking work. New York State took the lead. In Albany they enacted a measure—*The Law Against Discrimination*—declaring equal job opportunity a "civil right." They even created a "Commission" to put an end to unfair practices in employment. And by 1950 no fewer than seven additional states followed New York's lead. On paper and in publicly spoken phrases it looked and sounded encouraging to nonwhites. White America was about to turn over a new leaf. Hallelujah!

Kay Brown decided that someone who could make good use of her drawings ought to have a look at what she could do. If they liked what they saw perhaps they'd offer her work either as a staff or freelance artist. Following custom she saw that her portfolio reached a few such hands.

I'd wanted in those days to be a fashion illustrator for I had a flair for that. But even though I submitted my portfolio to a well-known New York company as well as to the magazine, *Seventeen,* and their response was quick, glowing, and supportive, that all changed when they saw me. Suddenly the job was nonexistent for me. In one case I was relayed to another place that needed a photo retoucher. I didn't take the job. Instead I went to work at the Metropolitan Insurance Company and discovered there was no promise there for advancement for blacks in the early nineteen fifties.

Married at eighteen, Kay's quick intelligence told her that if she truly wanted to move ahead she would have to acquire more education.

I constantly dreamed of school and of learning more and more and I also had a yearning for love and companionship. But my marriage was not a happy one.

Kay bore two sons, and she soon learned that the older was "a severely retarded child." Because she lacked direct and sympathetic communication with someone who knew what should be done for him she placed him in a hospital. Her brief statement of the result is etched in sadness.

He was ultimately destroyed at that hospital—what with the medication and lack of programming and training. So he is now one of the living dead. My second son, though not as bad off, had a slow learning problem and I had to deal with these things as best I could. Believe me, it hasn't been easy.

Kay believes that lack of knowledge of what being an artist means is what prevented the older members of her family from recognizing art as a fitting career for her. In their view art was not to be taken seriously as a means of earning a livelihood. Their concern had validity inasmuch as few artists eke out more than an existence from their art. Kay therefore became a rebel whose "strange" choice was then hard for her parents to live with, though her present status as a college teacher does please her surviving mother. Still, the years in between were hard. A desperately sick child and insufficient preparation for those things she wanted most to do were great contributors to Kay's unhappy marriage. A tiny escape route did, however, present itself to her.

I became interested in writing. Being at home with the children and watching TV dramas gave me an idea. I can do that, I thought. So I got some books on TV writing and began to work at home. I actually sold a few things to *Confession* magazine. Then I felt I should aspire to something higher in writing so I returned to

school—Columbia University—to take a course. It was quite difficult there, for most of the others were better prepared than I. They hadn't interrupted their study as I had done. Besides there were very few blacks there.

Kay hadn't been attending Columbia part time very long before discovering that if she hoped to earn a livelihood she would have to teach English, and to do that she would have to become an English major. Left with a choice between English and art she chose art. If she had to teach to exist she would readily teach the subject she most loved and enjoyed. The diminutive woman capsules in brief words her struggle to finish school.

I eventually became a daytime student at City College and often wound up as the only black in the class—though many blacks attended evening school. How I managed to summon the fortitude, with no family encouragement, to finish City College is still a mystery to me. But by nineteen sixty-five I had earned a Bachelor of Fine Arts degree.

There is no doubt that the earning of a degree did much to restore Kay's sense of her own worth. She had, after all, achieved what seemed for a while to be the impossible. Yet she soon began in New York to discover what painter Bert Phillips was simultaneously discovering in Illinois, and that was the limited use of the B.F.A. degree in a commercially geared society. She did, however, through being college-trained, find a job totally unrelated to art.

The City of New York was engaged at that time in the restoration of some of its old dwellings that were structurally sound enough to justify needed repairs. Many such buildings were on the city's Lower East Side and a training center was set up there for unemployed men of the area who would be taught building rehabilitation.

Kay Brown was hired as administrative assistant to the program's director. And while her job had little or nothing to do with drawing and painting, it did provide a livelihood as she looked about for opportunities more closely akin to her interests and special training. Things went well for a while until the director, caught up in some shady dealings, was fired. Kay was fired along with him. Again, she began to experience strong negative feelings about herself—what with the failure of her marriage and her lack of success in finding the kind of work she really wanted to do. Then one day she stopped by the Countee Cullen Branch of the New York Public Library and encountered something that reversed the direction of her life.

I was told of the opening that evening of an exhibit and was urged to stick around. The exhibitors would be there with their work and I was assured that I would find it interesting and worth my while. So I waited.

The Countee Cullen Branch of the New York Public Library is adjacent to the famed Arthur Schomburg Collection in Harlem. One of its features is a modest but pleasant mezzanine suitable for displaying small exhibits of paintings, drawings, and sculptures. Countee Cullen's previous director, Mrs. Dorothy Homer, had made a point during her leadership there to encourage black artists by presenting showings of their works to the public. The tradition continued after Mrs. Homer's retirement. Upon this occasion the library was presenting the showing of the works of the Harlem-based Weusi artists. It was an occasion Kay Brown likes to recall.

It marked my first meeting with the Weusi artists. That was in nineteen sixty-seven and I remember that the group was entirely black and entirely male. . . . As I met and talked with them I was reminded of one of my teachers at City College who knew Charles Alston

and Romare Bearden. He encouraged me to make contact with them even then. . . . I didn't, of course, but I respected them and what they were doing. . . . Then my later meeting with the Weusi was a day I shall never forget.

The Weusi had a studio workshop in Harlem where they gathered and produced much of what was being shown at the library, and they invited Kay to visit them. She did, and once again she was impressed by the seriousness and the sincerity of their aims.

When I began to visit them I noted how warm and friendly they all were and how their work blazed with the vitality of color. It seemed to me in some way related to Africa—to our people—our heritage.

She made her visits more frequent, and what really captured her was the profound respect that each of those men held for her as a *woman* as well as an artist. As she went in and out of their studio not once did any of them suggest that she sleep with him. "They only wanted to help me and that, for me, was a refreshing experience." In that regard she found the Weusi to be a group that truly lived up to its stated philosophy, *"To use our work as a means of teaching our heritage and of looking up at one's self."* Most of the members of the group had taken African names, though among those who had not was quiet Otto Neals.

Within a year, as a result of her close association with them, Kay was asked to join the group—the first woman to be so invited. Another woman artist, Dinga McGannon, had been affiliated with Weusi through her husband who also was a member. But Kay Brown was the first to come in completely on her own, and she retains her membership, working occasionally in the studio and exhibiting with them as well. She recalls her work during that early association with Weusi.

At the time I joined the group in 1968 I was strongly under the influence of the collages of Romare Bearden. I saw them as a form of protest and I was also doing protest things. But soon thereafter I began to incorporate the Weusi philosophy of the recognition of the African heritage and of looking up at one's self into my graphics. That was a high point for me since we were in the nineteen sixties and we were showing not only at our own gallery but at college art centers as well. It was quite reminiscent of the Harlem Cultural Renaissance of the nineteen twenties.

It may well have been so reminiscent, but the similarity was purely of surface nature. The period of the 1960s brought far more drama, violence, and pathos into the determination of black Americans and their few white allies to destroy racist practices than ever occurred during that brief cultural boom of the 1920s. True, there was a Marcus Garvey who in the 1920s was imprisoned, pardoned, and swiftly deported before white America could comfortably resume its practices of wholesale discrimination in voting, employment, and public accommodations.

But the 1960s were different. They did indeed harass and finally kill Malcolm and Martin but they also had to relax their lily-white stranglehold on basic human rights. And white America of the 1960s was brought face to face with the suicidal nature of its own savagery, what with the beating death in Alabama of Unitarian minister James J. Reeb, and the shooting death of Mrs. Viola Liuzzo. Both were white and both were protesting white racist practices. Blacks began to see they were not completely alone in their struggle. Kay Brown says,

> The nineteen sixties marked a period of new black self-awareness for me. My work then was directly political. Now it is less directly political but still political.

It was then that Kay landed what she calls "my first real job in art." *The Childrens Art Carnival* is an art center in Harlem where talented children are able to develop their skills in the arts after school and on Saturdays. Its director is Betty Blayton Taylor, a gifted and highly regarded painter, who received her art training at the University of Syracuse. Kay joined Betty Blayton during the early stages of the carnival's development. And because this seemed precisely in line with her adopted Weusi philosophy of teaching, she waded into her work there with maximum zest.

I was Betty's assistant there for a time, and I stayed for a while. But since I wasn't as comfortable as I would like to have been in that situation I left to take a teaching job elsewhere.

The "elsewhere" turned out to be a public school in Brooklyn. Previous hard experiences with scant and sometimes no employment coupled with having to support her younger son as well as herself had taught Kay much about the art of survival. She had wisely prepared herself for New York City's teacher's examination, taken it, and received a license to teach. When it became necessary for her to use it she did. But teaching in the public school and working with children in that restrictive and often chaotic setting was far different from what Kay had envisioned the teaching of children to be.

So I sent my resume to Medgar Evers College, not expecting it to mean very much. To tell the truth, I'd never before heard of the college. But do you know what? I had the job before I even knew I was hired! And that is a story in itself—a story I will tell you in a few moments.

In the interim months Kay had been painting, making drawings and prints, and exhibiting them. In 1970 members

of Weusi put on a show at the Studio Museum in Harlem, filling both of that museum's spacious galleries. It was the biggest show presented by the Studio Museum up until then and Kay Brown was well represented in it.

The following year Dinga McGannon and Faith Ringgold approached Kay about helping them assemble a show of the works of black women artists. The place selected was the Acts of Art Gallery in New York's Greenwich Village. Kay recalls that show with obvious pride.

> About twelve of us got together and put on what I believe to be the first show of exclusively black women's art. It was during the summer of 1971, and we did it not according to the usual custom but we did it just as we felt we should. We didn't open our show with cocktails but with food—SOUL food! And we called our show "WHERE WE AT." You can believe me when I tell you it was a huge success.

The original "Where We At" group of eight has, since the spring of 1976, expanded to twenty. Their plan is to open an arts academy for young adults who want to work under professional artists. It is a splendid proposal. That it is being initiated by a group of black women artists is fully consistent with the traditional concern of women for the young as well as for the nurturing and preserving of the arts.

Kay's enthusiasm for and participation in shows staged by black women is by no means indicative of her endorsement of the current feminist movement. Neither is it a repudiation of all the aims of feminism. She is justly proud of the respect accorded her by the men of Weusi. At the same time she takes exception to the description of her in Elsa Hornig Fine's book as a "militant feminist."

> The author labeled me without ever having interviewed me first. So that description is an error for I am a *cultural nationalist* whose viewpoint on many issues

differs from that of the white-oriented feminist move-
ment. My collage, *We Are Born To Stay,* is certainly
the very opposite of that view taken by the feminists.

Kay's strong stand against forced sterilization and the
kind of forced abortion that has been illegally performed
upon defenseless black women is rooted neither in religious
orthodoxy nor in hysteria. She simply shares the lurking sus-
picions of many others that a wave of abortions and steriliza-
tions among black women could signal a move of mass
genocide of the race. The ways of racism, she has learned,
are both devious and ruthless.

We black women artists find a certain amount of
racism among the white feminist groups and we're not
that anxious to join up with them. Moreover, we find
that the feminist movement divides the family. Our
traditional role as black women has been that of holding
the family together.

A few weeks prior to being invited to teach at Medgar
Evers College Kay heard about the Cari-Festa—a festival of
all the arts about to take place in Georgetown, Guyana. She
decided immediately that she would have to go. To finance
the trip she had handed over about $400 worth of her work
to someone to sell. The sales never materialized and only
through litigation was she able to retrieve her work. But she
could barter for her living expenses in Guyana and she had
bought a ticket and was thus determined to go—expense
money or no. She laughs as she tells what happened.

My mother lent me about fifty dollars and I had the
nerve to leave New York for ten days in South America
with no more than that and my round-trip ticket!
Luckily, Tom Feelings was there living in one of the
government houses and he had a studio. I'd written him
in advance and when I told him my predicament he

let me live in his studio which he used only for working.

I'd walk each day to the market and for ten days I bought vegetables and lived on them for that was all I could afford on a fifty-dollar budget. I did attend some of the programs. And though I didn't see everything because of lack of transportation funds, and though I didn't eat too well, I did have a glorious experience!

It was upon the very day of her return that Kay received a midnight telephone call.

Miss Brown?

Yes.

We've been trying for days to get you to let you know you are to be interviewed tomorrow for a job at Medgar Evers College. Will you be there?

Kay Brown was there—a bit of ahead of time. What astonished her about the whole circumstance is that she had hoped to stay a couple of days longer in Guyana, having even tried to readjust her flight ticket. It didn't work out. Had she stayed she might have missed a job she so desperately wanted—and needed!

Megar Evers College in Brooklyn was the only four-year college in New York City whose faculty and student body were predominantly black. The College hired Kay as its only full-time art teacher, though Gregory Ridley was also functioning there as an art adjunct. An excellent all-around artist as well as a specialist in the ancient art of repoussé, Ridley had previously served on the art staff at Fisk University in Nashville, Tennessee. A man possessed of a winning personality and considered a first-rate teacher, Ridley had been lured from Fisk to Medgar Evers with grandiose promises that were never fulfilled. Close friends and even those who knew him only casually considered that he had been badly treated in the Medgar Evers situation. Kay speaks warmly of him.

Greg was never permitted to function to his fullest capacity, and I really regretted that as I told him we could do great things together there. He should have been a full-time teacher. But I suppose some political considerations got in the way and he finally left to return to teaching in the South.

Kay finds her work at Medgar Evers College both challenging and rewarding. Though she has great rapport with her students she admits that her effectiveness in getting administration to do what she would like to see done for the arts falls below her hopes. Kay's political activism is more strongly seen and felt in her artistry than in her routine academic work. Still, as difficult as it may be to sell the idea of art as a full four-year course to administrators inclined to regard it as an adjunct to a "more practical career course," Kay Brown still hopes—and tries.

It was 1974 when Kay Brown made her second trip overseas. This time it was West Africa and her finances were in far better shape than on her trip to Guyana. Clayton, her teenage younger son, was with her. As in the case of Otto Neals and hundreds of other Afro-Americans, artists and nonartists alike, she wanted to see the land of her ancestors—to tread the soil, to breathe the air. For both Kay and Clayton the visit was well worth the time and effort.

Seeing these people from whom many of us came, feeling their great warmth, eating with them at their tables, was a great experience for us—my seventeen-year-old son and I. And if I could have found work there I would have remained. Clayton would have done likewise, for there he functioned quite differently than he does here. . . . We traveled by car from Ghana to Nigeria, seeing the countryside. Really, I did not want to come back here. And hopefully I'll get back there someday—perhaps if possible to work.

Kay's affiliations here, however, remain potent. She is involved with the twenty-year-old black National Conference of Artists (N.C.A.) group, having served as a panelist at each of its annual gatherings. N.C.A. is presently made up of "grass roots" artists along with those art educators who dominated it in its early years. And on being simultaneously black and female and an artist, Kay has definite thoughts she is not loathe to express.

As a woman trying to bring up a family alone I realize what it means to the black man not to know how to deal with his woman or his family. It seems to me that it becomes the duty of black artists to address themselves to this question. I know that my life would have been completely different had I raised my sons along with their father's help.

You listen to this sensitive woman talking of her life and you try to recall whoever or whatever it reminds you of. And then you recall that it is Billie Holiday's earthy singing. There is on one side the downbeat plaintive dirge. On the other side is that upbeat rollicking spirit that moves into both her conversation and her work. And in the background you hear Billie Holiday's swinging rendition of *Miss Brown to You.*

Alfred J. Smith, Jr.

You mention Alfred Smith to Valerie Maynard and she instantly glows with approval, "Now he really has it all together," she responds. Valerie is in a position to know. She has observed Smith as both artist and teacher, for he too is employed in the Fine Arts Department at Howard University in Washington, D.C. "And he's still a young man," you remark. Valerie smiles. "Yes, but he's also quite old—if you know what I mean." You do indeed know what she means, for the maturity is there to see in Alfred Smith's work as well as to feel as he shares his life's story with you. Still he is not yet thirty years old.

My father, Alfred Smith, Sr., is a sign painter, and my mother, Zenobia, is a housewife. My father's father, James Alfred Smith, was also an artist. He had fifteen kids and the outlets for his talent were not too many in his day. But he did eventually hand the sign painting jobs over to my father and he then proceeded to paint as he'd always wanted to do. Most of what he did was lost in a fire. And I recall how, as a child in church, I'd stand on the pew and turn around to have a look at my grandfather's paintings on the wall. That was at Saint Paul's Baptist Church in Montclair, New Jersey.

Though Alfred never new Grandfather Smith except through the paintings, his memories of the old man are posi-

tive. "My grandfather was a good painter." Recollections of the home in which he and his slightly older sister grew up under the loving supervision of their Virginia-born mother are likewise positive. That was fully evident in the parental attitude toward Alfred's early attempts to express himself through drawing and painting.

Al had decided as early as age seven that he would be an artist and was then producing paintings on castaway boards. By the time he was ten he was working on stretched canvas and, in his own words, "acting the part of the artist."

Through all of that he was never once admonished by either parent to change his course and look for something from which he could be sure to earn more money. Never did his father's inability to "cash in" on his own talent prompt him to steer his son away from the art they both loved. Zenobia, wise and strong, knew well her husband's personal frustrations in art as well as his hopes for their son. She encouraged him all the way. Still, young Alfred face a tough hurdle—school.

It wasn't that the boy was dull and slow. Actually the very opposite was true. His intelligence combined with a competitive and combative personality made it impossible for him to accept meekly the racist attitudes he encountered among the teachers in the Montclair public schools. They were attitudes similar to those experienced by Bertrand Phillips a few years earlier in Chicago; and they typify a point of view held by many northern whites who have convinced themselves that antiblack prejudices exist only in Dixie. Al speaks of those early school years.

> The school was ninety-five percent black and all our teachers were white. There was that thing about our being "lazy" and that business of pumping a defeatist attitude into us. . . . And even though I was ahead of the other kids as far as art was concerned I

had what was considered "the wrong attitude." The other thing was that even at an early age I was known also for my skill as an athlete. Then, too, I was defiant and very mischievous until I got into the ninth grade, where I realized I'd have to learn to get along better with others.

Al's special aptitudes in art and athletics revealed themselves at about the same time. Even as he had begun painting on stretched canvas before reaching the age of ten, he was playing little-league football and baseball. And as his abilities, especially in athletics, made him a local celebrity to sports fans and to other youngsters, his pugnacity and defiance made him less popular with his teachers.

They considered me arrogant. And though I managed to do my lessons I didn't get on too well with teachers. I almost stayed back in the sixth grade because the teacher put me in a special room with kids considered to be "unteachable." And that teacher actually stopped teaching us for a while—demanding to know meanwhile why we couldn't be more like so-and-so who happened always to be another black kid whose appearance and manners he preferred to ours.

Al readily admits that by the time he reached the seventh grade he was on the wrong track. He was in the school's slowest class where everyone called everyone else "stupid" and where other expressions of self-hate were painfully abundant. That was compounded by constant threats of corporal punishment at the hands of certain teachers. Al Smith was sure he had been "totally written off" by those assigned by the city of Montclair to teach him. He is equally sure that he could not have withstood the pressures alone and without the support of a mother he describes as "very strong."

Zenobia Smith had come from the rural community of Chase City in Virginia's southernmost Mecklenburg County. And while most Virginians are justly proud of their state's revolutionary history during the founding years of this nation, Virginia's historic handling of the slave issue is far less admirable. It was in 1832 that Thomas R. Drew averred that Virginia was a "Negro-raising state" able to export 6000 slaves each year because of the slave breeding industry. Blacks were lynched in Virginia—twenty-three, to be exact, between 1889 and 1915. Even after the enactment in 1965 of the Voting Rights Act, Virginia, along with Alabama, Georgia, Louisiana, Mississippi, and both the Carolinas, were still using the literacy test as a means of preventing blacks from voting.

Zenobia Smith had not migrated north and settled down to raise a daughter and son to have them humiliated, Yankee style. She went straightway to Al's school to find out why her son, who had shown no tendencies toward idiocy at home, was relegated to the lowest class. Al chuckles as he recalls that first visit in which the school authorities brought out the records showing his "scores."

"I don't care a thing about your scores," she remonstrated. "I just want you to take my son out of that class and put him where he belongs."

For a brief instant Al thought his mother and the teacher might come to blows. But Mrs. Smith won her point, and as soon as Al got into a different environment his teachers discovered what he and his mother already knew—that he wasn't stupid at all. From that day on Zenobia Smith was at the school the instant any hint of teacher prejudice showed itself to either of her children. By the time Al reached the ninth grade his scholastic record was good enough to warrant his thinking ahead to college.

High school in the interim presented its own opportunities and challenges. As is true of many of America's small

communities, athletics, and particularly football, occupies a large place in the scheme of things. The Montclair High School football team was the team of the area and Al Smith was on it. In fact he was a star offensive and defensive half-back of the team that, in his junior year, was rated the nation's third best. That wasn't all, for he excelled in track and was the school's star baseball pitcher.

In general, Al was getting along more easily with his teachers than he had in grade school. He recalls in particular a Mr. McClosky, with whom he enjoyed so warm a relationship that he spent as much time as possible in that teacher's classroom. And though his art continued to grow, the rapport between art teacher and student was not as close as with Mr. McClosky.

There was another man who constantly reminded me of my "laziness." In fact, he told the entire class one day that, "Al Smith will never get into college." I was a junior when he made that prediction. A little later as I would receive letters of acceptance from colleges I'd show them to him. His response was to then declare that I'd never finish college and certainly never complete an art course. The man had a personal vendetta against me.

Likewise, Al and his athletic coach did not enjoy as warm a relationship as either would have liked, and while neither relished the stresses and strains between them, their differences eventually worked to Al's advantage. A more harmonious relationship could have steered Al into professional sports and away from art. Meanwhile there were the expected injuries, the shifting of positions on the team, and the rumors that this-that-or-the-other player would or would not be occupying his usual place on the team. Al relates the specific incident in high school leading him to choose between accepting the temporary status of local celebrity at

the expense of personal dignity or choosing the lonelier long-range route to who knows where.

When the baseball season came around the coach handed me six letters from colleges—letters dated as far back as December. He had held them out on me until February or March when he was sure I'd be going out for baseball. I was his number-one pitcher. In what was my first game I'd pitched a one-hitter when one of his favorites in the outfield dropped the ball. The coach came out to the mound after the bases loaded up and asked me if my arm was okay—as though I was to blame for the outfielder's error.

By then I'd been accepted at Boston University and I told him "no, my arm is hurting." Nothing at all bothered my arm. But I was fed up with the general attitude.

Realizing that his action would draw hostile comments of "yellow" and "quitter" from local team supporters Al, nevertheless, voluntarily left the team following that game. What he felt deep down inside he never bothered then to explain to them as he does now in these terse sentences.

What my attitude said was, "No, you're not going to mess over me—no, I'm not going to eat cheese. If we're going to be fair with one another you're going to give me just what I deserve." It wasn't conscious militancy on my part, but rather a matter of my knowing who I was and not letting them jam me like that. It was more than they could deal with. And even when I go back home now people mention to me that I quit the team. What I tell them is that I always knew where I was going and that even my high school coach did not hold my future in his hands.

What Al Smith knew so positively was that he was go-

ing to be an artist, football or no football, even though he had entered Boston University on a football scholarship. He knew that the moment he stopped playing the game his scholarship would be withdrawn. Three days after the season began Al quit playing the game though that had not been his intention at the outset.

He had arrived in Boston with the idea of majoring in Advertising and Commercial Art while taking added courses in painting. The former would equip him for earning a livelihood without departing wholly from the arts. He'd then no doubt play college and later professional football and paint during the off season. Al had it all figured out. It was not destined to be that way, however, for the first class he walked into was that of Richard Yarde, a black teacher of drawing and painting.

Yarde was the first and only black teacher Al Smith had during his freshman year at Boston University and he noted that he and a young woman were the only two black students in the freshman class. That however gave him no feeling of uneasiness when Yarde looked at his work and called him in for a private chat. It was a moment Al remembers with obvious feeling.

> Next to my father, Richard Yarde was my second influence in art. He took me aside and said, "Look, man, you've got to decide whether you want to be an athlete or an artist. You can't be down there on that field and up here in the studio too. If you want art you've got to give the other thing up!"

Perhaps they were words Al subconsciously had been waiting for. Seventy-two hours later he turned in his football gear and was completely on his own. The year was 1967, memorable for tensions and protests in America's black communities to which Alfred Smith was both attentive and responsive.

First, there was the removal of Congressman Adam Clayton Powell, Jr., from the chairmanship of the influential Education and Labor Committee as well as from his seat in Congress. The charges against Powell centered on criticisms of his personal conduct, specifically with an attractive secretary. Then a libel suit was lodged against him by a Harlem resident he had designated as a "bag woman" (collector of monies) for corrupt police. Though Powell was allowed to retain his congressional seat, critics of the action against him quickly pointed out that others whose misconduct had been far more flagrant had not been similarly stripped of their chairmanships. Racism, they declared, was the reason for the harsh treatment of Powell by peers who could ill afford to pronounce such judgments. However, the action against Powell prevailed.

Later in 1967 a young heavyweight boxing champion from Kentucky named Cassius Clay had embraced the Muslim faith, taken the name of Muhammed Ali, and refused to be inducted into the U.S. Army at Houston, Texas. Said he:

> No, I am not going 10,000 miles to help murder and kill and burn other people simply to help continue the domination of white slavemasters over the dark people the world over. This is the day and age when such evil injustices must come to an end.

The World Boxing Association and various state athletic commissions promptly and angrily stripped Muhammed Ali of his title. They were quickly followed by the federal government, which threatened to indict Ali for his stand against the draft. Though sentenced by a Houston, Texas, jury to five years in federal prison, Ali's conviction was overturned by the U.S. Supreme Court in 1971. The New York State Athletic Commission, however, had revoked Ali's heavyweight title and boxing officials around the nation barred him from the ring. Three years passed before a "rusty" Ali

regained his title in a bout with George Foreman. Because of the immense profits his skills brought to a "sport" that for lack of talent was almost dead, Ali's triumphant return to boxing made him an even more popular public figure than before.

Meanwhile Al Smith, thoroughly familiar with the price of taking a firm negative stand against established authority, grew more determined than ever to develop his skills in art. If he had to do so without the aid of football and the scholarship it provided, then so be it.

> At the end of the first semester my parents grew concerned about my survival . . . and it was tough. But at the end of that first year—a year of real scrimping— I won the freshman art award. That allowed me room for a little negotiating, and I decided then not to major in commercial art or in art education but to stick to painting.

It was a bold decision and one that formed the basis for serious arguments with family members who were sure Al would literally starve to death. But as he puts it, "I had no such plans for myself." Conscious of the need to prepare himself well for what he wanted most to be, Al rented one room in which he ate, slept, and painted. So cramped were his quarters that he had to crawl behind a stack of canvases to go to sleep. That did not bother him. It did, however, bother his mother, who made a trip to Boston to see how he was getting along.

One look at the room and Zenobia Smith raised her hands and her eyes toward heaven. "Lord, I can't stand seein' my boy livin' like this!" she exclaimed. Al's bland response that it wasn't really so bad only served to confirm her belief that privation had literally gone to her poor son's head. But Al managed somehow to assure his mother that she could return home knowing that he would soon be in better cir-

cumstances. He did indeed shortly thereafter find a job and an adequate apartment. Activities in the art studios at Boston University, meanwhile, remained routinely conservative.

> They were very academic there—taught you how to make your own paints. Many of them wrote books on how to paint in the European tradition. Michelangelo was God, himself.

Al won the sophomore art award, his second at Boston University. Simultaneously he had begun to teach for three days each weeks at the nearby Norfolk Prison Colony. He was barely twenty years old and the year was 1968. It so happened that the very year Al Smith was born Malcolm X had been tansferred to the Norfolk facility from the Concord Prison—a change of which Malcolm speaks favorably in his famous *Autobiography*. Here in part is what he says of it.

> The Colony was, comparatively, a heaven in many respects. It had flushing toilets; there were no bars, only walls—and within the walls you had far more freedom. There was plenty of fresh air to breathe; it was not in a city.
> There were twenty-four "house" units, fifty men living in each unit, if memory serves me correctly. This would mean that the Colony had a total of around 1200 inmates. —About fifteen per cent of the inmates were Negroes, distributed about five to nine Negroes in each house.
> Norfolk Prison Colony represented the most enlightened form of prison that I have ever heard of. In place of the atmosphere of malicious gossip, perversion, grafting, hateful guards, there was more relative "culture," as "culture" is interpreted in prisons. A high percentage of the Norfolk Prison Colony inmates went in for "intellectual" things, group discussions, debates, and such.

Instructors for the educational rehabilitation programs came from Harvard, Boston University, and other educational institutions in the area.

For Al Smith, coming a full generation after Malcolm, teaching at Norfolk was an experience he vividly recalls. From his sophomore through his senior years he went back and forth to the colony working with its talented inmates. In a sense his impressions paralleled those of Al Hinton, who had done similar work in Michigan's Jackson Prison. Like Hinton, Al Smith noted that the majority of the inmates were black.

> The first guy I was introduced to was a guy I grew up with in Montclair. You weren't supposed to know anyone there, otherwise you couldn't hold the job, and that cramped my style because my natural impulse was to greet him warmly. . . . There were others I'd known in Boston. One guy had gone to Harvard. . . . We got things so organized that they'd have it all set up ready for work when I hit the gates. We were doing sculpture —using chisels on plaster—and were about to get to work in wood. When I left to come down to Howard each of them gave me a piece he had done.

Though he wasn't fully conscious of it at the time, Al now realizes the emotional and mental changes he went through working at the Norfolk Prison Colony. For a while after leaving the facility he found it difficult to indulge in small talk with anyone. He had formed very close ties with some of the men whom he describes as "the only real friends I had." He could, and did, talk heavy stuff with them because he found that they knew what was happening in the world surrounding them. And as they went through their various emotional changes, Al, too, felt much that they felt.

> They came to depend upon me so. I'll never again

work in a prison, for I found it too hard to leave the guys to come to Howard University. They wanted me to stay and I wanted to stay with them—hoping and believing I might save some of them from "flipping out" altogether. It was hard seeing a guy going up for parole and knowing he wouldn't make it . . . that he'd say the wrong thing and turn the parole board off.

In the interim Al was meeting with triumphs and failures in his studies. The latter began to close in on him during his junior year, the only year he did not win the annual award. That was the year he and one of his teachers continually locked horns over Al's choice and handling of the subject matter. At that period he was strongly influenced by Dana Chandler, another black artist of Boston, whose story concludes this book. Chandler, a forceful and vocal proponent of black nationalism, held views not readily embraced by all members of the local white art community. Al's teacher, no Chandler enthusiast, offered this bit of advice to his young student.

You'll have to forget all this "black" stuff, Smith—this stuff Chandler promotes all the time. We've put so much into trying to make an artist of you. So why get hung up on this business of blackness? Remember, you're first and foremost an artist!

Al listened. The words, spilling like acid into his consciousness, revived his childhood in Montclair. They resurrected the slowest class he had been tossed into along with the countless times "coon," "nigger," "dinge," and far worse were venomously spat at him as he was gang-tackled by opposing white players. They conjured up the ghost of the biased coach and the art teacher who had publicly predicted that Al Smith would never get into much less through any art school. And Al remembered the fellows at the Norfolk

Prison Colony—the brothers he had to leave behind. It all began to whirl crazily about in his head until he seized the controls and slowed it down. His head clear and his footing now firm, Al spoke to his teacher in a quiet and deliberate manner.

Mr. _____, when I am out there on that street the white racist cop and the white racist of whatever occupation never sees me as an artist first. Therefore my blackness in your world—but more important, in mine —can never be secondary to anything!

From that moment on that particular instructor refused to teach him. "He'd deliberately skip over me and over anyone else working either to my immediate right or left." That was the year the annual prize went to a white student who became Al's most formidable competitor. Al speaks with humor of how his competitor was "pushed."

For the entire four years they had tried to make him better than me. Man, they'd be working with him nights, giving the dude overtime as they pumped information into him.

It was during this difficult period that Richard Yarde once again came to Al Smith's aid.

He knew I was hurting and he knew why. The others were out there to clip my wings. Yarde knew I was trying so desperately to be my own person no matter what color that person might be. So, reverting to his advice that I go back to the old masters, Yarde handed me a large book on the *Art of Ancient Egypt*. "I don't know whether or not you'll understand this but I think this is what you need now," he told me.

That book was precisely what Al needed. Up to that point the academic tenor of the school had led all the stu-

dents of drawing and painting along the European classical tradition of seeking to create the illusion of three dimensions on a two-dimensional surface. Here in the book Yarde had handed him, the wise Egyptian painters, in full recognition of the limitations of their medium, made their paintings flat and decorative. Al was captivated by the rich, flat reds, browns, blacks, and yellows used in depicting the figures. In speaking of it now he still exudes some of what he must have felt as he took his first serious look at Egyptian painting.

> I realized then and there that something exciting had been done in art before the Italian Renaissance and that something had taken place not in Europe but in Africa! And I knew also it was for me—although to see it as the Egyptians and as black painters, Jake Lawrence and William H. Johnson, had seen it, I'd have to start all over again. You see, in order to gain something you often have to give up something. And that's the way it was with Richard Yarde and me. He always treated me as a friend, as a colleague—not just as another student. He knew more about the practice and the making of art than I did, but he knew also that I could think and feel.

Al's work during his senior year underwent a complete change. He painted a triptych, quite Egyptian in manner, that went from the student show at the university down to the Boston Museum show. *Essence* magazine reproduced it, and Al received enthusiastic encouragement from David Aaronson, his senior instructor in painting. Aaronson, a devotee of Benin art in West Africa, was in full accord with Al Smith, who himself was now drawing inspiration from the art of the African continent.

> Aaronson who did not feel at all threatened by what I was doing, listened calmly to my gripes about the

previous year. My previous instructor refused to go to the Boston Museum to see the piece.

Al won the award in painting, and before he left Boston University he became a teaching fellow there—assisting John Wilson, one of America's eminent artists and teachers. Wilson is black and Al's praise of him is unstinting.

I learned much about teaching from John Wilson, with whom I had a warm personal contact. I can't imagine that there is a better drawing teacher than John Wilson. I've seen him make a small sketch for a student that summed up in three minutes all that student had been trying for hours to do. His excitement over what he is doing pervades the entire classroom. And he's an extremely sensitive painter.

It was 1970 when Al, twenty-one years old, was graduated from Boston University. For a short time he worked as a teacher at Boston's National Center for Afro-American Art, founded and directed by Elma Lewis—a place he had started working in during his undergraduate days. Elma Lewis, a dynamic black woman of Boston, has been able with the aid of grants to develop a huge complex in which all of the arts are taught. Dance, the theater, music, painting, sculpture, photography—studies in all these are made available to the people and it is based in Roxbury, Boston's famed black community. Al Smith lived just down the street from the center, so getting there in the evening was simple.

It was during that period that he and dancer Judy Moore met. Judy did traditional African dances and as Al watched her he became certain of two things. One was that he wanted to marry her. The other was that they would have to visit Africa together. After a courtship of one week they were married, and as he puts it nearly five years later, "so far it has been the ideal union." Judy's mother's people are Floridians and her father comes from the West Indies.

The second year after Al had finished his studies at Boston University he was asked by Jeff Donaldson to join the staff at Howard University as a teacher of painting. He accepted and is there as of this writing. For Al Smith teaching has a special attraction.

Here in Washington I feel I want to do for my students what Richard Yarde did for me. And I want to be so effective with students that some of them will think and speak of me as I do of Yarde. The opportunity to achieve that—just that—is here at Howard. But most times I think I am failing in my aim. Then suddenly I find that I did influence someone—and that helps me balance out.

The insistence upon balance is strong in Al Smith. For that reason alone he found that he could not be content merely to mouth the black nationalist rhetoric of the 1960s. He needed more. Indeed, he needed to make of himself an example through his work and through his mode of living from day to day. Critical of protests among blacks that do not impose personal responsibilities of morality upon the protestors themselves, Al's union with Judy became for him an important step in the direction of achieving balance. Their subsequent trips to Africa together served to strengthen that balance.

That is where the thrust of my work is. It deals with balance and harmony between male and female. I do everything creative in pairs. That's the male chair. This is the female.

That first journey to Africa had been seeded in Boston when Al had seen Nigerian sculptor, Lamidi Fakeye, do a woodcarving demonstration at the Center Elma Lewis directs. What he saw the celebrated Nigerian artist do convinced him that he'd have to go to Africa—specifically to

Ibadan in Western Nigeria. There he would watch Fakeye carve again—in his own setting. So in the summer of 1973 he and Judy set out for Ghana and Nigeria strictly on their own.

> We stayed in Lagos for about one minute for it is an insane city. From there we went on to Ibadan by bus. Judy and I now regard Ibadan as our second home.

What Al wanted to do in Africa was to get a first-hand view of functional art, for he considers it relative to black Americans whose African ancestors used their works of creative art. He sees no reason, for instance, why his relief carvings must become mere showpieces, and he will use one as a table top from which he and his guests dine. Another characteristic of African art that Al admires and incorporates in his own work is the African artists' respect for repetition. In direct contrast Western standards hold that to be "new"—to "change" constantly—is to be up to date. Al Smith's studies of the African approach have convinced him that the Western viewpoint need not be the standard for the world.

> African art is far more rhythmic than Western art. You can't have rhythm without repeating the beat. And the rhythm is there—in the music, the dancing, and the carving.

During the six weeks the Smiths spent on that first trip to West Africa they visited two unforgettable artists, both Nigerian. The first is an eccentric and extremely imaginative painter who calls himself Twins Seven-Seven. Twins comes from Oshogbo, in Western Nigeria, a Yoruba city of about 120,000 located on the banks of the Oshun River and sixty miles from Ibadan. Oshogbo, a politically active city as well as one of varied cultures, is also heavily Muslim.

Twins Seven-Seven is best described as a "character," who is likely to offer any number of explanations for the odd

name he bears. One is that his mother lost six pairs of twins and that he is the survivor of the seventh pair. He is known as much for the originality of his mode of dress and his dancing as for his painting. Twins has been seen at dances wearing a blouse with his name embroidered across the back, narrow trousers set off with pink buttons along the seams, pointed high-heel shoes, and an embroidered tassled cap. His spectacular get-ups have prompted critic and historian Uli Beier to comment, "Even in a colorful town like Oshogbo he created a minor sensation."

Al Smith was intrigued by Twins Seven-Seven's handling of the geometric patterns that run throughout his painting—an innovation he, himself, likes to use. Smith finds that such patterns transmit energy throughout the canvas, visually achieving what the musician achieves through the use of rhythms. And he was to discover the same rhythmic quality to an even greater degree in the creations of Jimoh Buraimoh, another Nigerian artist.

Buraimoh, an electrician attached to a theater company, began as a painter. From that beginning he developed a mosaic technique through the use of strings of local beads. Al and Judy were overwhelmed by what they saw of his work.

To get to his studio I crawled through filthy back alleys. After finally climbing some stairs and groping down a hallway to a curtain I pulled it back. And there it was as if you were looking at the sun! The cat had beads all over the floor. He's in his thirties, has three wives, and is really "smokin'"! Twins has five wives—a fact that shook Judy up a bit.

The Smiths have a sample of Buraimoh's work, one Al describes as "a good piece." Indeed their home in Washington is reflective of the philosophy he has adopted and that he teaches, that of making art a part of everyday living. As is

true of Kermit Oliver of Houston, Texas, Al makes much of the furniture he and Judy use. He made some of it before going to Africa and has made other pieces since, using mahogany and oak. The two carved chairs one sees in the downstairs living room—one male, the other female—were designed in Africa and executed in Washington. His interest in the relation of music to painting and carving is leading him toward a project that should be exciting in every aspect. Al speaks spiritedly of the hopes he has for it.

It involves my producing a whole set of sculptured musical instruments that can be played on the bandstand. To do that I need to study and experiment with acoustics. . . . Actually I'm doing these things, chairs, musical instruments, for those yet to be born. It is my way of stimulating them to make art not for the museums but for the home. It is Western man who, in creating his art has said, "To hell with the people; I'm making my art for the museum." But a view of the highest and most developed forms of art reveal that they were made for the use of society.

Al Smith makes a serious study of African art as he develops his own ideas. He has found, for instance, that as he listens to the traditional music of the Congolese, and then looks at their graphic patterns, the two seem singularly similar in their rhythms. To him, "Yoruba art looks like the way the Yoruba people talk and dance." That observation suggests a direction for him that will be meaningful to Afro-Americans.

The future of my work lies in being able to translate the way Afro-Americans look and talk—the way their music sounds—in visual terms.

Al finds he is not alone in seeking such ends. He observes that many Afro-American artists are being caught up in the internal spirit of things African rather than the mere

externals. Many of those artists who have never met one another are working in the same vein. He mentions John Hendricks in New York as one who along with him embodies a similar sense of motion in his work. Charles Searles and he share many themes in common, and Ed Sorrell of Philadelphia has been doing sand paintings. This latter artist's work has really surprised Al Smith.

> Before I knew of Sorrell's creations I just knew nobody else here but me had developed sand painting since I had developed it from a brother back in Uganda!

Yes, Al has been to East Africa, too. His trips to the African continent coupled with observations of what many current black American artists are doing in their own studios convince him of the existence of "an internal language we are not consciously copying from each other." From that Al evolves and clings to a hope for the not-too-distant future. It is that black artists will cease to compete for what he calls popular acceptance in "the New York slots."

> What's been happening is that we've all been blowing our solos—each one of us speaking an independent and different language.

He believes that black painters and sculptors, like creative musicians, can function together and still retain their individuality. Most of all he believes that what such a collective effort would produce would be of inestimable value to the very existence of black people at large. His own work as artist and teacher leans in that direction.

Though all Al Smith's work has grown immensely over the past decade, he still recalls his recent past. In no way has he compromised his principles for public acclaim or ready acceptance. To the delight of his contemporaries and the students who respect him enough to believe in the validity of what he is doing, he remains pretty much the same young

man who abruptly dropped a promising career in athletics to pursue one in art. To that extent he was accurate when, as a high school senior, he resolved that he and only he would chart the course of his life.

Onnie Millar

WHILE ten-year-old Alfred Smith, Jr. was floundering unhappily in the slowest class of his grade in Montclair, a petite and gifted black woman was having a struggle of her own in New York City. She is Onnie Millar of Brooklyn, and she is an artist whose talent, patience, and creative drives alone have sustained her through some rough encounters with exploitation. Indeed she didn't have to wait until her adulthood with its accompanying career in art to know how artists are exploited. As a child Onnie had seen her father misused by those who profit through others' talents.

Onnie, the second of three children of Olive (Bruce) and Herbert Millar, was born in New York City's Harlem Hospital one year following America's signing of the Armistice pact with Germany in 1918. Her older sister, Agnes, and younger brother, Eddie, were likewise born there. Onnie's earliest memories, however, are not of Harlem.

My earliest recollections center about life in Asbury Park, New Jersey. We occupied a private house and I recall standing at the window waiting for mama to come home. . . . My father was trying to become a successful playwright and mama made the performers' costumes. The cast was always black as my father's plays always dealt with Egyptian kings and queens. They were long Biblical plays in which all of us took part. We

kids would come on stage holding the ends of the robes to keep them from trailing the floor. And the old hotel dining room temporarily converted into a theater was always packed.

Talented Herbert Millar, ever conscious of history's omissions and the theater's neglect of the full and varied participation of black people in human affairs, sought, through his writing and staging of plays, to alter that deficiency. That his efforts were eagerly patronized by local blacks was a testimonial to their hunger for theater fare of which they could be proud. Certainly they had had enough of the minstrel type of entertainment replete with banjo picking, eye-rolling, the cake walk, and the coon song. Expertly as such may have been performed by black artists and nostalgic as it may have been, the times and environment fairly shrieked for something more relative to reality.

America had sent its troops to Europe "to make the world safe for democracy," and some of those troops were black. Among them were those who died in battle and those who returned maimed in body. But what happened to their spirits was even worse. In addition to being harassed and maligned overseas by their own white fellow soldiers, they were greeted upon the return home by whites fearful and resentful of black men in uniform. Moreover, the clamor for jobs in the recession following the war boom gave birth to the first of several migrations of southern black workers to northern cities. The competition for jobs between black and white workers grew fierce.

Vicious and bloody race riots exploded in Charleston, South Carolina; Longview, Texas; Omaha, Nebraska; Chicago, Illinois; and Washington, D.C. Blacks in Asbury Park heard and read about them with more than casual understanding. Their own city, while not the site of a race riot, gave them enough to worry about. Most blacks lived along

the west-side Springwood Avenue area and they were forced at that period to use a separate beach at the ocean front.

Hotels and places of public accommodation welcomed them only as servants. There were but two restaurants in which they could sit and eat a meal, Water's Restaurant and the West Side Dining Room. The latter, owned by Albert J. Moore, was clean and dignified, and because of its home-cooked meals was especially popular with blacks visiting from middle Atlantic seaboard cities.

Blacks who wished to spend nights in Asbury Park did so with family members, friends, and those local black families able and willing to rent rooms to them. Such was the tone of Asbury Park, New Jersey—and indeed the nation at large—a half-century or more ago. That is why blacks living there received Herbert Millar's dramatic offerings with enthusiasm—and hope.

But Millar was never rewarded in a practical way for his work. Though he wrote, directed, and finally got his plays before audiences it was his sponsor, usually a sharp community businessman, who got the lion's share of the profits. Herbert Millar was given just enough to tantalize him into taking further plunges from which his sponsors continued to harvest the money he had earned. The Millar children were still young, and Onnie was not yet enrolled in school, when they returned to New York City. Onnie tilts her head reflectively as she remembers the New York she knew as a child.

> We lived all over Harlem. At that time landlords practically begged you to move to Harlem for there were lots of apartments to rent. In fact they'd offer one or two months' grace on the rent just to get you in. For that reason mother used to pick and choose and we moved quite frequently. So we learned early to be flexible and adaptable.

Though that was the housing situation in Harlem of the mid 1920s, Olive Millar would have met a more hostile reception there a decade earlier. Harlem's rapidly growing population then numbered 50,000 and the area's white property owners were panicked. They hastily formed an organization, the Harlem Property Owners Improvement Corporation, which between 1910 and 1915 waged a bitter but futile battle to keep Harlem white. A few of New York's black churches, meanwhile, bought property in Harlem and they as much as any other force did much to open Harlem to greater numbers of black residents.

America had boldly flung itself into the lap of prosperity of the jazzy "roaring twenties" and with her largest city presided over by dapper, fun-loving James J. (Jimmy) Walker, New York was a "wide-open town." During those loose, frivolous, free-spending times even poor blacks of the city could find ways of getting by honestly. Olive Millar was one who knew how.

> During the day our mother held two or three jobs as a domestic. And when she came home her work was not over. After supper she'd teach us songs—especially how to sing them in harmony. Agnes sang the lead and I the alto. . . . And she taught us to perform, too, and how to entertain our friends. After school when our friends came in and my mother was home she'd have little impromptu parties. They weren't elaborate, but whatever she could afford to serve was done with artistic flair. The platters were always so attractive! Memories of my mother are extremely pleasant.

Olive Millar's own inspirational youth had prepared her well for being an inspirational mother. Her scholarly father, John Edward Bruce, had been one of the nation's outstanding journalists and political activists during a sixty-six-year life span that began in 1858. Throughout his constant fight

for equality of opportunity for his own people, John Bruce also maintained open lines of international communication. In the effort to bring knowledge of Africa to black Americans, Bruce and Arthur Schomburg in 1911 formed the Negro Society for Historical Research through which they established close associations with Casley Hayford of Ghana, Duse Mohammed Effendi of Egypt, and James Aggrey of Liberia. Later, as a writer and editor for Marcus Garvey's weekly newspaper, *The Negro World*, his "Bruce Grits Column" was a standout feature.

Throughout my childhood my mother talked with me about her father. She was his only child, though my mother's mother had other children before she married him. . . . So it was from her learned father that my mother inherited her love of scholarship. She was well acquainted with the works of Charles Dickens from which she would frequently quote. Paul Laurence Dunbar's poems were other favorites of hers. And though life had been difficult for her she never lost her zest for things cultural and progressive.

Little Onnie loved learning as well as art, and school was sheer joy for her. It began in Harlem's P.S. 119, which she recalls now as her "second home."

I could hardly wait to get there. Our teachers were white and extremely dedicated. They knew, for instance, that my mother was struggling to do the best she could afford for us and they made every effort to help her and others in similar circumstances.

Those efforts made at the school on behalf of kids and their families were considerable indeed when one realizes there were few if any social-service agencies functioning during the 1920s. Whatever was done for youngsters in school was done by and at the expense of school principals and teachers. Onnie remembers the principal of P.S. 119 as

"an Irish woman, Miss Lawton, who grew incensed at the thought that kids had to go without breakfast or lunch or anything else essential to sustaining life and health." Miss Lawton, therefore, saw to it that her dietitian, Miss Delany, of the well-known Harlem Delanys, fed the youngsters.

But all the children were not from homes needing such help. Onnie recalls that one of her classmates was the grandchild of Frederick R. Moore, founder, owner, and publisher of *The New York Age,* a distinguished black weekly newspaper. Mr. Moore himself served on the local school board. Nor was P.S. 119's staff completely white, for its music teacher was a black woman, Miss Peace, who obviously was both efficient and forceful. Ruby Dee recalls that a few years later Miss Peace had moved on to the staff at exclusive Hunter High School where Ruby, too, was one of her grateful students.

Harlem, then, with all its problems, has never suffered from a lack of strong and productive residents. Among the less admirable forces operating in Harlem, however, were the white mobsters and their black hirelings who controlled the sale of illegal liquor in the community during the era of prohibition. The mob was also in control of the famous Harlem nightclubs in which the black stars performed but from which black patrons were barred. Most black Harlemites, while resentful of the gangster presence, preferred remaining silent and alive to risking confrontation. Onnie remembers the period.

We finally moved from Harlem. Things were getting rough, what with bootleggers getting into the area. My mother realized that the changing environment was not the best for us to be in. I was in the fifth grade and the year was nineteen thirty.

The nation's economic health had begun to show signs of failure that in three years would bring on a ruinous de-

pression. Olive Millar had found an area to live in where one of the houses was occupied by black families. Others living in the southeast Bronx were Jews, Italians, Polish, and Irish, and Wilton Junior High School, which Onnie and her sister Agnes attended, was a vastly different experience than Harlem's P.S. 119 had been.

Racism ran wild at Wilton. It was seen and felt from all quarters, beginning in the office of the principal. Onnie recalls that it was as if the teachers went out of their way to show the contempt they held for blacks—a contempt that became effective because blacks were so much a minority as to have no voice in what was being done to their children.

> We black kids were always placed in the back seats and, of course, there was no encouragement there for me in art. But for the strength of my mother I would have suffered terribly. But she followed her custom of encouraging through example. Just as she had taught us earlier to play creatively at home in a sandbox of her own making, she taught me to work at my art at home. Besides that she never let up on her campaign of letter writing to the school in protest against racial bias.

> A move to another section of the Bronx landed Onnie in Paul Hoffman Junior High School, where she found racism mingled with a lesser degree of personal hostility. In spite of her tiny stature Onnie was assigned a back seat, a place she would never have been thrust into by her white teachers in Harlem. In retrospect it becomes clear that the difference lay in the fact that at P.S. 119, where all the youngsters were black, white teachers did not feel the pressures from white parents who might object to having their children sitting behind black children. Such clearly was not the case in those schools in the Bronx and in other sections where white teachers readily aquiesced to the bias of white parents—a bias they themselves often shared.

Even though a teacher at Hoffman, noting the excellence of the book cover designs Onnie made, graded her "A," not a soul ever suggested that she be enrolled in the special art class. A glimmer of special recognition did come from her biology teacher, Mrs. Terwhilliger, who was visibly impressed by the carefully done drawings Onnie prepared for her course. Mrs. Terwhilliger did offer encouraging compliments, but that was all. The glimmer flickered out, and Onnie Millar, her talent virtually unacknowledged, was graduated from junior high school. Her plan was to enter Roosevelt High School, but she never got there.

> The Depression was on. My mother was quite active then in the Workers' Alliance—making speeches in defense of those who were being evicted from their homes for nonpayment of rent. I was fifteen years old and I hired myself as a nursemaid to small children whose mothers were members of the Workers' Alliance. My first family paid me two dollars a week!

Olive Millar had rented a house in a Bronx neighborhood comprised mainly of poor whites. There, even though she herself was receiving public assistance, she kept such living space as she and her children did not use available to destitute people who had no other place to go. Theirs was a neighborhood Onnie recalls as fascinating and memorable.

> I heard many good conversations at that period—conversations carried on by the radicals of the Alliance. Many of their young men had gone to Spain to fight along with the rebels there. Some died in battle. My mother, herself, was completely and sincerely immersed in the workers' cause . . . believing it to be a just cause. We kids never knew when we came home just who might be there in the house—some unfortunate person or family with no place to stay.

Through her work as street speaker for the left-wing Workers' Alliance and as a friend of the destitute unemployed, Olive Millar was running true to the tradition of her illustrious father. John Edward Bruce would have admired the valor of his only child who, in need herself, still managed to summon the character to help others whose needs were even more pressing. Nor were those early lessons in concern for the needs of humanity lost on impressionable teenage Onnie.

She now had her first set of oil paints, a present from her mother, and a little later she acquired a box of pastels. With these she began to do portraits of family members, for she had a natural leaning toward the kind of character delineation which portraiture entails. And though she lacked formal training she now realizes that she did bring a freshness to what she attempted. More than that she was dealing with truth—a quality she had to abandon temporarily in her subsequent struggle to wrest an existence from various forms of commercial art.

But even though Onnie thoroughly enjoyed painting family portraits and even copying the art of others, from Gainsborough's *Blue Boy* to Milton Caniff's *Terry and the Pirates,* she hadn't decided what to do for her life's work. Dancing and singing, which she loved to do, suggested a possible career on the stage as it probably has to many sixteen-year-old girls. At that point, however, she lacked both the experience and the contact needed for entry into show business. So as Onnie mulled over several possibilities she worked at routine chores.

I continued to make the coal fires at home and to take care of the little girl I looked after. When Agnes got a job on the W.P.A. we went off home relief. When the kid went back to school I went out and did domestic work for fifty cents or one dollar a day. On one occasion I washed the walls of a bakery along with some floors

and the woman wanted to pay me off in stale buns and cake! I will never forget it—how reluctantly she handed me the fifty cents.

The Millars moved from the Bronx back to Harlem where Onnie found work with the N.Y.A. (National Youth Administration) program. She was a member of the Choral Division of the Radio Workshop directed by Lavinia White. It was from Miss White that nineteen-year-old Onnie Millar learned sight reading and how to sing into a microphone. And, in singing the music of black composers Coleridge Taylor, Harry T. Burleigh, and Nathaniel Dett, she learned also "what it meant to be a young, gifted, and productive black person in this society." With the bombing of Pearl Harbor and the ensuing conflicts in Europe and Asia, however, the N.Y.A. and other federally sponsored programs came to an end. America was at war and cultural pursuits gave ground to "industries essential to the defense of the nation." Onnie found herself slogging along with thousands of faceless civilian factory hands.

I got a job winding transformers. It was a defense job, one of those to which workers were "frozen" for the duration of the war. And just like everyone else engaged in such work I didn't know then, and I don't know to this day, what I was doing! Yet racism was evident even in this dull setting. White girls who worked beside black girls refused to speak to us once we left the confines of the job site. They must have experienced terrible frustration, since they'd been led to believe their whiteness made them superior and still they found themselves doing the same routine work black men and women did. And neither of us knew just what we were accomplishing.

For Onnie, that experience gave substance to a contention of the Workers' Alliance that industry was no friend of

working people. While labor, especially black labor, was barred from gainful employment in times of peace, the same labor was hired and not allowed to quit while earning great profits for industry in times of war. When the war boom passed, black workers were among the first to be let go. So it went with Onnie Millar between 1941 and 1945, during which she also worked in the United States Postal Service. With the end of the war, however, the character of her employment underwent a more promising change.

One of the women with whom she had worked in the postal service was, like herself, a creative person in need of the opportunity to work gainfully at her craft. She was Zelda Wynn, a couturière, who after leaving the post office opened a shop on upper Broadway. Onnie speaks with genuine admiration of her contact with Miss Wynn.

> She'd seen some original fashion sketches of mine which she bought. Though the money was small, that was an important step up in my life—my first in that area. Zelda Wynn still works at her craft and is now with the Arthur Mitchell Dance Theatre. It gave me a sense of accomplishment to see some of the gowns I'd designed worn by stars of the theater. I'd even hand-painted a few creations.

With that as a start, Onnie went in search of similar work in the studios of midtown New York where she found a job on which she worked for two years. It was there that she learned just about everything she knows about the silk-screen process, including the proper use of poisonous dyes and lacquers. The work was sheer manual labor—a far cry indeed from the dreamer's concept of the quiet studio with fluorescent lighting and the latest in designer's equipment. But the tiny woman was physically tough and determined not to leave until she was ready to do so. This would be her way of getting her formal education in art. Onnie Millar is

quick to tell you that she has received every bit of art train-
ing she ever had through working at some form of art.

There in that studio in New York I observed every-
thing used around me—took careful note of it all. And
I asked questions constantly! Meanwhile I worked on
sample designs at home and it wasn't long before those
samples were exciting enough to the firm to induce them
to have me drop the heavy work for occasional design-
ing.

Hers was not, however, the ideal situation—the business
of filling two such contrasting roles at the same time on
the same job. But Onnie was biding her time. While trying
to decide how best to resolve an awkward situation at work
she picked up a copy of Ayn Rand's *The Fountainhead* and
read it. What she read changed Onnie's whole concept of the
individual and his creativity. And while she could not wholly
agree with the author's philosophy, the book did help her
find what she describes as "my own voice." With not another
day's hesitation she went to the boss and told him it was no
longer possible for her to work one day as a laborer and the
next as a creative designer. With that done she took off on
her own as a full-scale artist-designer.

The year 1950 was approaching and Onnie had begun
to work along with another black artist and friend, Joan
Cooper Bacchus. The two young women supported them-
selves for a time by painting designs on neckties. From there
Onnie found work applying color to commercially moulded
figurines before becoming immersed in the field of com-
mercial display. By now she had a daughter, Laurie, to sup-
port. And as her obligations kept pace with her increasing
skills she was still hounded by the bias that keeps women
and nonwhites from receiving pay commensurate with that
of white men.

Now even though all these jobs I did required special skill the pay was very low. Comparable work done by "respected" white artists paid them far more than I was paid. And the respect one got rested upon either his individual reputation or upon the strength of whatever organized group to which he belonged.

At one point Onnie came quite close to attaining that coveted position of respect.

I worked at one time in a huge display house in the Bronx with a Chinese designer named Jane Sai. Jane was a thorough artist and craftsman. Her feeling was that if one took time and pains to design the front of something he ought to be equally concerned with the design of the back. "Don't forget the raw edges," was one of her frequent admonitions to me. From Jane I learned how to place a beautiful object in an equally beautiful setting. . . . I was put in charge of making samples, and when Jane left I missed my chance to speak up in my own behalf for the designer's job. I knew very well that I could do the work but I hesitated to insist that I could. So they went outside and got someone else. That taught me a bitter lesson.

Onnie also recalls the many truly gifted artists she'd worked with in display—particularly a Spanish sculptor with an amazing facility, who let his job confine him to modeling Easter bunnies and Santa Clauses! Watching his abilities as well as her own exploited and squandered on such trivia for such relatively little pay cemented her resolve to do two things. One was to make every effort to reap more of the harvest of her talents and her labor. The other was to produce creations of which she could be justly proud. Her chances to give both a try came unexpectedly during a big layoff of workers in the late 1950s. Onnie Millar went out on her own as a freelancer.

With my daughter, Laurie, growing up, I thought of making and selling plaques that were so popular. So I got myself a sales representative, and orders began to come to me from all over the United States, including the Saks Fifth Avenue store here in New York.

At first it all seemed so beautiful, so perfect, until orders began to increase with alarming rapidity. Working alone Onnie could produce only so many plaques. Worse still, without capital or credit, she was unable to finance either adequate working space, materials, or labor assistance needed to complete those items she had started. Her comments on that experience form an excellent object lesson to any who might be contemplating a similar venture.

It was heartbreaking to be unable to carry on, especially when I discovered it was not because of lack of a market or lack of mechanical or artistic skill on my part. What I did lack was money along with the kind of special information one needs when he has something to sell that the public will buy.

Artists frequently fall into such snares, and not simply because they are artists and therefore incapable of doing better. It happens because like most humans many artists don't take the time and trouble to examine thoroughly and study their business before becoming badly entangled. The making of art is not magic but an orderly mental process. And the same mental capacities that enable one to produce art wisely and successfully can also be applied to disposing of it in a wise and satisfactory manner. Entrepreneurs who exploit artists' talents, however, want artists to believe themselves incapable by nature of being businesslike. Alert artists, however, reject such superstition and go about handling their affairs with intelligence and efficiency—a fact that Onnie Millar now is one of the first to admit.

With the coming of the 1960s Onnie was still freelancing. She sold original designs outright to commercial houses for whatever she could get, and in her own words, "whatever the manufacturers did with it and however well they did meant no profit to me." For the Carnegie Hall piano studio of Robert Harris she painted an eight-by-sixteen-foot mural, titled *The Evolution of Music*. Here again words of praise for her work were far more abundant than the pay she received. As a competent craftsman Onnie Millar was kept constantly busy working—at minimal fees.

There was her meeting with a popular and flamboyant Manhattanite known for the smart shadowboxes he fashioned and sold for substantial prices in the Saks Fifth Avenue stores and similar stores throughout the country. Onnie recalls him clearly since she was one of several artists who helped produce his work during the 1960s.

This man bought some things of mine for very little. Because he'd been a musician who knew all the greats of jazz he was personable and his place was pleasant to visit. He'd always feed you well and he'd play the piano for your entertainment. But he was without question an exploiter of other people's talents.

Tiring of that, Onnie Millar decided to venture completely on her own. With such little capital as she had managed to save she opened her own shop on Brooklyn's Underhill Avenue. She had made the place attractive, and since she had smart things to sell, people would come in and express the wish to own everything she displayed. But they had no money to spend so Onnie used the shop as a studio where she did her freelance assignments. Then, as if impelled by a force she would find all but impossible to explain, Onnie conceived and wrote a mixed media show.

She called it *Kaleidoscope in Black* and, with the performers and all the others connected with its production,

she went up to the Westchester County town of Mamaro-
neck, New York, to present it to the public.

> We gave six performances of it up there in Mamaro-
> neck, and George Bass, the playwright, was most help-
> ful to me. At the same time I can't begin to tell you
> how complex the thing became—what with all the per-
> sonalities and in-fighting. The church in which we put
> it on was conservative and fearful of dancing even
> though Pearl Primus helped us with costumes. I even
> had to fight to get them to use the word "black." When
> the press would come to interview me the others got
> in the way so that the stories would focus upon them.
> It was simply an unbelievable and fantastic experience.

Herbert Millar's frustrations of a half-century earlier
appeared to have fixed themselves to his daughter, Onnie.
But she, no pushover for adversity, came out of it wiser and
in many ways a bit stronger. Above all she learned two very
important things about herself. The first was that she did
have the ability to conceive creative and constructive ideas.
The second was that she needed to find the right way to
make her ideas work. Now Onnie Millar felt the urge to turn
her attention to an art form that would be creative and non-
commercial. For a long time she had been sidetracked and
decoyed away from such a pursuit and she felt that this was
the time to try to bring such a dream to fruition. It was in
a commonplace and quite unexpected manner that she hap-
pened upon one medium to which she could apply the full
range of her imagination. And she now had the maturity to
guide her in the handling of it. The year 1967 had just be-
gun. She speaks of what happened.

> Lavon Lewis is a talented young woman who is a
> friend of my daughter, Laurie. One day Lavon showed
> me a pebble upon which she had painted a face. I was

intrigued—especially when Lavon casually suggested I might want to try something similar. She then handed me a handful of stones.

At just about that time a burglar had broken into Onnie's apartment and she and Laurie went to live temporarily with Agnes. There, even though they felt more secure, Onnie was handicapped in not having her working materials right at hand. She had, however, gathered up a few things before leaving her place and she had brought along the stones Lavon had given her. As is so often true when one is isolated from the things one is used to working with, Onnie began to think quickly and to improvise with what she had brought with her into the limited space of her sister's home.

She hit upon a workable solution. Why should she stop at merely painting faces on pebbles and leaving them at that? Using a workable adhesive she fastened one stone to another to form complete figure studies. After painting and glazing them she knew she had finally created something that was her own. Then, to her surprise and pleasure, she discovered she had something people wanted to buy.

Like any other craftsman Onnie lets the shape and color of the rocks she uses determine what she will say with them. And her method of painting and glazing gives each the surface appearance of a ceramic. Mention of the resemblance evokes a laugh and this wry comment. "Had I been in possession of a kiln I'm certain I'd never have developed this technique."

Onnie's rock sculptures have been requested for showings by museums, among them the Metropolitan Museum of Art, the Brooklyn Museum, and the American Museum of Natural History. She has also entered them in exhibitions in Rochester, New York, and Spokane, Washington. Like most artists, showings constitute for Onnie but one facet of her current work, since in her view art cannot be confined to museum and gallery viewings.

For me art is life—it is one's mind and it is man's sanity. Without art we would go crazy for we can't look at nature as it really is. It is too much—and our vision is too limited to take it all in. So art becomes the mediator between man and the forces of nature.

It is Onnie's view also that the young are especially responsive to nature's forces and to art. For that reason a great deal of her present work is involved directly and indirectly with young people. Through the Brooklyn Arts and Cultural Association, Onnie Millar works with parents, with teachers of children, and with children themselves. The association covers the entire Brooklyn area. It is directed by Charlayne Victor and, through the Brooklyn Institute of Arts and Sciences, is based in the Brooklyn Museum. Onnie conducts her workshops under B.A.C.A.'s sponsorship in her own studio as well as in schools and centers requesting her services.

At the end of the summer of 1974 she started an enormous painting project in Brooklyn. Located in a five-block Day Care Center, it is a mural covering considerable interior and exterior footage. "The Learning Wall" portion of the project is outdoors. For two years it has been in progress and Onnie carries it along with her other works.

One of the latter is an eight-foot-by-twelve-foot painting, *Underground Railroad,* done expressly for the 1976 Bicentennial. The painting, using the theme of the legendary slave escape route to express aspirations current among black Americans today, will be made into a needlepoint tapestry by another gifted black artist, Lethia Robertson. Ms. Robertson is one of four members of a design co-op of which Onnie Millar is director. Jan Murray and Mary Chang complete the talented quartette that was the subject of a feature article in the February 1973 issue of *Essence* magazine.

Such then are the experiences of a gifted woman who is still hopeful and eager after many years of struggle and

disappointment. But it has not all been negative, as her own words clearly reveal.

The positive aspects of my life today—teaching, consulting, designing—all come out of adversity and the typically black American's way of having to find a way to survive. I am proud of having come through without the trammelings of any straitjackets!

Manuel Gomez

ALTHOUGH his name suggests he might be of Latin origin, Manuel Gomez and his family are Afro-Americans with deep roots in California. He is a tall, handsome young man and an extremely inventive and imaginative one. Like fellow craftsman Onne Millar, he got started at what he does after looking at an innocuous item of everyday use and deciding that it could be better and more beautifully designed and made. That will be described shortly. In the interim Manuel speaks of his forebears.

My paternal grandfather was an African born on the Cape Verde Islands off the coast of West Africa. The name "Gomez" probably was that of a Portuguese landowner who had settled on the islands. My grandfather came to this country in 1926 where he met and married my father's mother. Both my parents are Californians— he from Sacramento, she from Salinas.

A mere glance at Anita, Manuel's handsome mother, reveals her African-Indian heritage. Her great-grandfather, a Blackfoot Dakota Chief, left the tribe during the 1890s to acquire an education at Tuskegee Institute in Alabama under Booker T. Washington's presidency. Following graduation he married a black woman, the first of four wives. Outliving all of them, he died in 1966 at the age of ninety-eight.

His daughter by that first marriage was born in 1898 and she was Manuel Gomez's maternal grandmother. Of her more will be said later.

Born in Oakland, California, in 1949, Manuel Gomez was still an infant when young Onnie Millar was earning a livelihood painting designs on neckties on the East Coast in New York City. Of the three Gomez boys, Manuel is the middle. Michael is one year older, and Gary two years younger. When Manuel was three his parents were divorced and he recalls living with their mother in East Oakland while spending weekends with their father in West Oakland. During that period East Oakland was not the solidly black community it is today. Most blacks lived in West Oakland while the neighborhood of Manuel and his brothers was a mixture of races and nationalities. Manuel recalls,

> Ours was an international block, with Mexican, Italian, Jewish, Filipino, and white Christian families living all around us. We were the black family and as kids we played together with no feeling of being undesirable because of our blackness. My growing up experience was a pretty good one since Michael, always the imaginative one, would organize our playing to fit a particular theme. One day would be Navy Day, and we'd build a boat out of castoff lumber and operate a steamship, each taking a particular role in its operation. Another day might be Davey Crockett Day, and yet another Indian Migration Day—and so on. Michael had a great imagination and was a natural leader. He was the ramrod of the trio and it was he who looked out for us—at home, in school, and at my dad's.

Weekend visits with their father were fun in a different way. The black kids who were their playmates on such occasions were friendly, though Manuel notes that in most cases they lacked many of the simple items of pleasure that

were taken for granted by the lower-middle-class kids of Manuel's own neighborhood.

Their Christmases were slimmer and poorer, and the unevenness of their day-to-day living was clearly reflected in their behavior toward each other and toward outsiders.

Manuel remembers that fewer tensions existed for him and his brothers among their peers in East Oakland than existed among the kids of the area they visited on weekends. And as well as they got along in West Oakland, the Gomez boys often had to fight if they ventured outside the block their father lived on.

Such conflicts as Manuel, the boy, experienced were inner, and they centered on his feelings toward his father. Those early confrontations between his parents that ended in divorce constitute what he calls "the nonfun things of my childhood that upset me a great deal."

That uneasiness he felt as a tot was not totally erased when a few years later his mother remarried a man who worked at the race track. Manuel's father holds a stereotype view of people so employed—a view characterizing all of them as gamblers, drunkards, and hoodlums. Untrue as such a generalization is, Manuel, who likes the excitement of the races, finds it hard to convince his father that he does not indulge in the vices so often practiced by many racing people. So the three boys, growing up close together, have often found themselves jointly at odds with a father with whom they spent many memorable weekends. The situation has posed especially difficult problems for the sensitive Manuel.

Another thing that haunts him, particularly in view of the close relationship he and his brothers have, is a childhood injury suffered by Gary. At the age of six, Gary struck his head on the porch, receiving slight brain damage that necessitated his dropping out of school in the sixth grade.

Manuel sadly recalls the temper tantrums and the marked change in the personality of his younger brother—things that frightened him all the more as a youngster with no understanding of the symptoms of mental illness. That Gary never learned to read is still a difficult truth for Manuel to accept.

Learning, through reading, observing, and doing, means much to Manuel Gomez. For that reason going to school was serious business right from the beginning, as his terse assertion indicates.

In school I was quiet, shy, did my work and had no problems whatever. With my brothers it was different, but I did the work and passed through easily. . . . My creativity started at the age of ten—right here in East Oakland. I didn't so much as doodle until I was ten. And I always attended integrated schools where whites were in the greater number than nonwhites. My first classroom contact with a black teacher came in junior high school.

Manuel was ten when brother Michael took him to the Oakland Boys Club, where ball playing, swimming, and track were popular pursuits. As Michael plunged into some physical activity, Manuel wandered about until he found the crafts shop. On that particular day the instructor was carving a bowl from a block of wood. Manuel was fascinated with the piece of wood handed him along with the instructor's "go ahead" and he began to work. In three months he had made a bowl and was into something that would claim his study and attention from that day to the present.

From then on while my brother was in the gym you could count on finding me in the crafts shop. The instructor then introduced me to working in plastic and leather. That was the beginning of my being creative.

When Manuel reached junior high school he was so well advanced in the arts and crafts class as to breeze through every assignment and to duplicate, with variations, every item he made. The praise his efforts had drawn in those days, however, gave way to a less imaginative reception in high school. A well-meaning counselor in that setting, noting Manuel's work, suggested he prepare himself for carpentry. But the boy, having experienced the thrill of working more creatively, rejected the suggestion. The hours he had spent at the Boys Club had conditioned him to think beyond benches and sundry items fashioned from routine and hackneyed plans. Any such thing under his hand would have to bear the stamp of his individuality. His high school teacher was scarcely prepared to endorse Manuel's ideas with any degree of enthusiasm, as the following incident shows.

One day in the eleventh grade I told the instructor I wanted to carve a mask—a project he let me do with a bit of reluctance. I could have predicted what the reaction to it would be even before I completed it. The whites nicknamed it "Manuel's Jungle-Bunny Mask." And the poor black kids, not then conscious of the beauty of the African carvings that inspired it, were bewildered and, I suppose, embarrassed. But since I've never cared too much about others' opinions as long as my work satisfied me, it didn't matter. That day marked another development for me—my period of independent creativity.

Uninhibited by the taunts of those who could not grasp the significance of what he was doing, Manuel Gomez entered his mask in a county fair art show—his very first attempt at exhibiting. The piece was selected for showing and it won first place in its category. Manuel was still a full year away from finishing high school.

In the interim Manuel, though not as intensely inter-

ested in athletics as his older brother, Michael, was nonetheless attracted to a sport many do not normally associate with blacks. He explains it this way.

In high school I observed that if you were black you had to outrun somebody on the track or outjump him on the basketball court, and otherwise outdo the others in football and baseball. . . . Well, here again I felt the compulsion to enter an area black athletes hadn't trod. So I swam. At that time there were only three black swimmers in the Oakland high schools out of 25,000 students. I got into it deliberately—because we were so few. And I suppose I'm following a family tradition, for my maternal grandmother is much in that mold herself.

Meanwhile, during his final year in high school Manuel Gomez was one of the eager six hundred senior students who indicated on "Career Day" what they would choose as a life's vocation. When he looked over the prepared roster of vocations he discovered that his choice, that of becoming a sculptor, wasn't even listed. Four others of his class discovered that they, too, wanted to pursue work that hadn't been designated by the school authorities. Manuel asked for a conference with the school's counselor and he describes what happened.

I knew that our high school offered an art scholarship to any worthy graduate who applied for it—a scholarship to the California College of Arts and Crafts in Oakland. So I told her I'd like to go there—on that scholarship if possible.

Why do you want to go there, Manuel? What do you propose to study?

I want to study sculpture.

You do? Well, er—I'd suggest you think about studying something else, Manuel—perhaps some nice trade.

But I don't want to prepare for a run-of-the-mill

trade. I don't even want to be a cabinetmaker. I want a career in art.

Manuel, there's no money in that. Besides we don't have a scholarship to that school we can give you.

The icy finality of the words told Manuel what he would have to do. He would have to go to the school of his choice and apply for a scholarship on his own. He did, and he almost made it, losing out to one other applicant. Still he wasn't through trying, and as he talks about it you become aware of the controlled and beautifully organized strength that is in both the man and in the art he produces.

I applied to the California College of Arts and Crafts and was accepted, but I didn't have enough money to enter. So I decided that I'd go to Merritt College until I had enough money.

Merritt, a junior college, serves the needs of students whose money limitations prevent them from enrolling in the more expensive Bay Area colleges and universities. And though it was not Manuel's first choice he was wise enough to recognize that whatever its lacks it was better than no higher education at all. But there was yet another thing about his decision to go to Merritt that would be significant to Manuel Gomez. And it was as if it had been foreordained that Merritt College would become a part of his growth, for there he was thrust into contact with Roger Beard.

A sculptor working on his master's degree elsewhere, Beard taught jewelrymaking at Merritt College. Manuel's registration in both the woodworking and the jewelrymaking courses was mutually opportune for him and Beard; and the closeness that developed between the two is apparent when Manuel speaks of their association.

Roger Beard, a white man, was the first outsider to inspire me to do things about me and about my culture.

It intrigued him that though I am Afro-American, I was
closely tied to Africa by virtue of grandfather's birth.
Roger Beard exposed me to working with exotic woods
—especially woods from Africa.

Like many painters and sculptors, Beard was intensely
interested in music. His appreciation of Afro-American music
was as profound as was his enthusiasm for African carvings.
It was he who involved Manuel in the music of Nina Simone,
Charles Lloyd, Charley Parker, Sonny Rollins, and Miles
Davis. And it was Roger Beard who came closer than any-
one outside Manuel's family to making him conscious of
what it means to be black and productive in a climate that
too frequently strangles black creativity. Of those forces
within his family from whom he constantly drew strength,
Manuel is particularly appreciative of the women and espe-
cially of Frances Albrier, his aforementioned maternal grand-
mother.

All the women on my mother's side are strong, well
educated, and very "black." Their achievements have
spurred me to getting back into school and completing
my education. You see, my mother has a Master's De-
gree in Public Administration. And her mother has for
years been a politically active person.

For the past half-century Frances Albrier has indeed
been active in local and national programs affecting the
lives of Afro-Americans. During the 1950s she was campaign
manager for California's Lieutenant Governor, and along
with others she organized San Francisco's Negro Week in
the early 1960s. She presently serves on the President's
Commission of Senior Citizens. Manuel vividly recalls her
admonition to him and his brothers that as blacks they
would meet many challenges that would never present
themselves if they were white. And even as she made them
conscious of racist practices she also made them know that

they must learn to deal with racism in a positive way if they would successfully overcome it.

Such was the early conditioning of this talented man. Out of that conditioning sprang the drives that have impelled him steadily forward. As soon as he had acquired enough money to pay for it Manuel looked toward advanced training in sculpture and crafts.

In the spring of 1967 Manuel Gomez resumed his studies at Oakland's California College of Arts and Crafts. As has been previously noted, that was a time of agonizing economic and social stress in America's black communities. In the summer prior to Manuel's matriculation at the school of his choice a riot that brought out the National Guard had broken out across the bay in San Francisco. During the weeks that followed, the most impressive (and most frightening to white Americans) black nationalist group was formed in Oakland itself. It was the Black Panther Party.

In his excellent book, *The Negro in the Making of America*, Dr. Benjamin Quarles asserts that 1967 marked a new and disturbing apex in social outbreaks, with nearly 150 American cities experiencing violent civil eruptions. Eighty-three persons, Quarles reports, were killed, more than 16,000 were arrested, and property damage mounted to 660 million dollars. Obviously such tension gripping the nation explains the full meaning of the situation Manuel Gomez discovered and became an active participant in at the college he had just entered. In his crisp straightforward manner he talks of what he found there and how he reacted to it.

For the first one-and-a-half years I took the basic program given all students, and I discovered that my concept of art was quite at variance with what was offered at Arts and Crafts.

As if that were not disturbing enough, Manuel made yet another disappointing find.

There were only eight or nine blacks out of nine hundred students there. So I became involved between nineteen sixty-eight, sixty-nine, and seventy in getting more black students in. We had Ron Dellums and Cecil Williams come in as spokesmen. We confronted the school's president, and we succeeded in having a whole ethnic program set up at the school—complete with a class in African Art. Claude Clarke, Jr. was asked to come and teach a class in African Art History. We even had black entertainment come in so that white middle-class students would learn from their exposure to black music.

The drive succeeded in establishing scholarships for black students. Moreover the staffs of the Bay Area's predominantly black high schools were alerted to encourage their talented students to prepare for further study in the arts and crafts. For about two-and-one-half years a lot of this kind of activity took place. Then the movement finally died out. In Manuel's sardonic words, "Blacks fell out of vogue and that was it."

At the outset of this story on Manuel Gomez it was said that like Onnie Millar he was motivated to do something unique in art through an ordinary encounter with a commonplace item. During the drive to increase his school's awareness of talented black students and vice versa, Manuel felt the need to do something in art to which he could feel a personal kinship. It was something he had particularly strong feelings about as he worked in his class of African Design. The class was conducted by a man who, according to Manuel, "knew little about the subject other than what he'd just read in a couple of books."

One of Manuel's friends, meanwhile, had complained about an inexpensive African comb he had bought at an import store. The comb, it seemed, was constantly breaking

off under use. Says Manuel, "I knew I could do better than that and that's how I came to make my first comb." From that initial interest in making the item more durable, Manuel was soon to make a constructive contribution to practical community education. Simultaneously he set about the task of inventing exciting esthetic variations of the African comb.

Sculpture, particularly that of the British modernist, Henry Moore, had always intrigued him. Now Manuel found that he could apply Moore's sculptural principles, with their poetic shapes, to the fashioning of what would otherwise be a mundane commercial item. At the same time, and in the manner of Carole Byard, Valerie Maynard, Alfred Smith, and Otto Neals, he was embracing a point of view held by an increasing number of America's black artists.

> Though nobody at the school had steered me into the vein I was interested in, I continued to do more and more combs. Some have stories connected to them —stories that vary according to the kinds of wood I use. And I worked with an awareness of FUNCTIONING art that was and is the concern of many of us black artists all over America. You see, I've always believed art should be usable. And I wanted to give our people something they could use—something they could take pride in—and something of esthetic value.

Fees and materials at the California College of Arts and Crafts were expensive and Manuel's money ran out before he could get through the course. Luck was riding along with him, however. A friend who was teaching art at a black junior high school in West Oakland happened to ask Manuel if he would be willing to come to the school and give her youngsters a few ideas. When the children saw the combs they were so stimulated that Manuel was invited to give instruction in the making of them—a task he performed for a full year. He smiles reflectively as he speaks of working

with seventh, eighth, and ninth graders. Indeed the comb idea was so potent that practically all the kids tried their hands at making their own.

What they did, though not as highly developed as my own, were certainly good. The kids came from deprived areas—areas I had played in when I visited my father not too long before. The comb was something they could identify with as well as use.

Manuel's popularity grew to the point where youngsters were cutting other classes to get into his carving sessions. Not only did they learn how to use the carver's tools, but they became acquainted for the first time with the exquisiteness of hard woods. African and Philippine mahogany and black walnut woods became as familiar to them as pine and oak. And as Manuel notes with much satisfaction, "this turned them on to learning in a situation that prior to that had been completely barren."

As both Valerie Maynard and Kay Brown have wisely observed, one learns much through teaching. The esthetic growth of Manuel Gomez increased with that intimate contact he shared with creative children. Their imagination stimulated his own further explorations into the sculptural aspects of what he had been doing with combs. He found that working small enabled him to experiment with many forms he could not have gotten to as quickly working on a large scale. Moreover he continued to draw upon African art because of what its line, form, and movement said to his senses. As he studied he found that so called "primitive art" is not at all primitive but highly developed.

Manuel's observations of Mexican art, American Indian art, and African art convinced him of that. The way in which those artists design—especially their jewelry—completely caught his attention. Jewelry, as designed by Mexican, American Indian, and African artists, becomes a part of

those who wear it. So Manuel Gomez broadened his work to include the making of jewelry. Just as he was beginning to relish this area of creativeness he was drafted into the army. And, as has been true of countless draftees, he was thrust into a branch of service completely alien to his training, experience, and temperament. Manuel still talks ruefully of his army experience.

When they got me in the service they tried to make a missile repairman of me. I was supposed to work on the type of missile fired from a tank in the field. Now as a creative person I abhor the idea of killing and destroying so I deliberately flunked the algebra test they gave me. When I asked for work in arts and crafts they categorized me as "overqualified." I then suggested that anything would do other than being a cook or an infantryman.

The army, it seemed, had an abundance of cooks and infantrymen, but it was short on psychiatric specialists and it had a place waiting for Manuel. He was sent to San Antonio, Texas, for three months of training and from there to Fort Jackson in Columbia, South Carolina. There from the autumn of 1973 to the spring of 1975 he worked as a psychiatric specialist. In spare time he went into the crafts shop and when the man in charge found out how much he knew he urged Manuel to come in and work part time. It wasn't long before Manuel was teaching wood sculpture, jewelrymaking, framemaking, lapidary craft, and leather craft to army personnel and their dependents. He conducted those sessions in the evenings at the end of his regular day's work as psychiatric specialist. That evening work brought him in contact with another young black artist.

It was there that I met Larry Lebby, a very talented young South Carolinian. As the son and dependent of

a former army man Lebby had free access to the craft shop until he passed the age limit for dependents. Larry, who comes from Lexington, South Carolina, does exquisite black-and-white drawings on contemporary Southern life.

Larry Lebby's drawings are especially strong and, as is true when one artist admires the work of another, Manuel wanted to trade something he had carved for one of Larry's drawings. But for some obscure reason the exchange never came off. Along with Lebby's exceptional technical and interpretive skills Manuel was captivated by his determination to earn a living solely through sales of his work. That, as Manuel wryly observes, "is a most difficult if not impossible thing in a society that won't let him live off his talent."

When Manuel left the army in the spring of 1975 he returned to college, where he completed units for his B.F.A. degree nine months later. His creative energies centered on sculpture, which in contrast to his woodcraft was large and nonfunctional. Most of the themes were based upon his own childhood experiences augmented by what he had learned as a psychiatric specialist.

Manuel Gomez likes to take interested visitors to the studio workshop of the comfortable home he shares with his mother and stepfather in the delightful hills of Belmont just south of San Francisco. The room is scented with the aroma of hard wood shavings and one's eyes are drawn to the work bench, the neatly arranged tools, and finally the carvings themselves. The latter are in various stages of development —some nearly completed, others only partly underway. Manuel begins to talk about them, stopping first at one of his current favorites.

This sculpture I'm just completing now and that I call *Target Child,* is reflective of what was laid on me as a kid—what all kids become the target of.

Carefully carved from and inlaid with what the artist describes as "exotic woods," *Target Child* combines the abstract and the representational. Yes, the influence of African sculpture is there, but so also is the personal concept of Manuel Gomez. And this sculpture, like so many of his that he calls "my wall pieces," is designed to be hung. That, too, is in keeping with his concept that art should be a part of its environment. So these very high-relief wall pieces actually use the wall as both a source of or an environment for the sculpture itself. Manuel insists that he does not want to separate his art from the people since it is about people and since, in a very personal sense, it is about himself. As if to give emphasis to that last thought he designates another unfinished work.

This one I call *Chronic Struggle*. I use the word "Chronic" because medically it means an illness extending over a period of time. Obviously as a black I've come from a struggle, and will always be in a struggle. And this piece recalls the struggle between my parents as well as the struggle between my father and me.

Of the two figures of *Chronic Struggle* Manuel envisions the larger, rougher one as a power, towering above the smaller, smooth figure. And he sees this composition as a representation of his struggle from birth to the present. Time constantly evolves in this artist's sculptures. Yet, as personal as they are to him, he readily agrees that others are quite free to read into them anything to which they can relate. From the numerous honors and awards Manuel Gomez has won it is clear that others have indeed related their experiences to his creations.

Recognition first came to him in 1965 when he was only sixteen and when he entered his sculpture in the Alameda County Fair. In the intervening years up to the present he has been entering his works periodically in the fair shows

and they have been awarded honors. He has won three first places, two second places, and one honorable mention along with three "best-in-class" awards. One of his first-place awards was given at the National Annual Pacific Northwest Arts and Crafts Show held in Bellevue, Washington. Another first place was awarded at the Arts and Crafts Spring Show in Myrtle Beach, South Carolina.

Manuel Gomez has exhibited in Grand Junction, Colorado; Seattle, Washington; Boston, Massachusetts; Walnut Creek, California; and Richmond, California. Actually he averages participation in from five to seven shows each year. Thus far he has yet to have a one-man show, but that is in his present thinking. As he plans it, he will have separate showings of his sculptures, his combs, and his creations with plastic. Manuel picks up a plastic bracelet and examines it intently.

My bracelets are in the experimental stage—with the wrist as a base for something sculptural. And with this plexiglas I am dealing with color such as I don't get in wood. I find laminating plexiglas a long and drawn-out process.

He returns the bracelet to its place on the work table and points to the various combs he has spread out for examination.

The materials I use are reflective of the designs themselves. This comb is carved out of ebony. I wanted a comb made from wood from Africa, reflecting the essence of African art.

Ebony dominates the comb Manuel designates, though he has decorated it by inlaying dark brown African rosewood and ivory—the latter salvaged from the keys of a piano someone had junked. He picks up another comb made of Indian rosewood . . . and yet another carved from purple heart wood.

Some combs, like this, are inspired by simple inci-
dents of everyday life. I recalled my ice-cream-cone
days so I combined the inverted cone with a purple
heart, and hence this comb. This one next to it was
inspired by the wooden spoons my mother used to cook
beans and rice with. And that one was derived from
the giraffe.

The young artist-craftsman continues to talk of his
combs, conceding that some deal specifically with purely
abstract design. In achieving such he is not loath to laminate
his woods in the effort to get variety and interest of color
and design. He further concedes that "much of my sculp-
ture is larger versions of these smaller things."

Still Manuel never loses the focus he has on producing
functional art as a critical handling of his combs reveals.
They feel comfortable to the hand for there are no sharp
edges on the handles and the balance in them results from
a deliberate attempt at achieving balance. One finds the
same qualities in the best of African and American Indian
art.

Manuel Gomez, grandson of an African immigrant and
great-grandson of a Blackfoot chief, is working close to the
traditions of his forebears. And it appears that he has a long
and fruitful career ahead.

Miriam B. Francis

While I was still in junior high school I asked this teacher, Mrs. Sawyer, if I could apply to the High School of Music and Art. She told me that she didn't recommend that school for Negro children because they wouldn't survive there. So this same Mrs. Sawyer and the guidance counselor—both of them were white —advised me to become a beautician, suggesting that I could apply my talent to creating beautiful hair styles. But I said, "No, I won't become a beautician. I will go on to high school and it will be the High School of Music and Art." . . . You see, that was one of my dreams. Always on my way to school I used to see the Music and Art students on their way up through the park carrying those portfolios. And I'd tell myself I would soon be doing the same thing. But it never came to pass.

Though one detects the sadness in Miriam Francis as she relates that childhood dream, there is certainly no self-pity in this tall strong woman. No, she didn't get to the high school of her choice. But she did become an artist and an excellent one, too. Along the way she has never scorned or forgotten those sometimes unattractive and always bypassed youngsters who have also been roughly turned aside while pursuing their dreams. Miriam Francis knows a lot about

that. Her early life was frequently ruptured by adversities for which she was in no way responsible. Still she managed to meet and survive the challenges.

The year 1930, marking Miriam Dixon's birth in New York City's Harlem Hospital, was a bleak one indeed for this nation. One year earlier American voters had installed their thirty-first president in the White House. He was Herbert Clark Hoover, a wealthy Iowa-born Republican conservative whose previous record as an administrative engineer abroad prior to World War I was most impressive. So also was his subsequent war record as Chairman of the Commission for Relief in Belgium. Moreover he had served in the cabinets of Presidents Warren G. Harding and Calvin Coolidge. As president of the nation, Mr. Hoover advocated individual initiative and the curbing of big government influence in the lives of citizens "moving harmoniously and prosperously toward equality for all."

Despite such lofty aims, however, the rise of industrial and financial monopoly and the concentration of wealth into a few hands had already rendered the Hoover dream an impossibility. One year after he had taken office a drop in industrial production, vast unemployment, and a contraction of business activity had descended upon the country. During the winter of 1929-30 conditions worsened and by 1930 four million workers were jobless. That year, the year of Miriam Dixon's birth, brought on the first visible effects of America's most serious economic depression.

The agricultural South had been the homeland of the majority of black slaves and their descendants until the first of the previously mentioned black northward migrations that began in 1910. By 1930, with the nation in the grip of a depression that impoverished southern farmers, black farm and mill labor in a desperate search for work continued to stream north. Those from the Atlantic seaboard states headed for Philadelphia and New York City. By 1930 Har-

lem, which only fifteen years earlier had been a predominantly white community, was mostly black. Mary Lee King, Miriam Dixon's mother, was among its newly arrived residents.

> My mother had problems just trying to survive in New York during the Depression—let alone trying to take care of me. She had been born and raised in Rocky Mount, North Carolina, and she had come to New York hoping to find work the very year I was born. She found the Depression instead. When I was nine months old she saw to it that I got to Raleigh with her people, and in that way she spared me from the toughest things she was enduring in New York City. I never knew my natural father, though I later had a stepfather who was a kindly man.

Miriam stayed with relatives in North Carolina until she was five years old. Her memories of those years resurrect visions of thin newspapered walls, smoky kerosene lamps, and hunger, *hunger,* HUNGER! That the family who remained in the South was also feeling the bite of the country's economic illness was evidenced in an urgent message they dispatched to Mary Lee King in New York City. It implored her to come and get Miriam if she wanted her child to survive. So Miriam was reunited with her mother in New York City.

The pair existed together as best they could, moving frequently in search of the least expensive places. Mary Lee's earnings as a laundry worker and a domestic in the mid-1930s allowed for only the most spartan existence. Little Miriam, wearing the key to their apartment on a string around her neck, joined the army of New York's poor youngsters who learned early to get about on their own as parents worked to keep them alive. Reminiscing on that period of her childhood, Miriam's tone grows wistful.

I was always a dreamer—perhaps because of those traumatic first five years of my life. For a time afterward I found it hard to accept the real world. So I would sit quietly by a window and stare out—imagining that I could fly. . . . Then, too, I was always drawing. I don't remember where or how I learned to draw, I just remember that I was always doing it—drawing faces, people, children.

Miriam continued to dream and to draw all through elementary school and into junior high school. By the time she was ten her mother had left domestic work for employment as a hospital attendant, and from there she entered practical nursing. Miriam, meanwhile, went into junior high school, the dreaded P.S. 136 in Harlem, where Shirley Stark had learned only months before to defend herself from attack. Like Shirley, Miriam soon learned of the dangers lurking in the bathroom. Unlike Shirley, Miriam circumvented the necessity of fighting her way out.

It was a notorious school—a very rough school. I lived about three blocks from there so I trained myself physically to go to the bathroom only in the mornings and at lunch times—when I was at home. In that way I didn't have to be confronted by the rough girls who hung out in there.

The threatening of tough lesbians was not, however, Miriam's number-one menace at P.S. 136. There was the teacher, Mrs. Sawyer, of whom she speaks so pointedly at the very beginning of this chapter. Through the exercise of self-discipline Miriam, an honor student, was able to bypass the school's toilets and thus stay away from molesters. But there was no earthly way she could bypass a teacher who had decided that black girls had a specific place in the society and that it was her duty as teacher to see that black girls stayed in their place.

I still recall Mrs. Sawyer with mixed feelings. She had me assist her and other students with problems of drawing and using color. In fact some of my work was on permanent display there after I graduated; and I had thought that through her I would be encouraged to pursue a career in art—that she would more or less guide me. You see, my mother at that time was so concerned with pure survival—you know—paying rent and keeping food on the table. And she just didn't have the know-how or the energy to guide me toward a career in art.

Moreover, a younger half-sister, Olivia, was born when Miriam was thirteen, adding yet another responsibility in which Miriam was frequently called upon to assist. True, Thaddeus King, Miriam's Jamaican stepfather, was a quiet and gentle man who took time to help his stepdaughter with her lessons. But interested as he was in her general welfare he was unable to apprehend the depth of Miriam's desire to be an artist. Such unintentional lack of enthusiasm from home quarters merely added to the letdown imposed by Mrs. Sawyer in school. Miriam Dixon's subsequent entry into Washington Irving High School was not for her the happy event she had anticipated.

Electing to take a straight academic course, Miriam set aside temporarily her art and her dreams for a career. She made no drawings whatsoever. She resolved instead that if she had to forego art for the moment she'd do without it entirely. Whenever such time as permitted her to continue with it presented itself, she would return to art. The dream was one she would never permanently relinquish, for she was quietly keeping it alive on the forge of her personal conviction and faith. Some day she would pull that dream from the fire and hammer it into shape.

Faith and Miriam Dixon were close allies. They had

joined forces as early as 1935 when Willie Lee King took five-year-old Miriam to the Friendship Baptist Church in Harlem. For the next twenty years Miriam's closest friendships would be formed with those she met in church: Gwendolyn Hurley, Joan Rea, Doris Cox, and Ethel Lanman. Miriam was baptized in that church and later taught Sunday School there. Her recollections of the Reverend Thomas Kilgore as an inspirational leader during her teen years are still vivid.

There was Mrs. Harriett Bailey—"Aunt Hattie"—no blood relation but a former coworker of Miriam's mother who "adopted" Miriam as her "niece." Aunt Hattie was a strong woman whose faith in God and righteousness reached out to all who were close to her. With such forces surrounding her—forces one finds wherever beleaguered humanity looks up and ahead—Miriam was able to summon the faith she needed during those periods of anguish. With that as her guide she went on to finish her courses at Washington Irving High School.

After high school in nineteen forty-nine I did consider nursing as a career, so I began by being a nurses' aide. For one year I worked on Welfare Island at Metropolitan Hospital, and I found it a painful and traumatic experience. I suffered right along with the sick and their families, and death on Ward H was more than I could take. One patient, Mr. Boucher, finally died after an agonizing bout with terminal cancer. His widow had her arms around me trying to help me accept his passing.

Shortly after leaving Metropolitan Hospital Miriam learned that one could, with additional study, become a laboratory technician. And since science had always been a favorite study she enrolled at Brooklyn Community College. Two years later, in 1952, she completed the course and be-

gan working in bacteriology, an area that still occupies a part of her attention. Miriam had been at that work but a short time before she was involved in a disaster that could have taken several lives, including her own.

It happened on Friday, the thirteenth of January nineteen fifty-three, and I recall that I had been most depressed for several days. We lived on Saint Nicholas Avenue near one hundred thirtieth Street in Harlem and sometime in the middle of the night I was awakened by the sound of breaking glass. That, in a tenement, is commonplace for fights are frequent. But when I opened my eyes and saw the red glare I knew!

Every family in that tenement and those on the first three floors of the one next door were completely burned out. Sympathetic neighbors who were untouched by the fire took in the unfortunate families. Miriam's folks stayed with neighbors until they found another place of their own, while Miriam stayed with the family of Doris Greene, one of her closest friends.

So badly were both buildings damaged that no one was permitted to reenter after the fire had been extinguished. Her personal losses notwithstanding, Miriam managed to find something of positive value in the tragedy. She was of age and this forced separation from her relatives made her acutely aware of her responsibility to herself as an adult. She welcomed being on her own, especially when she met the man she was soon to marry.

The parents of New York-born Edmund Francis had migrated to America from the Caribbean island of Saint Lucia. Obviously Miriam was as impressed by the Francis family as she was by Edmund.

I shall always remember that first dinner I had at Edmund's home before we were married. It was spiced

with conversation about Africa and Marcus Garvey in particular. Edmund's father was tall, strong, black, and he was proud of being black. He transmitted that pride to Edmund and to his other son, Arnold. So from childhood Edmund and Arnold were exposed to Africa and Africa's culture as reflected in what we find of it in both the West Indies and here in America.

The couple married in 1956. Two years later their son, Carl, was born, and shortly thereafter Miriam formed a friendship that would reunite her with the thing she wanted most in life to do.

Mildred Byers, a lab technician, was one of Miriam's coworkers, and Mildred's husband, Al, loved to draw and paint. Entirely self-taught, Alfred Byers, during his service in the navy, had learned a considerable amount through watching the navy artists work. As he shared more and more of what he knew with Miriam she discovered to her great joy that she had not really forgotten her art and that she was eager to pick up where she had left off back in junior high school. Her daughter, Diane, was born, Edmund was gainfully employed, and Miriam had cut her work in the lab from full to part time. Besides, she was doing volunteer community service tutoring high school students in biology and working with senior citizens. It is of the art she was doing, however, that she speaks with a genuine passion.

From nineteen fifty-eight to nineteen seventy my art was a very private thing—something I did at home in the presence of my husband and children—no one else. I'd draw with chalks because I never had the courage to try oils—a dream I'd always entertained. But the dream of being a recognized artist was stirred up again, though I didn't know any artists except Al Byers. But I went on working just the same. I'd go to work at the lab and on weekends I'd work at home on my art. I'd

take the children to the park and I'd take my sketch pad, charcoal, and what not, and I'd draw.

At almost precisely the same time an ad placed in the daily press by the Brooklyn Museum Art School arrested Miriam's attention. This, she thought, could well be the answer to her desire to learn to paint in oils. She registered in 1970 and for two years went faithfully to her class one night each week. Especially encouraging and inspiring was Mr. A. D. Tinkham, a young teacher Miriam recalls as "most personable and not patronizing to students as were so many of the others." Perhaps the "patronizing" was due in large measure to the attitude of the evening class students themselves. Most of them, and this included the two other blacks, were there for "relaxation," and they chose painting because of what it might mean to their social status among friends. Miriam's interest was far more profound, as her subsequent art activity would reveal.

Meanwhile her progress with oils increased rapidly, as she lost no opportunity to paint and draw at home, using family members as models. At this point Miriam, her confidence steadily mounting through the weekly studio sessions with others, was becoming less secretive and more public in the practice of her art. No longer was she nervous or timid about going outdoors to sketch; she was now setting up her easel in full view of passersby.

By now the Francis family was living in a nice apartment in Brooklyn overlooking a park which in good weather was a rendezvous for many people. It was just the kind of setting an artist wants and needs for study and practice. The possibilities it offered were not lost on Miriam Francis.

I began to take my easel outdoors and there I'd paint. One day I had observed an old man sitting there and I asked him if he'd mind modeling for me. He consented, so I began going out on successive days look-

ing for him. Sure enough he'd be there and he'd pose as I painted. On this particular day, however, my main objective was not to paint the old man but to be on the lookout for something else I had been aware of for some little time.

The "something else" Miriam was hoping to find was a group of boys. It would be neither inaccurate nor unkind to describe them as a roving gang of restless hell-raisers who were the scourge of the neighborhood. Ranging in age from eleven to sixteen they lived, or more accurately, existed, in the nearby Fort Greene Public Housing Project. Grimly nicknamed "The Fort" because of its desolate and forbidding atmosphere, the Project offered little to most of its residents beyond the four walls and the roof necessary for protection against the elements.

Its residents—poor, low-income families—were, for the greater part, black and ill educated. Their numerous children, often hungry, insecure, and defiant, roamed the streets day and night in search of excitement that would bring some color and occasional small material rewards to their otherwise barren existence. Purse snatching, fighting, and breaking into parked cars provided them with both amusement and neighborhood prestige.

Without knowing them intimately Miriam knew them well enough. As a community volunteer she had tried without success to get them interested in the center she had worked in. In a more personal vein she recalls the day a rock had come crashing through the window of her apartment—a rock thrown completely at random. Looking down on the street below she recognized members of the gang scampering away to safety.

While not happy at having her window smashed Miriam was not vindictive. She reasoned that the youngsters were not born the way they were behaving—that indeed they

needed someone even as her own son needed his father and her. Simultaneously aware that she was neither a trained teacher nor a social worker, Miriam nevertheless firmly believed in her ability as a good mother to help those boys. That is why she had packed some iced tea with her paints and canvas. She smiles in recollection of what happened.

As I'm sitting there painting the old man I hear them coming up behind me—cursing loudly. There were six of them—all shabby in appearance. They pushed one of the group close to me. He was their spokesman.
"Watcha doin', lady?"
"I'm painting."

Miriam admits to being a little frightened as they packed so closely around her. Then the fright vanished as it had come. This, she reasoned, is really a child—an uncertain child.

"Hey—that's good, lady! Looks jes lak that ole guy. Don't it?"

The others chorused admiring "yeahs" as their gazes traveled from model to canvas. Miriam poured and offered them iced tea which they greedily gulped. Again the spokesman.

"Say, where you live, lady?"

Miriam pointed in the direction of her apartment, taking care not to reveal its exact location as she didn't want them to know it was her window they had so recently broken.

"What's your name, lady?"
"Miriam Francis."
"You think you could draw me?"

A chorus of guffaws greeted the spokesman's question, and for the moment he looked embarrassed. One of his companions followed quickly.

"Draw you? You wanna put that lady outta business wid your ugly face?"

More guffaws as the spokesman lunged at his tormentor in mock anger. Miriam's quiet answer quieted them.

"Yes, I can draw you—each of you. I'll be here every afternoon when the weather's good."

The pack promised to see her again and they did— many times. Miriam came to know each by name and she painted portraits of them, talked with them, and even brought books for them. One book was *Black Rage*, to which they could easily relate. Rickey, the oldest, was sixteen, and the leader and spokesman. He literally lived in the streets and the pack was the only real family he could claim. Rough as he was he still clung to the vestiges of traditional courtesy one finds black youngsters extending to adults they respect. To him Miriam was always "Miss Miriam," and his pack followed suit. Miriam was encouraged by her modest success in communicating with that group of street boys.

Here were kids who looted cars, broke bottles in the streets, drank wine, and smoked who-knows-what. Still they were not completely removed from customs we as blacks hold sacred. . . . So I decided to get back in school and better prepare myself to help young people like Rickey. . . . Oh yes, I must tell you that Rickey's married, holds a job, and takes care of his family. He had even brought the girl he married for me to meet and approve while they were still going together. The younger boys of his pack are still in school.

With the support and the all-out encouragement of her husband, Edmund, Miriam did return to school in 1972. She chose Medgar Evers College in Brooklyn, named for the Mississippi civil rights leader slain nine years earlier. Miriam was attracted to the school because of its name, its location

in a largely black section of Brooklyn, and the fact that it was a four-year community college. Prior to 1970 she had shied away from even the serious thought of studying art at any of the city's other major colleges, but the thought of studying that which she held most sacred in a predominantly black setting was reassuring and settling. So, with the full support of her understanding husband, Miriam, spirits soaring, entered the college.

The first class I walked into was my drawing and painting class. That was when I met Kay Brown. It was her first semester teaching drawing and painting at Medgar Evers and my first semester as a student there. When I looked at her I remembered that I had seen her picture, for I had previously read an article on black women artists of whom she was one. She began telling us of her own life and work.

That was not all Kay Brown talked about. Miriam distinctly recalls that Kay spoke also of the talents and achievements of Carole Byard, Valerie Maynard, Carole Blank, and Dinga McGannon. It was that kind of continuous reference to other contemporary black women artists that convinced Miriam Francis there was a place for her in that group.

She studied diligently. Hers was not the approach of the starry-eyed young woman convinced that she alone would conquer the world. Here was a mature woman, a mother, and a devoted wife, who still found wonder and excitement in the learning process. Miriam Francis knew enough of life to submerge personal vanity to the subordinate place it must occupy as one seeks to grasp fully the elusive essence of true learning. She glows with pride in recollection of another course she took during that first year.

It was called African Art and Music and it was taught by Dr. Edna Adett, who had lived in Africa. I recall her asking us for words we ourselves quickly associated

with Africa, and we responded with the usual stereo-
types—"jungle," "monkey," "primitive." Dr. Adett's first
lecture, then, was devoted to replacing those clichés
with more substantial information. So there at Medgar
Evers College in nineteen seventy-two I was reborn.
Here was someone who knew, and she was speaking of
my people in terms of pride and dignity. It made me
know how much I had to learn.

Miriam Francis learned more and more with each
passing day. And the course that arrested and held her at-
tention most firmly was taught by Gregory Ridley, Jr.

Repoussé, the technique of hammering designs in relief
from the reverse side of metals, is an ancient art, dating back
to 2500 B.C. Painter-sculptor-teacher Greg Ridley, mentioned
in the chapter on Kay Brown, is an excellent practitioner of
that ancient art. Moreover Greg, who had taught at Fisk
University in Nashville, Tennessee, was personally ac-
quainted with nearly all of America's black artists. Miriam
Francis, eager to learn all she could, was immediately drawn
to this talented teacher whose personal contacts were so
broad.

In Greg's course we had the lecture during the first
hour and the workshop for the second hour. Professor
Ridley showed us slides of African masks, stools, and
drums. He explained the functional character of African
art in the lives of its users—from birth to death. But we
did more than simply listen to Greg. Each of us had
to create our own forms. He had brought some of his
own work in copper repoussé and had shown us how
it is done—the technique of working up a design from
drawing paper to the metal itself.

Miriam drew her first such design and from that simple
line sketch hammered her first copper mask in Ridley's class
in 1972. Thereafter, even when not in his class, she sought

Greg's advice on the techniques of this venerable medium. And while for the rest of the students repoussé was merely a diversion from the other studio courses, Miriam Francis decided that it would be her principal medium of graphic expression. From her beginnings with a simple mask she has developed figure compositions and portraits. Because she works primarily in copper, a fairly expensive metal, her larger arrangements are her three-figure "family" compositions.

Miriam's progress was rapid. In May 1973, only months after she had entered Medgar Evers College, the school presented her first one-woman show. Of that event one particularly poignant memory stirs Miriam to speak of it.

I remembered Al Byers, the friend who had sat patiently with me and shared his knowledge when I was in such desperate need of encouragement. So I invited Al to come and see my first show. He came. And though Al hadn't gone that far with me and isn't doing anything with art now, he had been the force that kept me creatively alive during the years of discouragement and disappointment. And we stood there and cried together because he realized that I had finally reached the place I had spent my life looking for.

Because of the credits she had earned twenty years earlier, Miriam completed her study at Medgar Evers in three years, graduating summa cum laude in 1975. As she stepped forward to accept her degree and the special honors she had earned, she wryly recalled the teacher in junior high school who had advised her to become a beautician because "Negro children as a rule don't make it much beyond that."

Aside from the things she has sold (and sales have been frequent), Miriam's best works hang in her Brooklyn home. Copper repoussé dominates the walls and though she has yet to visit Africa the influence of traditional African

carving is strong in what she does. One notes also her pre-
occupation with the theme of family unity as well as her
almost exclusive use of black subject matter.

That is probably because of my being a black woman
and my having been so frustrated for so many years of
my life. . . . Even the people I do in copper are black.
I go out of my way to make the mouth very full—this
in repudiation of what I was taught earlier in life about
the "ugliness" of full lips and flat noses. Now I see the
beauty in them and I want our children to see and
respect them for what they are.

An arresting exception to the human subjects on her
walls is a copper panel bearing the Latin phrase which in
English translation reads, "*I Sing of Arms and the Man.*" A
beautifully executed piece, the Roman letters precisely ham-
mered in relief offer startling contrast to the Africa-inspired
head and figure compositions. You ask about its origin and
Miriam reveals that it was done as an assignment for a letter-
ing course she took at Hunter College while still attending
Medgar Evers College. Though it did not have to be
rendered in metal the teacher did require that the Roman
letters be done three dimensionally in any medium of the
students' choosing.

I asked if I could do mine in copper relief, Miriam
states, and the teacher advised that such a medium would
be too difficult. When she took in the finished assignment the
surprised teacher, who had not previously been familiar
with the repoussé technique, awarded her an "A."

Other pieces around the walls include *Kenya Lady; An-
cestor Figures; The Family;* a commissioned double portrait;
a pair of masks—one male, one female; and a figure piece
called *The Shepherdess.* That all of the aforementioned are
rendered in copper does not indicate the artist's disinterest
in using other metals.

I've been trying other metals, brass, for one, and I've done some on my own at home. But it's not yet at the point where I can show it. It's a more resistant metal, and since I have a few commissions for copper I'll do them before proceeding with my experiments in harder metals.

One reason for the swiftness of Miriam's growth as an artist is that she was asked to tutor others in the repoussé technique while still an undergraduate student at Medgar Evers. Moreover she is presently a part-time teacher there and she joins the others who have found that teaching can be a great learning experience. Another thing contributing to her rapid progress is a close and ever expanding contact with other practicing artists. Kay Brown, for instance, is a friend as well as colleague. Other associates with whom she exhibits include Marian Straw, Dinga McGannon, Charlotte Amévor, Ann Tanksley, Marcia Jameson, Shelia Beckles, and Camille Billops.

Through Kay Brown, Miriam came to know the Weusi-Nyum-Ba-Ya-Sanaa group mentioned in the chapters on Otto Neals and Kay Brown. And she formed an affiliation also with the *Where We At* group of black women artists as well as with the National Conference of Artists. In the famed black Brooklyn community called Bedford-Stuyvesant, Marjorie Harding and Teddy Funn serve as Communications Specialist and Curator, respectively, for the Bedford-Stuyvesant Restoration. Miriam works closely with both community art activists because she is in accord not only with their aims but with what they actually accomplish in promoting art produced by talented residents.

Miriam Francis speaks constantly of how she can make her work meaningful to future generations. In this regard, what she believes in and strives for echo the sentiments of others to whom we have been listening throughout the pre-

ceding chapters—Kay Brown, Otto Neals, Alfred Smith, Carole Byard, and Valerie Maynard in particular. They all speak of the day close at hand when they can open and operate a school of many arts where black people and especially black youngsters will learn to give free expression to that beauty of which they are so much a part.

To achieve that they know they must raise money, especially if they hope to attract foundation support. That they are willing to attempt to do through plain hard work. Miriam Francis adds a little something more to her personal effort. A quiet profoundly religious woman, she puts it quite simply.

> I can't tell you what I may be destined to do but one thing I want to do is be a part of that school we are planning. The rest is up to the Creator.

Emory Douglas

H<small>AD</small> Emory Douglas grown up in the Fort Greene section of Brooklyn, New York, he would have belonged to a street gang much like that led by Rickey. Indeed the odds are that he would have been a gang leader. Street fighters of the caliber he once was don't follow easily. They lead.

Born and largely self-raised in the typical American urban black slum environment, there was every reason for Emory Douglas to be written off as completely hopeless. He probably was; and not only by the professionals assigned to his "case" but by many of his own peers as well. And to be quite honest there were those times when Emory all but gave up on himself. But the many variables in the human personality and in the environment immediately around it impair and often destroy the accuracy of such predictions.

Today Emory Douglas does not practice his craft in the bleak solitude of a prison cell. Nor do those things which he draws and paints radiate the kind of hopeless bitterness dictated by his street and his reform school experiences. There is no escaping his anger. But he has that firmly under control now—thanks in large measure to his dedicated membership and work in an organization familiar to everyone capable of reading a headline or hearing a newscast. The story of Emory Douglas's harrowing youth is the story of the breeding of a Black Panther.

What really affected me in those early days was my
mother's conflicts with my father and, later, with her
boyfriends. My personal involvements were on my
mother's side, and I've seen a lot of blood shed during
those conflicts.

Conflict consorted with violence and together they rode
the child at home, in the streets, and (when he was there)
in school. Always a willing and eager participant in a fight,
the tapering off period came, luckily, to Emory Douglas be-
fore brawling had a chance literally to destroy him. Between
infancy and early adulthood he found another and more ef-
fective mode of self-expression. Fittingly, his training for it
started in a corrective institution. Ironically, the peaceful and
constructive use of what he learned is currently being made
by a group still inaccurately regarded in the public mind as
a gang of irresponsible hooligans.

Lorraine Crawford and Emory Douglas were southern
migrants who married and settled in Grand Rapids, Michi-
gan. She was from Oklahoma, he from Georgia. Their only
child, Emory, was born in Grand Rapids in 1943. As has
been said, life between them was stormy, and by the time
their son was three or four they were divorced. The senior
Douglas went to live and work in Detroit. Emory recalls that
his father would make periodic visits to Grand Rapids to
see them, even though it was a recognized fact that any
thought of reunion was impossible. He remembers even
more.

We were very poor. I was a sickly kid suffering with
asthma, and even at an early age I used to run away
from home a lot, especially in the second and third
grades. After school I'd go off and play with my friends
and when it grew dark I'd be afraid to go home for fear
of a beating for staying out so late. So I'd go to my
maternal grandmother's—sleeping on the porch under

the rug behind the couch. In the morning I'd go back home and sit on the back steps until my mother left the house.

Although the wily instincts of elemental survival that took root so early in her son's life gave her a bit of concern, Lorraine became most upset over his poor state of physical health. Michigan's winters were especially harsh for the poor compelled to exist in drafty substandard homes. Many were not equipped with central heating, and Lorraine Douglas with limited skills could not provide the comforts needed for her child and herself. In sheer desperation she took her child to California in the hope that the milder climate and the change of surroundings would somehow change their fortunes. Emory was eight when they arrived on the West Coast. He remembers it all with a startling clarity.

> Our first home here in California was in Doublerock, near Candlestick Park in San Francisco. My mother's sister lived there and the conditions in those old World War II makeshift houses were wretched. You see, they'd previously been used as military barracks! . . . Because she had no formal education my mother had to take whatever domestic work she could get. Her wages were small and sometimes she slept in, leaving me with my grandmother. I recall that she also worked in a cannery and a box factory—working late at night. I'd often be playing in the streets and I'd run by the cannery and holler at her—causing her to wonder why I was out so late alone.

Lorraine and her son lived with her sister, Willie Mae Rogers, between 1951 and 1952. It was a period he recalls as providing a sense of security he had not experienced with his mother, much as he loved her. Still Lorraine yearned for a home of her own. Black people, caught up in the harshness of life in the Doublerock and Hunters Point sections of San

Francisco, moved as soon as they could to the Fillmore section. That is where Lorraine took her son.

Her hope was that the move would bring about a change in the rebellious behavior she found more and more difficult to cope with. She'd caution him against rock throwing. He'd throw more rocks. She'd warn against fighting. He'd come home from his first day in school with a black eye and bruises. Now that they were in the Fillmore district perhaps his conduct would improve. Emory recalls the move.

I was ten. We lived in two rooms—bedroom and kitchen. During the day the bedroom was our living room. At night I slept on a cot in the kitchen. It was horrible for there were thousands of roaches, and I'd keep covered up to keep them from crawling all over me.

Emory recalls also that when he was ten, Fillmore's legendary Victorian houses lined the area of Geary Street where the Japanese Cultural Center now stands. His memory of the district is one of wide-open pleasure operating on a full twenty-four-hour basis. Bars, eateries, and houses of prostitution magnetized high-spending and thrill-hungry whites out for uninhibited sport. None of that glitter, however, reached squalid Linden Alley near Fell and Buchanan Streets where Emory Douglas waged his nightly battle with the cockroaches. So whenever he had the chance he'd walk up to Fillmore Street where the action was, for just being near it made him feel a lot better. He went there often and it wasn't long before he came to know many "of our people there."

School? Ha! Emory's contact with school, never too intimate or enthusiastic, dwindled as he drew closer to adolescence. The nomadic existence he and his mother were constantly forced to follow because of chronic money problems was responsible in large measure for that. His earliest

school experience in San Francisco, however, was arresting and instructive in many ways, as he recalls in this recollection.

> I got along well with other kids. The first school in San Francisco I attended was practically all Chinese. I was the only black kid there and I was in that school for nearly a year. You see we'd lived all over San Francisco. At this time we lived on "The Strip," what you'd consider and what was actually called "Broadway of San Francisco." And during that year I went to this neighborhood school. To the other kids I looked strange and I felt out of place there. But my mother and I lived in a cheap hotel for that was all she could afford at the time. Besides, as is true now, the Chinatown area of San Francisco was as wretchedly poor as the black areas . . . even though Chinese of education and modest means live there too. Besides, their clannishness and family traditions held them aloof and I was quite suspect when I visited their homes. And even though I was young I was an outsider.
>
> I did have one close friend there, a Chinese boy who was considered a delinquent. We went to the movies together and because he too had family problems we were quite close. Still, in a school whose teachers were either white or Chinese there was no adult to whom I felt I could relate. So I was bound to this boy and he to me by reason of our own individual rebellion against all adult authority, whether at home or elsewhere.

During the following year Lorraine Douglas moved to Linden Alley and Emory was enrolled in the predominantly black John Muir School at Fell and Buchanan Streets. There it was, as Emory remembers, "practically all white." One teacher in particular seemed to take delight in beating the youngsters. A group of them, however, got together after

they had entered high school and went back to call on that teacher at John Muir. When the man regained consciousness his former victims were way across town. In the interim Emory, ever interested in drawing and painting, struggled with it at the John Muir School with little or no encouragement. His academic study and production were nil and he fell into the routine activities of his companions—basketball and street fighting.

Roosevelt Junior High School had Emory in its enrollment for a year until problems at home resulting in yet another moving landed him in the Benjamin Franklin Junior High School of San Francisco. Now there was a school with a "rep" for toughness—a school whose gangs were legendary. It held no terrors, however, for Emory Douglas. Though not yet twelve he had learned, as his mother's sole defender, how to fight. She, meanwhile, bedeviled by physical and emotional traumas, was also in dire need of surgery for cataracts. Then came an unexpected break. Lorraine Douglas found work providing not only better pay but a self-esteem she had never known in any previous work experience.

Juvenile Hall is a correctional facility for minors, a unit of the Youth Guidance Center. Among its features is a food concession facility where visiting parents and staff may stop off for snacks. The concession was traditionally operated by persons who are partially blind. Emory recalls his mother's good fortune.

The white woman who took my mother on as her assistant was blind and they operated this together. When her partner died my mother took over. She is still there. And she is no longer a domestic, having developed the business and gained the respect of the people around her. So after twenty years of struggling she's managed to get her own home and to work and live in dignity.

It was 1955 and Lorraine Douglas, her cataract opera-
tion successful, and her concession stand at Juvenile Hall
going well, had reason to be hopeful of the future, especially
the future of her son. Emory's life, meanwhile, was swiftly
being woven into the rough design of things at Ben Franklin
Junior High and the rehabilitated Hamilton Playground
nearby.

> The young brothers and I used to shoot dice and we
> were constantly ridden by a pair of young black cops,
> Finney and Weatherspoon, who were building up their
> reputations in the department. They thrived upon "bust-
> ing" black youth even for the slightest infractions.
> So as we were there shooting dice for nickels and
> dimes—thinking what hip dudes we were—the police
> came in from both sides. They busted us and took us in.
> I was just turning thirteen, and didn't even have to go
> to court. But they took me to Juvenile Hall where my
> mother had her concession, and kept me there for about
> a week before letting me go. This was a great embar-
> rassment to my mother.

That first arrest was but the prelude to a succession of
them between 1955 and 1956, mostly for truancy. Emory es-
timates that he was at Juvenile Hall on the average of once
each month, largely because school failed to motivate him.
And because his mother was so highly regarded by the au-
thorities for her industry and integrity, it seemed to Emory
that their treatment of him was understandably severe.

> Some of the brothers were in and out of there in three
> or four days, whereas they'd lock me up for three or
> four weeks. And while it really wasn't a harsh place it
> confined me. That's what hurt me so much!

That he would eventually be arrested for fighting was
inevitable. By the time he was ten or twelve, Emory had

gained a "rep" as a brawler among his associates, all of them older boys and girls. To gain their acceptance he went out of his way to be rough in the fights they waged with rival gangs. Axe handles, zip guns, sticks, knives, and chains were formidable weapons indeed, and this handsome, good-humored man marvels today "that I was lucky enough to survive all that nonsense."

Finally, double-charged with truancy and fighting, Emory drew a nine-months' sentence and was sent to Log Cabin Ranch, a county facility for juveniles. The Ranch was the last stop before the notoriously tough Youth Training Center. In a sense his being sent to Log Cabin Ranch provided respite from a far more hazardous existence, a fact Emory now readily acknowledges.

> To be honest the place was like a summer resort. I found it difficult because it was in the country away from everything I knew. And I was there longer than I had been at any other place of confinement. But it was new and clean and I lived in the newly built dorm.

Emory spent one year at Log Cabin Ranch, after having waited ninety days at Juvenile Hall for a vacancy to occur. Admittedly he got little out of the formal schooling they provided. His feeling in retrospect is that while the teachers held valid credentials, they were people who for various reasons could not make it in the regular schools of the city. Students who regularly copied answers from the backs of the books were never challenged by teachers who stood in mortal fear of them. So the teachers collected their pay with as little friction as possible, and as Emory humorously puts it, "They weren't about to stimulate any adrenalin whatsoever!"

But life for Emory was good at the farm. Up at six A.M., his days were filled with working, hiking, studying, playing. At the eight o'clock bed hour he was tired. The boys kept

their rooms clean, made up all beds military style, and observed a strict sense of order in their general surroundings. Lorraine Douglas was relieved and overjoyed that her son was in such a pleasant, well-run setting. One detail is worth noting here. Each boy was assigned to a particular job on the farm. Emory's was taking care of the pigs and keeping the pigpen clean.

Emory was sixteen when he left Log Cabin Ranch, and was just entering predominantly black Polytechnic High School. There, because of his skill in basketball, his energies might well have been channeled into the sport. Racism and Emory's negatively defiant reaction to it would not permit that.

I'd gained a reputation as a basketball player on Benjamin Franklin Junior High School's championship team. Here again was an example of a school where academic excellence was almost nonexistent but where basketball and rowdiness set records. . . . So when I went to Polytechnic High School, though I was good at basketball I was constantly "sliced" by white players whose court records couldn't match mine. That was demoralizing and I quit basketball. But I found ways of getting back at them.

The ways Emory Douglas found of "getting back at them" did not include acquiring scholastic excellence. And even though he could and did draw he preferred to give his attention to illicit pursuits—particularly those from which he could extract some personal benefit, no matter how small. One involved the securing and selling of class "cut" slips. Each time a student cut a class a slip designating his absence was made out in his name, and the guilty would have to line up to receive their slips. Emory found a way of making that procedure profitable.

I'd get someone to create a ruckus on the line which would distract attention long enough for me to snatch

the cut slips and run with them. I'd tear mine up and sell others for twenty-five or thirty-five cents each to others who would destroy them. In that way I was able to foul up the cut records and make a little change too.

Among his set in the black community having lots of clothes gave one status. To get them Emory used wit and guile.

I had learned how to get into any place with a screwdriver and a pair of pliers. And I learned from the best burglars I've ever known—heroin addicts.

Tape recorders burglarized from stores and sold for as little as thirty-five dollars enabled Emory to buy clothes. Thefts from cleaning establishments and sales of the loot yielded added cash. In these ventures, as in burglaries from private homes, Emory and his consorts concentrated on fairly affluent white areas. To augment whatever he gained through theft Emory, a good pool player, hustled that skill whenever the spirit or necessity moved him to do so. He also helped older fellows in crime by "setting up" white men who came into the Fillmore area in search of sex with black women. Once maneuvered into a given hotel the thrill seekers were beaten and robbed by the gang, who "tipped" Emory for his assistance.

Oddly enough he was never caught in the commission of any of those crimes. At one point when his mother missed her television set suspicion immediately fell on Emory. That was one instance, however, in which someone else, not he, was guilty. It was remarkable that, in spite of his contact with dope addicts, he was lucky enough not to be "hooked," though he was, at fifteen, experimenting with tranquilizers, marijuana, and cheap wine.

We fought rival gangs—especially the Lakeville and Hunter's Point gangs. First we'd get juiced up on wine and on the way over we'd practically take over the bus

and terrorize passengers in the process. Then we'd play basketball with our rivals and the fights would usually start there. . . . Because I had moved about so much as a child I was known by the residents of every blighted area of the city. So I could go into all areas without being molested and I could get information about what our rivals were doing. . . . Yeah, I had a "rep" as a fighter but to tell the truth my battle victories had often been blown way out of proportion to their reality.

Before he was sixteen Emory Douglas knew the humiliation of making a public spectacle of himself while under the influence of alcohol. He had been beaten off a bus by an irate driver and driven out of a club by an outraged broom-wielding woman. He still shudders slightly in recollection of the day he might have become a heroin addict.

I was in the company of a guy I knew who had done time for murdering a white bartender in the district. He asked jokingly if we wanted some heroin and my buddy and I said "Yeah." The only reason we didn't get it was because the guy was kidding. He didn't have any heroin. Thinking about it now makes me know how close I came to being another victim.

Emory's luck in avoiding the snares set by his own deportment and associations could not hold out indefinitely. He was sentenced to thirty days in Juvenile Hall as a result of being picked up on suspicion of burglary. During that month he distinctly recalls his concentration on drawing and painting, primarily of peaceful bucolic scenes. Once out on the streets of San Francisco, however, he sought his old companions in crime. One was a boy who had just been released from Youth Authority.

We were out on Fillmore Street the same day I had gotten out of Juvenile, and the cops stopped him, found a butcher knife, and took him in their car. Thinking I

could distract the cops long enough to allow my buddy to escape, I spied a carton of empty bottles which I began to throw at the police car. By that time another squad car was upon me and I, too, was taken into custody.

Because of his attack upon the police plus the fact of his having been just released on suspicion of stealing his mother's T.V. set, Emory drew fifteen months at the Youth Training School in Ontario, California.

He remembers the institution as a place that "locked you in, though you didn't live in degradation there." In view of his previous confinement elsewhere he felt he could "pull the time without cracking up," though the school's location in southern California, many miles from where he lived, limited visits from family and friends.

While there, Emory recalled with some irony how only months before he and a companion from San Francisco had been induced by a white youth to come to nearby Pomona. There, the trio engaged in forgery in which the two black youths took all the risks while the white youth took the bulk of the profits. Emory and his pal had pulled out uncaught and returned home. Now here he was, locked up in the same area on a far less serious charge! And as a grim reminder of what might well lay ahead he was being confined just across the fence from Chino, the dreaded men's penal colony.

Some positive things came into Emory Douglas's life at Youth Training School. First, he worked in the printing shop where he was to acquire his first knowledge of the graphic arts. And though he was not fully conscious of the value of the techniques he was using there, it all came back to aid him in later work. Second, when he left the institution at age seventeen, he had the equivalent of a high school diploma, a fact that still stuns him.

To this day I don't understand how I got my diploma, because it is on my record that at Polytech High School I took United States History and passed it with a "C." Now I know good and well I never did take it. I've been credited and graded for subjects I never once took! In other words it seemed to be the policy to grind out black high school graduates at Polytech whether or not we were prepared. And under the pretext of doing us a favor they were actually sounding our intellectual death knell.

Such misgivings notwithstanding, Emory Douglas left Youth Training School "with a skill I didn't then know I'd find so useful." His mother wanted him to enter the military service, an idea that had no appeal whatever to him. He hated the uniforms, the haircuts, and the regimentation so bitterly that he intentionally flunked the entrance test. Today he laughingly recalls that his action worked to his advantage when he was later ordered through the draft to report for induction. One look at his early medical history, juvenile court record, and enlistment exam papers convinced the army it neither wanted nor needed Emory Douglas. Blithely shrugging off the rejection, Emory took several civil service examinations, one for the U.S. Post Office. He flunked them all.

Deficiencies in math and just plain lack of understanding of the English language were my problems.

Not really wanting a career in crime and realizing at the same time his need for preparation for something else, Emory decided upon commercial art. His work-study experience during the fifteen months he spent at Youth Training School was beginning to stimulate ideas. But with no money and, worse still, with inadequate academic preparation, where would he go? One possibility existed during the

1960s. It was a possibility brought about through previously
described efforts of young people like artist Manuel Gomez,
who along with concerned community leadership stimulated
opportunities, then made minority youth aware of those op-
portunities.

 I enrolled in the City College of San Francisco for
the course in Commercial Art. It was only because the
school was designed for the poor and disadvantaged
that I was able to get there at all, and while I made it
in, I flunked the math and English parts of the test and
I had to take the "bonehead" math and English courses
in order to qualify to remain. . . . I went almost four
years to that two-year City College because I had to
constantly repeat the "bonehead" math and English
courses. But I made it.

During his attendance at City College, where he fre-
quently saw a husky athletic student named O.J. Simpson,
Emory Douglas had few close friends. Though like Emory
all were in need of aid, few had come through as wretched
an existence as he. And many who did know him were re-
luctant to associate with him. Emory, determined to prove
that he was as able as they, made no effort to force himself
upon them. Pride burns fiercely in the person determined to
move beyond the degradation of a recent past.

 I wouldn't push myself on them and I had no inten-
tion of breaking friendship with those I'd grown up
with. And even though I was illiterate and naïve in
many ways I was certainly street-wise and I knew that
with determination I could rise above my handicaps.

As a serious student of commercial art Emory noted—
as did Bertrand Phillips, simultaneously studying in Chicago
—that all assignments done for the course were directed at
appealing specifically to a white consumers' market. That

troubled him even as it was troubling Phillips. In Douglas's
case the source of frustration sprang largely from his growing
consciousness of a huge civil rights movement of which he
was not then a part. Moreover he was uncomfortably con-
scious of his penchant for party-going and it wasn't long be-
fore he had to make a decision vital to his future. Would it
be good times or serious study? He chose to study.

Noble as his purpose was, Emory still needed money for
books, supplies, clothing, and food. Working full time would
not permit ample time for study, so he settled for working
part time. What he decided to do for the money he needed
was what he knew best how to do. The trick was not to be
caught in any illegal act. Luckily he wasn't. And he was able
to support himself as he prepared for a career in a far dif-
ferent direction. Emory speaks with mingled feeling and
wit of a particular assignment he worked on at San Fran-
cisco City College.

> One of the school projects involved our doing story
> board drawings for an animated film. I chose to do a
> "brother" being denied courtesy and service in public
> places until he donned the garb of an African V.I.P.
> The theme had been suggested to me by a white teacher
> with liberal leanings. As he took a look at what I was
> doing he suggested that I needed to be more provoca-
> tive. . . . Ha ha ha ha! The man had no idea how
> provocative I actually was. The thing was that I hadn't
> been able up to that time to apply my anger to my
> drawing and painting.

Emory found his teachers sympathetic to his attempts
at featuring black consumers in the drawings and paintings
he prepared for class assignments. Still all of them cautioned
that several years would pass before he could hope to find
a market for his ideas. It was 1968 when he completed his
studies at the college.

Political activism among young black students was, as has already been noted, quite high during the 1960s, and Emory Douglas was drawn into it while still a student at San Francisco City College. There he had joined the Black Students Association, which was then trying to join forces with the Black Students Union at the University of San Francisco. A strike staged by that group had made a lasting impression upon the black students of the Bay area.

Still, while Emory acknowledges the admiration he held for Malcolm X, he, like Bertrand Phillips in Chicago, was initially hesitant to form any close association with the Muslim movement. He freely admits that their vituperative and uncompromising early rhetoric about the "blue-eyed white devils" used to frighten him. Yet he quickly and laughingly acknowledges the inconsistency of that feeling and the fact that the only people he personally ever robbed and harbored a hatred for were white. So he was ripe for what he now calls "my first consciously political act."

It was 1966 when two young black men, Huey P. Newton and Bobby Seale, formed *The Black Panther Party for Self-Defense*. They started it in Oakland, California, where both had been students at Merritt College. Seale is five years Newton's senior. A man whose dour frown, accented by a formal moustache and goatee, lent him a formidable appearance, Seale looked like what edgy white people expected a Black Panther to be. Moreover he was a splendid organizer and a soul-stirring speaker. In private Seale, when not absorbed in reading Franz Fanon and Mao Tse-tung, could "cut the fool" with the best of them.

Newton, handsome and full of charisma, was respected by their followers because of his ability to back up his oratory with his fists. Like Seale, he, too, was a political scholar with plans for pursuing a career in law. Both young men and the group they gathered around them were serious about learning.

Racism was rife in the California Bay Area. It was especially visible in the mistreatment of nonwhites by white policemen, and intelligent blacks like Seale and Newton decided it had gone far enough. For that reason alone the group they formed included "for self-defense" in its title. But that wasn't all they represented.

The ten points of their original platform included a call for (1) The power among black people to determine the destiny of their own communities. (2) Full employment of black workers. (3) Housing fit for the shelter of human beings. (4) Exemption of black men from military service. (5) Education for blacks that teaches the true nature of "this decadent racist society," and that teaches black people their true place in the society. (6) An end to the robbery of the black community by white racist businessmen. (7) An immediate end to police brutality and murder of black people. (8) The release of black men held in city, county, state, and federal jails, since they had been tried and imprisoned by racist whites. (9) The trial of black people by members of their own peer group—a peer being one of the same socioeconomic, religious, and racial background. (10) A summary demand for land, bread, housing, clothing, education, justice, and peace.

That, basically, was the Panther platform as written by the founders in 1966. Since then the party has dropped "for self-defense" from its name because of current emphasis upon political action. They have combined points eight and nine and included the poor of all groups in that demand. And they have added demands for free health care for all black and oppressed peoples along with an end to all wars of aggression. A decade ago, however, they made no effort to conceal their determination to defend themselves and their community against physical attacks.

Newton, the scholar, carefully read California law on firearms in the hands of citizens before placing them in the hands of party members. The result of that study was dra-

matically shown in the demonstration Emory Douglas wit-
nessed shortly after the party's formation.

Eldridge Cleaver, a scholarly ex-convict best known for
his book *Soul on Ice,* joined the Black Panther Party. A
devotee of Malcolm X, particularly the Malcolm who broke
with the Muslim tradition set by Elijah Muhammad,
Cleaver's life like Malcolm's had been that of the street
hustler converted, by dint of study, to an intellectual rev-
olutionary. Cleaver's writings attracted a wide audience and
among the many who wanted to meet the brilliant essayist
was Betty Shabazz, widow of Malcolm X, who had been
assassinated two years earlier in New York City. Arrange-
ments were made for Mrs. Shabazz and Cleaver to meet and
talk at the offices of *Ramparts* magazine.

Because it was feared that an attempt might also be
made on the life of Malcolm's visiting widow, the Panthers
assumed responsibility for her safety by providing her with
a disciplined, smartly uniformed armed guard. From the
airport to the offices of *Ramparts,* Mrs. Shabazz was escorted
by the guard headed by Huey Newton. Police at the airport
and in San Francisco itself were furious. But they had to
acknowledge there was nothing illegal in the Panthers' car-
rying of loaded guns. And Cleaver, noting Newton's chal-
lenge to a city policeman who, wanting to shoot, backed
off instead, was impressed. He became the Panthers' Min-
ister of Information. Emory Douglas, who had accompanied
the escort group to the airport and back, was also impressed.

I was drawn to it because of its dedication to self-
defense. The civil rights movement headed by Dr. King
turned me off at that time, for in those days nonviolent
protest had no appeal to me. And although the rebel-
lions in Watts, Detroit, and Newark were not well orga-
nized they did appeal to my nature. I could identify
with them.

In the earliest days of my association with the Pan-

thers in January 1967, Leroi Jones (Imamu Baraka) had me do the "props" for his street plays when he was assigned by the Black Students' Union at San Francisco State College to work for two months. And I was active with the Party when we went to Sacramento to view the State Legislature and to exercise our right to bear arms. That was in May nineteen sixty-seven.

Huey Newton did the layout for the first Panther newspaper. Upon his return from Sacramento Emory Douglas did the layout for the second and subsequent issues, breaking away in the interim from Leroi Jones to devote full time to the Panthers.

That is where I felt I could best express what I truly felt in my art work. There was where I could comment upon the environment that I knew and grew up in.

Even as Emory was enjoying the work he did with the Panthers he was also uncomfortably conscious of the effect his association was having in yet another quarter.

My trip to Sacramento—my name in the papers—picture on TV—all this began to have an adverse effect upon my mother's business at the concession. Business fell off. The probation officers and others who patronized her were serving notice that they didn't approve of her son's actions and therefore no longer approved of her food. . . . And my mother became conscious for the first time of the fact that only if you play the game their way will you be able to make it. She found out that they cared nothing for her, and that in their view her son's being a common criminal was far less to be condemned than his being a "dangerous radical" threatening the status quo. And that was really the thing that brought her closer than anything else to understanding me in support of the party.

For a while, after extensive and lurid press coverage of the Panthers, Lorraine Douglas's life was indeed harried and tortured. Harassed by agents of the FBI, she was also constantly hounded by the fear that her son might be among those singled out for "liquidation." And her resistance to Emory's continued membership in the Panther Party was occasioned by the killings of prominent members at the hands of police. Emory stood firm nonetheless.

But she eventually realized that this is what I am going to do and it was going to be my life. She's accepted that and we've become closer out of this experience.

Emory Douglas is thoroughly committed to his work as official graphic artist for the Panther Party. When he first joined the group he worked out of their offices then located on North Oakland's Shattuck Street. He followed them to San Francisco in the early part of 1967 and finally to their present location in East Oakland. In those days Stokley Carmichael was much in the news, and whenever he was in the California Bay Area he would look up friend Connie Williams and have dinner at her famous Connie's Restaurant in San Francisco. Because the Caribbean and southern cuisine are legendary all over the area Carmichael would often be joined at Connie's by Emory Douglas and other Panthers as they conferred over matters of mutual concern.

Emory is swift to admit that certain community programs of the Party—the breakfasts for children, and the food and shoe give-aways in particular—exerted a great influence upon his art.

Watching the expressions of appreciation and the joy of the recipients—getting the feedback from the community in spite of what the press was saying about us inspired the art work I produced. . . . We started off

with the cartoons—the pig cartoons which originated under Huey [Newton] and we developed them. Our target was the reactionary politicians and we decided that if we were going to call them "pigs" we ought to draw them as pigs. That's where my experience at Log Cabin Ranch came in handy, because up there my job was to look after the pigs. Man, I had become an expert on the way pigs look and act. So the pig cartoons became a feature of our paper. Readers looked forward every week to seeing them. Our purpose was to make the people aware of the character of those who oppressed us, and we showed pig-policemen as symbols of that oppression.

Cartoons are but one facet of Emory Douglas's art. He has done posters bearing the likeness of Rap Brown, Stokley Carmichael, and Leroi Jones. Those were men in the news whose influence during the 1960s was especially strong among black youth in the slums of American cities. Yet another set of Douglas posters depicts the black family, and Emory recalls that the one showing the mother holding the baby on her shoulder was especially meaningful to black women. These drawings are in no way "prettied" or idealized, as it is the artist's intention to make them true to life.

Now I couldn't, for instance, see myself doing my kind of drawing—say—for *Ebony* magazine. It is a quality publication and I'm not taking that away from it. But because of the kind of magazine it is I'd have to "refine" my drawings down to fit its needs. In this regard my background at San Francisco City College gave me insights into how to appeal to the audience I was trying to reach, since art is an emotional statement.

The Panthers ran a test on the effectiveness of the posters Emory does. Running off ten or twenty thousand

and placing them around the black community produced almost instant comments. "Man, that looks jes' like my mother's sister." Or, "Gee, you sure caught an expression in that old man that I've seen on my father's face many a time, bless his soul!" There were sharp and outraged objections too from certain people. But Emory and other Panthers knew that the criticisms from middle-class blacks who had escaped the slums were denials of a past they feared being reminded of. They couldn't bear to look at the truth of shoeless black women wearing head rags so familiar to the majority of blacks still crowding the nation's ghettos. Of those drawings and the black bourgeoisie fire they draw, Emory comments with simple calm.

From my point of view such a black woman is the common denominator from which we all came. These are our roots which we should never forget.

When he isn't drawing designs for posters at Panther headquarters the artist is painting portraits at home. His two children, Dessaline (five), and Cindy (two), will not have the harrowing childhood their father knew so dreadfully well. Emory, meanwhile, continues his work in spite of what he describes as "increasing harassment."

We're even more harassed now by the authorities than before since much that we accused law enforcement of in the way of breaking the law itself has come to public light. Besides, we are now more constructively involved in the political electoral process. We have built institutions in the community—a learning school, for instance. People look to us now for aid and we have a constituency. Any time you can gather 24,000 votes for a city council seat and only lose by 4000 votes means that you have a constituency the city authorities know they have to contend with.

Douglas reminds you that when Bobby Seale ran for mayor in 1972 the 47,000 voters the Panthers polled knew they were voting for a Panther. "Those people were voting for our programs, and our ideals." The latter are continually set forth in the Party's weekly newspaper, *The Black Panther*, ably edited by David DuBois. Covering both national and international news of significance to black readers, its circulation runs between forty-five and fifty thousand. It sells no advertising space in the traditional journalistic sense. Says Douglas on this point,

> We don't take ads except from local firms who contribute to our survival programs. Also different African Liberation movements have calendars and materials they distribute in support of the African liberation struggle, Angola, for example, and we run their ads. But we sell no ad space as such.

Like so many of America's young black artists, Emory Douglas believes what he does should be functional and that "it should function for the people." It is easy to believe him as he tells you:

> The Party is my life. My convictions grow stronger. And they come on stronger with the years.

Editor DuBois smiles and warmly refers to Emory Douglas as "The People's Artist." The designation is as heartfelt as it is accurate.

Rosalind Jeffries

SHE seats herself comfortably on a couch in her sunny, spacious living room and looks approvingly out the picture window. The greenery is lush and the air of this north Jersey town invigorating. The corners of her mouth lift in a smile as you mention what a splendid view of earth and shrubs and trees and sky she has to gaze out upon. She agrees.

Yes, it is nice here. But do you know that when I was a child sharing a small room with my sister in our Harlem apartment I looked at a blank brick wall. That's right! I never could tell if the sun was shining or not unless I raised the window, looked out, then craned my neck up toward the sky. Only then would I know if there was any sun outside. I used to even dream wildly of being able to fly out of such a place.

Her eyes gleam as she laughs. And if you are not a knowing observer you miss the tinge of sadness that tells you how rocky the path from the sunless tenement flat to suburbia has really been.

A "Depression baby" born in Harlem Hospital, Rosalind Robinson, along with brothers Edmund, Gerald, George, and sister Barbara, are all native Harlemites. Their parents, Mary (Gibson) and Edmund Robinson, Sr., were

adopted New Yorkers, having migrated from South Carolina in search of a better life in "The Big Apple." Actually the Robinson family was what Rosalind calls "a part of the extended family" here in New York City. There were numerous aunts, uncles, and cousins who likewise had come north from the Palmetto State and they were living in the Bronx and Staten Island. A few even lived in the not-too-distant oceanfront city of Asbury Park, New Jersey. For Rosalind that has very special meaning.

> The fact that we were all from "down home" and living in this new strange area gave us the feeling of belonging to each other. That was the extended family from which we youngsters drew nourishment. . . . That family included those who were not always blood relatives but folks who, like ourselves, were transplanted. It included not only the respectable and the hardworking but the drunk and the racketeer who also were part of the extended relationship. So as children we felt a sense of security in that Harlem setting.

Rosalind found the setting, in spite of its thorny aspects, "a beautiful and exciting place made up of pockets of people who were so diverse." Harlem's religious cult leaders of that era were legendary, with "Daddy" Grace and Father Divine holding spectacular sway over their respective flocks. "Daddy's" rollicking House of Prayer was directly across the street from where Rosalind and her family lived. Its leader's august presence offered a memorable spectacle.

A pudgy, well-groomed brown man of middle age and mysterious origin, he wore his silky hair long and flowing well before the advent of the "hippie." Daddy sat imperiously in a huge arm chair, his soft bejeweled hands relaxed, as beautiful young women stood on either side fanning off flies and the musty heat. From that throne he offered coun-

sel, prayer, and the promise of a good life in the hereafter
to his followers, and a superb show to the casual visitor.
His troupe consisted of singers, dancers, and instrumental-
ists who jazzed it up in the name of God and Daddy Grace.
Rosalind recalls him well.

> In Daddy Grace I saw a man deified by his followers.
> They'd bring money to him, actually pin it on him! And
> you'd see the whole wall inside that house covered with
> paper money. A next-door neighbor was a member of
> the Daddy Grace Band and from him I learned how to
> dance the *Daddy Grace Stomp*.

Obviously "Daddy," or "The Bishop" as he was also
called, wasn't struggling to exist during the Depression,
what with headquarters and adoring followers in black com-
munities over the country. He had a rival, however, in an
even more phenomenal black religionist, Father Divine.
Known during his days of obscurity as George Baker, Divine
rose to the place where ardent followers declared him to be
God. The diminutive leader, choosing to live up to his
newly conferred title, never bothered to dispute them. Ros-
alind makes a shrewd and accurate observation about the
members of that cult.

> The Divinites, of course, were "strange" then to me
> because they refused to straighten their hair and they
> addressed each other as "Brother" and "Sister." Kids
> today think that is all new and that it began with them.
> In essence it was the germ of the meaning of black
> communal life.

Religious cult leaders of Harlem, colorful as they were,
had to be content to share the public spotlight with more
conventional churchmen. Not the least of them was a young
Colgate University graduate who used to lead picket lines
outside the shops of white Harlem merchants who weren't

hiring black sales help. He was Adam Clayton Powell, Jr. There was also the still-vocal, highly visible residue of the followers of Marcus Garvey. A decade or so earlier they had flourished in the Harlem Rosalind Robinson knew and loved so profoundly. All of that was meaningful to black school children who, like the Robinson youngsters, developed a consciousness of how positive their blackness could be. In Rosalind's case it was both at home and at school that she learned so much about herself and what her place in life should be.

At home it was my mother who was kind, gentle, sweet, and patient. She'd tutor us, see to it that we got music lessons, for she believed music could be a great disciplinary force. So I learned to play the piano before my hands were big enough to do an octave. My mother was high on Gospel music, my father was into Country-Western, my sister Rock-and-Roll, and so on. One brother was into jazz and the older brother into opera.

Rosalind recalls tagging along with that older brother downtown to the opera house. And she now knows that what she saw on the great stage was a replica of what she would see later on that same summer's evening upon her return to Harlem.

As I sat on the tenement steps spitting watermelon seeds out toward the curb, there in Harlem were our neighbors . . . those who liked to wear finery, those who fought and quarreled, the lovers, all reenacting the human drama I had seen downtown that same day.

School was an important thing in the life of Rosalind Robinson, especially P.S. 184 on 116th Street, close to where she lived. It was an all-black school—that is, the student body was completely black. Teachers were all white. And Rosalind's experience at that school was a happy one, for

as a bright girl she was always in those classes receiving lots of teacher attention. She was not happy, however, at entering Junior High School 101.

As was true of Kay Brown, Rosalind wanted to go to P.S. 81. Kay Brown got there but Rosalind didn't. It was a predominantly black school and Rosalind wanted to be there with her friends. But because of the side of the street her family lived on, she was assigned to P.S. 101. She cried for a week. Going into junior high school with strange white and Spanish-speaking kids was not her idea of fun. As she recounts it all now, however, she views it differently. "That was the best thing that could have happened to me."

At P.S. 101 she came to know youngsters whose fore-bears had come from Italy and Ireland and those with family roots in Ecuador, Panama, Cuba, and Puerto Rico. Contacts with them, and in some cases with their families, marked Rosalind's initial entry into an area she would later explore in greater depth. Of that she was totally unaware at the time. Besides, she was struggling to overcome a handicap not uncommon to many school children—the problem of learning to read.

> I had been experiencing difficulty in translating tonal Afro-American speech into English on the printed page. Luckily a reading and speech expert helped me over that and when I finally got it straightened out I was better able to absorb knowledge through reading. In that I was luckier than so many of my peers.

The "peers" to whom Rosalind alludes were the black youngsters who attended the predominantly black P.S. 81. Speech therapy was seldom available to black children in their "neighborhood schools" and Rosalind's assertion that P.S. 101 "was the best thing that could have happened to me" is no idle comment.

Fine Arts? Rosalind wasn't giving art a thought in those

days. She didn't know any artists and because she didn't know about them she now admits she didn't think much of them. So Rosalind carried her ignorance of art and artists with her as she entered New York City's Washington Irving High School.

> Because kids went to Washington Irving from all parts of the city I didn't experience the community warmth I'd had in grammar school and junior high. So I managed to keep that warmth alive through church groups and through Camp Minisink.

Though the college preparatory course captured and fixed Rosalind's attention, she combined her studies with classes in art. Still she knew no artists even though she had seen murals by Aaron Douglas and a showing of paintings by William H. Johnson at the same library in Harlem where Kay Brown had become acquainted with the Weusi group of black artists. Obviously what she saw and felt stimulated Rosalind enough to cause her to decide upon making art a major study.

Hunter College in New York City was one of three tuition-free colleges available to qualifying resident students. Standards were high and only those with good academic high school preparation could hope to pass the entrance examination. Rosalind Robinson met the requirements.

> I went to Hunter College because it was free and because my brother had set a pace for me. Competition there was Jewish and it was strong. The Toussaint Club formed by a group of black girls used to invite speakers there, and I remember that they twice invited Malcolm X. By the time he was asked to come for a third time he was considered far too controversial by the Hunter authorities.

With art as her major subject at Hunter College Rosalind was beginning to form her initial contacts with well-known artists. Classes with Richard Lippold were especially rewarding in that regard, for they introduced students to numerous "names" in contemporary art whose visits to Hunter were memorable occasions. Robert Motherwell was one. Then there were the Madison Avenue galleries which handled and showed the works of America's best-known artists —all within easy walking distance of Hunter College.

Such stimulation compelled Rosalind to seek even more specialized study of art than she could get at Hunter, so she took a course in painting at the National Academy of Design. Robert Phillip was her teacher there. As a devotee of Rembrandt, Phillip constantly urged his students to study the master's works. With the splendid collection of Rembrandt paintings at the nearby Metropolitan Museum, a firsthand study of the great Dutch artist was as convenient as it was profitable and pleasant. One of the two other black students attending academy classes with Rosalind was a handsome young man trying with some difficulty to decide whether he would pursue a career in painting or dramatics. The latter won out and so did the young man. He is Billy Dee Williams.

Like other students without the backing of monied families, Rosalind worked at various jobs to support herself while in school. At one point she was a typist, and at others she did whatever she could find to do. A meaningful influence in that period was the Church of the Master located in uptown Manhattan between Harlem and Morningside Heights. For many years this little Presbyterian church had served the spiritual needs of a white membership. As the community on Morningside Avenue near 125th Street began to change from white to black, a change of pastors at the church also took place. It proved to be a change that would be remembered for a long time by a lot of people.

Young, progressive, and black James H. Robinson took over leadership of the Morningside Presbyterian Church in 1938. Born in a Knoxville, Tennessee, slum, the Reverend Robinson had been through it all as he made the climb from abject poverty and ignorance to a place of international respect and recognition. Not only did he organize a strong congregation but he enlarged the work of his church so that it functioned as a community center for youth and adults.

A quiet and remarkably persuasive speaker who never indulged in banal theatrics, he was, nevertheless, one of the most forceful of American platform orators. College students, especially whites from comfortable backgrounds, were drawn to him like pins to a magnet. New England landowners hearing Dr. Robinson speak on behalf of disadvantaged Harlem children responded by giving him two land sites in New Hampshire. Then white middle-class college students gave their labor to the building of summer camps for black kids on those sites.

From that idea, and following two trips to Africa, the Reverend Robinson developed the notion that American students could do in Africa what they had done in New Hampshire. He quickly founded Operation Crossroads Africa, forerunner of the U.S. Government-sponsored Peace Corps. The first group of Crossroaders, fifty-nine predominantly white college students, went to West Africa in the summer of 1958. Two years later Rosalind Robinson would herself be a Crossroader. She speaks of her earliest contact with the late Dr. Robinson.

The Church of the Master was a big thing in my life. I came to know it while at Hunter. And because Robinson is my family name the Reverend James H. Robinson who founded the church and who founded Operation Crossroads Africa used to think of me as his daughter. I was somehow led by impulse to the church

and the first person with whom I spoke there was Helen Brody Robinson, the pastor's first wife.

What excited me about it all was the church's involvement in social service programs—the summer camps it ran, and so forth. And it embodied the United Nations' idea in its everyday functioning—what with Gary Oniki, the Japanese-American assistant minister who worked along with Reverend Stenhaus, a white assistant. The Reverend Stenhaus practiced meditative silence that was at first quite difficult for me to enjoy. But I finally got around to appreciating it.

Rosalind worked summers as a camp counsellor during her undergraduate days at Hunter. She came to know the personnel of the Church of the Master who were always active at Camp Rabbit Hollow and Camp Forest Lake, the New Hampshire camps operated by the church. During the school year she continued with her study of drawing and painting. Then someone introduced her to Mary B. Brady.

Miss Brady was then director of the Harmon Foundation, the first organization to present Afro-American artists in serious exhibitions as far back as the late 1920s. With Miss Brady's help Rosalind met some of the artists whose first public acclaim had come through the foundation's exhibits. Among them was Hale Woodruff, a distinguished painter and teacher with whom Rosalind subsequently studied at New York University. Because of the degree of Miss Brady's interest in African art and contemporary African artists, she also saw to it that Rosalind met the latter as the Harmon Foundation introduced them to the New York public. Her getting to know Africa firsthand was much closer than Rosalind Robinson imagined.

I was still a college student when my first traveling opportunity came. Through Operation Crossroads Africa I went on a partial scholarship to Nigeria. It was

the first plane ride I had ever had and the first time for me in any tropical area of the world. The year was nineteen sixty. And though it was all new to me—a completely different culture and living out in the bush— I really didn't find it difficult because of my previous experience back home at Camp Minisink.

Our assignment was building a marketplace. We mixed and poured cement into blocks and often when they were done a heavy rain would come and destroy our work. But people who lived there and who'd watched us work would pitch in and help us rebuild. We were thirty miles from Enugu in a place where most of the dwellings were thatched huts.

The lone black American of her group of seventeen, it was natural that village attention would focus upon her. She smiles as she recalls the proposals of marriage made to her and laughs heartily about the times the young white men of her group were approached by Nigerian men wanting to know "how much money they'd accept for me, though nobody interested in buying bothered to consult with me first."

But Rosalind was not totally disinterested in marriage. The year following her summer in Nigeria she met Leonard Jeffries, who had been a Crossroader in 1961 to the Ivory Coast.

I'd heard him speak at a program at the United Nations and in nineteen sixty-five we were married—the result of our having "grown on" each other through our common interest in Africa.

Graduation from Hunter came meanwhile for Rosalind in 1963, while Leonard Jeffries was at Columbia University working on his doctorate. Returning to the Ivory Coast constituted a part of his doctoral field work. So the couple married and Leonard and his bride returned to Africa together.

When we went there to live we looked about for other Afro-Americans and we met Will and Irene Petty. He was USIS director at Abidjan, having previously taught art in the public schools of Washington, D.C. and also having known James A. Porter at the Howard University art department. When Will learned of my art training he immediately put me to work preparing displays.

The displays Rosalind prepared were of two types. One was for cosmopolitan Abidjan viewers, the other for the provincial locales. Subject matter treated themes of particular interest within any given month to the people of both audiences, and some displays were of almost mural size. Some of the information sent out from Washington for exhibit was not, in Rosalind's opinion, any better than many of the "blood and thunder" films selected by the USIA for showing to overseas audiences. "I often did not put up some of the display material that I thought was too demeaning."

Maintaining good rapport with the people of the Ivory Coast enabled Rosalind and Leonard to enjoy the two years they spent there. In the interim they were able to get to Guinea, Mali, The Cameroons, and Senegal—spending a full month in the latter country. And during both trips to Africa Rosalind found that what she had previously learned of contemporary African artists and their work through Mary Brady rendered her meeting with them in Africa mutually meaningful.

When, for instance, I finally did meet Ben Enwonwu in his native Nigeria I was thoroughly familiar with many of the Ben Enwonwu stories as told to me by Miss Brady. Likewise by the time I met Ethiopian painter, Skunder Boghossian, I'd already known his work through having seen it in the exhibits along Madison Avenue in New York.

Following their African sojourn the Jeffries returned to New York, he to teach at City College and she to resume a job she had left as art teacher in the New York public school system. For a time things went well, until trouble erupted at both City College and in the New York City public schools. Students' demands at City College for a meaningful Black Studies program began to mount in much the same way they were mounting in the California Bay Area. In the New York City situation, however, the college refused to acquiesce in the demands.

Since Leonard Jeffries was the man wanted by the students to head such a program, his position, in view of official college resistance to it, grew tenuous. Simultaneously the United Federation of Teachers in a dispute with the New York City Board of Education threatened a strike, raising the probability of Rosalind's being forced out of the classrooms for an indefinite time. For the Jeffries couple as well as for thousands of others the immediate future looked bleak. Then came a break. Recruiters from San José State College in California talked with Leonard and Rosalind in New York. Would they be interested in teaching at San José?

For the next three years California was home. Leonard set up the college's Black Studies Program and Rosalind taught in the art department. Then another turn of events occurred which Rosalind recalls with some amusement.

City College in New York finally relaxed its opposition to Black Studies. Actually white students also wanted to gain a more realistic view of nonwhite groups through such a program. So the president of City was willing to introduce it. A group of students and faculty from City College flew out to California to get Leonard to head the department of Black Studies. At first Leonard refused. After all, he'd been at San José for three years and was building something there. Besides, Cali-

fornia is far more beautiful than the cement jungles of
New York City, so why should he leave to return to
that? But the offer became so luscious that Leonard
could not sensibly refuse it so we returned to New York.

Leonard Jeffries's work required that he operate suc-
cessfully at three levels, African, Caribbean, and Afro-
American. All three groups were and are in evidence in
New York City and their particular needs and problems
must be considered by anyone heading a Black Studies Pro-
gram at City College. Leonard is the proper man for that
task. Rosalind, meanwhile, continues with her career as
artist-teacher-art historian.

As a painter she has had one-woman art shows in the
Ivory Coast (1966); at Lafayette College in Pennsylvania
(1968); and at the Rainbow Sign Gallery in Berkeley, Cali-
fornia. And she has participated in numerous group shows
in California, Connecticut, Mississippi, Nevada, New Jersey,
and New York. Her teaching experience, spanning six years
as of 1976, includes work at both public school and college
levels. And in working with young people Rosalind aims at
something that for her is a very special target.

I am interested in closing the so-called generation
gap. There's a lot of heavy and profound stuff among
the old folks we tend to look upon as "square." . . .
When we lived in the Ivory Coast we'd see this old man
from our balcony. Every day he'd be sitting there and
we'd see different people standing or sitting around
talking to him. At first they appeared to be idlers—
folks just hanging around. What I had to learn was that
in their culture "just hanging around" meant coming
for counsel. Those people—many of them at least—had
traveled through the bush for miles just to bring their
problems to this wise old man who lived just next door
beneath our balcony.

Rosalind cites that experience as an example of the lack of understanding among so many of us in America of the role of the elders in cultures predating our own. Her hope as a teacher is that she can inspire students to communicate freely with her. As a student she knows the value of the relationship that induces one to seek the counsel of the seer. And Rosalind is still very much the serious student. Besides her activities as artist-teacher in New York she commutes to New Haven, Connecticut, where at Yale University she pursues study toward a doctorate. She gives her reason for so doing.

After teaching for three years at City College I decided that to do the art historian's job properly I needed to return to school.

In applying for admission to the graduate school at Yale, Rosalind cited her teaching and her overseas travel and work experience in Africa. The latter was especially important to mention, since her choice of specialization at Yale would be American Art and African Art. And to get the very most out of her study there she chose to work under the direction of Dr. Robert F. Thompson, "whose unique work," in her own words, "cannot be found elsewhere."

Rosalind's practical work as art historian moves ahead even as she continues with her study. A good example is seen in an excellent catalogue, *African Art Today: Four Major Artists*, May 14–August 31, 1974. The exhibition, shown at the African-American Institute in New York City, featured the paintings and sculpture of Skunder Boghossian of Ethiopia; Valente Malangatana of Mozambique; Twins Seven Seven of Nigeria; and Admir I.M. Nour of Sudan. The catalogue's explanatory text is the work of Rosalind Jeffries.

The artists are individuals with whom Rosalind has become personally acquainted, for it is her belief that contact with those of whom she writes and lectures is vital to any

profound understanding of what they are doing. Evidence of her familiarity with traditional African art is ample as one looks about the rooms of her home. There she and Leonard have assembled a collection of masks, figurines, stools, and drums.

The forming of closer ties with artists of the African continent is becoming increasingly vital to many Afro-American artists, as we have seen through the activities of Otto Neals, Alfred Smith, Jr., and now Rosalind Jeffries. Still their efforts in that direction in no way negate or even dilute their acknowledged ties to that which is native and dear to them here in America.

Rosalind is active with the previously mentioned black National Council of Artists, who are also alert to any possibility of forming international communication with fellow artists. Indeed it was at a conference held in Indiana that such Afro-American artists as Rosalind Jeffries, Jeff Donaldson, Ed Spriggs, and Dana Chandler came to meet Skunder Boghossian of Ethiopia and Ibriham el Salahi of Sudan. Simultaneously Rosalind Jeffries's appreciation of what we have going for us and what we are remains sharp and clear.

> We must never overlook what is right here under our noses. . . . A re-creation of our Black Studies programs, a re-understanding of our own worth is most vital to us as a black people, for after all, we are one people. I was made so aware of that when Leonard and I were married. At our wedding we were gratified to see not only our family members but also our neighbors, including the "numbers" man!

Her laughter fills the sunlit room.

John W. Outterbridge

Like many California residents, John Outterbridge is not native to that state. It is a fact he quite readily acknowledges.

> I was born in nineteen thirty-three in the tiny North Carolina village of Greenville, a community responsible to the people who lived in it. I have a slew of brothers and sisters—four brothers, three of them professional artists, the other a musician. I have three sisters, one of them eight years my senior. I'm the oldest of the boys.

The rich, resonant baritone bears traces of a southern accent this man makes no effort to conceal. He is tall and muscular and his natural manner makes you feel quite warm and comfortable. Moreover there is an eloquence in him. It is the kind of eloquence one recalls in the old-time black southern revivalist ministers who gripped and held fast the attention of their flock. Like those old brothers and sisters, John W. Outterbridge needs no coaching or prodding. He can talk, and his talking commands your attention too.

> Because it was always something I had an interest in I can't remember how and when I started in the arts. This came through my parents, for my mother always drew. She also played piano and clarinet, and it mat-

tered not how busy she was with us, there was always time for drawing the children and the activity around the house.

Olivia Outterbridge had an admiring and sympathetic partner in her husband, John Ivory Outterbridge. A native of Maryland, he too was creative, having always yearned for the chance to be the professional musician his leanings indicated he might be. His son describes him as "a kind of John Coltrane spirit" who exercised creativity in landscaping and in salvaging discarded items from which he made useful things. He did the latter solely for pleasure, his own as well as others'. From the junked parts he rebuilt bicycles for kids whose parents couldn't afford new ones. And he made small toys, carts, wagons, and the like which he gave as presents.

To earn a livelihood John Outterbridge, Sr. did landscaping for affluent whites and for the nearby East Carolina Teachers College. Insisting first and always upon being his own boss, he was equally insistent that his children stay in school. On that issue son John quotes his father with great feeling.

Whatever it takes I'm gonna be my own man. Now I'm not skilled with the pencil but I have my shovel and dump truck. And because I love you I'm making that shovel and dump truck my tools to support you. But I'm gonna kick your ass if you don't stay in school . . . or if you don't go back to school at night should you be foolish enough to quit!

John Jr. recalls that there were many times indeed when the family had nothing for breakfast other than corn bread, blackstrap molasses, and salt herring. Still, he never knew he was poor until he heard someone else say so. That the family was able to carry the burden of its financial shortage with

dignity was due in large measure to neighbors like the Reverend Highsmith and Mrs. Carrie Glover. John remembers the former as "a black man who lived in the forest."

Tall and with flowing white hair, the patriarch who walked barefoot the year round often stopped to have breakfast with the Outterbridges. His doing so gave the family the feeling of being able to afford to share what they had with another. In exchange for meals the Reverend Highsmith would read and interpret the scriptures. Mrs. Glover's function was quite different. A practical woman, she'd often appear at the Outterbridge home with a steaming and savory dish.

She'd call,

> Livy, I got some greens here. I—I guess I cooked too many. You-all will have to take these to keep 'em from goin' to waste. Wastin's sinful, you know.

Olivia Outterbridge took the greens as both women thanked each other—one for the gift of cooked greens, the other for being relieved of the burden of sinful waste. John Outterbridge chuckles softly as he recalls such exchanges.

> Mrs. Glover hadn't cooked beyond her need by accident. She planned it that way so my mother could share what she had and still hold her sense of pride and dignity. It was people like her and Reverend Highsmith who made me know I came from a very strong place and a strong people! It's the kind of strength we are trying to recapture as a people. It is what we once knew and it is being broken down.

School and church activities were prominent in the daily lives of the Outterbridge youngsters. And while John was by no means unimpressed by what went on in school he was often all but swept away by the fervor of the services in church, especially in one church not far from where the family lived.

My brother Warren—he's a package designer now—
well, Warren and I used to head out on Sunday for the
Sycamore Hill Baptist Church which was, in that small
community of ours, the sophisticated Baptist church
with a choir. There the services took a little while to
"warm up." But Warren and I liked the sanctified
churches. Man, they had drums and tambourines, and
one old sister used to blow trombone. Those churches
"jammed" all the time and that's where we wanted to
go. There was one right in back of us and we'd start
out like we were going to Sycamore Hill Baptist, but
we'd backtrack and slip into this sanctified church
where we could enjoy the music and watch the show!

When John was about twelve and in junior high school
he became involved in the building of model airplanes, which
he describes as "not mere toys but technically built model
aircraft." Through arduous study he had taught himself to
build them. Normally there would be little outlet for such a
hobby practiced by a black schoolboy in a small southern
town. John was luckier than most. An enterprising Yankee
from Massachusetts named Bundy had come to Greenville
and opened a hobby shop which sold model planes. When
he saw what John could do he gave the boy a job building
planes for his shop. Young as John was, his models sold very
well. Moreover he gave lessons in model plane building to
white boys several years his senior.

The family fortunes in the interim were on the upswing
because of America's entry into World War II and the in-
creased earnings of the senior John Outterbridge. Since most
of the men of the neighborhood had taken jobs in the nearby
war defense plant, the elder Outterbridge was strongly
tempted to forego self-employment and join them. When he
asked his wife if he should take such a job and she, as usual,
left the decision to him, he hit upon an idea typical of his
creative free-wheeling spirit.

All them boys that's got them war jobs down at Cherry Point Marine Base ain't got no way of gettin' there. I can do somethin' about that!

Trading his dump truck for a flatbed truck, he improvised a "bus" for transporting as many as he could carry. In a short time he had more than twenty riders. He then convinced a few others that by getting trucks they could form a small transit line between Greenville and Cherry Point. The others followed and for five years that is how they earned their living without having to go into the plant to work. Such was the inventive spirit of a man who made the most of untrained skills. When he could not afford to buy toys for his children he made toys for them. And as he had earlier watched his son laboring past bedtime on a model plane he understood the nature of the urge.

Son, I don't mind if you stay up all night building your model planes 'cause I like 'em too. I ain't gonna make you go to bed, long as you ain't wastin' your time!

Through the steady practice of constructive creativity father and son had grown to understand and respect each other before the son had reached his teens. That understanding and respect still exists between them. Meanwhile, the boy attended the C.M. Epps High School in Greenville where Madge Allen exerted an enduring influence upon him. Coming from Boston with excellent training, she looked at the paintings John had made on discarded window shades and proceeded to help him understand what art was all about. So inspired was John by this interested black woman that he began to think seriously of continuing his studies beyond Epps High School. But where?

Seven minutes' walking distance from where I was born was a beautiful college—East Carolina Teachers College. But in my days as a school kid you didn't go

there. In fact, you could barely go on campus! Even before graduating high school I used to think what a beautiful thing it would be if I could go there because it was so close to home.

There was a chance, however, for John to continue his education at the black A. and T. College in Greensboro, and that is where he went. There he enrolled in the department of engineering but spent a lot of time poking around A. and T.'s art department. H. Clinton Taylor, who had established the department a quarter-century earlier, was quick to recognize talent. As he examined John's work, Taylor urged the young man to take his art more seriously as long as he was still interested in it. Meanwhile, America's entry into the Korean conflict forced a change in John's plans.

The only way I could hope to stay in school was either by joining the R.O.T.C. or by getting a deferment. So I enrolled at A. and T. in the Air Force R.O.T.C. in nineteen fifty-two, and took the written exam only to be rebuffed by a semiliterate sergeant. Here's what that cracker told me. . . .

"You did pretty good on the exam but I'm sorry to tell you that they gotta quota for y'all an' that quota's full up."

Even as he speaks of it today, John's recollection of that unhappy encounter threatens to overwhelm him. For a few angry seconds he lapses into the argot of the streets.

Man, I was so hurt I kicked that cat's desk. I cried and walked outta there and DIDN'T SAY NOTHIN' TO NO-BODY FOR THREE DAYS, MAN! I could see myself ending up in one of them hills in Korea with a machine gun! THAT AIN'T MY THING, MAN! LET ME FLY ABOVE THAT SHIT, MAN, 'CAUSE I'M READY FOR THAT! That cat made me MAD! !

The following day John took the exam for the army and wound up going to Camp Atterbury for training for Korea. He finally ended up in Germany, thoroughly skilled in the art of killing. For three years he served as a specialist in ammunition.

The man had taught me how to take apart any weapon used at that time. It was a little later that I became an ammunitions specialist. And after I came out of the army and civil strife began to surface I thought of myself as a person who could lead a guerrilla contingent successfully because of what I knew about bombs and explosives. But I felt that my responsibility might fall in the area of creation rather than destruction. I suppose that was my father's influence.

In Germany John, because of his R.O.T.C. background, ended up as "a minute minority" in his division. By then the services had become integrated. The Germany he saw in the early 1950s was closely related to his own bitter experience with racism.

I saw university professors digging ditches and old ladies pushing wheelbarrows as they rebuilt Germany. And I saw white American soldiers brutalizing the elderly Germans. Black soldiers, however, who'd been kicked in the ass had compassion for the Germans. You'd hear them yelling at their white fellow countrymen, "HEY, MAN, DON'T KICK THAT OLD LADY!"

To the Germans who had never before seen a black, John Outterbridge was a phenomenon—one not to be hated or feared but one to be looked at and wondered about. Within eighteen months he was speaking two German dialects fluently and was using every spare moment sketching and painting his surroundings. Naturally he invariably drew a crowd each time he worked outdoors and he soon lost

count of the many times he was approached and spoken to by the German people.

"Are you from Africa?"

"No, I'm from America, I've never had the opportunity to go to Africa."

"Aah-ah!"

John would begin to tell them about the part of America he had come from and he often discovered that the scholars among them already knew a lot about the American South.

Man, those people knew more about your history than you did. They were really into it! They invited me freely to their homes and I had girlfriends aplenty.

Though it took a little while for him to discover it, John had another good friend in the U.S. Army. He was Captain Robert Cook and one day when the captain came around to inspect barracks he saw John's locker full of paintings and sketches.

"Whose are these?"

"They're mine, Sir."

"Where'd you get them?"

"I painted and sketched them, Sir."

"Hm-m-m-! Come to my office when I'm through here."

"Yes, Sir."

The things Captain Cook had seen were done from what John had observed around the encampment—German dwellings, the landscape, village people, oxcarts, a little old peasant lady. Captain Cook was impressed. In fact he bought five of the paintings for his own collection.

"Outterbridge, how'd you like to be set up here in a studio?"

Unexpected as the question was John was by no means lost for a reply.

"That would be just fine, Captain—but just what would I have to do?"

"Just keep on painting. I can always get other men to do this routine stuff. My first assignment for you is to create an environment in the Officers' Club—you know the kind of thing needed—scenes of America familiar to our officers here."

John was flabbergasted but not too much so to thank the Captain and get out of the way before the man had a chance to change his mind.

Captain Cook gave me a budget, a jeep, and a studio! Man, I took full advantage of my good fortune and let the white boys go up in the hills with those machine guns and all that shit. I was still mad about what had happened to me at A. and T.

As John relates this story one of the brothers sitting around jokingly suggests that he had become "Captain Cook's nigger." The artist's reply is as quick as it is practical.

Yep, that's right, I was. And under those circumstances I WAS DAMNED GLAD TO BE!

In addition to decorating the Officers' Club John did an appeal display for aid to polio victims complete with an iron lung facsimile. Not only was the display exhibited in the mess hall but it wound up reproduced on the front page of *Stars and Stripes*. He also left murals in a German high school and easel paintings with German friends. In another instance John assisted a friend, who was an automobile mechanic, with his study of English. Before John left Germany the friend brought him a present—a Mercedes Benz, and a collectors' item at that!

The return home from Germany was a great letdown. John was distressed to find that many friends and acquaintances in Greenville were stuck in the same rut he had left them in. And it was all the more heartrending as he realized that while he could greet them in German and relate incidents of unusual human interest, they were still hanging out on the corners telling the same old lies and swilling the same old poisonous booze. For his part, returning to school was paramount.

He could easily have returned to A. and T. College at Greensboro, but he felt that the school was not able to offer him all he needed. With his G.I. Bill it was possible to go almost anywhere he chose. As a boy he had been taught by his father to find his way alone out of the woods. Moreover, he had not only survived in Stuttgart and other German towns but, with a fair command of the language, had gotten on rather well. There was no reason, therefore, why he should hesitate to try life in one of America's metropolitan cities. John took off for Chicago.

The American Academy of Art was his choice of a school in the famed Windy City, but when he enrolled he discovered that his G.I. allotment was not enough to cover the cost. That was no formidable barrier to the objectives of John Outterbridge. Like most boys he had learned early to drive a motor vehicle, so to earn what he needed for school he found work driving a bus for the Chicago Transit Authority. It was a job that paid very well indeed. His memory of earlier days at the Academy, however, when he had no such work, are still fresh in John's memory.

There weren't many of "us" there at that time. Those who were there were not really of our stripe at all. They were very "white"—very conforming in their thinking. Even Mr. Van Brocklin, the teacher of life drawing, didn't grasp the significance of what I was—that I'd

been in the war—that I lived on the South Side of Chicago—that at that particular time I owed rent—and that for lunch I was making it on a small carton of milk and vitamin pills. . . . So when he looked at what I was drawing he told me that I was doing okay but that I should be doing it on a better grade of paper than the newsprint I was using. What he had in mind for me was more than I could afford at that moment so I bought what my money could pay for.

While the teacher was not deliberately cold and unfeeling about his pupil's tight circumstances, it jarred his esthetic senses that good drawings would be made on cheap paper. He did, however, finally select one of John's newsprint paper drawings for hanging in the place of distinction on the bulletin board. A few weeks later a couple of other classes began using newsprint. And, as John humorously puts it, "If I'd done what Van Brocklin suggested I'd have been evicted from my room!"

One of the few fellow black students at the school with whom John had easy rapport was a fellow named "Buck" Brown. In fact, they drove buses together in order to get through the course. Today Buck Brown is known to thousands of *Playboy* magazine readers through his hilarious cartoons.

Buck was a tall, talented, handsome black dude and he had the attitude to go with his work. He went down on Ohio Street to *Playboy*, ivy-leagued to the hilt, and with no appointment, demanded to see Hugh Hefner. He saw him and showed his portfolio. The following month his first illustration appeared in *Playboy*. Three months later he had three more in, and he's been in ever since.

Outterbridge spent ten years in Chicago, during which time he met and married Beverly Marie McKissick. Then

for a time he was in show business as a singer with a jazz quartette and was persuaded by a friend to think about moving to the West Coast where the winters are far more benign than those of Chicago. So after two years of marriage he and Beverly decided, since there were no children at that time, to make the move west. They drove out in 1960 and within a week Beverly had a job. Because of his position as instructor in bus driving for the Chicago Transit Company John could have followed that work in Los Angeles. Instead he waited three weeks and found a job in art.

I worked with Tony Hill, the internationally known ceramist, who died suddenly of a heart attack in Cairo, Egypt, in nineteen seventy-five. I stayed there three or four months with Tony before going to Contemporary Crafts in East Los Angeles. They employed about thirty-five artists—none black—and my portfolio got me in immediately at two dollars and seventy-five cents an hour.

There were about nine artists in the department John worked in. Of those, two were Oriental and two Chicano. The others with the exception of John were white, and the majority had been trained at the Otis Institute of Art. Contemporary Crafts was a nonunion shop. After working there three weeks John learned that the department he was in shipped out $10,000 worth of work daily. After revealing what he had learned to the rest of the group they jointly decided to walk out for better pay. After their first week out the company offered each worker $350 per week to return.

I was painting in many styles for eight hours each day on that job and I left after five years. What I wanted to do was some creative work that in no way reflected what I was doing in the commercial studio. My interest in sculpture had always been high so at home I worked in three-dimensional forms rather than painting.

John left Contemporary Crafts Studio in 1965 to pursue what he considered more serious painting. The decision was doubtless motivated in large measure by a holocaust that struck in Los Angeles and ricocheted across the nation during the summer of that year. A potentially explosive unemployment rate of 30 percent, along with poor housing and poor school facilities, was holding the black area called Watts in a viselike grip.

More than a half-million people (90 percent of the blacks in Los Angeles County) were boxed into Watts with no prospect of escaping its poverty. And though Watts residents were far from satisfied with their situation they had managed to make an emotional adjustment to it in anticipation that conditions would grow better. They didn't. All that was needed to set off a fatal blast was a single incendiary incident. That incident came at 7:45 P.M., August 11th, 1965.

Twenty-one-year-old Marquette Frye and his brother, who were passengers in a car, were stopped by two white highway patrol officers and charged with "drunken driving." Marquette was the driver. A crowd that included the young men's mother quickly gathered and began to protest what it considered unnecessary force used by the officers in seeking to make arrests. Tempers rose and verbal insults directed at the officers by onlookers were soon accompanied by the hurling of rocks and bottles. As the crowd's numbers increased and police were unable to control them the situation assumed the form of a full-blown riot.

For six days angry mobs smashed, burned, and looted the area. Thirty-four persons, most of them black, died. Hundreds sustained injuries. Loss and destruction of property was estimated to be between forty million and two hundred million dollars.

The violence at Watts during "The Long Hot Summer of 1965" set a pattern that was repeated elsewhere through-

out the nation two summers later, notably in Newark, New Jersey, and Detroit, Michigan. With his particular experience and temperament John Outterbridge could not bear witness to such human tragedy and not be moved by what he saw, heard, and felt.

I began to work in sculpture and to show them. One of my early shows was held at Coleman Methodist Church and through that show I met Alonzo Davis and right then and there in nineteen sixty-seven we formed an instant union.

That meeting of Davis and Outterbridge proved to be an important event in the lives of both men. Southern-born Alonzo Davis, himself an artist, is the founder of Brockman Gallery Productions with its handsome and well-located quarters in Los Angeles. Opened in 1967, the Brockman Gallery has shown, and continues to show, the works of black artists, many of whom for a time had no other regional place to get such exposure and recognition. John Outterbridge is unstinting in his praise of the Brockman Gallery as he and Alonzo Davis sit over a bottle of wine and homemade fruitcake to discuss some of its most important activities.

Some strenuous problems and questions have been strenuously thrashed out right here at the Brockman Gallery, as well as in the board rooms of important museums and galleries in Los Angeles and in New York. We discovered here that many of us artists met on common ground. Alonzo [Davis] here, Bernie Casey, Dale Davis, Suzanne Jackson, Ruth Waddy, Milton Young, Samella Lewis, E.J. Montgomery—all of them and others, too, have had some connection with this place. Suzanne Jackson later opened Gallery Thirty-Two. . . . And Watts Summer Festival was a very important thing to black artists and to black people of Los Angeles at large.

Both Outterbridge and Davis feel that they owe much to the inspiration provided by Noah Purifoy, a native of Snow Hill, Alabama. They speak of him with reverence and respect, as this Davis comment implies.

> Noah is an older gentleman who came out of the Watts riot period. In a sense he was the father of the energies that came out of the riot. Noah was and is a powerful man who can, on a grass-roots basis, engage you in an intellectual dialogue that will blow your mind!

Inspiration of the sort Noah Purifoy offers came at a time when it was badly needed by the adherents of the Brockman Gallery. They were scarcely known and had been given a rather cavalier going over by art critic William Wilson of *The Los Angeles Times*. A group of black artists including Charles White, Samella Lewis, and John Outterbridge had a TV confrontation with critic Wilson in which Wilson was flatly told he had no idea of what black artists and their statements were all about. Their suggestion to him was that he first familiarize himself with what they were doing before writing his views. To Mr. Wilson's credit he did not ignore them, as John reveals in the following statement.

> Wilson came to the Brockman Gallery and wrote as positive a review as we could ever hope to get from him. And when we started to get ink from that source other recognition began to come.

From the viewpoint of the black artists of the Los Angeles area the breakthrough was as significant outside California as it was locally. First, it gave them confidence to know they had a place of their own where they could show and be recognized as professionals by the media. That was vital to artists who had previously been obliged to take their chances with the established white galleries who were sel-

dom prepared to understand what they were doing and why.
For John Outterbridge it was a personal triumph.

My first one-man show was also the first one-man
show put on at the Brockman Gallery. We sold out
everything and it was purchased by the Jewish com-
munity collectors who supported this gallery. . . . And
what followed was a realization that we needed not to
be so concerned with getting recognition and accep-
tance in that well established apparatus. What we say
now is: "Walk up and down Forty-third Street and Cen-
tral and find a warehouse and out of that build your own
accommodation." We're serious artists here and if a
white artist wants to show here he is welcome—as long
as he knows and understands what we're all about. . . .
As to sales, many are made to the brother or sister who
has to put down a small deposit and pay the rest in in-
stallments. Alonzo has paid many an artist for a work
marked "sold" without ever getting all of his from the
purchaser.

That, basically, is what the Brockman Gallery and offi-
cial recognition of it have meant locally to its participating
artists. Its influence, as has been suggested, does not end
there. Alonzo Davis and his group established immediate
contact with East Coast artists, among them Benny Andrews
of New York, and Dana Chandler of Boston. The latter had
a concern for the manner in which black artists of their area
were being received or not received in recognized art cir-
cles. Both the Whitney and the Metropolitan museums had
come under fire from black artists. The black artists charged
both institutions with discriminatory treatment because they,
the artists, were not producing what was being currently ap-
proved and sought by those who establish and fix trends in
art.

In many ways this California group is reminiscent of

the Weusi group in New York with whom Otto Neals and Kay Brown are affiliated. Certainly they share common aims also with the National Conference of Artists to which a number of the artists already mentioned in this narrative are contributing their support. John Outterbridge in particular insists upon his right as an artist to individual expression—an insistence that expanded following his affiliation with the Brockman Gallery.

I began then to follow an inner voice telling me to stop working for a while in the conventional sense and to try concepts that extend beyond the museum system.

His recent works are startling testimony to that fact. Moreover John, who devotes considerable time to teaching, knows how valuable the experience can be. For three years between 1970 and 1973 he taught Afro-American Art History at California State College. He conducted that class on a long lunch hour two days each week while his full day's teaching was done at the Communicative Arts Academy in nearby Compton. And on Saturdays and a couple of evenings he held a sculpture class at the Pasadena Art Museum.

I had one of the first combined adult-children's classes there in sculpture even as I carried on my work in the installation department of that museum. My work there afforded me the chance to meet big-time artists, for one thing I did there was help install their works.

One such artist, upon observing the tools (or, more aptly, the lack of them) John was trying to use, was shocked. He brought in a set of tools.

Here, hold these for me until I can pick them up. Meanwhile use them if you need to!

John had been bending metal with his hands until that moment when he was handed electrical tools for bending, shearing, and welding.

That artist was a *real* friend!

On the other hand, there was the museum curator who would drop around John's backyard to see what he was doing. His questions were constant.

What's that material? I don't understand what you're doing.

John was welding copper to aluminum—a process the curator didn't fully comprehend. The artist kept on welding without attempting to explain anything.

That man carried me back to the day the sergeant told me how well I'd done on my test but that "there's a quota on y'all and it's full up."

The anger passes as quickly as a summer sprinkling of rain.

But then I began to contemplate my early life. Where did my inspiration come from, I ask myself. To whom am I responsible? It came from Greenville, North Carolina—from all those sincere souls I knew there. . . . It came from all the crudeness I found in making my adjustment to the world after leaving home. It came from experiences in Germany—especially from the love of the people and even from the German cat who saw me as a black demon and tried to decapitate me with a shovel. All of these combined elements made me work!

As to where and to whom he felt responsible, John's answer is that in his investigation of the elements that made him work he had to leave the confines of his studio. For him the real studio—the studio where the truth exists—is the streets where people are.

In 1974 he was awarded a commission from the Watts Housing Authority. With the money allotted John was to do

something symbolic of the community and its needs. He chose to do a piece of sculpture near *The Freedom Tree,* a significant Watts landmark. The tree was the one bit of vegetation left after the burning of 1965, and it became a gathering place for militants because of its representation of survival. Outterbridge tells what transpired.

I had invited several others to join me in coming up with this concept. They were Dale Davis, Elliott Pinkney, Nate Foranz, and Charles Dixon. Each of us worked separately and we were to put our contributions together when we finished. And it was to be changed each year by four other artists. We had planned a thirty-seven-foot, four-sided structure made of steel, concrete, and wood.

Well, the thing was sabotaged by an artist who burned out the wooden panels installed in steel framework. Each artist would have had a chance eventually to work on it for we planned it that way. But this fellow couldn't wait. He destroyed what was there and his destruction of it became his contribution to the creation. In fulfilling his ego he eliminated his opportunity to make a valid statement. But the piece is still living in photographs of what was there before the burning and the later bulldozing by Urban Renewal Project.

That tragic incident has by no means divested John Outterbridge of either spirit or ideas. Along with others, including Noah Purifoy and Suzanne Jackson, they hope to establish a "museum on wheels," using freight cars as galleries. Their thought is "to bring visitors to the freight yard and to our side of the tracks to see what we are doing." The plan as presently envisioned goes beyond dealing with single patrons, involving also banks, foundations, the National Endowment for the Arts, and the Los Angeles community at large. With black Mayor Tom Bradley heading the city ad-

ministration they feel their chances at succeeding are good. John sums it up this way.

> Our idea is to explore what we can do to make art not mere decoration but culture. It is to explore how we can use art to bring about change. And it is to create reality in the way of accommodation from the community point of view. That is our aim.

Horathel Hall

I was born here in Houston and I celebrated my forty-ninth birthday not long ago in Abidjan, Ivory Coast, in West Africa.

The soft-spoken lady, trim and attractive, looks considerably younger. Nor does she reveal in either mannerisms or mode of dress the exciting creativeness that is a part of her. But it is there nonetheless. It is in both the mind and hands that, working together, transform Horathel Hall from the seemingly routine teacher to the splendid designer-craftsman she also is. This artist, in recording her narrative, is the antithesis of John Outterbridge. She is frugal with words.

One of two daughters of Isabel and Horace Dickey, Horathel attended the Douglas Elementary School in Houston's Third Ward. Then as now the majority of Houston's black citizens occupied that city's Third, Fourth, and Fifth Wards. Following the pattern of the neighborhood school concept all children attended schools in their respective wards. Schools in the black wards were staffed by black teachers and their facilities were rarely, if ever, equal to those of schools in the white wards. Douglas Elementary was no exception. It was the school the two Dickey children attended until the separation and eventual divorce of their parents moved them to another ward.

In the Fifth Ward I went to Crawford School. That was a sad time of my life because with my parents' breakup I also had to leave all my friends of the Third Ward. My mother, sister, and I went to live with my mother's sister, Clara Woods. Both changes were hard for us kids to accept.

The sorrowful events notwithstanding, Horathel found joy in growing her own little plants in the family's yard— lining them up in tin cans and caring for them with all the love of a seasoned gardener. That, and making doll clothes, were great hobbies. Even before they ever owned dolls she and her sister, Clara B., would make them out of soda pop bottles using rope for hair. When the real dolls came (usually at Christmas) Horathel in particular designed clothes for hers out of scrap materials, trimming them off with bits of fur and felt.

Home, school, and church formed the three big .segments of the children's lives, with home and church jointly absorbing their attention and energies. In that regard a close parallel may be drawn between the early experiences of several other black artists already mentioned in these pages.

Going to church was also a part of our family's tradition and we hovered between the Baptist and Methodist faiths. The Methodist church we attended while visiting our grandparents in the country was one of those shouting Methodist churches where folks really let go of their emotions whenever the spirit moved them. . . . We'd go down to the country every summer after school to visit Grandma Olivia Jammer, my mother's mother.

Horathel describes Grandma Jammer as a hard-working woman who was a very strong force in her life as a child. Widowed at a fairly early age, Mrs. Jammer was left with six girls and one boy to raise. She did it alone, choosing not to

marry again. A woman physically capable of performing manual labor in the fields, she taught the young ones around her to help—especially with the raising and picking of cotton. Horathel readily admits now, as she did then, her inability to match her strength against that of her grandmother and others who could work in the fields.

> Though I tried—and I mean I tried—I was never able to "chop" cotton or to make a bale as a picker. So I learned to work in the house. I learned early to cook and take care of the house for her and the others while they were working outdoors.

Such was life for Horathel and Clara B. during the summers they were out of school and had left the city to visit with their country relatives. Contact with her father was by no means dead.

> Through all of this we kept in close touch with my father, who had moved to California and later remarried. He was an excellent houseman, cook, and butler. At the same time he didn't like being so closely dependent upon white people for his livelihood. So he taught himself to be a shoe repairman and established his own shop in nineteen forty-five and maintained it in Los Angeles until he died about three years ago. My father didn't drop us. He paid my way through college, and I am quite proud of his memory.

Between grammar school and college, Horathel was a student at Houston's Phyllis Wheatley Junior and Senior High School. Up to the time of her enrollment there, the only drawing she did was copying comic strips, and since there was no art class at Phyllis Wheatley she settled for music and sewing. Both she and Clara B. had been given piano lessons and Horathel had advanced to the fourth grade book before shortage of money forced her to give up the in-

struction. Conscious then that college music majors were
more advanced than she was, Horathel voluntarily went back
to dressmaking "for my guide to advanced study." Her deci-
sion was wise, for the guide she sought was right there in
her school.

In a large measure I am indebted to my dressmaking
teacher in high school, Mrs. Couch; and while I was an
honor student all the way through I worked closely with
her for three years. Mrs. Couch encouraged me to con-
tinue on to college and she recommended Prairie View.
It didn't matter to me at the time what I was going to
study in college. My concern was with getting there,
for I felt once there I'd find my way into something
that would be right for me. I finished high school in
nineteen forty-four and entered Prairie View that same
year, with my father paying my tuition and my mother
assisting in other ways. And though they'd hoped I'd
major in music they went along with my choice of tail-
oring in the department of Industrial Education.

At Prairie View, just a short distance northwest of
Houston, students were permitted to choose electives and
Horathel chose art as one of hers. Theresa Pratt Allen and
Janice Walden became her first formal art teachers during
her junior year; and because the courses they offered were
designed to accommodate the department of Home Eco-
nomics, Horathel held little hope that they would be inter-
esting. She imagined, for instance, that she'd be working
with stencils, and stenciling designs on glass was not her
idea of creativity. But Janice Walden was young and imag-
inative. Out of Atlanta, Georgia, and on her first job, she
brought enthusiasm and vibrancy to her work. She had her
students drawing and painting from still-life arrangements,
which for Horathel Dickey and many others was a new
experience.

This was the first time I had the opportunity to do drawing as such and I wish I'd gotten it sooner. But I made the most of those last two years at Prairie View with what Miss Walden offered. And I had enough credits to have art as a minor subject, and I was graduated in nineteen forty-eight.

At that very time a man from Mexia, Texas, up in the Waco area, was looking about for someone to teach tailoring during the summer of 1948 to a group of veterans of World War II. Horathel, who had just been graduated, got the job, and left home for the first time to fill the assignment. Returning home at the end of the course she began looking about for work as a tailor, only to learn, ironically, that no women had ever been hired as tailors in Houston. While she was good enough to train men in tailoring, precedent was not about to be broken for her. Moreover, with all her skill and knowledge, she couldn't work on her own at home for she had no equipment—no heavy-duty machine. Horathel took a job in a retail store in Prairie View. It was then that she and Howard Hall, a former fellow student, decided to marry.

For a while Howard continued to teach in his hometown and in 1950 he and his wife returned to Houston, where their first child was born. When the infant was old enough Horathel applied for and got a job as a teacher in the Houston city schools. She got it on the strength of the courses she had taken in art at Prairie View and on condition that she return to school for further credits. That is when she decided upon study at Texas Southern University right there in Houston. Horathel Dickey Hall describes her initial experience as a student of art in a new but swiftly developing department of art specialization.

At that point I needed contact with someone who could help me strengthen my weak background in art.

John Biggers was that person. And though his depart-
ment was barely more than a year old I took mural
painting, from which I learned a lot. John Biggers was
most encouraging, especially in view of my self-con-
sciousness of working with students eight and nine
years my junior.

Drawing and painting intrigued Horathel and she
eagerly absorbed as much knowledge of it as she could
from the abundance shared by Biggers and his assistants,
Joseph Mack and Carroll Sims. Still she searched for yet
another medium to which she could more personally relate.
At the same time she felt the need to earn a master's degree
in art and T.S.U.'s young department was not ready at that
time to offer it. New Mexico Highland University in Las
Vegas, New Mexico, did, however, offer the courses she
needed. Since the university was just over in the adjacent
state to the west and easily accessible, it seemed the logical
place to go. Horathel's brief description of how her family
united to help her achieve her objective is a lesson in the
power of the kind of hope, faith, and love required of such
an effort.

Though I had two children, both my mother and my
husband's mother helped look out for the children dur-
ing the summers—enabling me to pursue my advanced
study. And my husband was very cooperative. It took
me five summers to get through but I stuck with it . . .
even through a third pregnancy.

Weaving came into Horathel's consciousness during
her second summer at New Mexico Highland University.
There was something about handling the fibers and dyes,
especially the natural dyes extracted from roots, onion skin,
and bark, that in her own words "turned me on." She went
to the houses where raw wool was brought in, purchased it

in that state, washed and carded it, and spun it before taking it to the loom to weave. Beginning the study of weaving in 1956, Horathel was out one summer with the newborn infant and resumed school again in 1959. At the end of that summer she had three more to go.

> Each successive summer found me studying further out in New Mexico and in nineteen sixty-two I had earned my Masters in Weaving and Pottery. . . . I'd spent so much money on wool I was afraid I'd not have enough for my fare home. And my excitement about weaving made me know I'd have to have a loom. My mother-in-law, Clara Hall, a home demonstrating agent who'd also done a little weaving, suggested I look in the Sears Roebuck catalogue for one at a reasonable price. I found one and paid ten dollars a month until I owned it.

Back in Houston with her newly acquired skill and a lot of imaginative ideas, Horathel Hall, along with two others she knew, applied for membership in the Contemporary Handweavers of Houston. Never before had the group received applications from black weavers. Unsure of what to do in such an unusual situation, the association decided to take a vote on the matter. First, they had to see what these three black applicants could do. Horathel quietly and briefly relates what happened.

> One of the white members who was friendly with one of our black craftsmen knew I had been to New Mexico and she'd heard of the weaving I'd done. So I was invited to bring in my work and present it as the program of that particular month. This really turned them on. The three of us were admitted to membership that night.

Horathel Hall readily admits that during the early days of her membership some of the white weavers were cool

and hostile. But as she explains it, she knows her ability as a weaver and it did not take them long to discover that integrating the association was not a one-sided arrangement. The white craftsmen stood to learn from their contact with competent blacks. Meanwhile, keeping her creative work alive while earning a livelihood as a public school teacher of arts and crafts is no easy task. Horathel Hall manages to do both.

I remember Dr. Biggers's advice to "keep something creative going at all times and do a little something every night." Very often I do that. And even better, I do a lot of weaving off the loom . . . on a small portable frame I carry about with me. Finger weaving and such doesn't confine me to the loom. And doing it provides inspiration to the children, who are stimulated by what they see me doing.

Although the classroom occupies an important place in her life, it is in her work as a weaver that this artist takes particular pride. She is especially given to working with natural fibers, having begun her career handling the natural fibers of wool. With her newly acquired membership in the Contemporary Handweavers of Houston she began to show her creations and has been doing so ever since. Recognition has by no means eluded her.

In 1969 a macrame vest by Horathel Hall won first place in a convention competition. That achievement quickly dissolved any reservations about her skills that might previously have existed. Indeed, it may be said to the credit of most true art lovers, and Texans are no exception, that their concerns in judging the works of artists of any ethnic group center primarily upon the quality of achievement. That is evident in the acceptance of yet another brilliantly talented young black woman, Jean Lacey.

Ever since the early 1960s when she became a member of the Contemporary Handweavers, Horathel Hall has kept

her affiliation with the group active. By so doing she is kept informed not only of what its members are currently achieving locally but also with the work of other weavers elsewhere. The network of interest in the craft she practices extends well into distant areas of the world, as Horathel Hall discovered only a couple of years ago.

At one of our Contemporary Handweavers' meetings the white member in charge of that particular evening's program had with her several examples of African handcrafts from Liberia. One of the items that captured my fancy was a rice bag. I examined the bag—its very special weave, and especially its shape.

The rice bag Horathel held in her hands at that meeting wasn't particularly large but its cylindrical contour and eight-strand braid weave excited her. She deduced that while the bag had been originally designed in Africa to hold a small quantity of rice, its general utilitarian possibilities were limitless. In fact, the Liberians themselves often use the item in a general way. It took only moments for the wheels of creativity to start in Horathel's consciousness. She began to ask herself a few questions.

Could I not weave a large version of the rice bag? What particular kind of fiber should I use? Must I confine myself to using any of the traditional fibers I've been working with? While asking herself such questions yet another thought came to her. Why not go to the source and see not only the subject itself in its varying forms but also the setting in which it is fashioned and used? From such a visit she could gather enough information and inspiration to form in her own thinking the various possible designs she could derive from that particular craft object. Seeing one in Houston was intriguing. Seeing scores of them in their African setting would be a truly stimulating experience. It was an experience Horathel knew she must have.

The summer of 1975 offered the chance to visit West Africa, and Horathel seized it. She visited Togo, and the capital cities of Lagos, Accra, and Abidjan in Nigeria, Ghana, and Ivory Coast respectively. While Liberia was her immediate objective and she got there, her most exciting personal experiences came in Ghana and Ivory Coast.

> The visit to Liberia was brief and while I did not get to the villages where the weaving is done I saw the results in Monrovia.

Horathel not only saw the results, she brought several rice bags back to Houston. Full of excitement over what she had at hand as models, she was soon browsing through Houston's stores in search of fiber for weaving. Because she had resolved to weave a large version of the rice bag she began to search for a large quantity of weaving material. Shopping took her to many places, one a local Army-Navy Surplus store where she found a lot of belting available at a reasonable price. She purchased all the store had in stock. The rice bag, because of its cylindrical shape, is not woven on a loom, but on a hoop. With the material she had bought Horathel went feverishly to work weaving creatively and thinking simultaneously about the Liberian creation that inspired her.

> I made about six pieces. And as I worked I found that the belting I was using is not as strong as it should be for the size bag I wanted to make. So I'm still looking around for a fiber that will hold up well.

You look at this woman's exquisite work and you immediately know why she is respected by her peers. Many artists are far more verbose than she and one enjoys as much listening to them speak of themselves and their work as one does viewing what they do. Though Horathel Hall is quiet and sparing of speech you find her not only informative but

pleasant and easy to be with. Indeed she is the near-perfect example of the truth that the making of art is not sleight-of-hand but a mental process in which the hands become merely the instrument that performs the dictates of the mind. You ask her for a statement that covers her approach to weaving, and you know her response will be concise and direct.

I like to have lots of raw, unspun materials on hand—rope, jute, feathers, even driftwood. I study it and finally things begin to happen—mentally. . . . So in doing my work I prefer nowadays to work with a mental image of what I want to do, rather than with a sketch. . . . I like to let the materials I am using suggest what I shall do with them as I work. . . . In this way the creative effort remains in a state of constant improvisation.

The most celebrated of the world's artists have never voiced nor practiced that principle with greater conviction.

Leo F. Twiggs

SOUTH CAROLINA was a rough place in which to be black and poor when Leo Franklin Twiggs was born there in 1934. Rural South Carolina could be, and often was, a nightmare—especially for black males. Such had been the case for a long time.

In the thirty years between 1889 and 1919 South Carolina mobs lynched 119 individuals. With few exceptions all were black males. Only a year prior to Leo Twiggs's birth Norris Bendy and Bennie Thompson were murdered by lynchers in Clinton and in Ninety-six, South Carolina, respectively. Among the knowledgeable, South Carolina's record of brutalizing its black residents from the late nineteenth century into the 1930s ranks among the nation's worst. The large numbers of black migrants from rural South Carolina to northern cities testifies to that fact as well as to the general poverty that for so long gripped the workers of that state. Leo Twiggs speaks of his birthplace.

> I came from Saint Steven on Route fifty-two, forty-five miles from Charleston and sixty miles from Florence. We lived on a small farm and my father, Frank Twiggs, worked in a mill. He had come to Saint Steven from Mississippi, and Saint Steven grew as a mill town dominated by the Santee Mill Company.

Leo Twiggs is a handsome, friendly man. The warmth he exudes is part and parcel of his southern rural upbringing in a black community where the open hospitable manner is commonplace. There people address each other as "brother" so-and-so, and "sister" so-and-so. The greeting itself suggests that they care what happens to each other. And they like to engage in conversation—a social grace one misses in the terse impersonal atmosphere that pervades our large cities. Leo enjoys conversing and he does it well. To tell him he reminds you of some of the "good ole country boys" you've hob-nobbed with in his native South Carolina pleases him immeasurably.

My mother, Bertha Lee Meyers, was a native of Saint Steven. Her people were rural South Carolinians and when she and my father married they moved closer to town [Saint Steven] and bought an acre of land from my uncle. Her side of the family owned a little land. So my father, working at the mill, bought his lumber cheaper and built the house we were raised in. I was born at my grandmother's house and I was the first-born of six boys and one girl, since that is where Mom and Dad lived when they first got married. As the family grew my parents added rooms to the house to accommodate us all (the girl didn't come until the last) and that is how we managed to be together.

In the Twiggs's home, church activities were closely interwoven into family life. Leo describes his father as having been "a great church man" who was not only a deacon in his church but superintendent of the Sunday School as well. Bryant Chapel was the church and it was named for one of Leo's maternal great-uncles, who donated the land on which it was built. And Bryant Chapel was scarcely more than four or five blocks up the road from the Twiggs's home.

To this day Leo cannot fathom why his father became

so devout, since from all he had heard the elder Twiggs had
not been especially religious prior to marriage. Still his son
recalls seeing him reading his Bible with regularity. And as
is true of most religionists of the fundamentalist school, he
was a strict disciplinarian. In Leo's words, "my father was
so strict that we had to do our chores or get our tails cut up."

Bryant Chapel was not of the traditionally Baptist or
Methodist denomination but a "Sanctified" church whose
worshipers followed the Biblical adage "Make a joyful noise
unto the Lord." Tambourines, drums, and an occasional
brass blended with clapping, stamping, and singing to pro-
duce that joyful noise in hypnotic syncopated rhythms. Leo
laughs in recollection of how the church "rocked and jumped
when the spirit caught hold and the brothers and sisters
began to get with it." That such fervor provided a needed
release from tensions induced by the constant threat of Ku
Klux Klansmen and lynch mobs is a grim truth of which the
rejoicers themselves were not always fully conscious.

The schools of Saint Steven were separate and unequal.
Leo recalls entering the Saint Steven Colored School at the
age of six and that a cousin who was in the tenth grade used
to walk him there each day.

Finally some enterprising black fellow got an old bus
and charged our parents thirty-five cents a week to pick
us up and take us to and from school. The white kids
rode a bus supplied by the county and for which their
parents did not have to make direct payment. But be-
fore we had that old bus we walked, and this cousin of
mine used to take me through the woods by the ditch
bank and across the track to the school. . . . Interestingly
enough the very poor whites fared just as miserably as
we did. But those whites with whom we had little or
no contact were the ones who rode the county buses
and who were in a world completely to themselves.

Leo was a sickly child. He did not drink milk and his frail body caused him to develop a shyness. It took him fully three or four grades to get into reading, and he doesn't recall that he was any more talented in drawing or even more motivated to do it than any of the other children in his classes. In fact, he was sure that even up to the fourth or fifth grade he would never make a go of school. But encouragement at home was ever forthcoming.

> Though my father never got beyond the eighth grade and though we had to study by kerosene lamps at home, both he and my mother encouraged me to learn.

When he reached the sixth grade Leo discovered that people admired others for what they could do. By that time he had developed a love of school—probably because of his inability to compete physically with the stronger boys. As a skinny unathletic kid he soon learned he would have to rely upon mental ability and achievement for recognition. Leo concentrated upon developing his mind above all else and the effort gained results.

> It got to the place where it began to mean a lot to me when others would come to me when they wanted help with their lessons. That was a department where the muscle boys were of no help, and that built my confidence in my own worth.

Teachers, of course, had much to do with Leo's development. His most enthusiastic praise goes to Miss Boyd, a teacher of English from Sumter, South Carolina. Until Miss Boyd came into his life Leo recalls that

> I had to get all the way up to the eighth grade before anyone told me anything about the eight parts of speech.

Miss Boyd was new to Saint Steven and not in the pattern of those local teachers who let the youngsters' poor speech

and ungrammatical writing slide by unchallenged. To a
rural southern youngster, especially a poor black one, learn-
ing properly to express oneself verbally and through the
written word is often a difficult and long undertaking. Strong
and dedicated black teachers of English such as Miss Boyd
are priceless gems to whom their students are ever grateful.
Leo Twiggs is. He knows now what articulateness in speech
and writing mean to him, especially when asked to relate
how he got started in art.

I'm often asked that and I remember that Field Day
was a big thing during my school days at Saint Steven.
Those who could cook well baked cakes and those who
were the best agriculturists displayed their achieve-
ments. I did a drawing of a lion, for the lion was our
school's mascot. It was a huge drawing and everybody
said it was "just great." I'd done it in color and even
though it evoked a lot of fine comments I realized I
hadn't done a really creative piece of work. I'd copied
it from a print.

The drawing was put on display in the local library and
though Leo enjoyed hearing the pleasant things people said
about it he wasn't satisfied. Scrounging about for paper he
found a piece of unused wallpaper which he took with him
as he set out for his school. Seating himself in front of the
building he proceeded to make a drawing of its façade.
Though the paper threatened several times to rip apart be-
fore he finished he finally completed his drawing. That, too,
went into the Field Day exhibit and it also drew local
praise.

Encouraged by the reception his drawing received, Leo
sent twenty-five dollars to an out-of-state correspondence
school for a course in art.

Ten dollars of that money came from my mother's
pocketbook, and I later told her I had taken it.

The rest of the money he earned by working as a janitor in a local movie house. All that the course really provided was the motivation to practice drawing with regularity, for he found himself repeating the same exercises over and over. Such was Leo Twiggs's introduction to the formal study of art, and he never finished the correspondence course.

When Leo was in the tenth grade his father fell terminally ill with cancer. Luckily Bertha Lee Twiggs, who believed each of her children should have an education, did not encourage Leo, her oldest, to quit school. Equally fortunate was the fact that Leo was able, through his after-school janitorial work, to earn some money while continuing his studies.

The Star Theater was Saint Steven's only movie house and, following southern custom prior to the late 1960s, it admitted blacks to one section of the house only—the balcony. Leo distinctly remembers that the balcony had exactly eighty-eight seats. Because the man who had formerly been janitor there did not want to work on Sundays, Leo had the job for that one day. His ailing father was dismayed. Badly as the family needed money, Frank Twiggs fretted because Leo had to miss Sunday School. But need outweighed other considerations and when the janitor quit and Leo had the job full time, his pay went up from the three dollars weekly he had been getting for working on Sunday mornings. Leo speaks of what transpired for him at that time.

> During my cleaning up chores I used to go up to the projection booth and carry sodas to the white projection operator who was bored with being stuck up in the booth all day. So he showed me how to change over from one projector to another and how to control the lighting while he stepped outside for a bit of air.

Another of Leo's chores at the movie house was to ride each week about town with the owner-manager, Mr. Funk,

and put up posters advertising the theater's coming attractions. Funk did the driving while Leo nailed the posters at designated points about Saint Steven. The relationship between Mr. Funk and Leo had always been friendly enough considering the mores of the region and the fact that the white man was the black boy's employer. Leo puts it this way.

> I used to read cast-off copies of *The Reader's Digest* that my classmate, Thaddeus Smith, gave me. He got them from the drugstore he worked in. Well, Mr. Funk liked to engage me in conversation because I used to talk about some of the things I'd read and he found them interesting. . . . So I assumed the man liked me and had a degree of respect for me—though I did notice that for all the extra work I did he never offered me more than my janitor's salary of nine or ten dollars a week.

Still Leo chose to believe that the boss was a friend. An incident occurred, however, that revealed not only the basic character of Mr. Funk but that of Leo Twiggs as well.

People were always losing and leaving items in the theater and one night a wallet and a U.S. Government check were lost. Leo found the check and immediately slipped it under the door to Mr. Funk's office where the owner would see it. The wallet, it seems, was found and kept by a young black roustabout who had been in previous trouble. Funk had failed to notice that Leo had slid the missing check under his door and Leo was summoned along with two other suspects to the magistrate's office at the town hall. The magistrate was none other than Mr. Funk. Leo recounts what happened.

> Suddenly the man I worked for after school hours was transformed into the big, fat, redneck cracker inquisitor.

"YOU STOLE THAT WALLET, NIGGER!" He was bellowing at Elijah Hall and hitting the boy with a wire coat-hanger. It was a shocking experience for me, for I had never before seen that side of the man.

Then he turned on me. "WHERE'S THAT CHECK?" I'd never heard him use that tone. I told him I'd slipped it under his office door, and he checked and found it. "OKAY, YOU CAN GO BACK TO WORK IF YOU WANNA!"

The truth is, I didn't want to. I wanted more than anything else to leave. But my father was sick and I was helping support the other kids while going to school. I couldn't afford to leave so I returned to my job.

Back at the Star Theater the white projectionist demanded more money. Funk came to me and told me to learn to operate the projector. That I knew how to do, so he told the projectionist he couldn't pay him any more and the guy went to a better job at the Navy Yard in Charleston. I was in the tenth grade when I became the theater's projectionist. The night my father died I ran my first movie!

Funk paid Leo fifteen dollars a week for projecting not only the regular shows but also for doing the morning "specials" for school kids. To make those shows Leo had to be let off from school early. Moreover, he ran matinees on Mondays, Wednesdays, and Fridays and had to be in the projection booth at three P.M. Though he himself didn't get out of school until two-thirty, he never missed a matinee.

I was never paid one cent more for my extra work. The white fellow who left for the Navy Yard had received twenty-three dollars for his work—with no extras to do without extra pay. It was nineteen forty-nine and I asked in vain for a raise. Funk was making plenty of money. Finally he gave me a raise to sixteen dollars—A ONE-DOLLAR RAISE!

When Leo reached his senior year in high school Mrs. Funk made him a present of his first set of oil paints, with which he made for her a painting of the theater's façade. The trunk he received as a graduation gift from the Funks could well have been Leo's cue in planning his immediate future. Certainly it appeared to lie well beyond Saint Steven. Besides, as the number-one student in his graduating class, it was generally taken for granted that Leo Twiggs was going to college. Indeed everybody just knew he would be in college the following fall—everybody, that is, except for Leo and his family. There was simply no money for college. Leo explains what the situation was in that regard.

> The principal of my high school talked about my going to college but that's as far as it went. In fact, any number of our own people in town talked about how important it was that I go to college but none of them seemed to come up with any scholarship ideas. . . .
>
> A lot of white people in town knew me because of my work at the movie house and it remained for one of them to take the initiative and come up with the needed help. The pastor of the white Baptist church, the Reverend Brown, came by my house one day. "We want you to go to college, Leo, and I will take you to see Reverend Roy O. McClain."

Leo bundled his artwork and went with the Reverend Brown to see the Reverend McClain. The latter took one look at the work and put in a phone call to Dr. John Seabrook, black president of Claflin College in nearby Orangeburg. A short time later Leo and the Reverend Brown were seated in Dr. Seabrook's office. Seabrook was brief and positive.

> Well, you'll still have to come up with some tuition but we'll give you half of your board if your mother can make the other half.

Leo registered at Claflin College. His mother had promised to send the school sixteen dollars each month and he would match that amount with earnings derived from regularly cleaning the art studio. Pleased as he was to be in college, Leo was uneasily conscious of leaving his mother to struggle alone with his five younger brothers and baby sister. He began to look about Orangeburg for anything else he could find to work at while at Claflin. Then he quite unexpectedly was called upon on campus by E.G. Bowman.

The manager of Orangeburg's Carolina Theater, Mr. Bowman, had been alerted by someone in Saint Steven that a motion projectionist named Twiggs was available at Claflin College. Bowman was in need of a projectionist and he hoped Leo would be interested. Leo found it impossible to hide his elation.

Man, I practically flew down to The Carolina from the Claflin Campus! Mr. Bowman sat with me in the booth and showed me his machines. As compared with what I'd operated at The Star these were GIGANTIC PROJECTORS!

With his knowledge of and experience with basic projection operation, Leo was confident he could quickly master the intricacies of these huge machines. And with need as his motivator he plunged into his work at The Carolina with verve and confidence. He needed both. The Carolina ran matinees at three P.M. every day, and Leo could not be on the dot all the time. But Mr. Bowman would get the projectors rolling the film so that Leo could rush in after class and take over. "He was," says Leo, "a very kind man." The gentility of E.G. Bowman was evident in just about everything he did at The Carolina. It was he who taught Leo the esthetics of movie projection—the art of easing the film from one projector to another to avoid the abrupt and jumpy effects that are seen when one switches too quickly

from one machine to the other in following the sequence of a film. Leo soon found that The Carolina, catering to the taste of a fairly intelligent clientele, was several steps up from The Star back in Saint Steven.

> The first movie I ran at The Carolina was *Roadhouse*, starring Richard Widmark, and Bowman complimented me on the way I handled it—the music—the opening of the curtain—the whole works. I began to see that there was an esthetic to that just as there is in using colors from the palette. And what made it all so pleasant was that Mr. Bowman paid me forty dollars weekly.

That too was a vast improvement over the situation with Funk back in Saint Steven. Still Leo worked extremely hard. He was carrying a full load of courses at Claflin even as he worked every afternoon and evening at the movie house. The money he did not send home he banked and from his account was able to put himself through college. So impressed was local businessman and South Carolina State College alumnus, Paul Weber, that he had Leo decorate the window of his college luncheonette. He later presented Leo an award for skill in handling his money affairs.

As exciting as Leo found his off-campus activities, he found study at Claflin just as challenging and exhilarating. The art department was, and currently is, ably directed by Charleston-born Arthur Rose, a gifted painter and sculptor, who thoroughly understands the needs of students. Close friends that they are to this day, Leo speaks of Arthur with warmth.

> Being under Arthur Rose at Claflin was the best thing that happened to me. He was new there and while he had his ideas about art he did not want me to paint as he did. That, I think, is Arthur's most signifi-

cant attribute as a teacher. Throughout my time as his student I never regarded him as an authoritarian figure above me but that we were colleagues learning from each other. And because I stayed in Orangeburg the year round I recall that one summer he let me paint a mural for my credits. That was in nineteen fifty-six, and the mural is still there.

Leo's remaining in Orangeburg continually from the time he arrived until he was graduated from college was due to his employment at the movie house. It was employment that he enjoyed as much as he wanted and needed it. He learned so many things of value there, including the meaning of promptness and reliability. Says he:

The show had to begin on time and I made my time. I think that is what Bowman respected in me. And I respected him for his decency.

So conscientious was Leo about his job that he would spend as much time as he could spare from his college work reading the trade journals. In that way he was able to create a few promotional ideas of his own. For instance, when The Carolina was about to run Alfred Hitchcock's *Dial "M" For Murder,* Leo got the local telephone company to give their sponsorship to a card urging moviegoers to *Dial "M" For Murder at the Carolina Theater.* For that he received Bowman's verbal praise plus a bonus at the end of the month.

As television began to cut in on the movie houses the latter tried experimentation. First there were the three-dimensional pictures. Leo ran the first in South Carolina. They were replaced by Cinemascope and Leo ran the first such picture in Orangeburg. Oddly enough few people there seemed aware that a black man was holding such a job, and if it were known it wasn't talked about. Leo sums it up this way.

Orangeburg has been plagued by racial tensions. Perhaps it is so deeply rooted, as is all of South Carolina, in the old Confederate traditions. So except for Mr. Bowman, Paul Weber, and some people on campus nobody knew. But if it was known in the community nobody ever mentioned it. After all they couldn't see me up there in the booth.

During his four years at Claflin Leo Twiggs received several plaques and special citations along with making *Who's Who in American Universities and Colleges.* He had his first train ride from Orangeburg to Tallahassee, Florida, when Arthur Rose took him to Florida A. and M. University and he met many black artists, including Hale Woodruff and Samella Lewis. The occasion was the founding of the NCA (National Conference of Artists). In 1956 Leo Franklin Twiggs was graduated summa cum laude from Claflin.

A year of military service sent him to Arizona and New Jersey between 1957 and 1958. The most meaningful aspect of that period was being close enough to New York City to get there from Fort Dix in New Jersey. For the first time Leo had a look at some of the museums and art galleries he had read and heard so much about. Aside from that he counts his army service as of little value in his life. Of far more interest to him was his initial teaching experience. That came upon his discharge from military service.

My first teaching assignment was at Lincoln High School in Sumter, South Carolina. And I was completely lost with the kind of material I was prepared to offer youngsters. So I began to take them right into their own neighborhoods with the understanding that they would draw the things they felt and that they knew best.

One of Leo's promising students at Lincoln High, a boy named George Day, brought him a drawing showing cotton pickers at work. It was, in Leo's words "a typical stereotype

scene" and under questioning the boy admitted he had never picked cotton. With a little urging from Leo, George Day went to Mayesville a few miles away and actually picked cotton. Back at school he took a piece of blue print paper, sponged out the color with clorox and when it was dry started in again to paint what he had experienced at Mayesville. Leo laughs as he tells what happened.

> That student came up with a group of working people floating in this field of white. I asked him what happened to the cabin at the end of the row, and all the other sentimental props that he had put in his earlier version. The boy's reply was funny. . . . "Doc," he said, "Man, 'long about noon I looked 'cross that field and all I could see was waves. An' I was floatin' 'round in this sea of cotton. Man, I thought the MONKEY had almos' got me!"

Leo's pride is unconcealed as he tells how that picture by George Day won the First National Scholastic Art Award for the State of South Carolina. But that was not all. During the same year his students won eight of nine awards. Two of those were the highest taken in the state and one was the First National Award given in New York State. It was shortly thereafter that Leo decided to spend a summer studying outside South Carolina, and he chose the famed Art Institute of Chicago.

Abstract expressionism was in high fashion then. At the Art Institute Leo found that practically all the teachers he was in contact with during the summer session were from New York City. He resolved that for the following summer he would go directly to the source, and the summer of 1961 saw him at New York University. There he pursued work on his Masters Degree under the guidance of eminent black painter, Hale Woodruff.

Twenty-seven-year-old Leo Twiggs was thrilled to be

the pupil of a man of whom he had read and heard so much.
Most of all he was hopeful that his work would capture
Woodruff's attention and perhaps just a little praise. Wood-
ruff, however, while not aloof, was quiet and noncommittal
as he looked casually from day to day at what Leo was
doing. Finally, Leo overheard his teacher telling someone
else with great pride that "Twiggs is really coming along."
At the end of the summer Woodruff graded Leo's work "A"
and two years later Leo had his Masters Degree from New
York University.

Back in Sumter, meanwhile, the superintendent of
schools, L. C. McArthur, Jr. was most favorably impressed
by Leo's classroom work. A man who knew and liked art,
Mr. McArthur readily and voluntarily increased Leo's salary
as he commended local school board members for buying
the works of Leo's students. And to make life even more
perfect, Leo had married attractive library assistant, Rosa
Johnson, who had left college and who was encouraged by
her husband to return and complete her studies.

Rosa was pregnant with our first son when an offer
came to me to take the job in art that had recently
been vacated at South Carolina State College in
Orangeburg. Benner C. Turner was President of State
then and Mrs. Ethel DeVane was the art department.

Though Mrs. DeVane was known to be somewhat diffi-
cult to work with, Leo established and maintained good re-
lations with her. At the same time he worked at the sub-
sidiary Felton Laboratory School with the young people
enrolled there.

At the Felton School I got right to basics as I had
done in Sumter at Lincoln High. It was a new building
and we took some of the construction materials and
made things from them. We made drawings of the
building and of the workers. The following year we won

ten state awards. Two of my students won top state awards and another took the First Scholastic Magazine Art Award for a print titled *The Art Class*. Her name is Bernette Gilyard and as an art major she will be graduated from State this year [1976].

After three years at State College the school's president informed Leo that there was federal money available for continued study at the University of Georgia. Had Leo not already done graduate study in both Chicago and New York the offer to go to Athens, Georgia, might have held a strong appeal. Besides, along with the rest of the nation, he had been hearing, seeing, and reading about the difficulty Charlayne Hunter (now a writer for *The New York Times*) had experienced trying to break the color barrier at the Georgia university. Leo finally decided to accept the offer, however. Along with three other black students he entered graduate school at Athens in 1967. His full tuition and his keep were paid by the government and he received half his salary from State College. Leo was quite unprepared for what he found at the University of Georgia.

I hadn't expected what I found there. Shucks! They had the most contemporary buildings imaginable and the head of the department was LaMarr Dodd. He said to me, "We won't think of you as a student but as a colleague." I was skeptical. Dodd looked like a Southern colonel—well-groomed and sleek, and I thought to myself, that's what they all say.

The doctoral program in art at Athens did not begin until after Leo had entered his studies there and it was LaMarr Dodd who encouraged him to apply for admittance to the program. Prior to that Leo had been content just to take courses at the university. At the end of his first quarter, with a straight A average, he was accepted into the program. Later, in a manner so typical of him, Leo chose a subject for

his dissertation that he felt needed serious exploration if art was to be meaningful to those with whom he worked most closely.

> My dissertation was on *The Procedure of Looking Critically at Art.* I'd chosen that because in my teaching I had discovered that while my students could make art, few of them knew how to look at it and to understand what they were looking at. After all, they wouldn't all be artists. There had to be consumers of art among them.

Leo Twiggs received his doctorate in Art Education and Art Criticism in 1970. And just as he had led his graduating class at Claflin College several years before, he was the only doctoral student in Art at the University of Georgia to be accepted into the National Honor Society of Phi Kappa Phi. With all his outstanding achievements there and the respect they engendered, he was, however, made conscious of racist attitudes in certain quarters.

> My rapport at the University of Georgia with the art department was great. Outside that department I found many students who would not speak to you outside the classroom. I'd give it right back to them by not responding in the classroom when they asked for my help or my opinions—AND I TOLD THEM WHY! In retrospect it is easy for me to understand why, of the four of us blacks who went there, I alone remained.

Leo's observation was sensitive and accurate. Even though barriers were tumbling in some areas of the South, they remained fiercely intact in others. A tragic example occurred at South Carolina State College while Leo was pursuing his studies at Athens, Georgia. Trouble grew from the refusal of All-Star Bowling Lanes of Orangeburg, South Carolina, to permit blacks use of its bowling facilities. On

the evening of February 5, 1968, a group of students from Claflin College and its next-door neighbor, State College, sought to use the All-Star Bowling Lanes. They were told that the establishment was a private club and as nonmembers they were not welcome.

The following evening more black students presented themselves at the bowling alley and when police were called a fight erupted in which windows were smashed and cars overturned. Seven students were hospitalized and seventeen arrested. National Guardsmen were called and on the next day, after students stoned cars passing the campus, one hundred highway patrolmen cordoned off the grounds and opened fire. Three students were killed and a score wounded. Tensions between blacks and whites in Orangeburg remained tight for many months thereafter. Meanwhile Leo Twiggs, with his doctorate, received offers to resume teaching elsewhere but he preferred to remain at State College and offer art as a major course of study. He wrote up a program outlining his intentions.

> So many Art Education Programs deal heavily with education and barely touch upon art. I believe that if you're going to be a teacher you ought to feel a few things. So I developed a program with a very strong studio emphasis on design. The students had to know something about composition—line, form, and color. Now we are constantly looking for strong talents in painting and printmaking.

Along with the expanded courses in art, Leo, in 1972, established an art gallery at State. The only art gallery in a black school in South Carolina, it shows not only the works of nationally known artists like Benny Andrews but also works by artists native to the state. One such was a collection of quilts by eighty-nine-year-old Roxene Brimmage of Saint Steven. For the first time in her life Mrs. Brimmage

permitted the removal of her quilts from her home, and then only because of her long friendship with the Twiggs family. And also for the first time in their lives many viewers of this lady's work learned that the making of beautiful quilts is a fine art.

Dan Robert Miller, a former truck driver who suffered a heart attack that forced him to give up driving, began to carve. His exquisite and highly individual work was put on view in the gallery at State so that, in Leo's words, "our students can learn that there are people around here who, with no formal training, comment upon the human condition in a way that is rarely matched by the art sophisticates."

The teaching of talented people and the directing of art programs constitute a full-time job. How he manages to function also as a practicing artist while doing the other two jobs seems a near-miracle. Yet Leo Twiggs does it, as one observes when looking over the artist's sensitive "batik paintings." He speaks of his work in that medium as he designates certain of those to which he is especially attached.

> This, as you see it now, started when I came here to State in nineteen sixty-five. Prior to that I'd been introduced to it at the Art Institute of Chicago—making scarves. But once I got here I began experimenting to see what I could do with it as a painting medium. . . . In using it in the painter's manner I began seeking ways of using the crackle texture, which is the character of batik, as plastic elements in the composition. And I've worked at controlling the crackle and applying the color to achieve depth rather than mere surface decoration.

What Leo does after he has used the drawing, hot wax, and dye on the cloth to achieve the batik is to stretch it over a board as one would stretch a canvas. He is then free to work further on it as he chooses. Borrowing liberally from his ex-

periments in abstract expressionist painting with Hale Woodruff at New York University and Sam Adler at the University of Georgia, he had found the color he wished to use. Next was his choice of a theme. That, for Leo Twiggs, posed no problem.

> I went back to my own experience as a child and I began to draw the figure, the BLACK FIGURE! . . . I painted old men, old women, and children. And I did them with a feeling for their dignity and their humanity.

For Leo, making batik paintings of the children was—and is—a most serious effort, for he sees them as "our future." Freely admitting that he has found it difficult not to lapse into sentimentality, he nevertheless does not hesitate to remember the little things—a towel hung over a crack—a piece of newspaper to conceal a wall blemish—rugs that never match. One notes also that the heads are symbolically similar and that the mother-image and especially the father-image are both visible and strong.

It is interesting to Leo that most of the purchasers of his batiks are young whites of the middle and upper classes who identify his creations with their own experiences. Their wanting to have such works near them—wanting to live with them—convinces Leo that the "black experience" is but a segment of the broad human experience.

> I tell my students constantly, "When you forget where you came from you don't know where you are going."

Leo Twiggs has by no means forgotten or abandoned the truth and the meaning of his own beginning in Saint Steven, South Carolina.

Dana Chandler

No ONE who spends fifteen minutes with Dana Chandler comes away with vague and uncertain feelings about him. You like him or you don't and the intensity of what you feel is about the same in either case. For one thing, he is as demanding of himself as he is of others and he is not likely to compromise his principles for anyone at anytime. That is a trait he cultivated growing up in a home where character, principle, and learning were held in high esteem.

My parents believed in education and in serious study. If you came home with a "C" or a "D" you were in deep trouble. That's also the position I take with my children who, fortunately, have more than average intelligence, and they had better use it if they want to live around me! I can deal with people who don't act intelligent because they have no other choice. But I don't believe in having people around me who don't act intelligent when they are.

Dana's grandparents immigrated to the United States from Barbados and Nova Scotia. His parents, Ruth and Dana Chandler, Sr., are natives of Massachusetts. Of their seven children, Dana was second to Gordon. When Dana was five the family settled in Boston's predominantly black Roxbury section, where in 1945 he was enrolled first in the Asa Gray

School and later in the Sherwin School. Never hesitant to speak his mind, especially about racism, Dana recalls his earliest school years.

> I wasn't conscious of race as race while I was a kid in school, though I was certainly conscious of racism all around me. There weren't many of us in Boston as I remember my grade school days of the nineteen forties. So there was less racism then in the schools, though most of the public school teachers in Boston did not want to work in Roxbury. But they went to teach where they were sent and my feeling is that we in Roxbury were not sent the best teachers. So while what I got in the schools was adequate much of my early education came from other sources.

The Chandler home was one of those "other sources." Dana's mother, Ruth, had not completed high school but she learned to use excellent diction and insisted her children do likewise. The results are obvious in Dana's speech. Moreover, both Ruth and her husband were "heavy handed" when they had to be, a fact that Dana neither conceals nor deplores. Though he was fully aware that there was little money around for him to squander on things that might have pleased him, he never as a child knew that he was poorer or that his neighborhood was less fancy than anyone else's.

> It was only when I grew up that I became angry at my upbringing—and then only in terms of what could have been done for us if my parents had been allowed to work and earn at the top level of their ability. We would have had much more—though we wouldn't have had much more love. The fact that I wore knickers in nineteen forty-nine when they were fifteen or twenty years out of style and the kids teased me wasn't really important.

Dana attended Boston's J.P. Timothy Junior High School, from which he was graduated in 1956. From there he went to Boston Technical High School. He had enjoyed drawing ever since he was a child and it was in high school that he had his indoctrination in approaching art with serious intent. Above all others he credits one of his teachers, Ralph Rosenthal, for goading and nagging and supporting him during his three years at Boston Tech.

> Ralph Rosenthal was an American Jew who believed in one thing only—EXCELLENCE! And he didn't give a damn what color you were. In his class you had better be excellent or he'd be right on your case! He was good for me for he was the first to make me really work at art. And it was he who was responsible for my getting the First Annual Technical High School Art Award— which came to me as a delightful surprise.

Dana hastens to add that his parents were no less enthusiastic about his desire to pursue the study of art, though his mother was concerned that he might find earning a living at it difficult. Neither parent, however, felt that art was a senseless pursuit and that artists were all "crazy." In fact they were joined in their encouragement by Dana's younger sister, Jean, who to this day is similarly supportive of all the family members. That collective boosting within the close-knit circle was rewarded with Dana's being the first of them to be graduated from college. Still Dana does not fail to say that it was Ralph Rosenthal who stood tall and strong at Tech where and when encouragement was so desperately needed.

Since then and to the present time Dana Chandler has been at decided odds with many individuals and groups representing authority. Among the latter is the Boston public school system, of which Ralph Rosenthal was still a part

when Dana was freely launching his attacks. Dana recalls an exchange with his former idol and teacher.

When I talked with Ralph Rosenthal several months ago he told me he was quite upset to hear me say that I learned very little from the Boston school system. I said, "Ralph, I'm not talking about you but about the system you worked for and got positive results in spite of. When you spent your own money to help students—and I include myself—you were going above and beyond the system that employed you. And whenever I have a chance to publicly clarify this I shall certainly do so." I learned a lot from Ralph and he was one of the strongest influences in my determination to go into art.

Along with Rosenthal Dana was strongly influenced at Tech by Gunnar Munnick, the teacher in charge of the woodwork class. Munnick, a man with extensive knowledge of woods and the handling of the woodcraftsman's tools, was also a respecter of serious work. His concerns were with conscientious application to study and quality of performance, and like Ralph Rosenthal he was not concerned with the race or the color of the craftsman. While neither teacher nor pupil was consciously aware of it at the time, the potency of the former's influence would shortly lead Dana Chandler to a serious and important decision.

During his last two years of high school Dana had a job at the Retner Foundation, a science center where research in cancer was done. While he carried the title "Laboratory Technician" he admits that in reality he was "little more than a glorified bottle washer." But the pay was adequate and useful and he remained in the job as a full-time employee after completing high school in 1959. A year later, as he was turning twenty, Dana could see little future for himself at the Retner Foundation. He began to think about his parents—their hopes for him—and he thought also about

Ralph Rosenthal and Gunnar Munnick and all they had done to encourage him. Bundling his drawings and paintings together he took them to the Massachusetts College of Art and asked if he could obtain a scholarship. He got it.

> I decided upon that school not only because I wanted to be an artist but because I wanted at the same time to earn a living at it. So I entered their program for teachers. What I didn't know then was that I did not want to teach at the elementary or junior high or high school level. I wanted to work with college level people.

At the Massachusetts College of Art Dana quickly recognized the value of the technical skills they could teach him to master. Still he could not in his own words, "deal with their philosophy at all." The philosophy with which Dana had no wish to deal was coming into vogue in Boston during 1960. It was a philosophy of giving noticeable representation to local ethnic groups who had heretofore been ignored. Prior to that, equal opportunities as well as positions of power and responsibility had gone to the old-line guard so solidly entrenched in Boston's political life.

For generations prior to 1960 Massachusetts was enmeshed in the cogs of a stagnant Democratic political machine. It was a machine often described as "tribal and feudalistic" and dominated by the powerful Kennedy and McCormick clans. The resultant corruption had given the state such an unsavory name that progressive forces in Boston resolved to establish a better state government by breaking the strangleholds of both the Democratic rogues and the aloof Republican Yankee bluebloods. They also resolved to bring in new ethnic names—and faces—to offset charges that positions of political power were the fiefdom of the long dominant powers.

One of the first moves in that direction was the election in 1960 of the first Roman Catholic Republican to the gov-

ernorship of Massachusetts. He was John Volpe, a man of Italian origin. Two years later the Republicans offered an Irish, a Jewish, an Italian, and an Afro-American candidate. The latter, nominated for Attorney-General, was Edward M. Brooke.

That policy of infusing the local political body with ethnic blood carried over to a slight degree into higher education. But it was never believed by the truly serious-minded that in either place had any truly significant transformation taken place. Certainly bright and perceptive students like Dana Chandler harbored few illusions, as his observation of what he saw, heard, and felt at the Massachusetts College of Art indicates.

What had come out of African culture interested them not one bit. There was nothing there to remind me of me. So I found myself wandering the halls for I didn't want to deal with their philosophy—an attitude I now regret, for I'm sure I missed out on many of the skills I need as an artist. But the place depressed me. Though Cal Burnett was there doing his job as a professor he was not the image I needed at the time—when we were in the integrationist phase where we'd all be brothers and sisters together. Now, with more black students to work with, Calvin Burnett is more into the Black Experience with them.

In addition to his studies, Dana was involved with the National Conference of Christians and Jews and the National Association for the Advancement of Colored People. His feeling about the function of both groups was that "they were trying to let white folks know they were oppressing us." Moreover, Dana was certain that white folks' idea of being brothers and sisters to black folks required that blacks forsake their honest feelings and become as "white" as possible in both attitude and outlook. That had no appeal to him and he began drifting toward the philosophy of "black

separatism"—the theory of blacks governing themselves in their own land. There, he admits, he hit a snag for he wasn't interested in the least in the rough pioneering work such a step requires.

Between 1962 and 1967, when Martin Luther King, Jr. and Malcolm X were much in the public consciousness, Dana Chandler's loyalties were far from certain.

I was not more than two hundred yards from Martin as he was making his famous "I Have a Dream" speech. After the March, Malcolm came to Boston and commented upon how the March had been taken away from blacks by white liberals. I swung toward Malcolm's views. Then both he and King were murdered.

Prior to his awareness of Malcolm, Dana's art had been a mixture of abstract painting and "message canvases" treating the integration theme. He describes those essays as "all compromise because I didn't have enough technical skill to handle the human figure or human imagery." Then in 1967 Dana Chandler witnessed something that was to bring about a complete change in his work.

A rally was held up in the Grove Hall at the welfare office here in Roxbury, Boston's black community. A group of mothers and their community supporters had gathered to try to make the welfare system more equitable—a struggle that is still in progress, by the way.

The police were called to disperse the crowd and the police rioted. That has to be made very clear. The police went beserk—beating pregnant women. Many of my friends were beaten. And one of the things I saw was something Malcolm had been saying quite clearly. Martin and Dick Gregory had also been saying it, though up to then I hadn't really known it. What they said was that it didn't matter what your economic, social, or political situation is here in America; if you were black you were still a NIGGER. And you were fair

game for any European American who wanted to beat your black ass.

Thus convinced of the futility of trying to establish rapport with such unreasoning attitudes, Dana immediately went about resetting his course as an artist. He then knew he must direct his imagery toward creating the visual story of what was happening to black people in America. The inclusion of whites in his art would therefore occur only in terms of the part they played in what was happening to blacks. As a result, those areas of his work that commented upon white oppression of black people would contain no white images but images of the symbols representing white Americans in power.

Dana clarifies the point as he explains that his anger is not directed at all whites in this country. It is meant specifically for those in power who suppress black people as well as for those who collaborate in the suppression. And he is "quite willing to work with anyone of any color who will help free blacks from the oppression of this nation." Chandler knows many such individuals and he works well with them, as will shortly be seen. Still he maintains a vigilance, not only against white racism but against the insecurities and resultant jealousies and machinations of his own people.

They can and they do bring a lot of damage upon us. A lot that happens to us comes because we allow it. We don't have to allow dope "pushers" in our neighborhoods but we do. The same goes for the other crimes. We've adopted some of the worst habits of European-Americans. One of them is not wanting to get involved. How do you change anything unless you get involved?

Dana Chandler began early to be involved. Quite recently, with a grant of $1000 from a local group, The Boston

200, he has created a work that he is certain will not send shivers of joy through members of the sponsoring group. It depicts two men. One is an obviously hopeless drug addict. The other is a person who, even as he clings to his wine bottle, uses the drug in moderation and maintains basic mental and physical health as he proceeds with his black nationalist program of nation building. *The Bicentennial Choice* is the title Dana has given that painting. And it summarizes the changes that have come into his work since the deaths of Martin Luther King, Jr. and Malcolm X.

Even before he conceived the idea for the painting, Dana had been "involved" in yet another way during the latter part of the 1960s. Following graduation from college he worked at nonart jobs for a while. Because of his skill at verbally articulating ideas and simultaneously relating to people of the streets, he was called upon to work in certain programs based in the black community he knew so well. Meanwhile, having married at twenty-one and having left school against the wishes of his wife, Dana's growth expanded under the pressures of his blunders. He makes no attempt to lift blame from himself.

> I married far too young. A lot of the problems and the ensuing divorce I can place squarely on my own head. I had two more years to go in college and was married and working full time. Young men are very arrogant and I was very young. My wife had told me to stay in school and if I didn't she'd leave me, but I didn't believe that—didn't choose to believe it. I am egocentric and a son of a bitch to live with—I'd be either up or down and I made up my mind it would be up and everything would have to stop while I was moving up. So with my arrogance coupled with male chauvinism there was no way our marriage could work.

The full-time job Dana held was with the Poverty Program. He lived on the edge of Roxbury in the Jamaica Plain Housing Project and was the Community Organizer for the Jamaica Plain Area Planning Action Council. The council was a division of the Office of Economic Opportunity. As a resident of the housing project, Dana observed that "living there was like living in a zoo," what with fatherless families, congested quarters, and the constant menace of drugs. One of his comments on that experience bears repeating.

It was while in community work that I had a chance to learn that all black people weren't wonderful and all whites weren't arrogant sons of bitches. And it was a difficult lesson for me because I wanted to believe that black people were wonderful. But I found out that there were those of our people who wanted to see me die rather than see me with that job. And there were others who, along with whites, wanted to see me succeed. So I came to know that human vices and virtues exist among us all, and that I am not so wonderful as I like to think I am.

Upon leaving that job Dana went to work for the Brandeis-Lindbergh Center for the Study of Violence. His summary of that encounter is at once ironically grim and hilarious.

I was supposed to interview black folks about why they get violent. A couple of us who worked there turned the tables. Our resolve was simple and direct. "We ain't gonna do this shit!" So we interviewed white people on why they got violent. It wasn't hard for us to find hippie types for our purposes. I found out very quickly that this was just another "nigger-checking station"—a nigger-research center where they study niggers

to find out how niggers function. The information they gathered and were supposed to use merely for study would eventually work its way back into nigger control at the hands of the CIA and the FBI.

Dana Chandler made yet one more important discovery involving a number of the "white liberal friends" of black folks. They could be relied upon to show up at meetings, demonstrations, and along picket lines. They were out, so they believed, to help blacks get their rights—until the violent police "went upside their heads a few times." Their liberalism then took swift and permanent flight. So after six or nine months with the Center for the Study of Violence, Dana quit.

I could not in good conscience work at a place set up to study black people so that white folks could continue oppressing us. And whether or not those who set it up originally saw it that way was their problem. But this I know. At no time did I ever supply them with information that was usable for what they had in mind. And I think they must have been happy to see me go.

The next job was more closely related to art, for Dana was hired as the Director of African Arts Curriculum Project at the Educational Development Center at Newton. Although it would have been pleasant in a purely physical sense to occupy an office somewhere in the tree-shaded upper-middle-class white Boston suburb of Newton, Dana made certain that the project's base was in the black community. It was he who wrote the project's proposal—"explaining to white folks how we black folks function. The job soon grew irksome."

From there he worked in the Model Cities Program which, since it brought him into direct contact with those who needed it, was more rewarding. Then there was the

brief and trying period at the aforementioned Roxbury-based National Center for Afro-American Art headed by Elma Lewis. Dana's recollection of that interlude is typically refreshing in its frankness.

> They do a great community job but there are so many egos there vying for attention. It was the first time I'd been in any place where everyone's ego was as big as mine. And that was a devastating experience!

Through both his community work and the showings of his art Dana Chandler was a name Bostonians were beginning to see, hear, and—most of all—remember. Because Dana was no shrinking violet to be pushed aside and because he saw to it that no one ignored or forgot him, his contacts began to expand. There were those among the influential who thoughtfully refused to be shocked or outraged by the things Dana was saying in either a verbal or a pictorial way. Indeed such people found the young black artist-spokesman not only challengingly articulate and intelligent but charming as well. Dr. William Holmes, president of prestigious Simmons College for women, was one of them.

It was 1970 when Dana, in conversation with Dr. Holmes, told the distinguished educator that he would like to become Artist-in-Residence at a number of the colleges. Most especially did Dana stress that he wanted to be in the position where he could be seen and heard not only by students but by people of the communities invited in by the schools. In that way the public could get a firsthand view of what the artist is and how the artist functions. What Dr. Holmes did was to see that Dana was hired as Assistant Professor of Art at Simmons.

> I had never before taught at the college level. The hardest thing for me was to develop a teaching program. I'd no idea what a hard job that is. You are teaching

people who are paying you to be taught. And I do believe that we blacks are required to be supermen in this country, and as such have no choice but to work three times harder than anyone else for equal—and most often less—recognition.

While Dana's words may seem exaggerated, those familiar with the Simmons traditions know how demanding its standards are. Its reputation as one of America's finest colleges is held firmly intact today as much by the demands of its students as by those of its staff. The Simmons women are no gullible starry-eyed females content to accept meekly every pronouncement handed them in the name of enlightenment. Coming as most of them do from affluent backgrounds where home environment, exposure to world travel, and specialized precollege preparation have been the norm, they are not to be bulldozed. The best of them listen carefully to what is said by their teachers. When it runs counter to what they believe to be true they have no hesitancy to say so. Dana Chandler's own leaning in that direction helped him understand and approve of their attitude. Yet another thing about the school held his attention.

Simmons has a very small black working enrollment—about five percent of the staff is black and about one-tenth of one percent of its teaching faculty is black. There are one hundred sixty black women there and they are my "reason for being." I arrived there in nineteen seventy-one and I teach Art History from a Black perspective along with two courses in painting.

Dana is convinced that his ouster was sought almost as soon as he arrived "by someone who had a problem there." At the time of this writing five years later he is still on the job. Moreover, on the basis of the credentials he earns as a practicing artist when he is not in the classrooms of

Simmons, he is seeking early tenure. The intervening years have not, however, been without their problems.

> In nineteen seventy-three someone destroyed the studio I had in the south end of Boston. Not to be confused with the infamous "Southie" where blacks are set upon by mobs of racist whites, my studio was at one fifteen West Brookline Street. It's a homogenous area with blacks, whites, and Puerto Ricans living together. . . . Well, I'd made my first trip out of the country—to Bermuda—and I came back to discover someone had done a real number on me!

Dana's studio had been broken into, his file cabinets and art supplies ruined with water, and his work ripped and torn. He even found fragments of the latter nailed to walls in and about the vicinity of the ransacked studio. That it was the work of a person or persons who knew him is something Dana has never doubted. Still, nobody saw or heard anything he or she is willing to tell the victim about. It looked like an act of deliberate sabotage—a not unlikely possibility, in view of the enemies Dana's verbal and graphic barbs have created. At the same time he has formed friendships that are just as warm and thoughtful as the hatred is unreasoning.

As soon as they learned of Dana's loss the black students at Simmons rushed to his aid with money they had raised from dances. Their gift amounted to $1009. Both the money and the concern that motivated its collection meant much to the artist.

> One thing I discovered was that no artist or his work is immortal. But to this day I am paranoid as hell about who comes to my door and who gets in my studio.

Simultaneously Dana quickly adds that the support he received convinced him that there were those who did care

about him and his work. That friends he didn't know he had came up with money when he was in trouble, reassured him that he was traveling along the right path.

For a complete year following the sacking of his studio Dana was on the hunt for studio space—space he could afford. One of the persons he spoke to about his need was the dean at Northeastern University, a man a few years younger than Dana, who had known of his work. Luckily there was available space at Northeastern which Dana was assured he could have if he'd be willing to teach a course. It was an offer Dana Chandler could not refuse. And what space it was!

The vastness of Dana's studio seems in keeping with the size of Northeastern University. With its 45,000 students it is, says Dana, "the largest private university in the world." To make the situation even more attractive he learned that he would be teaching his course at Northeastern in the Department of Academic Studies headed by able Ramona Edlin. The visitor to the Chandler studio who sees it for the first time is all but overcome not only by its size but by the relative comfort it affords. Warm in winter and cool during the summer months, it is the ideal workshop for any artist. You walk about the large area that is Dana's working space and you realize you are walking through but one corner of his entire room.

Then you look at the many paintings and drawings the artist has completed or is still working on. The primary colors are painted almost, if not entirely, flat and pure. One gets the feeling of being in an enclosure of organized space, line, form, and color—looking out upon a huge clearing under a ceiling supported by horizontal steel girders and vertical posts. The artist, a well-built, dark brown man, speaks and gestures easily as he discusses his work. A car horn sounds.

"Hold on a second," he says, striding quickly to a window to glance down at the street a couple of stories below.

No, it isn't the party he's expecting and he resumes talking about his works. His attention has focused upon a drawing depicting the white racist's pathological fear of what he imagines to be the super sexual prowess of the black super stud.

Take this phallic thing, for instance. "The man" can't deal with it—can't take it at all. Some black people can't either.

He laughs shortly.

An artist who looks for approbation is going to be disappointed—that is if he's doing anything.

The subject turns to methods of teaching.

I think an artist should be verbally articulate enough to tell people what he is doing. And in case people mis-state what he is doing he should be able to correct the misstatements.

In that regard Dana shares much in common with Benny Andrews, who makes liberal use of the spoken word even as he draws and paints.

I've learned a lot from Benny as a human being and I've admired his ability to survive in New York City.

At Northeastern University Dana teaches The African-American Art Experience. When asked about plans for the immediate future the artist does not hesitate.

I don't think imagery is going to change very much. The process of creating that imagery will grow and change but not the imagery itself. I'll try to get into silk-screen and such but I shall continue to talk about those things of great concern to black and Third World peo-ples. And it cannot be just "esthetically good." Besides it cannot be esthetically good without having a message,

and it can't have a message and not be esthetically good.

He glances about the studio momentarily.

—And I'll probably continue teaching. You see, I'm teaching to learn.

Index